THE ALLURE OF EMPIRE

THE ALLURE OF EMPIRE

Art in the Service of French Imperialism

1798–1836

TODD PORTERFIELD

Princeton University Press

PRINCETON, NEW JERSEY

Published by Princeton University Press
41 William Street
Princeton, New Jersey 08540

In the United Kingdom:
Princeton University Press
Chichester, West Sussex

Designed by Diane Levy
Composed in Garamond typefaces by Duke & Company, Devon, Pennsylvania
Printed by Paramount Printing

Printed and bound in Hong Kong
10 9 8 7 6 5 4 3 2 1

Library of Congress Cataloging-in-Publication Data
Porterfield, Todd B. (Todd Burke), 1960–
 The allure of empire : art in the service of French imperialism,
 1798–1836 / Todd Porterfield.
 p. cm.
 Includes bibliographical references and index.
 ISBN 0-691-05959-4 (cloth : alk. paper)
 1. Nationalism and art—France. 2. Art and state—France. 3. France—Cultural
policy—History—19th century. 4. Exoticism in art—France. 5. Romanticism in art—
France. I. Title.
N6847.P59 1998
701′.03′094409034—dc21 98-23442
 CIP

Contents

Acknowledgments vii

Introduction 3

1 ⊶ The Obelisk at the Place de la Concorde 13

2 ⊶ Paintings of the Egyptian Campaign 43

3 ⊶ The Musée d'Egypte 81

4 ⊶ *The Women of Algiers* 117

Afterword 143

Notes 153

Bibliography 215

Index 235

Acknowledgments

This book owes a great deal to the stalwart integrity, intellectual force, and collegial generosity of a number of scholars. As an undergraduate at Northwestern University, I began my study of French art and politics, inspired by the example and teaching of Susan Siegfried. Rick Brettell and Suzanne McCullagh then generously employed and trained me at The Art Institute of Chicago; from them I took—and no doubt perverted—an interest in a diversity of artistic media. In graduate school, Fred Licht nurtured and informed my thinking, conveying his understanding of the tragic underpinnings of modernism. My subsequent encounters with Edward Said's and Linda Nochlin's work on Orientalism were pivotal. They sent me to thinking anew about the main trajectory of art history, about significant but previously obscured monuments, and about the basis of France's modern, post-Revolutionary order. Professors Licht, Kenneth Bendiner, Jonathan Ribner, and Henri Zerner astutely guided me in my dissertation, which formed the basis for the current study.

Along the way, research and publication of this project have been supported by the Florence J. Gould Foundation, the National Endowment for the Humanities, the Forbes Foundation, and, at Princeton University, the Department of Art and Archaeology and the Committee on Research in the Humanities and Social Sciences.

Curators, librarians, and archivists on both sides of the Atlantic greatly facilitated the research itself. I am indebted to Pierre Rosenberg, Jacques Foucart, and Monique Kanawaty at the Musée du Louvre; Christophe Leribault at the Musée Carnavalet; Frédéric Lacaille at the Musée de l'Armée; Isabelle Klinka-Ballesteros at the Musée des Beaux-Arts in Orléans; Margaret Stuffmann at the Städtische Galerie in Frankfurt; and Neil MacGregor at the National Gallery in London.

I have had the opportunity of presenting some of my preliminary research in scholarly forums. My thanks to my hosts and interlocutors at the College Art Association, Connecticut College, Princeton University, Rutgers University, the Internationales Forschungszentrum Kulturwissenschaften in Vienna, and the University of London. The National Museum of Women in the Arts has kindly allowed me to reprint parts of my chapter on "Western Views of Oriental Women" from its book *Forces of Change: Artists of the Arab World.*

I would also like to thank my editors at Princeton University Press. The hard work and dedication of Patricia Fidler and Curtis Scott, and the energy, persistence, and talent of my copy editor, Linda Truilo, have been greatly appreciated.

Informed, generous, opinionated, and supportive colleagues are one of the pleasures of academic life. The following people came through with everything from a careful critique of drafts sent from a stranger to a constant and steady stream of material and friendship. They deserve to be thanked here, among them, Philippe Bordes, Anne-Marie Bouché, Jacqueline Sheehan Bredar, Gen Doy, Mary Hamer, Mary Harper, Lynn Hunt, Dian Kriz, Sarah Linford, Alisa Luxenberg, Carol Ockman, Sylvie Perrier, the late Nancy Rash, Arden Reed, Donna Rifkin, Mme Servoise, Carl Schorske, David Van Zanten, and Kate Walbert.

Other colleagues and friends lived with me and my work in closer proximity, and I relied on them and learned from them constantly. I warmly thank Robert Baldwin, Dorothea Dietrich, Denis Echard, Laurie Monahan, Adrian Rifkin, Robert Simon, and my friend, colleague, and partner, Benoît Bolduc.

Finally, this book is dedicated to my parents, with love, gratitude, and respect.

THE ALLURE OF EMPIRE

Introduction

To examine the cultural foundation of the modern French empire is to be enmeshed in the same web of obfuscations and interdictions that, just a few years ago, greeted scholars looking into Vichy's cooperation with the Nazi regime. France's modern empire began two hundred years ago when Bonaparte invaded Egypt in 1798. By the end of the nineteenth century, it extended to Senegal and Vietnam and included one sixth of the world. Its death knell sounded only three decades ago when Algeria achieved independence. Still, every day we are reminded of France's continuing engagement with its former colonies. Occasional sensations, in the Americas, Africa, Asia, the Mideast, and the South Pacific, alert us to its conduct in its former and vestigial overseas possessions. Today, two hundred years from the origins of this endeavor, the topic remains sensitive and relatively unexplored.

Look, for instance, how one of the best and most recent synthetic treatments of the history of French colonialism treats the critical moments in the founding of the modern empire. The *Histoire de la France Coloniale* recognizes France's 1798 to 1801 invasion and occupation of Egypt as the "major event in a new direction of French policy in the Mediterranean," the precursor to the invasion of Algeria, and the genesis of "the Orient of the French." Its authors say, however, that, at the same time, the Egyptian campaign was not "a true colonial event, but a typically exotic episode in the Napoleonic epic." Therefore, they conclude, "it must be classed apart." The next major step in France's intervention in the *proche Orient,* the Restoration monarchy's 1827 blockade of the harbor of Algiers, is usually ascribed to the blow with a flyswatter suffered by the French ambassador, an incident that, the authors admit, is "too famous." The real justification, they say, was "a sordid history of past debts [that]

3

grew into a diplomatic rupture that was more symbolic than real." The subsequent July 1830 conquest of Algiers, "the point of departure for France's second colonial period," was soon followed by the July Revolution, leaving the monarchy of Louis-Philippe with "an embarrassing heritage." Embarrassed or not, Louis-Philippe extended the French conquest to the rest of Algeria and cemented France's imperial plans, although, according to the authors, France was too busy with industrialization during the July Monarchy and had little "leisure" to occupy itself with this new field of action, colonization. Only "la vanité nationale," they say, kept France in the Maghreb, almost despite itself.[1]

To investigate governmentally supported culture promoting imperialism would then seem indelicate, at least, given the persistence with which French territorial expansion in the first half of the nineteenth century is presented as halting and nearly accidental. It would seem petty to examine something so haphazard, something so timidly entered into, something that seemed to turn on a series of embarrassing and trifling incidents. The focus of this book, however, is not directed toward the idea that French imperialism in Egypt and North Africa almost did not happen, but on the fact that it did.

———

It is the argument of this book that even before France conquered Algeria, that is to say, even before it acquired the first of its modern overseas "possessions," French artists and governments provided a rationale for the imperial project. Governments and artists produced an imperial culture that preceded France's enduring imperial expansion. By the time of the 1827 blockade and the 1830 invasion of Algiers, "the point of departure" for France's modern empire, an officially sponsored and widely broadcast rationale was already in place. Each post-Revolutionary government contributed to and called on this new national culture to justify imperialism in the *proche Orient,* as each sought to avoid the political and social fissures bequeathed by the Revolution. Each developed a national project, identity, and culture that fabricated and diffused rationales for imperialism in the Near East. Each helped lay the foundations for a sense of nationalism, or, as Max Weber defined it, a unified national project forged through "a specific sentiment of solidarity in the face of other groups."[2] Although, in fact, narrow economic interests motivated the imperial advances—Marseille merchants advocated the blockade of Algiers in 1827, Lyon silk manufacturers backed the invasion of 1830[3]—governments needed to create the sense that this was and should be a national endeavor. Weber noted that, as nationalism is based in the sphere of val-

ues, intellectuals (and artists, I would add) had a special role in its creation. Through images of the exploits of the conquerors, new realms of museology, the works of a most sophisticated artist, and the metropolis's plan and decoration, official culture promoted the rationale for a foreign policy that became a central focus of national identity in the nineteenth century and well into our own.

The allure of empire, I will argue, derived from its function as surrogate, mask, and displacement of the Revolution. Indeed, the relationship between revolution and empire is one of the central themes of this book. Alexis de Tocqueville, in an 1840 speech before the Chamber of Deputies, called it "the greatest question of the century."[4] France could destroy itself by continuing the struggle over the Revolution or divert its attention to intervention in the East. The revolutionary passion and the nationalistic passion were, he said, the two major currents in French society. Only the nationalistic passion, expressed through intervention in the East, would bring order at home.

The choice was not made. France dedicated itself to both revolutionary and national passions. However, histories and art histories overwhelmingly follow the vicissitudes of the revolution and counterrevolution. And why not? The revolutionary passion overturned regime after regime in the nineteenth and twentieth centuries. In the most official and monumental arts—sculpture, architecture, and public monuments—each regime tried to legitimize its authority by broadcasting the rationale for its power, annulling the logic that supported the previous regime, constantly revising and effacing the monuments that came before, and, by the end of the nineteenth century, relegating the most authoritative traditions of public art to banality, eclecticism, and bombast. The illustrious historiography of modern France, beginning with Burke, Michelet, and Marx, charts the fractured course, and a great tradition in nineteenth-century art historical studies follows their lead. These narratives chronicle how artists, critics, patrons, and their publics lived and died according to the revolutionary passion. It is by now a familiar story, often sparked by the urgency to renew or repress the revolutionary legacy. Its telling and retelling, however, serve to obscure the other, stable basis—the imperial basis—of French national identity.

———————

Concurrent with the divisive pattern of revolution and counterrevolution, ascendency and exile, monumentalization and iconoclasm, French governments from the time of Bonaparte's invasion of Egypt turned successfully and continually toward imperial projects. At the Place de la Concorde, France's revolutionary and imperial histories

come together. With the arrest of the king and the destruction of the equestrian monument of Louis XV in August of 1792, the stability and reliability of both art and government broke down spectacularly at the Place de la Révolution, formerly the Place Louis XV. Three decades later, Louis-Philippe and the July Monarchy sponsored the elevation of an ancient obelisk, taken from in front of the Luxor temple and raised at the (constantly) rededicated Place de la Concorde. From ancien régime to Revolution and Empire, from Paris to Rome to Egypt and Algeria, the Place de la Concorde affords a chronological and thematic overview of my subject, and so we will begin there.

Louis-Philippe claimed that he put the obelisk at the Place de la Concorde because it "would not recall a single political event."[5] Given the upheavals of this period, might we attribute the success of the obelisk to its blankness, its foreignness, its hieroglyphic unintelligibility? After all, one historian said that the July Monarchy was so without principle that it could only be named after the month in which it came to power.[6] Yet, in an era that was so historically conscious, how could the obelisk have meant nothing? Was the Paris/Luxor obelisk, the first monolith brought from Egypt to Europe since antiquity, a banal evasion of the republican-monarchal divide; or was it the culmination of a different, continuous history that linked together the post-Revolutionary governments? In spite of its apparent impassiveness, the obelisk tapped and spawned an enormous cultural output—scientific, archaeological, historical, governmental, itinerant, and journalistic—a sample of the pervasive and uncontested broadcast of ideas that helped fix France's status vis à vis Egypt and the *proche Orient*. The desire that seeks to conquer, possess, frame, and elevate the obelisk is a recurring impulse in imperial art of this age, as the foreign object is invested partly with glory, partly with scorn, and presented as proof of and path toward the regeneration of a deeply fissured nation. To end the violence and iconoclasm of French history, violence and iconoclasm are suppressed and displaced abroad.

Tocqueville was right. There was the revolutionary impulse on one hand, and the imperial and national on the other. Still, the revolutionary (and counterrevolutionary) art and politics that we must revisit undergird, haunt, and motivate modern French imperialism as it comes into being and focus. In revolutionary and counterrevolutionary art and politics we find disputes, contests, and divisions that, in these early years, do not extend to imperial culture and policy. In this period, when those imperial policies and cultural habits were being established, they were not contested.[7] That was one of the allures of empire.

In the next chapter, we will go back to the beginning. Even from the battlefields of Egypt, Napoleon solicited history paintings depicting the Egyptian and Syrian

campaigns, and they became a regular offering in Napoleonic Salons. It is no marvel that the Empire's arts administrators would cultivate public art that ballyhooed (and concocted) heroic exploits of its leaders, and so we will not linger over their motivations. What is of particular interest in this study is how the artistic and political strategies of the battle paintings were, unexpectedly, employed by the Restoration and July Monarchy, making of them a renewable legacy and the basis of a truly national culture. Here is the inaugural presentation in high art of the rationale for French imperialism in the Near East. Paintings such as Antoine-Jean Gros's *Bonaparte Visiting the Pesthouse at Jaffa* and Anne-Louis Girodet's *Revolt of Cairo* laid the foundation for the cultural edifice of France's modern Empire. Patrons, artists, and critics developed styles—ways of sponsoring, painting, and receiving accounts of the contemporary Orient—that rationalized and celebrated French intervention in the East.

In an investigation and description of diverse and influential paintings of the Egyptian campaign by Gros, Lejeune, Guérin, Girodet, and Franque, we will examine three interlocking strategies—historical models, moral contrasts, and authenticating rhetoric—that subsequently proved useful for decades of imperial representation. The first of these strategies is the invocation of historical memories that make the French heirs to the ancient Egyptians, conquering Romans, or crusading Christians. In the second strategy, national attributes are posited that pit French science, morality, masculinity, and intellectual rigor against supposedly representative traits of Easterners: fanaticism, cruelty, idleness, vice, irrationality, deviance, and degeneracy. The authenticity of claims made through the first two strategies is buttressed by a third, the authenticating strategy, which includes the adoption of pictorial conventions of naturalist picture-making, the rhetoric of scientific or eyewitness accounts. Indeed, one of the recurring themes will be the use of the scientific or technological both as artistic posture and as attribute, a defining essence of the French nation. These three strategies were marshalled by the generals and painters of the Egyptian campaign, and they would remain decisive in France's cultural arsenal, deployed from this moment and throughout the nineteenth century in the promotion of France's expanding Empire. In chapters focused on seemingly disparate types of monuments, we will see how flexible, useful, and pervasive the strategies were. At the beginning of the century, what did patrons request that artists say about the East? How did artists know how to paint subjects that were both new and foreign? And how did critics read these paintings, judge the quotient of their truthfulness, make sense of their historical claims? How and why did patrons, artists, and critics create and even enforce a certain style of ideology?

Some of the paintings discussed in the second chapter have long been posited

as hallmarks in the history of Romantic and modern painting. Battle paintings of the Egyptian campaign are also frequently mentioned as forerunners of the first modern Orientalist pictures, that is to say, of the first documentary, eyewitness accounts by Westerners of Eastern subjects. Traditional accounts of Orientalism esteem these pictures as authentic documents of the East.[8] Edward Said and Linda Nochlin have argued, however, that Orientalism, in whatever field, does not stand as proof of dialogue between East and West. Instead, they demonstrate how Orientalism is a discourse —an internally coherent and delimited, fantasy-based description of the Orient that has served to rationalize and advance Western imperialism in the very real and geographic East. Said's landmark study offers a history of the institutional, literary, academic, and corporate tradition of Orientalism that, he argues, defines "Orientals" to justify colonial domination.[9]

We should not lose sight of the irony. As military actions go, the Egyptian campaign was a failure, but it was a triumph on the walls of the Napoleonic Salons. As Antoine-François Callet's *Allegory of the Eighteenth of Brumaire* (figure 1) shows, the Egyptian campaign was a founding myth in Napoleon's rise to power. Paradoxically, subsequent and ostensibly hostile regimes continued to honor the Egyptian campaign. This apparent contradiction will be another focus of my work, for throughout I will probe the flexibility and usefulness of the Egyptian campaign to subsequent regimes in their intervention in the Ottoman Empire, Greece, and Algeria. Battle painters of the Egyptian campaign, with the backing of the Napoleonic arts administration and the complete comprehension of the critical public, coined an eminently convertible artistic currency.

The third chapter marks the political turning point. Twice returned to power, in 1814 and 1815, the Restoration monarchy of Louis XVIII and Charles X was founded in order to reverse, even erase, the Revolutionary and Napoleonic epic. Yet, despite the fact that Egypt was deeply associated with Bonaparte, the restored monarchy created the Musée d'Egypte, the first Egyptian department in the history of the Louvre. In 1801, France had surrendered to the British its Egyptian campaign trophies, including the Rosetta stone; it was the restored monarchy that acquired the first authentic Egyptian antiquities for the national collection, thereby instating Egypt at the origin of a new history of civilization. Moreover, they sponsored an extensive painting cycle that remains in situ, although it is relatively unknown. The museum's paintings by Abel de Pujol and François Picot, among others, put both ancient and contemporary Egypt to use for the dynastic interests of the Restoration. At the same time, however, the paintings also reveal the commonality of culture and purpose among

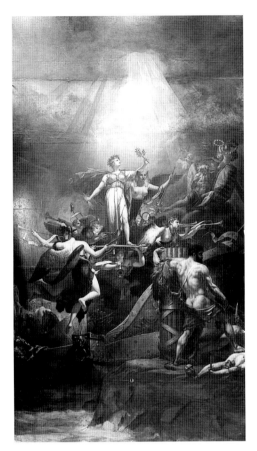

Fig. 1. Antoine-François Callet, *Allegory of the Eighteenth of Brumaire,* 1801. Oil on canvas, 20 ft. 2 in. x 16 ft. 4½ in. (616 x 500 cm). Musée National du Château, Versailles

Pujol and Picot, on one hand, and Gros and Girodet, on the other. Dictates of good taste and historical sensitivity to the innovations of Gros and Girodet's Napoleonic pictures normally oppose these works to the more technically conservative paintings of the Musée d'Egypte. To do so, however, would turn a blind eye to the common national ends served by both conservative and vanguard painters.

As I am concentrating on the public meaning that is construed around official works of art, I will be infrequently concerned with biography. The cultural engine of the imperial machine runs roughshod over the private ruminations and ambivalently expressed sympathies of cultural producers. That is part of its effectiveness. We will see how patrons and critics marginalize works of art that might be seen to sympathize too much with the imperial subject. In certain instances, however, the question of biography is not only instructive but essential. Such is the case with the first curator of the Musée d'Egypte, the decipherer of Egyptian hieroglyphs, Jean-François Champollion. Although in the early Restoration the Bourbons persecuted this "Robespierre de Grenoble," by 1827 Champollion was apotheosized in the Museé d'Egypte's painting cycle. In examining Champollion's public and private works, and in visiting the regime's official propaganda, its administrative gerrymandering, and its covert police work, we will see how the field of French Egyptology became sanitized of Napoleonic, even Revolutionary, associations and institutionalized as an apolitical and national enterprise. Indeed, we will return to this notion of the ostensibly apolitical as one of the recurring claims and attractions in imperial culture.[10]

The rhetoric of discovery and conquest snakes through the history of all the monuments under consideration as it posits a gendered identity for France and its Eastern counterparts. It is one of the ongoing explanations of Eastern subjugation, invoked to bolster post-Revolutionary authority. As the Musée d'Egypte was founded during the Bourbon Restoration but had its origins in the Empire and was somewhat transformed during the July Monarchy, its history permits us to account specifically for dynastic interests, while revealing the shared themes that helped weave a post-Revolutionary national identity. Thereby, I hope to avoid the pitfall of many studies of nineteenth-century French art and politics that portray political art as solely invested in the interests of a single regime.

The fourth chapter focuses on a single work by a single artist, Eugène Delacroix's 1834 *Women of Algiers.* If the Egyptian campaign battle paintings are considered forerunners of Orientalist painting, *The Women of Algiers* is often posited as the first modern Orientalist picture, accepted as a document of the artist's trip to Algeria and Morocco in 1832. At the same time, Delacroix's reputation is as an artistic revolutionary, a flag-bearer of Romantic independence, ennobled by Baudelaire in his celebration of Imagination as the Queen of the Faculties. Delacroix's experience and his finesse may have stood him apart from the crass boosterism of any regime, but we may also see the links of *The Women of Algiers* to the artist's and his public's learning about the East, which informed the intention, perception, experience, representation, and reception of the harem. Orientalist painting, rather than being invented here, is achieved. It comes to fruition as part of a broader culture, the importance of which lies in its direct relation to France's overseas colonial adventures.

Throughout, my discussion will alternate between painted representations of the contemporary East and the presentation and enframing of Egyptian monuments, for the imperialist rationale relies on an evaluation of both the present and the past. Delacroix's *Women of Algiers,* like the Napoleonic battle paintings, evoked moral judgments about the worthiness of the contemporary East, and they existed in conjunction with judgments about the Egyptian and Roman pasts of the *proche Orient* found in more archaeological realms. In this way *obélisque* and *odalisque* work together. Consequently, if we arrive at a critical history of the origins of Orientalist painting, it will not be from hewing the modernist line of the development of a single medium, but through the investigation of the artistic, political, and social formation of a broad and pervasive culture that gave rise to a national enterprise not reducible to a single artist, regime, medium, or style.

And yet, of course, there were individuals. This chapter on *The Women of Algiers* offers us an opportunity to puzzle over the motivations and rewards of the Orient in

the career of this singular but influential artist, just as we will examine the allure of imperialism for governments—the Directory, Consulate, Empire, Restoration, and July Monarchy. Delacroix's 1832 voyage to North Africa marks a turning point in his life and work. His encounters there provided him with subjects, sensations, and memories on which he drew for the remaining thirty years of his career. Following radical experiments in painting during the 1820s, *The Women of Algiers* created a place of concord for the artist, his patrons, and his critics.

With the loss of Quebec in the late eighteenth century, France's old empire began to dissolve; Bonaparte invaded Egypt in search of compensation. In the next decades, the old empire all but disappeared and a new one was collected along the way. With the increasingly apparent need to govern based on a popular mandate, with the Revolution's *liberté, égalité, et fraternité,* with the abolition of the slave trade, and with the Declaration of the Rights of Man, the modern empire, cultivated first in Egypt and then planted in Algeria, needed justification.

One hundred years after the Algerian conquest, exhibitions in Paris, such as the 1930 *Exposition du centenaire de la conquête de l'Algérie, 1830–1930* and the 1935 *Exposition artistique de l'Afrique française,* declared a success. They celebrated the role art had played not only in depicting imperial expansion but also as active agents in the quest. The critic Camille Gronkowski affirmed that the works of art shown at the exhibitions represented "the heroic fight which allows France to uproot the very anarchy with which this rich and dilapidated region has struggled since antiquity." And the doyen of French classical studies, Louis Hautecoeur, announced that Orientalist art had been effective in changing the nomad into a metropolitan.[11]

The works of art considered in the pages that follow created an alluring rationale, celebrated at the apogee of imperialism. In an afterword, I suggest the durability of imperial culture, the persistence throughout the age of empire of artistic and political strategies that were first practiced by the generations of Gros and Delacroix, particularly as they pertain to representations of the Oriental woman. The culture of empire came undone only during decolonization. In the desperate days of the Algerian Revolution (1954–62), on the steps of the city hall of Algiers and on the easel of Picasso's studio in Paris, the bodies of Algerian women were once again worked over. In the postcolonial era, if that is indeed in what we are living, the art of the early nineteenth century is once again contested, fought over as revolutionaries once fought over the Place de la Révolution, with hopes of imprinting a new culture and in an effort to fashion a new history.

1

The Obelisk at the Place de la Concorde

It is after having read on the Arc de Triomphe de l'Etoile the names of Aboukir, of Heliopolis, of the Pyramids, that the pilgrim entering Paris perceives it. He admires it for a long time before reaching it, and when he is at its base, all the memories of science and glory which are a part of it contribute their power to the first impression.

In recalling past triumphs, the obelisk becomes a new honor for our era because it makes seen that we have executed in our turn what the Roman people alone had executed before us.

—Edme Miel, *Le Constitutionnel,* 1834

. . . on the greatest, most beautiful of our squares where one must seek to recall only our glorious memories.

—Alexandre de Laborde, *Description des obélisques de Louqsor,* 1831

It is in the name of science and progress that the majority of these crimes {against monuments} are consummated. . . . It is science that travels up and down the universe, an ax in hand, which is going to despoil Thebes of its imposing ruins.

—Pétrus Borel, *L'Obélisque de Louqsor,* 1836

Taken from the Luxor temple in Egypt in 1831, a colossal obelisk stands at the crossroads of French history, the center of Paris's most important urban axis: the Place de la Concorde (figure 2). Reerected on the banks of the Seine in 1836, the obelisk is surrounded by an ensemble of decorative embellishments. To the north and south, two

13

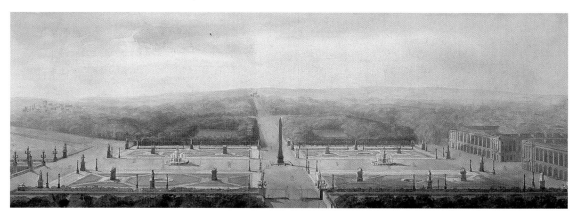

Fig. 2. Jacques-Ignace Hittorff, *Project for the Embellishment of the Place de la Concorde — Perspective View,* 1835. Pencil and watercolor on paper, 12⅝ x 19⅛ in. (32 x 48.5 cm). Wallraf-Richartz Museum, Cologne

fountains are dedicated to ocean and river navigation. At the base of each, tritons and nereids struggle to contain fish that spout jets of water in celebration of the symbols above: abundant harvests of land, river, and sea—the fruits of modern French science, commerce, and industry. Obelisk and fountains are, in turn, ringed by dozens of lamps and twelve rostral columns that carry ships' prows, recalling the emblem of Paris and a Roman device trumpeting naval conquests. Then eight statues of the major provincial capitals mark the perimeter, distributed as on a map—Strasbourg to the east, Marseille to the southeast, and so forth—so that the Place de la Concorde creates "a sort of image of France."[1] The obelisk and its accoutrements confer meaning on one another and deflect it on to the surrounding monuments: the Tuileries and Louvre complex to the east, the Assemblée Nationale to the south, the Arc de Triomphe to the west, and the church of the Madeleine to the north.

Although many contemporary commentators want to have the oblelisk stand for "nothing," the obelisk was inserted at this spot to negotiate the conflicting legacies of monarchal, revolutionary, and Napoleonic memories and monuments. It was placed there to conceal and suppress internal threats, to give France instead an urban, ideological, and national center to be read horizontally through space from the Arc de Triomphe, to Egypt, to Algeria, and backward in time to the Roman emperors and pharaohs, circumventing the untidy political menaces hounding France since 1789. In short, the obelisk was enlisted to do what Tocqueville would recommend for France in 1840: it substituted France's "revolutionary passion" with a "national passion" founded on imperial expansion in the East.

THE ETHICS OF A REGIME

The July Monarchy program for the Place de la Concorde came from above. The project architect was Jacques-Ignace Hittorff, but at each important juncture in the design process, Louis-Philippe and his minister in various posts, Adolphe Thiers, intervened, guided, and approved all meaningful aspects of the program.[2] No significant decision was made without them. The program for the Place de la Concorde had the highest approval and continual attention of the king and his minister. Yet the obelisk did not exclusively represent the ethics of their regime, as one might expect. In fact, Louis-Philippe said that he raised the obelisk there because it "would not recall a single political event." It would help avoid a repetition of that site's history, where, he said, "you were likely to see one day an expiatory monument or a statue of Liberty."[3]

Louis-Philippe was referring to the tumultuous history of this site, where each government from 1748 to 1830 attempted to monumentalize its central beliefs or val-

ues. Each created a cultural frame to support and extend its political authority and legitimacy.[4] And each, beginning in 1789, failed spectacularly, even dangerously. In his dynastic purposes, Louis-Philippe was neither unique, nor in the end successful. Unlike all the others who came before him, however, his monument remained.

The history of this site, the one that Louis-Philippe sought not to recall, must be entered into here briefly, even at the risk of contradicting France's citizen-king. While the revolutionary and counterrevolutionary history that it entails is more familiar than the imperial culture that this book explores, the dangers of that more familiar history must be revisited at the outset if we are to understand one of the most alluring aspects of imperial culture. At the Place de la Concorde—formerly the Place Louis XV, the Place de la Révolution, the Place de la Concorde, the Place Louis XV (a second time), the Place Louis XVI, and then, again and finally, the Place de la Concorde—France's modern crisis of governmental and artistic legitimacy raged.

Inaugurated in the eighteenth century, the Place Louis XV (figure 3) was a *place royale,* a particular urban form with its own conventions and its own political func-

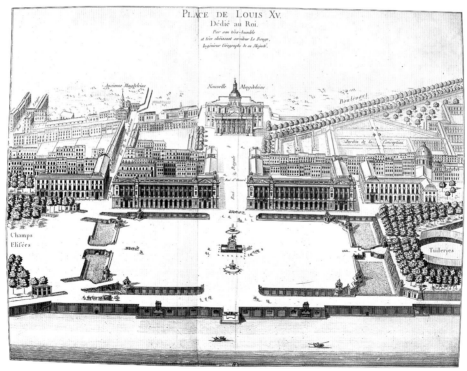

Fig. 3. Le Rouge, *Place de Louis XV,* 1763. Engraving, 19⅞ x 24⅞ in. (50.4 x 63.3 cm). Bibliothèque Nationale, Paris

tion: to demonstrate the power and presence of the king through the creation of a grand, regular, open space in the fabric of the city and through the symbolic presence of the king in his statue at the center. The king's director of public building solicited designs from the Academy of Architecture in 1748 and 1753, and Ange-Jacques Gabriel was chosen to synthesize from the various projects for what was then pronounced to be a truly national design. Louis XV donated land west of the Tuileries, the terrace between the Palace gardens and the Champs-Elysées, stipulating that the new square should respect the axis emanating from the palace. Departing from the model of the enclosed square in the heart of the city, as in, for example, the seventeenth-century Place Royale (now Place des Vosges), Louis expressly chose a site away from the heart of eighteenth-century Paris "to avoid upsetting the merchants and the busy neighborhoods," he said.[5] Accordingly, Gabriel broke with the traditional closed plan of the *place royale* by leaving the Place Louis XV open to the traffic and commerce of the city. With the main east-west axis established and with the Seine to the south, Gabriel designed two pavilions, pierced by a new street to terminate in a new church dedicated to Mary Magdalen.

At the center of the square stood Edme Bouchardon's equestrian monument of Louis XV, completed in 1772 (figure 4). Like Gabriel, the sculptor adjusted a seventeenth-century form, in this case the absolutist equestrian monument, in keeping with the reform culture of the mid-eighteenth century. His equestrian monument purveyed the image of a peaceable monarch through the king's Roman costume and through the supporting caryatids, which, rather than being enchained slaves, were allegories of Enlightenment virtues —love of peace, prudence, justice, and force. Nevertheless, Parisians destroyed it and other royal monuments following the arrest of Louis XVI on 10 August 1792 (figure 5). The legislative assembly ratified their actions, declaring that all royal monuments, "statues erected in honor of despotism," be destroyed in order to "uproot all royal prejudice," which evi-

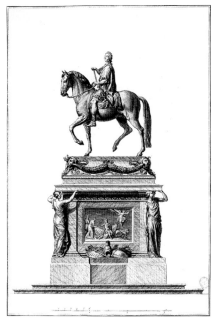

Fig. 4. Edme Bouchardon, *Equestrian Monument of Louis XV,* 1763. Etching by Benoît-Louis Prévost, 25¾ x 16⅛ in. (65.4 x 40.9 cm). Musée Carnavalet, Paris

dently resided in or radiated from the monuments themselves.[6] From this point forward the monarchal history of the square entered into an inextricable dialectic with the Revolution.

The revolutionaries raised two monuments on the rededicated Place de la Révolution. François Frédéric Lemot's monumental (plaster) statue of Liberty was inaugurated in the Fête de la Liberté, "on the remaining debris of the pedestal of tyranny."[7] Lemot's statue became one of the essential stations in the Revolutionary festivals, where the government attempted to forge a new identity on the ruins of the old (figure 6). It was then joined by the guillotine, which had been commissioned as a less painful and more efficient means of capital executions, as envisioned by the physician Joseph-Ignace Guillotin. The guillotine became the material manifestation, the monument, that more than any other was seen to embody the ethics of its sponsors.

At the Place de la Révolution, the guillotine was installed continuously from 10

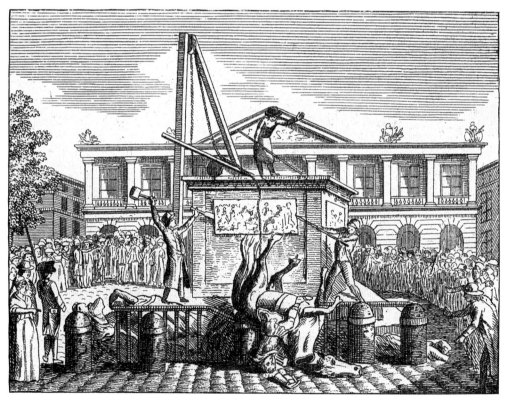

Fig. 5. Unknown artist, *Overturning of the Statue of Louis XV, 11 August 1792*, 1792. Engraving, 2⅞ x 3⅞ in. (7.2 x 9.5 cm). Musée Carnavalet, Paris

May 1793 to 13 June 1794. Only the blade was stowed away at night. Through the guillotine's use, representation, and reception, it came to symbolize the Terror. An engraving of the year II, *The Dagger of the Patriots Is the Hatchet of the Law* (figure 7), warns the enemies of the Republic: "Traitors, behold and tremble—its activity will cease only when you have all lost your lives." Looming above and silhouetted against the sky, the machine's sharp geometry submits, like the Revolution itself, to the unavoidable laws of nature. Moved from the smaller and more cloistered Place du Carroussel to the Place de la Révolution, the guillotine gained more visibility for its lesson in revolutionary justice.[8] It was the instrument of death for Louis XVI, Marie-Antoinette, the duc d'Orléans (the father of Louis-Philippe), and more than 1300 others. The razing of Bouchardon's equestrian monument of Louis XV was a preparation and rehearsal for the actual execution by guillotine of Louis XVI on 21 January 1793 at the Place de la Révolution. It has been properly understood as the death of divine right in France, as the severing of symbolic connections to the monarchy, and as an inverted sacrament, which, with the blood of the old king, consecrated the new Republic.[9] Lemot's Liberty and the guillotine were raised and used in antithesis to the

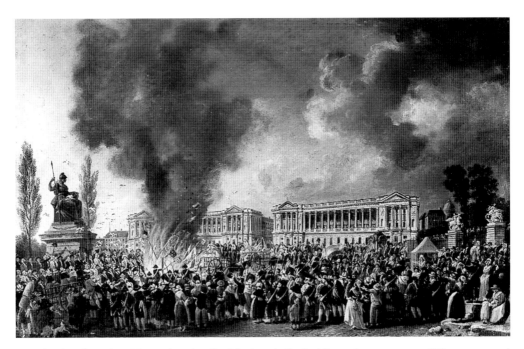

Fig. 6. Attributed to Pierre-Antoine De Machy, *A Capital Execution,* 1793–94. Oil on mounted paper, 14⅝ x 21⅛ in. (37.0 x 53.5 cm). Musée Carnavalet, Paris

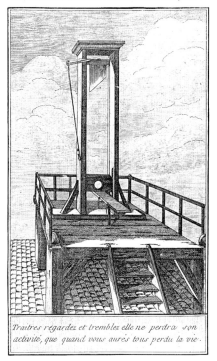

LE POIGNARD DES PATRIOTES EST LA HACHE DE LA LOI.

*Traitres regardez et tremblez elle ne perdra son
activité, que quand vous aurés tous perdu la vie.*

Fig. 7. J. B. Louvion, *The Dagger of the
Patriots Is the Hatchet of the Law,* ca. 1793.
Etching, 6 x 3½ in. (15.1 x 9 cm).
Musée Carnavalet, Paris

royal equestrian statue that had occupied the same site. For their meaning they depended on what they meant to destroy.

Is it any wonder that counterrevolutionaries responded with ire to the revolutionary history and monuments of the former Place Louis XV? To wit is the anonymous etching, *Robespierre Guillotining the Executioner after Having Guillotined All the French* (figure 8), a horrific fantasy on the efficiency of the guillotine that works with Robespierre to kill the executioner after all the other French have been killed. Robespierre is brought into relief by a pyramid-obelisk form. Far from being rational and enlightened machines, the guillotine in this print is multiplied endlessly, filling the space like a dense forest. The guillotine was made synonymous with the Terror, so that after the death of Robespierre, deputies ordered its destruction: "All guillotines, with their scaffolds, that exist in the Republic will be destroyed, broken and burned, the very instant this law is published, by those who execute criminal judgements."[10] Here the same spirit of iconoclasm that inaugurated the Revolution is enlisted to bring it to a halt.

Under the Directory, the square became the Place de la Concorde for the first time. Uneasy with both its monarchal and revolutionary past, the Consulate and Empire considered a number of military monuments (one of which we will see later), but they never settled on a single work. The dialectic of revolution and counterrevolution resumed under the Restoration monarchs, brothers of Louis XVI. Louis XVIII rededicated the Place to Louis XV in 1815, and Pierre Cartelier was nearly finished with a new equestrian statue of Louis XV when Charles X ascended to the throne. Charles X transformed the Place yet again, rededicating it to Louis XVI. At his command, Jean-Pierre Cortot began the Monument Expiatoire (figure 9), which was intended to recall the royalist account of Louis's martyrdom in which the Abbé Edgeworth stood at the foot of the scaffolding and pronounced, "Son of Saint Louis, rise to heaven!"[11] On a high socle at the site of his beheading, Louis XVI, dressed in his coronation robes and

carrying a palm of martyrdom, rises in apotheosis. Ready for casting, Cortot's model was destroyed during the July Revolution of 1830. Thus, when Louis-Philippe came to power in that year, the pedestal at the square's center stood empty. For Louis-Philippe and Thiers, both of whom sought to rule from the middle of the road, the Place de la Concorde presented an intersection of history where it was impossible to find a middle ground but that was, at the same time, impossible to avoid.

In 1832, both the dangers of the square's history and the questionable legitimacy of the new regime were menacingly observed by the caricaturist and publisher Charles Philipon. Even as the obelisk was *en route* to France, one of Philipon's lithographs proposed replacing Charles X's Monument Expiatoire with a *Monument Expia-poire* (figure 10), a sculpture that would make permanent and public the insulting sexual and scatological emblem that the king's opponents had devised especially for him. Philipon joked that only a giant pear, the fructification of the citizen-king, could "be raised on the Place de la Révolution, pre-

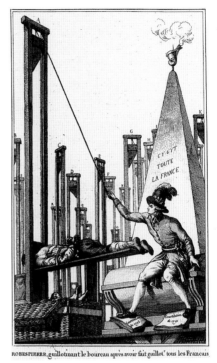

ROBESPIERRE, guillotinant le bourreau après avoir fait guillot.' tous les Francais

Fig. 8. Unknown artist, *Robespierre Guillotining the Executioner after Having Guillotined All the French*, ca. 1794. Engraving, 5½ x 3¼ in. (13.9 x 8.3 cm) image. Musée Carnavalet, Paris

cisely at the place where Louis XVI was guillotined." The caption pretends that the monument was raised on the Place de la Révolution to recall the July Days of 1830. The inscription on the pedestal, "27 + 28 + 29 = 00," suggests that those July days amounted to nothing. The regime was already declared a failure, worthy of the site's junk heap of monuments and history.

To squelch such criticism and the ominous reminder of the fate of Louis XVI, the government (unsuccessfully) prosecuted Philipon, claiming that the proposed monument was a provocation to murder.[12] They had reason to be insecure. The cartoon was published during the siege of Paris in a rebellion of the 5th and 6th of June 1832. The trial itself took place when Paris was under another state of siege, this time due to antigovernmental disturbances that were suppressed at the cost of 150 killed and 500 wounded. Philipon's *Monument Expia-poire* revealed at a most inconvenient

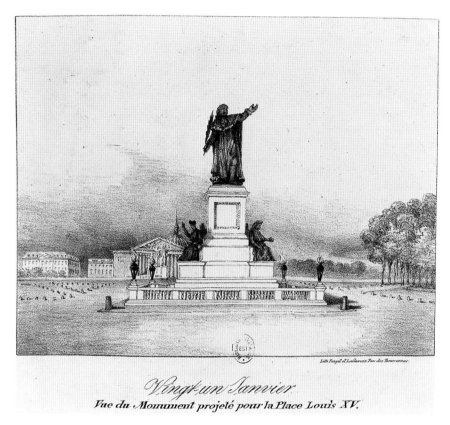

Fig. 9. Piaget and Lailavoix, *Twenty-One January. View of the Monument Projected for the Place Louis XV,* ca. 1827–30. Lithograph, 5¾ x 7⅞ in. (14.6 x 18.7 cm). Bibliothèque Nationale, Paris

moment that the July Revolution was unconvincing and that its figurehead was too. Moreover, in proposing a diminutive and flaccid pear for the spot already known to be the destination of an ancient Egyptian monolith, Philipon demonstrated how difficult it would be to sell yet another heroic sculpture of a sovereign after the succession of failed monuments and aborted regimes.

As Louis-Philippe's critics decried his political authority, his own architect, Pierre Fontaine, recognized a concomitant crisis of artistic legitimacy that the history of the Place de la Concorde divulged. Having worked for Napoleon, the Bourbons, and then for Louis-Philippe, Fontaine acknowledged how precarious it would be to install yet another monument dedicated to the latest revolution. He knew of the difficulty of working on the site, which was stained with the blood and memories of both monarchal and revolutionary martyrs. He wrote in his journal: "Hardly

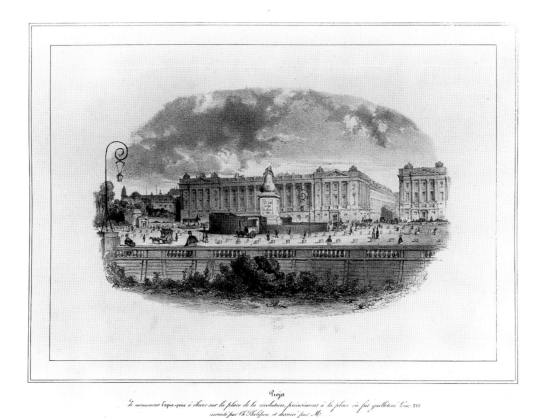

Projet

Le monument Expia-poire s'élever sur la place de la revolution precisement à la place où fut guillotiné Louis XVI inventé par Ch.Philipon et dessiné par M.

Fig. 10. Charles Philipon, *Le Monument Expia-poire,* 1832. Lithograph, 7¼ x 10⅝ in. (18.4 x 26.9 cm). Musée Carnavalet, Paris

touched by the honors that characterized each period, I saw the winning parties abuse the vanquished, hardly certain of the duration of these constructions that passion raised and that another passion destroys."[13] Of all the arts, sculptural monuments had been the most politically authoritarian and artistically conservative. They were raised as enduring and true representations of the permanence and naturalness of authority.[14] The history of the monuments at the Place, by contrast, revealed the extreme impermanence and instability of modern governments and their most meaningful and public monuments. At the Place de la Concorde, sculpture's authoritative tradition had come crashing down, along with the monarchy and the Revolution. Thus, the July Monarchy inherited a dual crisis of legitimacy: that of modern government and of modern art.

Rather than invoking any of the revolutionary or counterrevolutionary memo-

ries that hung over the Place de la Concorde, the July Monarchy imported the obelisk to obliterate the history of this site and to stave off the post-Revolutionary crisis of legitimacy. To this end, the northern fountain was placed on the former site of the guillotine. Its placement and function were first publicly suggested by Chateaubriand in an 1831 letter to *L'Artiste.* He proposed an enormous fountain, so that the "perpetual waters received in a black marble basin would indicate sufficiently what I want to wash." And the obelisk was destined, in part, to do the same work: it was placed on the site of the old sculpture's pedestal, as Laborde wrote, "on the greatest, most beautiful of our squares where one must seek to recall only our glorious memories."[15] Whereas we may be accustomed to seeing in the nineteenth century collective memory being used to build an emotional link to the past,[16] the July Monarchy decor of the Place meant to erase historical memories, to drive a stake in the heart of France's revolutionary history. At the center of the program, at the monumental center of Paris, the obelisk is mute on the subject of the Revolution that convulsed the nation for forty years, nowhere more frequently and more violently than on this precise spot. Thus, the program of the Place de la Concorde confronts what has always been considered the central question of modern French history, and it changes the subject.

The Ethics of an Era

In many narratives of the decoration of the Place de la Concorde, the obelisk appears only from afar, like an exotic character, "a timely gift," which solves the protagonists' vexing dilemma. That characterization confirms Louis-Philippe's claim that the obelisk was somehow "apolitical," or neutral, as historians have continued to insist.[17] Neither "a timely gift," nor a happy accident, the obelisk was ceded by Egypt, a client state of France, whose scholars and politicians chose the obelisk and then organized and paid 1.35 million francs for its transportation and erection.

Still, despite the critical involvement of the government, the obelisk at the Place de la Concorde is not strictly representative of the ethics of the July Monarchy alone. It is a monument that advanced the culture and politics of an era, not a regime. The obelisk represented a continuous point of agreement among post-Revolutionary governments. When it was raised in 1836, the program's origin was credited to Napoleon and France's 1798–1801 invasion and occupation of Egypt. During the Restoration, Louis XVIII opened negotiations with Alexandria and won the concession of one of its obelisks. Champollion revived the plan, negotiating with the Pasha of Egypt in July 1829. It was during the Restoration, and not the July Monarchy, that Cham-

pollion convinced both French and Egyptian regimes to agree to the cession of the obelisk that eventually came to Paris. When the July Revolution occurred, the agreement was not derailed.[18] Thus, the obelisk was a product of work done by each post-Revolutionary government. On this they could agree.

As for Napoleon, so too for Louis XVIII, Charles X, and Louis-Philippe and Thiers: the obelisk was so alluring because it had what no French monument could boast and what all post-Revolutionary governments sought—tremendous longevity and association with an enduring political and societal order. From the time of the Napoleonic mission in Egypt, contemporaries marveled at the age of the obelisk. The monument appealed to a shaky post-Revolutionary era because it was a product of a monarchal system that was also, as one commentator noted, vanquished with difficulty.[19] Barthélemy's ode to the obelisk celebrates it for representing an old society that preceded Greece and Rome, rested on immutable political mores, and thrived due to its lack of political factions. The reason why Pharaonic Egypt lasted so long was that "in its long days of calm and harmony / Never did the factions of disastrous Genius / Agitate its wise children."[20] Unlike France's monuments of the Revolutionary era, the obelisk had never been effaced.

When Louis-Philippe said that the obelisk would not recall a single political event, he was in one sense not being duplicitous. The obelisk did not engage the divisive political questions that plagued his government and all of France after the Revolution. Instead, it evoked a tradition of obelisk use in celebration of extra-European triumphs that proved agreeable to all internal factions. After the conquest of Egypt, Augustus began the tradition of taking obelisks as war spoils, and some fifty obelisks followed during the Roman Empire. Speaking before the Chambre des Pairs in June of 1836, just a month before the obelisk was to be elevated in Paris, the vicomte de Siméon recalled the Roman practice. He argued for more funding for work on the obelisk, a type of monument that "to the Romans appeared to be the most noble trophy that they could bring back from Egypt."[21]

In choosing to place the obelisk at the center of an open and regular urban space, Hittorff and the government explicitly recalled the papal-Roman use of obelisks as centerpieces of great civic spaces and focal points of long urban trajectories. In the arrangement of an obelisk flanked by two fountains, which Thiers requested from Hittorff, the architect based the plan on the piazza in front of St. Peter's (figure 11). In medallions below the projected aerial views, he likens an elevation of the Luxor obelisk in Paris—flanked by Gabriel's pavilions and viewed against the backdrop of the Madeleine—to the Vatican obelisk in the square of St. Peter's. Echoed by Hittorff,

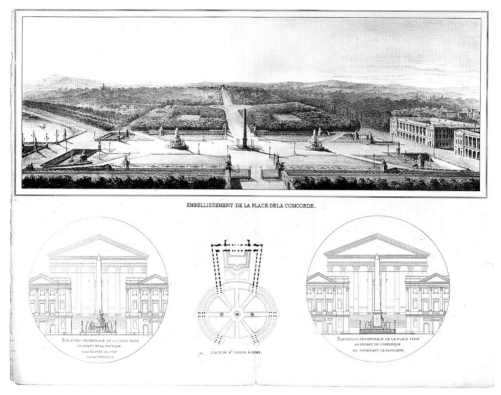

Fig. 11. Jacques-Ignace Hittorff, *Decoration of the Place de la Concorde,* 1834. Lithograph.
Bibliothèque Nationale, Paris

the papal-Roman usage celebrated both the Roman imperial triumph over Egypt and Christian conquests over infidels.

In addition, the use of the Luxor obelisk recalled several Napoleonic programs for obelisks to mask sites of revolutionary iconoclasm and to celebrate in their place the memory of Bonaparte's Egyptian campaign (figures 12–14). To replace monarchal monuments destroyed during the Revolution, Dominique-Vivant Denon, Napoleon's art czar and veteran of the Egyptian campaign, commissioned a statue of General Desaix, supported by an obelisk at the moment of his triumph in Egypt for the Place des Victoires; Napoleon ordered an obelisk in honor of the Grande Armée for the Pont Neuf; and Baltard (in 1801) designed two obelisks, one in honor of the Egyptian campaign, for the Place de la Concorde. In discussing the Place de la Concorde in the 1830s, critics recognized these precedents of obelisk erection in place of leveled royal monuments,[22] and Louis-Philippe continued to use obelisks to herald imperial ex-

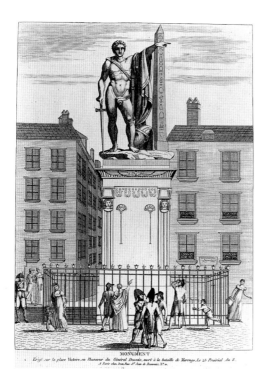

Fig. 12. Dejoux, *Monument Erected at the Place des Victoires in Honor of General Desaix,* 1810. Etching, 13⅜ x 9⅞ in. (34 x 25.2 cm). Bibliothèque Nationale, Paris

Fig. 13. Peyre neveu, *Project for the Obelisk at the Pont-Neuf.* Engraving by Normand fils, after A. Tardieu, 1822. Bibliothèque Nationale, Paris

pansion (figure 15). A squat, French-made obelisk was the centerpiece of the Salle Pérouse of the Musée Naval in the Louvre, a museum that honored the history of the military branch most responsible for colonial undertakings. Such a tradition that the obelisk at the Place de la Concorde engages and expands could only be "not political" if we are to focus exclusively on the politics of revolution and counterrevolution in France, while dismissing its imperial role outside Europe.

INSCRIPTION

By the time of the July Monarchy, knowledge of even the original function of obelisks had changed. Erudite and popular writers alike came to recognize that obelisks had functioned as "signs of victory" under the pharaohs. The Luxor/Paris obelisk thus recalled Egyptian, Roman imperial, and Christian triumphs. These were associations

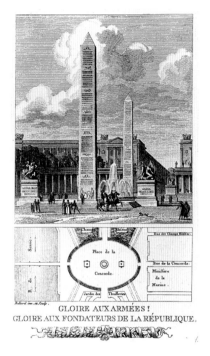

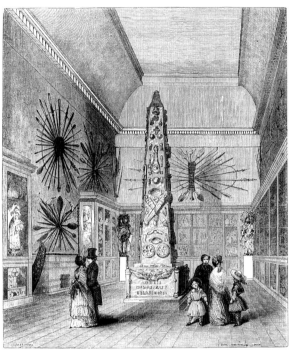

Fig. 14. Louis-Pierre Baltard,
Proposal for the Place de la Concorde,
1801. Etching, 6¾ x 4¼ in.
(17.2 x 10.8 cm).
Musée Carnavalet, Paris

Fig. 15. Jules Noël. *The Salle Pérouse of the Musée
Naval at the Louvre,* 1847. Lithograph.
Bibliothèque Nationale, Paris

that would have been evoked by any obelisk placed within Hittorff's adaptation of the Place de la Concorde. This obelisk, however, was unique. It was the first taken from Egypt and sent to the West since antiquity. With it came a legion of publications that flourished after the Egyptian campaign. After Champollion's 1822 decipherment of hieroglyphs, these texts were imbued with a new scientific aura. Consequently, obelisks were no longer seen as merely decorative but as essentially historical monuments, and the example from Luxor was one of the "primitive pages of their history."[23] It was expected to stand in Paris and "speak" to its listeners "like an old storyteller."[24] Unlike some other homemade obelisks that could be inscribed with a monarchal or revolutionary program,[25] the Luxor/Paris obelisk was not a blank face ready for inscriptions as it had a well-known history and prescribed meaning and tradition.

In his *Philosophy of Fine Arts,* Hegel had postulated that Egyptian art was especially ambiguous, but that it could accrue meaning through its setting and the ex-

pectations of its public. The example he cited was that the meaning of a pyramid may appear open-ended, but that when placed in a church it would clearly signal the Trinity.[26] Like the church that encompassed Hegel's pyramid, an explosion of pamphlets, articles, books, and images attended the Luxor/Paris obelisk, revealing and conferring upon it a history that gave meaning to its flat faces, giving features to the iconographic mask placed over the revolutionary body buried at the Place de la Concorde.

The obelisk tapped a prominent vein of European monuments and texts revitalized by Bonaparte's invasion of Egypt in 1798 and fed continually from that time forward. The number of publications describing the Luxor obelisk and its history, acquisition, transportation, and placement, is legion. These texts range from official governmental and Egyptological publications to more popular books, pamphlets, and articles. They vary in prestige, size, erudition, and quality of manufacture. What is most remarkable about them is their uniformity of content. They repeat incessantly, without dispute or equivocation, that the obelisk came from the origin of civilization[27]; that it recalled the brilliance of Ramses the Great[28]; that it, like Egypt, had then suffered ten centuries of barbarism[29]; and that in France it constituted a belated war trophy in honor of Bonaparte's Egyptian campaign.[30]

Denon's *Voyage dans la Basse et Haute Egypte* (1802) established the associations that would continually be evoked in the presentation and reception of the Luxor obelisk (figure 16). His *Voyage* went through four French and four foreign-language editions before publication of the *Description de l'Egypte* (1809–28), the work of the 164 savants who formed the scholarly apparatus of Bonaparte's Egyptian campaign. As a member of the campaign team, Denon produced a *Voyage* that was deemed both thrillingly Roman-

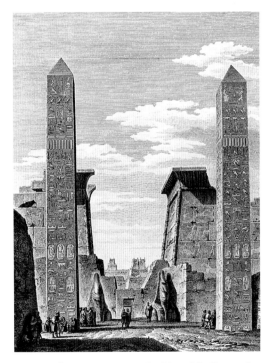

Fig. 16. Jean-Baptiste Le Père, *The Entry of the Temple of Luxor.* Engraving from Dominique-Vivant Denon's *Voyage dans la Basse et Haute Egypte* (Paris, 1802). Bibliothèque Nationale, Paris

tic and scientifically authoritative. What animated the Egyptian campaign and De-
non's text was the hope that the grandeur of ancient Egypt could be rescued by mod-
ern France. Denon dedicated his book to the agent of that revival, to Bonaparte: "To
join the brilliance of your name to the splendor of the monuments of Egypt is to bring
together the glorious splendor of our century to the fabulous times in history; this is
to reheat the ashes of the Sesostrises."[31] The grandeur of ancient Egypt could be re-
vived and Napoleon's name could be linked to that of Ramses the Great, Denon says,
by taking the obelisks from Egypt and sending them to Paris as victory trophies, com-
memorative of the Egyptian campaign.

Following Denon's *Voyage,* the *Description de l'Egypte* was the most authoritative
document of the Egyptian campaign, the urtext of French Egyptology. It embraces
the historicizing ideology of its Western sources. The section on modern Thebes, for
instance, begins with a quote from Volney's 1787 *Les Ruines,* which posits the grandeur
of ancient Egypt: "Here flourished an opulent city. Here was the seat of a powerful
empire." Since antiquity, the authors submit, Thebes has been "brutalized by despo-
tism."[32] The *Description* also reprints the view that Denon had published. The ancient
architecture is impressive in its height and expanse, but the building and its obelisks
are partially buried, subsumed under the weight of an Egypt in decline and decay.
Documented in twenty-one volumes of detail, this is the very premise of the *Descrip-
tion*: a cyclical history of civilization that insists on the grandeur of Pharaonic Egypt;
its capture by the Romans; its destruction and decadence under Muslim rule; and the
promise of its renewal now that it can be examined, documented, and known by mod-
ern France. In the magisterial "Préface Historique," Fourier explains that since the
passing of the Pharaonic dynasties, Egypt "has not ceased since that era to be subju-
gated to foreign domination." Now it is the turn of the French: "No significant power,
in the West or in Asia, has developed without directing its views toward Egypt, and with-
out considering it, in some measure, like its natural prerogative."[33] Due to Pharaonic
Egypt's grandeur, Muslim Egypt's depravity, and modern France's preeminence, Egypt
is now the theater of Napoleon's glory.

A student of both the *Description* and its authors, Champollion fulfilled the dreams
of the Egyptian campaign's savants. His publications helped fix the meaning of the
Luxor obelisk, and his public and backroom lobbying helped bring it to Paris. In
1830, following his return from Alexandria, Champollion wrote the Minister of the
Navy, explaining why he wanted the Luxor obelisks, rather than the Alexandrian ones
that had been promised Louis XVIII. In addition to their more impressive size and
condition, Champollion wrote, "these are the monuments raised to the glory of the

most celebrated of the Egyptian Conquerors—Sesostris." The inscriptions celebrate him and his great deeds. A Luxor obelisk would serve as a reminder of Sesostris's great glory and conquests, and "become in Paris commemorative monuments of our victories in Egypt."[34]

Champollion chose this particular obelisk because of its association with Ramses the Great whose achievements Champollion had established in his scholarly work. They read like a wish list of French imperial ambitions. In an 1824 publication, Champollion declared Ramses "the most celebrated of Pharaohs, conqueror of Africa and a portion of Asia."[35] In his 1829 "Notice Sommaire sur l'Histoire d'Egypte," Ramses was extolled as conqueror of the East: "He exhausted the conquered countries and enriched Egypt with immense spoils of Asia and of Africa." He was celebrated for his warfare and for his immense public works and credited with the "first idea of the canal of the junction of the Nile and the Red Sea." He represented the zenith of Egyptian power. Champollion concluded, "It is under the reign of Ramses the Great, or *Sesostris*, that Egypt came to the highest point of political power and interior splendor."[36] It is for these associations that the Luxor obelisk was prized.

After Champollion's death in 1832, Jacques-Joseph Champollion-Figeac further broadcast this cyclic history of civilizations and the association of the obelisk with the glory of Sesostris. In a book of 1833, he published his brother's letters that had led to the acquisition of the Luxor obelisk; he used them as the basis for his hope that the obelisk "can be animated by a religious and national sentiment to the memory of the children of France, dead for its glory in this same desert from which the obelisk has just been uprooted." What he envisioned was this:

> *I propose (but my feeble voice will not be heard) that, by a law, the obelisk should be elevated in memory of the French expedition in Egypt, the most memorable enterprise of modern times, due to its purpose, its means, the list of names which are associated with it, and by its numerous results, some already so useful to the prosperity of France, to the return of the people of the Levant toward civilization.*[37]

Hittorff and his political bosses agreed,[38] so the eastern face of the pedestal invokes: "Recentis Gloriae ad nilum Armis Partae."

This description of the way the obelisk recalled other monuments and texts and the way its acquisition inspired new texts demonstrates the strength of the historicizing ideology that the Place de la Concorde conveyed. The unimpeded construction and wide diffusion of this ideology stands, as the obelisk itself has, in contrast to the appositely contentious history of France's revolutionary (and counterrevolutionary)

history. This becomes apparent in a close reading of the strategic formation of the imperial discourse, its strategically located, primary texts (the *Description*), its strategically located witnesses to Egyptian history (Denon, Champollion), and now the diffusion of this ideology, without the slightest resistance, through the "citation of antecedent authority."[39] The same historicizing ideology is broadcast in scores of widely diffused and diverse publications. Of these we will discuss diverse and representative examples: Laborde's highbrow and frequently published *Description des obélisques de Louqsor, figurés sur les places de la Concorde et des Invalides, et précis des opérations relatives au transport d'un de ces monumens dans la capitale, lu à la séance publique de l'Institut*; a more ephemeral and aggressively middlebrow pamphlet in which the obelisk speaks, *Mémoires de l'obélisque de Louqsor, écrits par lui-même, et dédiés aux Parisiens*; and an anonymous article in the *Magasin pittoresque*.

The Count Alexandre-Louis-Joseph de Laborde's treatise was first read at a public meeting of the Institut de France in August of 1832. The sixteen-page text was then published in 1832, 1833, and 1834. Laborde's academic credentials are affirmed by the context of his paper, which is cited in the book's long title. Serving in the Chamber of Deputies and the Council of State in both the Restoration and July Monarchy, he also served on an 1829 committee to examine proposals for the transportation of the obelisk. From this position, Laborde reaffirms the cyclic history of civilization suggested by traditions of obelisk usage and by the scholars of Egypt. For him the Egyptian campaign was designed to end a thousand years of barbarism in Egypt:

> *Egypt, for ten centuries, has been mired in barbarism, and only a few voyagers were able to penetrate that land where Pythagoras and Plato had gone seeking inspiration from the* génie *of the sciences; then a great man undertook to bring to light its existence and its glory. His triumphant army, after having met with victory at the Pyramids, advanced toward Thebes; but there the army suddenly stopped, and cheered in view of the admirable monuments that it beheld. In its enthusiasm, it would have wanted to be able to transport it all to the capital with the flags of its enemies that it had just vanquished.*

Due to France's defeat by the English, however, war trophies of the Egyptian campaign were delayed thirty years. In Paris, the obelisk would recall and evoke the glory of Ramses the Great. Laborde also recommended that it be dedicated simultaneously with the Vendôme column "to honor thus the memory of the two greatest warriors of ancient and modern times."[40]

Unlike Laborde, the anonymous author of *Mémoires de l'Obélisque* strikes a hackneyed tone. In the eleven-page pamphlet of 1836, the author allows the obelisk to speak for itself: "I will tell my own story. I am 3,416 years old." The obelisk is grateful for having been rescued from his life as "a recluse" in Luxor, which was the most beautiful city in the ancient world, but now is dead, like Egypt: "a decrepit ancestor of the human species has been covered in prudery by a veil more impenetrable than that of a fresh odalisque." The obelisk was thrilled by the heroic invasion of the Napoleonic army, but then bereaved when he sat idly for the next three decades. Now the French have returned him to a thriving metropolis and taught him his own history. It is thanks to Champollion, his "godfather," that he knows the history of his "arrival in the world," his birthday, and his original creator, Ramses the Great. In the end, this long-surviving Egyptian is rescued by the military and intellectual achievements of modern France, a worthy inheritor of ancient Egypt's remains.[41] Between Laborde and the talking obelisk, across the breadth of these and many other publications, the tone may vary, but the message does not change.

Finally, the success of the imperial discourse was pithily revealed in an 1833 article in the first volume of the Romantic and middlebrow, *Magasin Pittoresque*. A full-page view of the temple of Luxor introduces the "Obélisque de Louqsor," and the text claims that the print reprises Denon's view in his *Voyage en Egypte*.[42] In the intervening thirty-one years since the picture's first appearance, thanks to the work of Bonaparte, Denon, and their followers, Egypt had became a client state of France. France's cultural and intellectual studies continued, and the obelisk was plucked from in front of the decaying Luxor temple, saved from the ravaging effects of contemporary Egypt. History had conspired to make the dream come true: the splendor of Pharaonic Egypt, buried and degraded by the Muslim interlude, would soon be revived, not in Egypt, but in the midst of modern Paris.

This strategy of cultivating the imperialist discourse in order to avoid the dialectic of revolution and counterrevolution began with the Egyptian campaign of 1798 and was elaborated by the subsequent regimes, as we will see in the following chapters. National identity based on an imperial culture and project was continually pursued as a basis for stability and harmony, and its logic was enlisted for French intervention in the *proche Orient*. It is a significantly different approach from the one advanced by Détournelle and Caraffe's proposal around 1797 (l'an V) for a monument in the Place de la Concorde (figure 17). Surrounded by Egyptoid columns, an enthroned figure of Concorde brings together two boys representative of France's previously warring factions. Below the shrine, framed by the crisp architecture of the pedestal, is a view on to the fractured base that first supported the equestrian monument of Louis XV

Fig. 17. Détournelle and Caraffe, *Project for a Monument to Concorde* (detail), ca. 1797. Engraving by Normand. Musée Carnavalet, Paris

and then Lemot's statue of Liberty.[43] This remnant of two monuments is chipped and cracked, but it is contained by a monument whose lines are crisp and unbroken. The old pedestal is preserved, but not to prove the triumph of a new ideology antithetical either to monarchy or republic. Rather, the monument attempts to make an object lesson of the destructive past, to hold it in check with its taut lines and above all to seal off a past, which, if accessible, could not be controlled. Not expressly antirevolutionary nor antimonarchal, this Directory proposal for the Place de la Concorde was anti-iconoclastic. Only in this way could harmony be conceived. In the enduring July Monarchy program for the Place, the iconoclasm and the violence of the revolution and counterrevolution, rather than being thematized as a history to be avoided, was, instead, suppressed and displaced abroad. It was also framed as a technological conquest, as Western obelisk acquisition had long been.

Technology and Barbarism

The theme of technological accomplishment in the narratives of obelisk acquisition is an essential one. Pliny had described the difficulty of transporting the first Egyptian obelisk to Rome and the subsequent exhibition of the boat in a permanent dock "to celebrate the remarkable achievement."[44] Champollion, too, used the rhetoric of "la gloire nationale" through technological feats when he convinced the Minister of the Navy to transport and erect the obelisk.[45] According to the tremendous cultural output on Egypt dating from the end of the eighteenth century,[46] and, in particular, according to the explosion of texts and images representing the Place de la Concorde obelisk, it was France's technological accomplishments that propelled it to the zenith of its historical destiny. Scientific and technological acumen made France the mod-

ern incarnation of the brilliance of Pharaonic Egypt as well as the capable and deserving caretaker of the contemporary Orient. This idea, relayed in all that was written and said in response to the obelisk, was uncontroversial, but, to be sure, hardly neutral.

At the forefront of those who wrapped the obelisk in meaning were those who had packed it off from Egypt to the Place de la Concorde. It seems as if everyone who worked on the lowering, transportation, and raising of the obelisk wrote his memoirs. These publications specialized in exacting accounts of scientific prowess, contrasting the French mission to Egypt's current barbarism. They proclaimed that the work of the project engineer Apollinaire Lebas surpassed the vaunted achievements of the ancients and of Fontana's raising of the obelisk before St. Peter's. These texts are often packed with facts and figures about the marvelous engineering feat and the dimensions, weights, and distances that had to be overcome in the process.[47] One of the only opponents of the project, the critic Pétrus Borel, mocked the obsession for numbers and measurement: "My God! What mania for taking and for transporting! Can you not leave to each latitude, to each zone, its glory and its ornaments?" Although unusual in his condemnation, Borel was penetrating in his recognition that this was part of European imperial competition and a demonstration of French science. He laments the misuse of science in the "knocking down" of monuments, as is evident in his quotation included in the epigraphs to this chapter.[48]

All the other many descriptions of the transportation of the obelisk uncritically replay what Angelin, the chief surgeon on the mission, called "that conquest made by science over barbarism." Egyptians, he wrote in 1833, occupied "a once flourishing country, today dull, abandoned. There a few nearly nude men—degraded by slavery, eaten away by distress—crawl more than they walk on antique ruins, sterile monuments of the splendor of their fathers." In contrast to Egypt's "fallen present," Angelin reports French achievements. The successful navigation of the obelisk around difficult passages of the Nile astonished the inhabitants. He said, "Our success appeared to them as miraculous, and to us they cried in envy: 'It is only the French who would be capable of such a bold undertaking.'"[49]

In an 1835 description of the lowering and transportation of the obelisk, Léon de Joannis, the lieutenant of the ship, details a hostile environment and alien people that his team had to overcome.[50] The contrast between French technology and Egyptian barbarism is conveyed in his lithograph of the lowering of the obelisk (figure 18). Although the size of the remaining monolith is enormous, running off at the top of the image without much tapering to its tip, French machinery, soldiers, and engineers are equal to the task. Meanwhile, as the machine lowers the obelisk destined

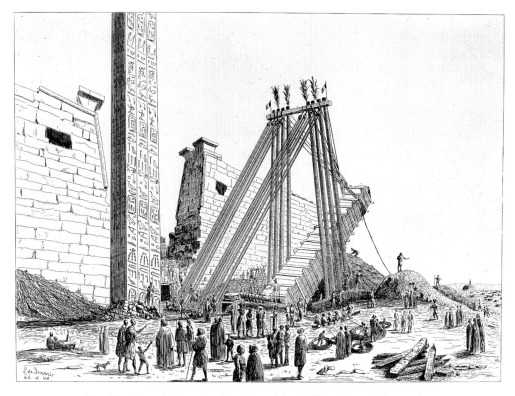

Fig. 18. Léon de Joannis, *Lowering of the Obelisk,* 1835. Lithograph.
Bibliothèque Nationale, Paris

for Paris, contemporary Egyptians are associated with the ruin of the temple. They stand idly. They gesture and gape at France's stupendous achievement.

Several times, in what might pass as digressions into local color and titillation, Joannis interrupted his narration of the actual transportation of the obelisk to tell his readers about sexual "victories" of the French team. After the obelisk has been lowered onto the boat, Joannis retires to the apartment of a Frenchman living in Egypt, a certain M. Vessière. The Frenchmen taunt two Egyptian women, Vessière's fiancée included, until the women become jealous of each other and perform a competitive striptease: "'Barra el hhamice (off with the shirt),' so went the preliminary commandment of M. Vessière, and in an instant, the two big blue shirts and the white veils fell and revealed the fine bodies of the two young women."[51] For Joannis, the story of the obelisk and the striptease provides a pretext to assert an image of French masculinity through sexual triumphs that demonstrate, by contrast, the degeneracy of the Egyptians and the virility and propriety of the French. One victory (scientific

and national) empowers and justifies the other (sexual and moral). Inserted, then, at the Place de la Concorde, the obelisk reverses France's short-lived rejection of patriarchy during the Revolution.[52] It also reverses France's sense of monumental impotence, which Phillipon's limp pear statue had revealed, by introducing someone else's phallic authority.

————————

If the project of retrieving the obelisk was framed as a rescue mission, the raising of the obelisk in Paris was played out like a resurrection. Angelin describes the process:

> *Thebes! this name alone awakens the memory of all glories; Thebes, the cradle of the arts and sciences where for centuries the powerful kings of Egypt ruled, Thebes is today buried in the dust. . . .*
>
> *Erected on one of our squares, it {the obelisk} will be there like the heritage of a fallen city, taken in by a flourishing city.*[53]

Contemporary prints concur, celebrating the raising of the obelisk at the Place de la Concorde (figure 19). Kaeppelin and Jung's lithograph is typical. It shows the most dramatic moment. The monolith is halfway elevated. The perspective is raised, so that

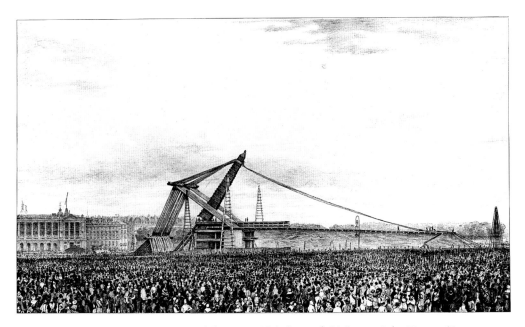

Fig. 19. T. Jung, *Erection of the Luxor Obelisk,* 1836. Lithograph by Kaeppelin.
Musée Carnavalet, Paris

the viewer sees thousands of figures, captivated and dwarfed by the procedure. The obelisk's scale is grossly exaggerated to demonstrate this apotheosis of French engineering. The picture evokes the epitaph offered by one commentator who proclaimed, "Glory to the engineer!"[54]

Science, industry, and commerce were also celebrated in the highly charged and unrealized plan of 1833 to harness the obelisk to a train for its erection. Lebas proposed the project to the administration, promising that it would inspire entrepreneurs. Thiers obtained funding for the plan in a speech before the assembly, and speakers in the Chambre des Pairs told how the plan would surpass Fontana's achievements.[55] Although the plan was scrapped, it did point to the political function of technology in French aspirations in the Near East. It was above all the railway that was the product, embodiment, and engine of the industrial revolution.[56] Raising the obelisk, the steam engine would have staged a technological gap between the contemporary East and West, just as it was permanently bringing together monuments and memories of ancient Egypt and modern France.

The gold-leaf inscribed decorations on the obelisk's granite socle presented the opportunity to record permanently this work, which added so immeasureably to the national glory. For the north and south sides of the block, Hittorff selected diagrams by Lebas to serve as models for the inscriptions (figures 20, 21). They show the machinery, the methods, and the felling, transportation, and erection.[57] Thus, they diagram French desire for ancient Egypt and its mastery and power over contemporary Egypt. The engineer's pictorial language—elevations, horizontal projections, transversal cuts—demands explanation in prose below the diagrams, for they are modern hieroglyphs. The link to the inventors of the original hieroglyphs is complete.

This is not all the hieroglyphs do, however. Their meanings, which were understood due to Champollion's decipherment and were published throughout the 1830s, commented on the obelisk's surroundings. As Miel intoned in the quote that begins this chapter, and as the author of the *Description de l'Obélisque* wrote, "The obelisk of Luxor will be placed at the center as if to link together all of the disparate monuments and to make of them an admirable ensemble."[58] While the texts celebrate the pharaohs and gods variously and repetitively, each side of the obelisk has its own emphasis, so that there is a correspondence between the texts and the monuments that they face. We know the obelisk was knowingly reoriented from its position at Luxor, so that the side that faced the Nile now faces the Seine.[59] What became the west side in Paris, facing the Arc de Triomphe, recalls, among other things, the force and victories of Sesostris, "his glory over the entire earth," which shook at his exploits. The

Fig. 20. Jacques-Ignace Hittorff, South face of the socle of the obelisk of the Place de la Concorde: "The Obelisk Lowered from Its Base in Egypt and Shipped to France on the *Navare Le Louqsor,*" 1840.

Fig. 21. Jacques-Ignace Hittorff, North face of the socle of the obelisk of the Place de la Concorde: "The Towing, Transfer, and Erection of the Obelisk in Paris," 1840.

obelisk celebrates the son of the sun, "the victorious king of the Oriental regions by his valor, he who by his victories reduced to slavery all the foreign countries." Facing the church of the Madeleine, the obelisk carries Ramses's royal or religious titles and proclaims him a vigilant warrior. Facing the Tuileries palace, Ramses the civic monument builder is celebrated: "It is what was executed for him the king . . . living always." Facing the Seine and the Assemblée Nationale, the inscriptions praise Ramses as legislator and the provider of water, crops, and prosperity. The king makes offerings to Ammon, seigneur of celestial waters, who in turn promises abundant floods to Ramses. Thus, the obelisk unifies the plan of Paris, directing its most powerful institutions to a national, imperial project.

EGYPT AND ALGERIA

However operative the obelisk was in the scenography of Paris, we still must ask in what way was the memory of the Egyptian campaign operational in the July Monarchy? What did it matter, these old memories, however burnished they may have been? The obelisk was a product of, and it in turn produced, an apparently disinterested cultural output that proffered historical, moral, and technological rationales for French imperialism in the Orient, in the same years that France was securing and expanding its imperial push in Algeria. In the very year of the raising of the obelisk, no less a figure than Thiers, the minister responsible for broadening France's imperial role in the Near East and the conceptual architect of the Place de la Concorde, confirmed the role that the memory of the Egyptian campaign could play in support of the government's expanding role in Algeria. Tracing the evolution of his thinking, first when he was a "declared enemy" of the Restoration, he told the Chamber of Deputies in 1836 that he had started out opposed to the conquest of Algiers, but when news of its success reached him he was "seized with an involuntary joy." This was the joy of nationalism in a military conquest that did not inflame revolutionary or counterrevolutionary passions. In the July Monarchy, Thiers was able to convince Louis-Philippe of his Algerian policy because Louis-Philippe wanted at all costs to avoid wars on the European continent. According to Thiers, Louis-Philippe liked saying that "the cannon of Algeria does not ring out in Europe."[60] He came to recognize that the Algerian conquest would utilize the vaunted memories of the Egyptian campaign and give France a global role the popularity of which would result, he hoped, in stability for the constitutional regime.

Addressing the Chamber of Deputies on 9 June 1836, the day before his govern-

ment requested more money from the same body for the obelisk project, Thiers traced the origins of the Algerian policy to Napoleon and declared that now "we are the authors, the fathers of Egyptian civilization." Algeria, then, would receive the same benefits from France in its productivity, agriculture, and industry. It would be part of an empire of French influence in the Mediterranean that would include Tripoli and Tunis.[61] French expansion in Algeria would, like the arms of Détournelle and Caraffe's figure of Harmony, bring together opposing factions in France. By effacing the bloody memories hanging over the Place de la Concorde, by uniting the urban plan, and by propagating a rationale for imperialism in the Near East, the obelisk would provide post-Revolutionary France with a monument that could last. It offered modern France an ideological center by which the country could not only survive but flourish.

The obelisk was presented not to proclaim a universally accepted national policy, which is to say that it was like all other works of art: it did not passively and magically reflect a political reality. It had more important work to do. It was inserted into this political and monumental void in order to assert the rationale for a real, historical, ongoing, and potentially future imperial role. It did so by calling forth a longstanding textual tradition that fixed France's superior status vis à vis the Orient, a discourse that enjoyed a continuing, uncontentious currency in contrast to the murderous revolutionary-counterrevolutionary dialectic. We will see in the subsequent chapters how the obelisk was the culmination and the most visible manifestation of a cultural practice undertaken by each of the post-Revolutionary regimes. The artistic and political strategies—the historical models, moral contrasts, and scientific rhetoric—that accompanied the obelisk to the Place de la Concorde were deployed earlier in the public setting of the Museum and the Salon. However fractured were the domestic fortunes of each post-Revolutionary regime, and however special were the actual interests that led France to its empire, the allure of a new imperial culture was such that it was elevated in an attempt to find a safe haven from the murderous revolutionary dialectic.

2

Paintings of the Egyptian Campaign

When Thiers programmed the Place de la Concorde, and when he advocated French expansion in Algeria, he was adopting a project that was laid out at the end of the eighteenth century. Foremost among the Enlightenment thinkers who animated both the Revolution and the Egyptian campaign, C. F. Volney broadcast a model of history that declared that French and European civilization—enlightened, rational, and technologically sophisticated—would spread the world over, leading to the inevitable extinction of all other cultural and political forms, in particular, the Eastern ones that were characterized by despotism, technological inferiority, and the ill-treatment of women. In the 1790s, "civilization" was defined as we know it, and its definition was predicated on an essential and opposed Occident and Orient. Late Enlightenment thinkers thus conceived not only the rationale for the Egyptian campaign but also the ideology that served the Algerian conquest and the entirety of Europe's colonial activities in Islamic lands throughout the nineteenth century.[1]

The dream of French imperial expansion partook of the same universalizing and expansionist spirit as the Revolution. Subsequently, a long tradition has maintained that, accordingly, modern French imperialism in general and the Egyptian campaign in particular, were simply extensions of the Revolution. In practice, however, when Volney and the *philosophes'* theories were put into action in the Egyptian campaign, imperial expansion was a diversion from, not an extension of, the Revolution. Named Commander of the Army of England in 1797, Bonaparte was supposed to extend the liberation of Europe to France's oldest and most implacable rival. But when his Army of England left Brest and turned south for the Mediterranean, rather than north for the Channel, it was an epoch-making turn. Bonaparte's forces at Brest had been perched

on the divide between the continuation of a continental policy that would spread the French Revolution to all the European countries and an imperial policy that would dilute competition among European powers and divert it to distant lands. As Talleyrand told a foreign diplomat, the invasion of Egypt was undertaken "in order to deflect revolutionary ideas from overwhelming the whole of Europe."[2]

Talleyrand and Bonaparte, inspired by Volney and the Ideologues, maneuvered together to engineer the invasion and win the Directory's approval for its execution. Bonaparte dreamed of striking at the Ottoman Empire by conquering its most strategically placed and historically prestigious possession—Egypt. He wrote the Directory in August 1797 recommending such an invasion, reasoning that it would weaken the British by cutting off their access to India. For his part, Talleyrand, as Foreign Minister, submitted a report to the Directory on 14 February 1798 in which he, too, proposed an Egyptian invasion that would take advantage of a collapsing Ottoman Empire, liberate the Egyptians, restore Egypt to its ancient wealth and splendor, re-create the Suez Canal, and gain commercial advantages by severing England's access to India. In words that Thiers would later echo in his July Monarchy adoption of the Directory's imperial blueprint, Talleyrand argued that French influence would spread from Egypt west across the northern coast of Africa and east to the remotest corners of Asia.[3] It turns out that Talleyrand had been secretly cooperating with the English, and that desires for stability and prosperity in Europe and easy victories in far-off lands decided the invasion of Egypt. As early as 5 November 1795, the Directory had declared itself devoted "to restore social order in place of the chaos that is inseparable from revolutions."[4] The path to order, the Directors concluded, ran through Egypt, not England. In choosing imperial expansion in the East in order to quell internal divisions, the Directory set a precedent that would be followed many times in the nineteenth century and it helped fix one of the central attractions in the allure of empire. As for the Egyptian campaign itself, it became the guiding light not for French revolutionary politics but instead for future French imperialism in North Africa, a cornerstone of French foreign policy until the second half of our century and a powerful focus and source of national identity.

The French expedition force left Brest for Toulon, and then Toulon for Egypt on 19 May 1798. They entered Cairo on 24 July, but by 1 August 1798, Britain's Admiral Nelson delivered a devastating blow. Only a week after the taking of Cairo, Nelson annihilated the French fleet at Aboukir Bay.[5] Although Bonaparte tried to extend his conquests by land, hoping to reach Istanbul, he only got as far as Acre, before he was turned back by a combined British-Ottoman force. He left for France while news reports still favored him. His Egyptian victories helped to propel him to power in the

coup of 18 brumaire (November 1799), although the occupational army that he left to govern Egypt surrendered to the British in August 1801.

A loss in military terms, the Egyptian campaign was represented in France, as it still is, as one of the most glorious—and uncontroversial—pages of the Napoleonic epic. Part of this perception is due to the luster of the intellectual wing of the campaign and its collective work, the *Description de l'Egypte*. Along with the military, Bonaparte brought with him to Egypt some 164 of France's finest minds, the cream of the Institut and the Ecole Polytechnique: scientists, mathematicians, astronomers, engineers, linguists, architects, draftsmen, and painters, including Monge, Berthollet, and Fourier. Engineers surveyed, doctors and architects designed military and civilian hospitals, architects and archaeologists drew the sites at Thebes, Luxor, and Karnak. In July 1798, the Institut d'Egypte met and discussed the Rosetta stone, marking the conception, if not the birth, of Egyptology.[6] Originally recruited to make the colony in Egypt profitable, the savants' enduring work is the enormous *Description de l'Egypte*. Publication began in 1809 and did not cease until nineteen years and two Bourbon monarchs later. As it was published mostly during the Restoration, it will be addressed in the following chapter. By the time it first appeared, the most important paintings depicting the Egyptian expedition had already been exhibited.

Even from the battlefields of Egypt, Napoleon had encouraged and commissioned history paintings depicting the Egyptian and Syrian campaigns, and they became a regular offering in Napoleonic Salons. That the actions of a regime would be heroized is something of a given. It is the particular artistic strategies that will concern us. For here is the inaugural presentation in high art of the rationale for French imperialism in the Near East, the foundation of the cultural edifice of France's modern Empire. As we will see in this selected catalogue of paintings of the Egyptian campaign, artists, patrons, and critics developed styles of sponsoring, painting, and receiving accounts of the contemporary Orient, all of which projected the Empire's authority based on its superiority over non-Europeans.[7] The subsequent chapters will show that they coined a currency that was then converted and reused by succeeding and ostensibly opposing regimes, making the Empire's artistic deposit an enduring imperial legacy.

GROS'S *BATTLE OF NAZARETH*, 1801

Antoine-Jean Gros's *Battle of Nazareth* (figure 22) was the initial volley launched in the propaganda campaign orchestrated by Bonaparte and his generals. For the first time in high art, generals and painters advanced the rationale for the modern French

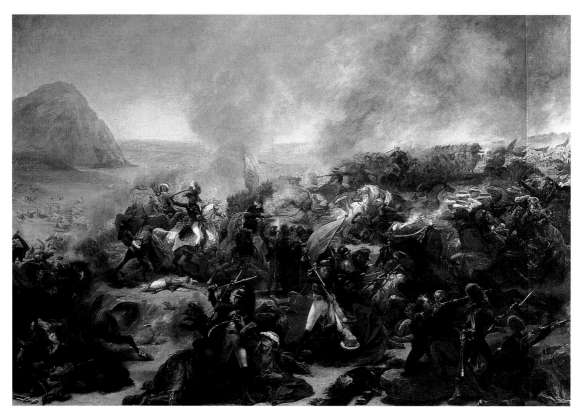

Fig. 22. Antoine-Jean Gros, *The Battle of Nazareth*, 1801. Oil on canvas, 53⅛ x 76¾ in. (134.9 x 195 cm).
Musée des Beaux-Arts, Nantes

empire based on three interlocking strategies: historical memories, moral contrasts, and scientific postures. These three strategies would remain decisive in France's cultural arsenal, deployed from this moment and throughout the nineteenth century in the promotion of France's expanding Empire.

The Battle of Nazareth commemorates the most successful episode of the failed Syrian campaign: the rout of 6,000 Turks on 8 April 1799 by General Junot and 500 French troops. In the days following the battle, Bonaparte sent word to France announcing a competition for a monumental history painting of the battle of Nazareth, although the event took place on the plains of Lobiau twelve miles from Nazareth. In April 1801, the second anniversary of the battle, newspaper notices announced "one of the first major artistic projects of the Napoleonic era."[8] Artists were invited to submit oil sketches and were offered an account of the battle, a map of the battle site by the commanding general, Junot, as well as Denon's own drawings from the Egyptian campaign for the study of Eastern costumes. Nine oil sketches were exhibited at the Salon, and when the jury met on 8 December 1801, Gros was declared the winner and asked to execute the painting on a canvas no less than twenty-five feet long.

The first of the artistic strategies in the service of French imperialism in the Near East posited a historical and recurring clash of civilizations. Gros consulted and indeed exhibited with his painting the plan of the battle certified by General Junot (figure 23). From this plan the artist made a somewhat less detailed map of his own, this time reversing the location of Mount Tabor, from the upper right (location B) in the Junot drawing (figure 23) to the left-hand side of the artist's scheme (figure 24). In the oil painting, Gros secured the pictorial and narrative importance of the hill by placing it in the left background, making it a strong anchor in the composition and a looming presence on the battlefield. To underscore the hill's importance, he voided most of the remaining topographical detail provided by the general. Furthermore, the artist switched the placement of Arab and French troops, so that, with Mount Tabor and Cana in the background, the French troops drive the Arabs away from the Christian holy sites. By evoking Nazareth, Mount Tabor, and Cana, Gros evokes the life of Christ, including his miracles at the wedding of Cana, Christian themes that would have been anathema to the Revolution. This historical—in the guise of religious—contrast would be repeated in the subsequent Salon paintings of the Syrian campaign. For instance, Louis-François Lejeune's 1804 *Battle of Mount Tabor* (figure 25) insists on the Christian history and pointedly offers a historical precedent in the Crusades. Lejeune's own description in the Salon booklet underscores the historical conflict: "At the left, Mount Tabor rises, famous for the miracle of the Transfiguration,

Fig. 23. Plan of the Battle of Nazareth sent to Gros by General Junot, 1801.
Musée des Beaux-Arts, Nantes

Fig. 24. Antoine-Jean Gros, *Plan of the Battle of Nazareth*, 1801.
Musée des Beaux-Arts, Nantes

Fig. 25. Louis-François Lejeune, *Battle of Mount Tabor,* 1804. Oil on canvas, 70⅞ x 102⅜ in.
(180 x 260 cm). Musée National du Château, Versailles

and by its position close to the sites such as Nazareth, Cana, etc., which were the
cradle of Christianity." If the tradition of the French role in the Holy Land was not
clear enough, the center foreground features, in Lejeune's own words, "an officer [who]
discovers a Gothic stone with the arms of France which recall for him"—and now for
the viewer—"the Crusades of Louis IX."[9]

The competition and Gros's painting helped construct what became the glori-
ous essence of this battle, the moral contrast between French and Eastern civilizations
—and the second of the three imperial artistic strategies. It was delineated by the
government, pictured by Gros, and enunciated by the critics. As the writer for *Le
Moniteur universel* told it, the French faced overwhelming numeric superiority. Thus,
they formed themselves into tight geometrical formations and allowed their oppo-
nents to charge them with "typical impetuosity," to which the French responded with
"calm and true courage." Even though Gros was criticized for a lack of narrative cen-
ter in his picture, critics overcame Gros's rendering and identified faceless, disciplined
lines of French soldiers in the background in contrast to a ferocious assault by the

Turks. "French valor bore its stamp," the critic concluded, "the calm that character-izes it contrasts with the blind impetuosity of the Muslims."[10]

Critics identified the precise vignettes that Gros had painted, following notes he had made from the official program. These were moral or cultural oppositions that Junot requested in order to "characterize the two nations." At the bottom center of the picture, a French soldier earnestly reaches back to stab the Turk, who struggles wildly despite the superior position of his captor. The Turk defends his flag with furor and fanaticism, which is why he cannot be given French mercy. As asked, Gros de-picts "the barbaric custom of the Turks to cut the head of an enemy on the ground" and contrasts it with "French loyalty, which, in this situation, means that he [the French soldier] sees only that a prisoner must be made to respect."[11] Decorously, the artist fulfilled the specifications of the program without actually showing the decapi-tation of a Frenchman. At the bottom left of the picture, a French soldier has just knifed a Turk who has collapsed on top of him. The hair of the prostrate Frenchman is then seized by a Turk who prepares to decapitate him but is shot by a French dra-goon. The intended stabbing of the defenseless French soldier is contrasted with the next group to the right. There a vanquished Turk is merely held to the ground by his French opponent. Gros's and his patron's message was conveyed. The critic for the official *Moniteur universel* repeated the message, noting how differences in soldierly behavior were introduced to typify and contrast the moral character of the two na-tions: "A little distance from that scene where the barbarism of the Orientals is painted, and by a contrast perfectly understood, a dragoon saves the life of a Turk who gives himself up."[12] To assert French discipline, order, and clemency was an especially ur-gent task because, in fact, no Turkish prisoners were taken that day; they had all been killed.[13]

Gros did not limit beheadings by Eastern troops to this painting alone. In his entry for his 1806 Salon picture, the *Battle of Aboukir* (figure 26), Gros wrote that the Turks "leave their position to cut the heads of Frenchmen left dead or wounded on the field of battle." Critics noted with relish that these barbarities outraged the French army and precipitated the charge depicted in the painting.[14] In these details of the *Battle of Aboukir*, Chaussard saw what had first appeared in the Salon of 1801: a funda-mental clash of civilization and barbarism, as when Homer pitted Europe and Asia beneath the walls of Ilion. Chaussard saw that Gros had contrasted "the calm of superi-ority, the enlightened valor, [with] the other—the brutal carriage, the stupid feroc-ity and blind courage; as if he had wanted to indicate the triumph of the enlightened and of civilization over shadows and barbarism."[15] Chaussard helped secure Gros's

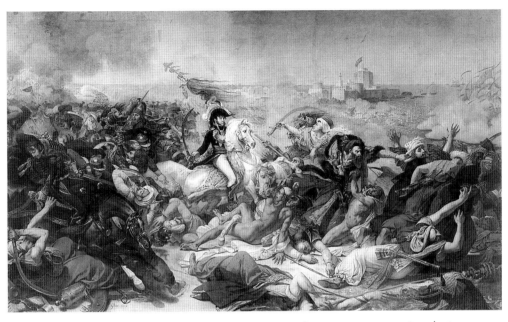

Fig. 26. Antoine-Jean Gros, *Battle of Aboukir,* 1806. Oil on canvas, 18 ft. 11$\frac{1}{2}$ in. x 31 ft. 9$\frac{1}{8}$ in. (578 x 968 cm). Musée National du Château, Versailles

place as an heir to his Homer, a bard of the Occident in its historical struggle against the East.

The third strategy that recurs in art for French imperialism in the Near East is also requested in the official program—what I call authenticating strategies or a scientific pose. In a striking innovation in exhibition techniques, Gros displayed his sizeable painted sketch above three documents: the map of the battle certified by Junot, Gros's pen and ink sketch after the official plan, and his "Extrait du Programme," in which he synthesized the program requirements and other eyewitness accounts followed in his painting.[16] Through his installation, he thereby attested to the truthfulness of his picture through its proximity to written eyewitness accounts and unartful, quasiscientific representations of the battlefield and battle. The citation of less exalted but more authoritative types of pictures and representations to undergird the truthfulness of the image would become a hallmark habit of art in the service of French imperialism.

As Gros wrote in his synthesis of the government's program, artists were to render authentically their subjects, paint in a scientific style, correctly record the battle movements, and accurately render the light and atmosphere.[17] That authenticity was

one of the official criteria is confirmed by the anonymous critic for the *Moniteur universel,* who began his description of the sketches by saying, "Let us see up to what point the authors came close to the site and the truth of the action."[18] Gros satisfied this critic and the government with what came to be accepted as a convincing evocation of the color, light, atmosphere, and costume associated with the Orient. His brushwork suggested a freedom that connoted uncalculated spontaneity. He executed a tableau redolent with the action and atmosphere of the battlefield.

Hovering over the plain, a great cloud of dirt and smoke thickens and darkens in some areas, then thins and catches light with great nuance. At the lower left a French soldier fires on a Turk; his gun emits a palpable cloud of smoke that engulfs the middle part—but only the middle part—of his right arm, so that his hand is not yet obscured. The passage is as successful in conveying battlefield atmosphere as it is precise in depicting an instant of the conflict. The program requested that the painters show the precise time of battle as well, 10:00 a.m. to 3:00 p.m. Accordingly, critics of the Salon (who among them had been to Syria?) found in Gros's painting a remarkable fidelity to Syrian light at three o'clock in the afternoon. Gros's patrons and critics knew the subject bore the stamp of Bonaparte and his generals, an imprimatur that to this day is accepted as credible.

Art historians have long and properly understood Gros's technical innovations as breaks from the classical structures and formulae of both neoclassical battle paintings and Davidian history paintings.[19] According to many genealogies, this is the beginning of an alternative but equally French tradition, Romanticism. In *The Battle of Nazareth,* Gros risked being accused of "going native," of somehow identifying with the Eastern foe. What with the violent subject, the sensuality of the handling, the lushly applied and distributed colors, and the weakness of the narrative focus—as if Gros lacked the rigorous and lucid thinking demanded by *historia*—*The Battle of Nazareth* might have been labeled Gros's Turkish picture. However—and we will see this dynamic again—Gros's public refused to read it that way.

Even his detractors did not question the truth of the paintings. Instead, partisans of a more classical and less naturalistic style focused on his "overreliance" on the eyewitness accounts. Boutard, the leading neoclassical proponent, admonished Gros for painting "a pantomime" of the battle of Nazareth. He sarcastically suggested that artists such as Gros, who had the courage to follow the program, produced paintings "divided by commas, periods, and paragraphs."[20] From this perspective, *The Battle of Nazareth* was an artless, laconic, prosaic, but, even his detractors agreed, truthful picture. Just as the Egyptian campaign was undertaken to suppress the Revolution,

Gros's *Battle of Nazareth* departed from neoclassical aesthetics and began to institute what would become a new orthodoxy,[21] a series of clichés about French and Eastern civilizations, ways to represent and view them, and habits that would be repeated, adapted, and elaborated to help forge an imperial identity for a new post-Revolutionary regime.

Gros's *General Bonaparte*
Visiting the Pesthouse at Jaffa, 1804

Gros's sizable oil sketch of *The Battle of Nazareth* remained critical to nineteenth-century painting despite the fact that the twenty-five-foot-long version was never executed. The artist had won the competition and been given permission to use the *jeu de paume* at Versailles as a studio. Bonaparte, however, ordered Gros to stop production and paint a different scene from the Syrian campaign: Bonaparte's visit to the plague hospital at Jaffa. Thus, the Nazareth canvas was sacrificed; it was so large that Gros used the canvas for both *General Bonaparte Visiting the Pesthouse at Jaffa* (figure 27) and the *Battle of Aboukir.* New urgencies had intervened since the 1801 exhibition. Bonaparte had become Consul for Life, and negative stories were leaking out about the Syrian campaign.

Like the battle of Nazareth, Gros's new subject concerned the period after prospects for colonization had been dashed, when French sea power was annihilated by Nelson's victory at Aboukir Bay. Bonaparte had still hoped to fulfill his Alexandrian dream of conquering the Orient by land from Cairo to Constantinople. Departing from Cairo on 10 February 1799 and taking El Arich, Gaza, and Jaffa in the next month, the French forces pulled from Acre in failure on 20 May 1799 and retreated to Egypt. Two episodes of the campaign added a public relations disaster to the military defeat.

In the course of the assault on Jaffa, the French had obtained capitulation of the garrison in exchange for the promise to protect the lives of the prisoners. Bonaparte then bucked the agreement and a massacre of 2,500 to 3,000 Turkish prisoners ensued, with French forces plundering the town and terrorizing the civilian population.[22] The French army was also struck by the plague, especially violently on the day after the taking of Jaffa. Bonaparte and René Desgenettes, the chief medical officer of the Syrian campaign, agreed to deny the presence of the sickness in order to prevent further erosion of troop morale.[23] Two months later, on the retreat to Cairo, Bonaparte ordered Desgenettes to poison French plague victims, rather than take them back to Cairo or leave them to the incoming Turks. Desgenettes refused, and large

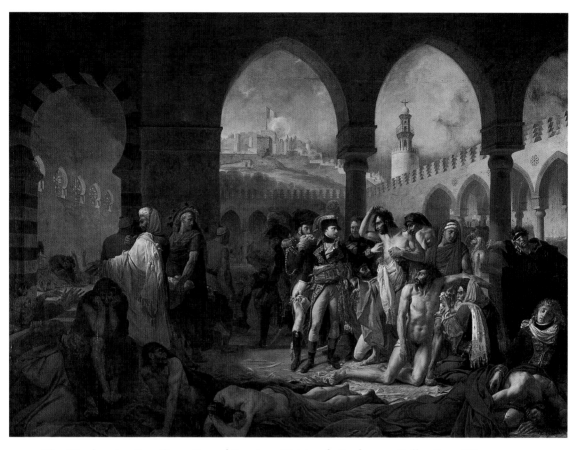

Fig. 27. Antoine-Jean Gros, *General Bonaparte Visiting the Pesthouse at Jaffa,* 1804. Oil on canvas,
17 ft. 1⅞ in. x 23 ft. 5½ in. (523 x 715 cm). Musée du Louvre, Paris

doses of opium were left for the soldiers to do themselves in. A few soldiers vomited the poison, survived the plague, and told the English who arrived ahead of the Turks. The English press was rife with accounts of the atrocities.[24]

To counter these damaging stories, Gros's painting was meant to commemorate Bonaparte's first visit to the pesthouse. To convince the soldiers of the noncontagiousness of the disease, Bonaparte had visited the plague hospital on 11 March 1799. Although some published accounts maintained that Bonaparte avoided the sick and even lightly kicked infested men with the sole of his boot,[25] Desgenettes's 1802 memoirs describe Bonaparte entering the hospital with his chief of staff and Desgenettes at his side. "Finding themselves in a narrow and very encumbered chamber, he [Bonaparte] helped in lifting the hideous cadaver of a soldier whose shredded clothes were soiled by the opening of an abscessed plague sore."[26] In an oil sketch (figure 28) Gros

Fig. 28. Antoine-Jean Gros, *General Bonaparte Visiting the Pesthouse at Jaffa,* 1804. Oil on canvas, 28½ x 36¼ in. (72.4 x 92.1 cm). New Orleans Museum of Art

represents this moment, but in the final work both the setting and the action are changed. Gros's Bonaparte shows no fear in touching the horrible bulbous sore of a plague victim, thereby inspiring his downtrodden troops and visitors to the Salon. In Girodet's ode to the painting, the admiring artist recognized that "the hero can cure at a glance." Bonaparte touches the sore of the plague victim, in imitation of Christian saints such as Roch and Carlo Borromeo. The gesture gives Bonaparte the king's legendary touch, the "touche des écouelles," which healed scrofulous abscesses and had been a power of French kings since the year 1000. Thus, Napoleon appears as a new "roi thaumaturge," a miracle-working king.[27]

This is only one of Gros's historical references, however. If Egypt was the theater of Napoleon's glory, then the stage set for his healing touch must be acknowledged: the makeshift hospital is a mosque. Although we now know that the hospital was set up in an Armenian monastery,[28] this is not a point that any critic of the day conceded, nor is there any indication that Gros intended to convey this. Gros shows Bonaparte bringing his Christian and French monarchal touch to the Christian Holy Land dominated by Islam since the seventh century.[29] The Christian touch and the Islamic setting denote the historical confrontation that *The Battle of Nazareth* had staged on the battlefield.

In the earlier oil sketch that follows Desgenettes's account, Bonaparte lifts the weakened body of a plague victim. The scene is placed in a rather nondescript box with little Oriental ornamentation (figure 28). Subsequently, when Gros introduces the saintly touch in another preparatory work (figure 29), he also changes the setting. The final picture evinces a distinctly Oriental or Arab context for contemporary critics.[30] Individual architectural elements unmistakably describe an Islamic locale: the horseshoe arches on the left, the early Mameluke crenellation rising above the court's arcade, and the minaret hovering over the right corner of the building. The floor plan evokes the standard Friday mosque with a large open forecourt, surrounded by covered porches, the largest of which houses the main action in the painting.[31] The historical drama acted out before us suggests that France has returned to bring civilization to the Holy Land. On the hill, over Bonaparte's shoulder, the French tricolor flies triumphantly over a Franciscan monastery. The historical cycle is complete.

If in *The Battle of Nazareth,* Gros conjured the essence of French civilization through moral contrasts to France's Muslim foes, here Gros displays science as an attribute of French civilization. By "attribute" I mean not just an essential component but a badge of honor, like the attributes carried by Christian saints in traditional religious painting—signs of martyrdom and, ultimately, of divine favor that justify and insure their eventual triumph. French scientific advancements in medicine were

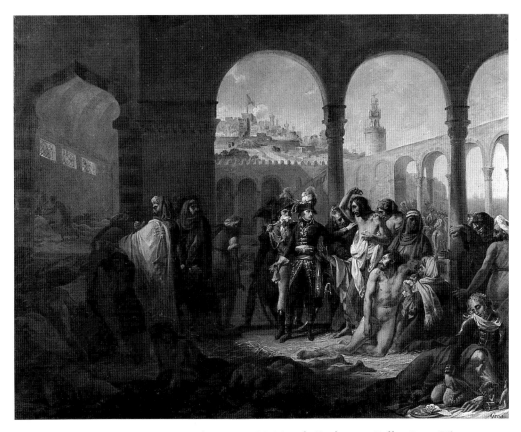

Fig. 29. Antoine-Jean Gros, *General Bonaparte Visiting the Pesthouse at Jaffa,* 1804. Oil on canvas,
35⅞ x 45¾ in. (91 x 116 cm). Musée Condé, Chantilly

used to demonstrate the rewards of French imperialism in the Near East. As *La Dé-cade Egyptienne,* the journal of the Institut d'Egypte, reported during the occupation, "Knowledgeable Europe would not know how to see with indifference the benefits of the applied sciences to a country where they were brought by the wise army and by the love of humanity, after having been so long exiled by barbarism and religious fury."[32]

In the space between Bonaparte and the distribution of bread, two black men in red tunics carry a stretcher toward a resting camel, an "ambulance volante." The battlefield stretcher itself was a fundamental medical innovation of the Revolutionary army: the immediate on-site treatment of the wounded ended the centuries-old practice of moving casualties after battle to distant hospitals.[33] Outfitted to carry the wounded, the cameline "flying ambulance" was an Egyptian campaign adaptation, described in Dr. D. J. Larrey's campaign memoirs[34] and in the *Description* (figure 30).

In Gros's painting, the camel is not merely an exotic detail, but, like Bonaparte's mastery over the plague, represents a French triumph over the strange diseases and bizarre animals the French associated with the region.

A second reminder of French scientific acumen in the *Pesthouse at Jaffa* is the prominence given to Desgenettes, who is placed between Bonaparte and the plague victim. Desgenettes was a symbol of pride, described by one Salon reviewer as "director of medicine of the army, as famous for his knowledge as for his courage."[35] While Gros stated in the Salon *livret* that Desgenettes implored Bonaparte to cut short his visit, and while some critics concurred,[36] the painting makes more of Desgenettes's appearance. The doctor's presence is underscored by the column behind his head. He does not appear anxious. He knowingly peers out at the viewer. His left arm reaches out to Bonaparte, and his hand comes down on the general's shoulder; Bonaparte in turn touches the plague victim. It is as if Desgenettes is conferring on Bonaparte the healing powers that he himself had developed in his well-publicized achievements in the army's medical services.[37]

So much attention has been paid to Bonaparte's touch that a balance needs to be struck in order to restore the medical/scientific attribute of the painting's theme

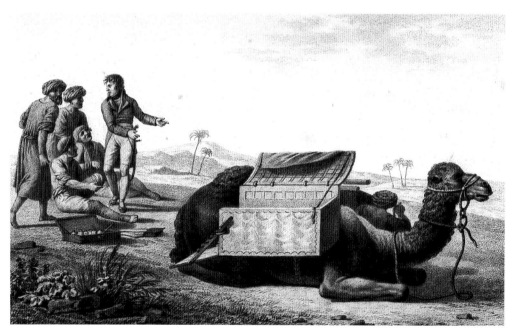

Fig. 30. Dominique Larrey, *Ambulance Volante.* Engraving from *Description de l'Egypte* (Paris, 1819), vol. 2 bis, plate 31. Bibliothèque Nationale, Paris

and execution. In a rare extended study of battle paintings written at the end of the century, Arsène Alexandre, a physician and art historian, wrote that the *Pesthouse at Jaffa* has a clinical appearance, that "in all the different figures, all the phases of the contagious disease" are illustrated.[38] Critics of the 1804 Salon also stated that the depictions of the plague are scientific and central to the painting's meaning. "It is said by art people and those who have had the occasion to observe the effects of the plague," one reviewer wrote, "that the painter has faithfully rendered the symptoms and progress of these diverse maladies."[39] And another noted that "the details of that sickness, the most murderous of all, were frightening, even repulsive, but they were essentially tied to the subject."[40]

Indeed, Gros's *Pesthouse at Jaffa* seems informed by Larrey's report on the diseases encountered during the Egyptian and Syrian campaign, which he published in his 1803 memoirs. Although not every figure is a textbook example of a particular malady or symptom, the different diseases of the campaign and each stage of the plague are clearly, horrifyingly, represented. The two prostrate figures in the immediate foreground recall the typical first stage of the illness. One pulls out his hair with his crossed hands, and "all his limbs contracted announcing the excess of his suffering." Next to him another victim twists his body for a look at Bonaparte, suggesting the restlessness also found in the first stages of the plague.[41] The two seated covered figures to their left demonstrate symptoms of the next stage: they both look very weak; the completely covered figure tries to fend off the shivers, the other falls off to sleep. Behind them, bodies are, as one critic noticed, "attacked by convulsive fits,"[42] thus recalling the delirium that sets in next. In the typical progression that Larrey charts, these symptoms run their course in about four days, and the patient may appear cured but then die. Others go more quickly (figure 31). The frightening symptoms accompanying the less typical and quickest route of the plague seem imprinted on the face of the young doctor at lower right who, while fully in the process of caring for a soldier, succumbs himself. His features slacken, his lips distort, his tongue loosens, his eyes open and become unfixed, and we can next expect that he "contorts on himself, screams lugubriously and dies all of a sudden."[43]

The frightening variety and detail of Gros's plague descriptions lend authenticity to a picture whose central thesis—the godliness of Bonaparte's actions among the French plague victims—sorely needed verifying. Gros meets the standard for accuracy in pictures set in the Orient, as he had in *The Battle of Nazareth.* Moreover, his scientifically informed exactitude made for an artistic display of the same national scientific acumen that the picture celebrated. Larrey's reputation for science bolsters

Fig. 31. Antoine-Jean Gros, *General Bonaparte Visiting the Pesthouse at Jaffa* (detail of fig. 27)

Gros's, as had the three documents that he exhibited below *The Battle of Nazareth* in 1801.

Still, in spite of Bonaparte's and Desgenettes's powers, the viewer of Gros's monumental *Pesthouse at Jaffa* confronts a heap of dead bodies. Gros's rendering of the effects of the plague in the most immediate and accessible areas of the canvas give the viewer a *frisson,* which suspends disbelief and makes convincing and welcome Bonaparte's healing gesture depicted higher on the canvas. At the same time, the body count testifies that neither Bonaparte's saintly touch nor modern French science has succeeded in resuscitating these victims. Redemption for these dead and dying men is instead implied in a progression from right to left, which subtly determines the composition. It is the same progression that leads occasionally to healing but more assuredly to death. In the right part of the picture, soldiers seek healing and contact with Bonaparte. At the center, Bonaparte imparts his healing touch. Yet most of the soldiers die, as shown on the left. Neither Bonaparte nor Desgenettes can save them. We might conclude that Gros's picture is merely a Romantic orgy of death; that would satisfy our placement of this picture in the cadre of the development of Romanticism. In this very successful Salon painting in the tightly controlled and first of Empire Salons, the subsequent development of Romanticism could not have been foreseen; however, the picture's own presentation of the contrast of civilizations was evident. The dying soldiers receive bread, a reference to the Christian sacrament, and are promised burial, the last Christian rite and appropriate recompense for nineteenth-century French crusaders, new claimants to the Holy Land.

LEJEUNE'S *BATTLE OF THE PYRAMIDS*, 1806

Exhibited at the Salon of 1806, Louis-François Lejeune's *Battle of the Pyramids* (figure 32) is a luminous and dynamic picture. At sunset on 21 July 1798, on the plains of the west bank of the Nile, between the Giza Pyramids and the village of Imbaba, the French forces encountered their Mameluke opponents. This battle preceded—and insured—the French occupation of Cairo and the subsequent conquest of Egypt.

Lejeune's picture presents a fundamental contrast. The French troops are depicted as a unified, geometric force that systematically marches across the plains. They are the force of order, driving their wild, chaotic, disorganized enemies into the Nile. Lejeune's own words in the Salon *livret* direct the viewer to understand the political order symbolized by the painting's compositional regimentation. "At the bottom of the plain that the Nile floods each year rises the Pyramids," he wrote. "The squared battalions in the background are those of General Regnier at right and, more to the

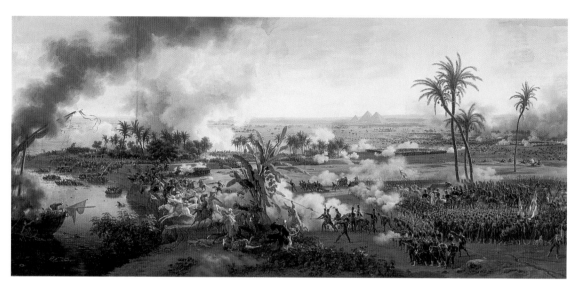

Fig. 32. Louis-François Lejeune, *Battle of the Pyramids,* 1806. Oil on canvas,
5 ft. 7½ in. x 13 ft. 7⅞ in. (180 x 425 cm). Musée National du Château, Versailles

left, those of General Desaix. . . . The Mamelukes and Arabs are in disorder around these battalions."[44] Critics of the Salon described the picture using the same terms of French order versus Oriental chaos, regardless of their conflicting aesthetic allegiances.

Frédéric de Clarac summarized the action of the painting in which the charges of the Turkish "cavalry dissolve in disorder [when] faced with the French infantry who await them on firm foot."[45] Boutard noted the contrast between France's "three squared battalions" and the "Turks running pell-mell in these vast plains, massacring our wounded."[46] And Pierre Chaussard saw that Lejeune precisely described the lines of the battle, showing the tumult and despair of the Turks and the march of the square French battalions. A staunch supporter of the Napoleonic regime, Chaussard went on to say that some other critics found fault with the order and tranquility of the French troops. They complain, he wrote, that we are witnessing a military parade and not a battle. "The response is easy," Chaussard replied, "the superiority of our Strategy is due to that [tranquility]. . . . Genius, which leads us to Victory gives our Warriors their steely assurance and a kind of impassiveness in the face of extreme peril."[47]

The critic for the liberal *Publiciste* suggested that this French order is a modern, active parallel to the vertically dominating, equally ordering and imposing pyramids in the background:

> *The view of the Pyramids leaves not a trace of a doubt regarding the subject that the painter chose: the symmetry, which most often is harmful to picturesque effects, here lends them new help.*
>
> *The eye promenades with pleasure over these square battalions that are vainly faced by the reckless Mamelukes.*[48]

Heirs to the ancients, the French drive out representatives of the Orient's unfortunate history that separates them from the grandeur of the Pharaohs. Victorious, the French inherit the Pyramids as emblems of their own grandeur.

This model of the evolution of civilization, in which French power and rationality is aligned with Pharaonic Egypt and set off against the East's contemporary rulers, is sounded in many other paintings, where it is contrasted to Oriental chaos. In François-André Vincent's contemporaneous oil sketch of the same subject (figure 33), for instance, lines of faceless French troops advance against the frenzied, chaotic Turks. The scene is set against a background of the order and geometry of the Pyramids.

In Philippe-Auguste Hennequin's 1806 painting of the same subject (figure 34), however, the order of the French troops is less pronounced than in Lejeune's or Vincent's. Hennequin's pyramids are almost lost in the haze of the desert battle. In the

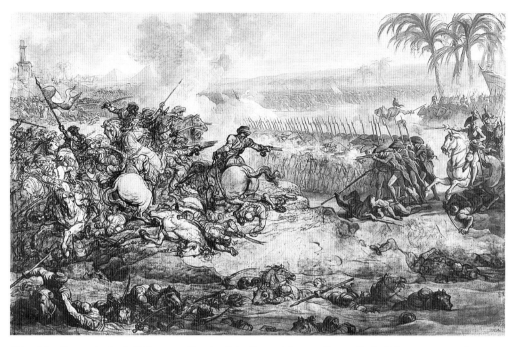

Fig. 33. François-André Vincent, *Battle of the Pyramids,* ca. 1800–1806. Oil on mounted paper, 31½ x 49¼ in. (80 x 125 cm). Musée du Louvre, Paris

distance, the troop formations disappear into the landscape. In the foreground, the battle is a tumult. The clarity of opposition is given over to a spectacular death here, a rearing horse there, each plucked out of the chaos, each with its own individual light. This is his error according to Chaussard and other critics. Hennequin failed to delineate sufficiently between France's "admirable order" and the "tumult, terror, rage and despair of the barbarians." Hennequin should have concentrated on this fundamental meeting of opposites, Chaussard dictated.[49] This criticism shows that when the artist did not dedicate his work to the opposition of East and West, critics faulted him for it because they knew that it was there. Hennequin's more chaotic view of war —in which essential traits of opposing civilizations are not visualized—was discouraged, and Lejeune's clear historical and moral contrasts were instated as official and acceptable history.

An arch-neoclassicist like Boutard did not like Lejeune's work, but he could only assent to its accuracy. Virtually everyone agreed with him about Lejeune's pictures in general and about the *Battle of the Pyramids* in particular, which are "not so much picturesque compositions as exact representations of the facts of armies such as

they happened and in most of which the painter had himself participated."[50] Whether that was what artists should do was another question. Lejeune's exactitude in describing the geometry of the French force was credited to (or blamed on) his double role as general and artist, which is underlined in the Salon *livret* where he is listed as: "Lejeune, battalion leader in the imperial corps, student of M. Valenciennes."[51]

One critic, "D. B.," wrote that "it is easy to recognize that he [Lejeune] had the camps for studios and the battlefields for models." This critic admired Lejeune's paintings for the exact description of sites, clarity of action, observation of strategic position, and richness of tones. He granted the artist an important place among battle painters but insisted that Lejeune was not a history painter because he merely copied nature. This argument protected the exalted category of history painting, which demands imagination and intellect and, simultaneously, it fortified the perception of Lejeune's realism.[52] Indeed, Lejeune's detractors neatly argued for the artist's fidelity to nature; that was their objection. Boutard summarized this view. In writing on the 1804 Salon, he denigrated Lejeune's habit of precisely describing battles for he "sacrificed the interests of art to those of history."[53]

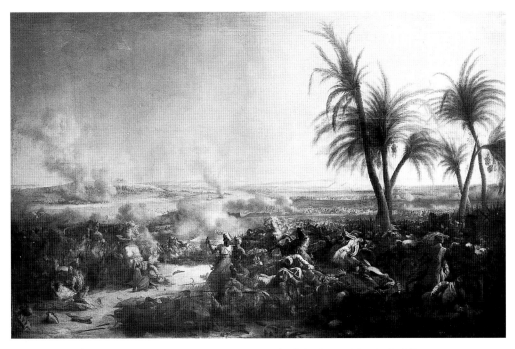

Fig. 34. Philippe-Auguste Hennequin, *Battle of the Pyramids*, 1806. Oil on canvas, 10 ft. ⅞ in. x 15 ft. 9¾ in. (307 x 482 cm). Musée National du Château, Versailles

Lejeune never aspired to the traditional path of history painters. His early ca-
reer shows him devoted to naturalist teachers, scientific drawing, and new artistic
processes. He studied drawing under the landscape painter Pierre-Henri de Valenci-
ennes and prepared for the Engineering Corps of Bridges and Roads. In 1792, at age
17, Lejeune joined other art students in the Revolutionary Army's Company of the
Arts. As General Berthier's chief of staff, he met Senefelder in Munich, who intro-
duced him to lithography; later Lejeune claimed credit for bringing it to France.[54] It
was above all his participation in some of the battles that he painted that earned his
pictures credibility.

The central impression of Lejeune's work from his day to ours is expressed in a
painting of the artist-general by his student and goddaughter, a certain Mme Chas-
saignac (figure 35). A twentieth-century description of the picture captures Lejeune's
reputed bravura and commitment to the eyewitness account:

> {It}*admirably explains Lejeune's oeuvre. The sum of his character exhibits a refined
> distinction not exempt from research. . . . A vast forehead, which, under hair blown
> by the wind of bullets, reveals his imagination, his precise and sure spirit. Around
> the daring artist, the battle grinds on, but his eye is clear, scrutinizing, smiling,
> and it continues unabated in observing. And the hand draws. In front of this mar-
> tial and decisive allure, one can tell that he painted as he fought:* à la française.[55]

Lejeune's military training, his bravery, and the arguably limited intelligence that
compels him to stop and draw in the middle of a battle lend his paintings a sense of
immediacy and credibility. His military hat has a dual function: in the portrait it
serves as a drawing board, enabling him to sketch on the battlefield; at the Salon, the
same hat gave support to the authenticity of his paintings. From this vantage point
of the privileged observer, he advanced an eyewitness posture that became definitive
of Orientalist painting and that later informed the work of Horace Vernet and Colonel
Langlois, to name just two.

In the context of the *Battle of the Pyramids,* Lejeune's documentary pose had a
particularly important and powerful precedent in the work of Dominique-Vivant De-
non. Denon's description of himself at the beginning of his *Voyage dans la Basse et Haute
Egypte* evokes the same risk-taking, eyewitness position found in the portrait of Le-
jeune. Following Desaix's division to Upper Egypt and motivated by nothing more
and nothing less than transmitting the unvarnished truth, Denon says he sketched
constantly, frequently finding himself in the heat of battle without realizing that war
was not his vocation. He made his drawings most often on his knee, "or standing, or

Fig. 35. Mme Chassaignac, *Général baron Lejeune,* after Pierre-Narcisse Guérin's 1810 portrait of Louis-François Lejeune. Oil on canvas, 45⅛ x 30¾ (114.5 x 78 cm). Musée de l'Armée, Paris

even on horseback: I never was able to finish a single one of them to my satisfaction."[56] Cool under fire, artists Denon and Lejeune exemplify the same "steely assurance" ascribed to the French troops in the *Battle of the Pyramids.* Authenticity accrues to their pictures through their "impassiveness in the middle of extreme peril," the same quality that guarantees victory over the frenzied and fanatic Oriental. The virtues of this determined rationality justify the injection of pharaonic order in the Oriental political and geographical landscape. For artist, soldier, and society, science is a badge of superiority, power, and truth.

An art historical note needs to be sounded here. Lejeune's *Battle of the Pyramids* and Gros's *Pesthouse at Jaffa,* like the careers of the two artists, cannot and should not be confused, just as we should not elide the careers of Lejeune, Gros, and Denon. At the same time, however, we may lose something if we fetishize their differences. In the evolutionary biology of art history, Lejeune and Gros issued very different species of painters, based on the development by Gros of what Siegfried calls the "affective mode" and by Lejeune of the documentary mode.[57] In the case of the *Pesthouse at Jaffa,* Gros's affective mode, or Romanticism, is recognized by conventions associated with the sensual or irrational; it is found in the physical immediacy of his diseased figures, the exotic architecture, the diverse physiognomies, the palpable atmosphere, and the Venetian palette. In the *Battle of the Pyramids,* Lejeune's high Enlightenment style evinces clarity and rationality, which is conveyed through the artist and viewer's distanced and commanding view of a clean war; through the specificity not of architecture but of topography, not of atmosphere but of crystalline light; and through a palette and surface that are not smokey and textured but

enameled and matte like the landscapes of Joseph Vernet or Lejeune's teacher, Valenciennes. Their different techniques, however, do not serve divergent ideologies. Lejeune's high Enlightenment style does not promote revolutionary egalitarianism any more than Gros's Romanticism promotes the artist's or individual's freedom from the constraints of authority. Instead, each in its own way makes believable, modern, and alluring the rationale for the Egyptian and Syrian campaigns.

Guérin's *Bonaparte Pardoning the Rebels in Cairo*, 1808, and Girodet's *Revolt of Cairo*, 1810

Napoleon commissioned Pierre-Narcisse Guérin's *Bonaparte Pardoning the Rebels in Cairo* (figure 37) in 1806, and it was exhibited at the Salon of 1808. The following year he commissioned Anne-Louis Girodet-Trioson to paint the *Revolt of Cairo* (figure 36).[58] The paintings concern the uprising in French-occupied Cairo in October 1798. According to Girodet's Salon entry, the French occupation was going smoothly when some uprisings broke out. General Dupuy, commander of the area of the great mosque of El-Azhar, went out to investigate accompanied by a small escort. He was assassinated, and his guards' throats were cut. The Egyptians took refuge in the mosque, and the French "formed themselves into mobile columns."[59] The official story held that after the French quelled the riot, Bonaparte made a public show of clemency. Guérin's subject follows Girodet's, for it shows Bonaparte on the public square El-Bekir pardoning the rebels two days after the riot: the barbarians' violence, which precipitated the action of the first painting, is, in the end, met with Bonaparte's pardon.[60]

At the bottom and center of Girodet's *Revolt of Cairo,* a supine torso spills blood onto its uniform and onto the floor below. The artist has decorously obscured the view of the neck with the soldier's empty helmet. Above and slightly to the right, a black turbaned figure wields a bloody knife in one hand and, with the other, holds the severed head of the French hussar by the hair, a "precious trophy of these barbarians," according to the critic Boutard. "The beauty, the youth, the majesty of the traits," he wrote, "a certain character of sweetness and softness, usual attributes to a prosperous life, must excite regret and pity on a cruel death."[61] For artist and critic, lamenting the butchering of a soldier who led a productive life obscured the real events of that day. For the French had beheaded insurgents, thrown bodies into the Nile, and rolled heads on a public square. The official report, as well as the paintings of Girodet and Guérin, are part of a cover-up, a projection onto the Oriental "other" of the worst actions of the French occupation.[62]

To erase the moral contradictions of an imperialism based on force and domination, Guérin and Girodet's paintings work together to assert French superiority by defining France's peculiar characteristics against an historical, religious, and moral opposite.[63] In the *Revolt of Cairo,* the dignity of the anonymous French soldier is contrasted to the nude slave and dying pasha who represent different corruptions of the East: slavery, voluptuousness, and homosexuality. Cairo's most important mosque, the definitive Islamic setting, serves as a dramatic backdrop to the severed head, Christlike in its tresses and in its martyrdom. The confrontation was described by one critic as "a popular riot in a conquered city, an enterprise that remained without results, the useless revolt by the sword of the Barbarians."[64] Girodet contrasted the unsuspicious, brave, eventually benevolent, and Christian French against the alternately violent and cowardly Muslim inhabitants of Cairo. That the savagery was so brutal in the Girodet heightens the magnanimity of Bonaparte's pardon depicted by Guérin.

Unlike Girodet, Guérin rendered discernible French portraits rather than anonymous, if heroic, soldiers. Unlike their Oriental counterparts, the French soldiers act in either a casual or a businesslike manner. Murat is in the foreground leaning on a cannon, Napoleon stares down the rebels, and Denon sketches in the background. Guérin's Bonaparte is paternal, expressing simultaneously "firmness and indulgence," whereas the prisoners give thanks or express shame.[65] They plead, beg, and grimace before the General. "Some," Boutard observed, "are still prostrate in the attitude of supplicants and already some raise their hands to the sky, their hands freed from chains."[66] The expressions of the subject figures are grotesque and exaggerated. They fiercely stare at Bonaparte or childishly plead, humiliated and resigned, wild-eyed and crazed. Guérin's description inspired an anonymous reviewer to exclaim that the rebels "wear on their faces expressions of ferocity; vengeance is imprinted in their glance: these are tigers thirsty for blood."[67] Guérin has successfully conveyed French "nobility" faced with Oriental "animality."

Although pendants by virtue of their size and subject, the two pictures differ greatly in composition and technique. Their divergent stylistic approaches support complementary explanations of and justifications for French stewardship in Egypt. Girodet divests the French forces of their actual conduct and instead associates the mosque with darkness, through his highly wrought chiaroscuro, and with irrationality, through the quickly rising and teeming composition. In a strategy analogous to the disowning projection described by Freud,[68] the memories of the murderous actions are projected elsewhere, so that the ego can act against it. As Girodet's painting is part of a larger French project of disowning its actions, in the painted version it is

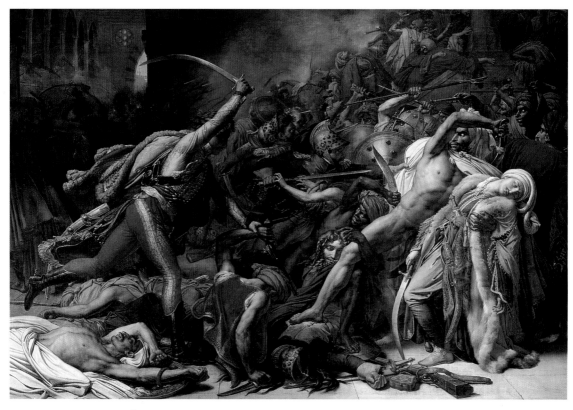

Fig. 36. Anne-Louis Girodet-Trioson, *Revolt of Cairo,* 1810. Oil on canvas,
11 ft. 11¾ in. x 16 ft. 4⅞ in. (365 x 500 cm). Musée National du Château, Versailles

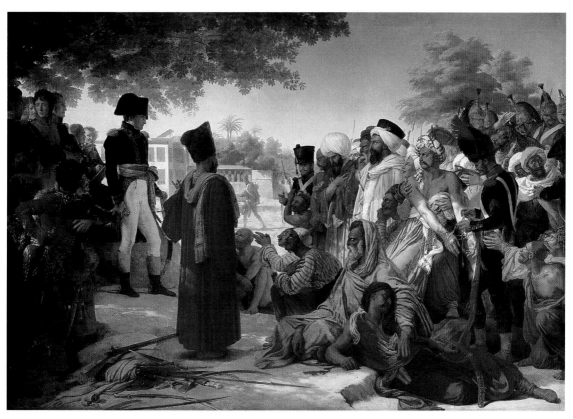

Fig. 37. Pierre-Narcisse Guérin, *Bonaparte Pardoning the Rebels in Cairo,* 1808. Oil on canvas, 11 ft. 11¾ in. x 16 ft. 4⅞ in. (365 x 500 cm). Musée National du Château, Versailles

the Egyptians, not the French, who are in flight from the sword of French justice. French power is expressed by the force of the great pinwheel figure suspended on tiptoe; he and a few brave Frenchmen drive back hordes of Arabs. The enemy recoils in response to his raised sword. He stops the action of his ferocious opponents in the foreground and sends the others fleeing into the background. Violence is twice displaced, most immediately from the French to the Egyptians, but more remotely, too, from France to Egypt. The decapitations of the El-Bekir square are a result of the Egyptian campaign, the Directoire's flight from the violence of the Place de la Révolution, its search to restore order at home.

If Girodet's picture is a demonstration of French power and Oriental subjugation, Guérin's demonstrates French control and the promise of an eventual Egyptian liberation. At peace, the combatants have come into the light. A guard unties the shackles of the central prisoner on the right. France's moral superiority is demonstrated by Bonaparte and his men's ability to control—and liberate—the vanquished, despite being outnumbered. The French surround and contain the more numerous Arabs. The recitation of a few Frenchmen versus hordes of Arabs highlights the bravery of the French, another aspect of their moral superiority and a theme found before in Gros's *Battle of Nazareth.*

Guérin and Girodet's projected historical fantasies and moral contrasts are authenticated in various ways by the artists. In the *Revolt of Cairo* everything is in the process of happening. The French hussar is on one foot, his sword at the height of its trajectory, his coat flying behind him. Opposite, the young Albanian is being held, but only for the moment. He is too lifeless, too heavy, and too inclined. In an instant he will fall out of the picture space. By this time the nude Arab will have struck at the charging Frenchman, for he eyes his incoming enemy and stretches backwards to insure the greatest power to his blow. But, alas, he may not, for another dragoon has pulled back the Arab's drapery to sink his sword into the enemy's chest. The suspended animation of this picture, its life-size figures, and its violence and horror all physically, emotionally, and sensually engage the viewer in the affective mode of painting.

Guérin's technique is more obviously studied and calmer, more appropriate to the moment of clemency after the rebellion. His use of thin and lucid paint, several critics remarked, was meant to evoke the "brilliant sky" and the "brutality of hot light such that it is in Egypt."[69] Salon critics in 1808 knew Egyptian light, just as the critics in 1801 recognized the Syrian atmosphere that Gros had conjured.

Both artists carefully render a potpourri of physiognomies—Turks, Arabs, Africans, Mamelukes. Boutard notes that each of Girodet's figures is distinguished "according

to his age, his temperament, his profession, his national customs."[70] In contradistinction to the discernible French portraits, Guérin meticulously recorded a variety of physiognomies and costumes amongst the pardoned group. For the older Mameluke seated upright in the foreground, Guérin quoted a plate of physiognomic studies from Denon's *Voyage dans la Basse et Haute Egypte* (figure 38).[71] In so doing, Guérin gains the authority of an eyewitness sketch in a large-scale history painting, helping to authenticate the truthfulness of his historical, moral, and national claims.

Guérin and Girodet's pictures, along with those by Gros and Lejeune, are often placed at the beginning of a modern Orientalist tradition in French painting.[72] The hallmark characteristic is the Western artist's faithful recording of the East, resulting in a valuable document of mores, customs, landscape, or architecture. By positing a genealogy of such documents, however, the traditional view of Orientalist painting cannot sustain its own logic. Rather than being a faithful document of the East, the painting is a repetition of that which is already found in Western representation. This is how the West makes itself.

Guérin's luminous atmosphere and the variety and precision of his faces speak in the language of transparent naturalism. However, by including his source, that is to say, by depicting Denon sketching in the background, Guérin reveals that rather

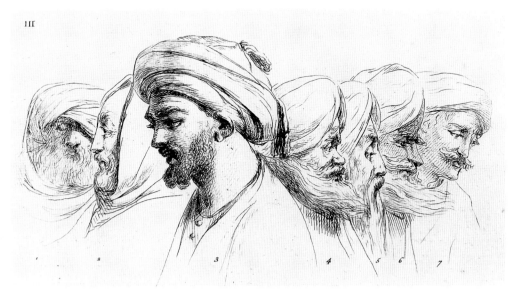

Fig. 38. Dominique-Vivant Denon, *Local Arabs from Rosetta*, 1801. Engraving from *Voyage dans la Basse et Haute Egypte* (Paris, 1802). Bibliothèque Nationale, Paris

than being a firsthand eyewitness account, *Bonaparte Pardoning the Rebels in Cairo* is an exercise in intertextuality. Like the obelisk, this painting's meaning and legitimacy were produced through the citation of antecedent authorities, one of whom was, in both cases, Denon. Guérin cites Denon, and the next generation will cite him, too, as we will see in the next chapter. In each instance the artists will represent a historical truth that was presupposed even before the purported encounter in the Orient. Girodet, for instance, wrote Talleyrand in 1797 and asked for a commission to paint the presentation of the Turkish ambassador to the Directory. It would evoke, he wrote, the "opposition and contrast between Asiatic sumptuousness and the dignity of Constitutional costume."[73] For the demonstration of such truths, the artist's presence in Egypt was no more necessary than was Guérin's when he painted *Bonaparte Pardoning the Rebels in Cairo.* To accept uncritically the scientific and documentary poses of these artists is to recapitulate the historical models of civilization and the moral contrasts that they proffer. Battle painters of the Egyptian campaign characterized, delineated, and differentiated the French and Egyptians in their physical, intellectual, moral, and religious attributes, helping to construct a sense of solidarity in the face of an inferior but menacing Orient.

GROS'S *HIS MAJESTY HARANGUING THE ARMY BEFORE THE BATTLE OF THE PYRAMIDS,* 1810, AND FRANQUE'S *ALLEGORY OF THE CONDITION OF FRANCE BEFORE THE RETURN FROM EGYPT,* 1810

"From these monuments, forty centuries look down upon you." Framed by his soldiers, officers, and captive enemy, Bonaparte pronounces these words.[74] This is Gros's presentation of the dream of the Egyptian campaign that he exhibits in his Salon of 1810 picture, *His Majesty Haranguing the Army before the Battle of the Pyramids* (figure 39). Egypt's ancient grandeur, though long since passed, could be revived by France. Talleyrand had invoked this dream in his argument to launch the campaign. Denon said in his *Voyage* that the mission's goal was to "reanimate the dust of Sesostris"; and the same historical fantasy helped propel the Luxor obelisk to Paris nearly forty years later. In the Egyptian campaign, France's contemporary physical, material, military, and technological presence would smash the degeneracy into which the country had fallen.

The reverse side of the coin is found in another painting from the Salon of 1810, Jean-Pierre Franque's *Allegory of the Condition of France before the Return from Egypt* (figure

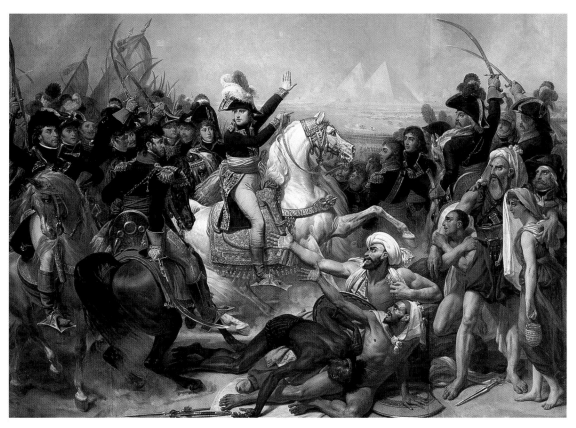

Fig. 39. Antoine-Jean Gros, *His Majesty Haranguing the Army before the Battle of the Pyramids,* 1810.
Oil on canvas, 12 ft. 9⅛ in. x 16 ft. 9⅛ in. (389 x 511 cm). Musée National du Château, Versailles

40). Here Bonaparte is called from the shadows of the Pyramids to save France. He is roused from a dream and beckoned by France, who is surrounded by personifications of Crime and Blind Fury. Plenty and the Altar of Law are overturned; Commerce and Order are in peril. France was in dire condition before Bonaparte's return from Egypt. The inscription on the altar reads, "France, suffering under an unhappy government, summons from the bosom of Egypt the hero on whom her destiny depends."[75] Thus, Bonaparte, in his ascent to power following his return from Egypt in the coup of 18 brumaire, was infused with the glory of the Egyptian campaign and its wondrous monuments.

The historical model, then, cuts both ways. In modern Egypt the grandeur of antiquity was to be restored by the French presence. Modern France could in turn reach out to the banks of the Nile and to its hero of the Egyptian campaign, who could bring pharaonic stability to a convulsed nation. In this way, the allegory of Bonaparte's rise to power reverses the revolutionary origin of the Egyptian campaign. If for Volney and the Ideologues the Egyptian invasion was an extension of the Revolution, by 1810 the Franque allegory shows the value of the Egyptian expedition as having invested Bonaparte with the authority to put an end to the chaos of the Revolution.

Gros and Franque's respective pictures reveal—inadvertently, no doubt—the price of the regeneration of Egypt and the salvation of France. Gros's picture insists on the abject status of contemporary Egyptians, "the vanquished nations in the war of Egypt," as a critic wrote in 1810.[76] And, although Franque's picture suggests that Napoleon's coup resulted in a return to order, Bonaparte's return from Egypt, infused as it may have been with pharaonic grandeur, led undeniably to authoritarian rule.

Casualties and Survivals

We have already seen how Napoleon's regime could benefit from the paintings of the Egyptian campaign. The proclamation of victory and the demonstrations of clemency were intended to obscure quite opposite realities. Military and scientific celebrities were promoted to add luster to the regime. Additionally, specific domestic policies were supported, for instance, by the Syrian campaign pictures that renewed France's ties to Christian and Crusader histories. The Syrian campaign pictures that we have discussed all date from 1800 to 1804. They coincide with the Napoleonic regime's secret reconciliation negotiations with the Vatican, which had begun by September 1800, with the announcement of the Concordat in April 1802, and, finally, with Napoleon's coronation, attended by the pope, in 1804.

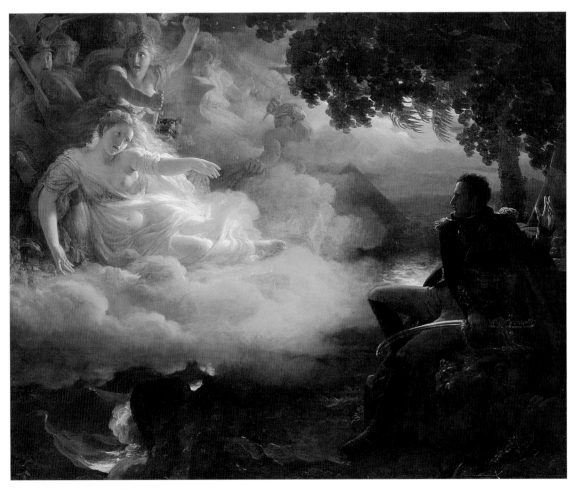

Fig. 40. Jean-Pierre Franque, *Allegory of the Condition of France before the Return from Egypt*, 1810.
Oil on canvas, 8 ft. 6¾ in. x 10 ft. 8⅜ in. (261 x 326 cm). Musée du Louvre, Paris

Furthermore, the rationale for the Egyptian campaign that the Salon paintings put forward could have been reactivated for the support of further military excursions, as Napoleon had not yet abandoned the idea of another Egyptian invasion or an Algerian expedition. As early as 1802, he sent General Sébastiani to Egypt and Syria to make contacts with local leaders. Sébastiani's report of 30 January 1803, published in *Le Moniteur universel,* said that a reconquest of Egypt would require only 6,000 Frenchmen.[77] In 1808, Napoleon sent an advance team to investigate a possible invasion of Algeria. Thus, in the presentation of the Egyptian campaign, the Empire explained—and obfuscated—past events, promoted the rationale behind some of their particular dynastic policies, and began to forge an imperial culture that could be manipulated by other regimes.

During the Restoration, paintings of the Egyptian campaign were among the Napoleonic monuments that were suppressed. It was Napoleon, not the Egyptian campaign per se, that was forbidden. There were exceptions. Lejeune's *Battle of the Pyramids* and Gros's *Battle of Nazareth* and *Pesthouse at Jaffa* were reexhibited in May 1826 at a benefit exhibition for the Greek War of Independence against the Ottoman Empire. By recalling glorious Napoleonic episodes and Revolutionary events, the exhibition solicited liberal sympathy for the Greek cause, which was likened to the French Revolution.[78] What is most important for our purposes is that their redeployment also demonstrated how the monuments of the Egyptian campaign had a certain transferability, how they could be enlisted to support other French military actions in the Near East.

After the July Revolution of 1830, the storerooms were unlocked. The luster of these paintings and their subjects only increased while they were out of sight. For Alfred de Musset, the Napoleonic treasures were the object of Romantic longing for a past that was only a couple of decades gone but seemed too distant and too impossibly exalted to repeat. They were, he wrote, "contemporaries of a century which is already very far from us."[79] On an official level, Louis-Philippe resumed and revived Napoleonic monuments in order to manipulate Bonapartist sentiment to his own advantage.[80] Monuments of the Egyptian campaign, as we saw in the case of the obelisk, played no small part in his program. Reliefs on the Arc de Triomphe and, as we will see, painted friezes in the Musée d'Egypte, for instance, paraphrased the Egyptian campaign paintings by Gros, Girodet, and Guérin.

These pictures, although a fraction of the Napoleonic production, were an enormous success and, artistically and ideologically speaking, had a preponderant influence. The first time the Egyptian campaign was played out, in Egypt and Syria, it was a

quick defeat. The second time the Egyptian campaign was conducted—on the walls of the Napoleonic Salons—it looked like a triumph of French civilization. Although Napoleon's name would later be either suppressed or restored to the history of the Egyptian campaign, according to the dynastic politics of the moment, the artistic strategies and imperial program that were sketched out would endure.

3

The Musée d'Egypte

In an anonymous engraving that appeared soon after the return of the Bourbon monarchy, Vivant Denon appears in the guise of a satyr paying homage to an ungainly Egyptian goddess (figure 41). His cleft foot is planted on the Belvedere Torso, the incense from his brazier obscures the Medici Venus, and cobwebs grow over a niche framing the Apollo Belvedere. The printmaker—playing on Denon's role in the Egyptian campaign, his dictatorship of the arts under Napoleon, and his earlier career as a pornographer—blames Denon for endangering the true origins of Western civilization. The classicizing setting and composition, however, signal the survival of neoclassical aesthetics. The inscription promises that the restored Bourbons would reverse the irresponsible, perverse, and bizarrely primitive "reign of Egypt": "Dans l'enfance des arts on adoroit apis, ibis, chats, et magots—trop illustres de nom. On les fêtoit encor avec Napoleon. Mais les arts pour fleurir n'attendoient que les Lys."[1] Under the Bourbons, the cloud of smoke would dissolve, the cobwebs would be cleared, and the Belvedere Torso would be returned to its pedestal.

Given the vigorous Napoleonic patronage of Egyptomaniacal works, such a Bourbon backlash was to be expected. Some ten years later, however, the Bourbon monarchy sponsored the Musée d'Egypte—the first Egyptian department in the history of the Louvre—and created an elaborate painting and decorative program that remains in situ although relatively unknown (figure 42). The Musée d'Egypte marks a fundamental change in the Louvre Museum's history of civilization, throwing into question the status of classical Greece and Rome as it was inherited from the Enlightenment and Revolution. Here French Egyptology was not so much born as it was institutionalized. Egypt became a field for conciliation between the Empire and

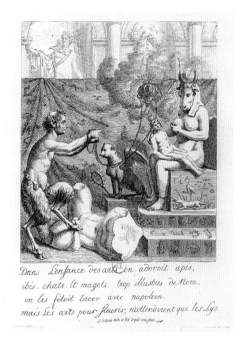

Dans *L'enfance des arts ... on adoroit apis,*
ibis. chats. et magots. trop illustres de Nom.
on les fetoit Encor avec napoleon.
mais Les arts pour fleurir, n'attendoient que les Lys.

Fig. 41. Unknown artist, *Dans L'enfance des arts . . . ,* ca. 1815. Engraving, 5¾ in. x 4¾ in. (14.5 x 12.1 cm). Bibliothèque Nationale, Paris

Restoration, and then between the Restoration and the July Monarchy. Champollion, who began the Restoration as one of its most virulent antagonists, curated the Musée d'Egypte and was apotheosized in its painting cycle. With the newly acquired core of the Louvre's Egyptian collection, Champollion's prestige was installed as a symbol of French national genius. The museum rationalized French stewardship of the arts and civilization, advanced the reactionary tenets of the regime, and expanded the scientific work of the Egyptian campaign. It defined French historical, scientific, military, religious, sexual, and racial attributes and conscripted them in the cause of imperial expansion in the *proche Orient.* The creation and presentation of the Musée d'Egypte reveal that what had seemed dynastic (Napoleonic) was coopted and transformed by the succeeding and ostensibly opposing (Bourbon) regime. In short, the Musée d'Egypte marks the political turning point. The culture of imperialism becomes a national culture.

The restored Bourbon monarchy set about to reverse the crimes of the Revolutionary and Napoleonic eras: Louis XVIII ordered a new equestrian statue of Louis XV for the Place de la Concorde (then Place Louis XV), moved the itinerant bodies of Louis XVI and Marie-Antoinette from anonymous pits to the dignified royal mausoleum at Saint-Denis, and erected churches and monuments to exclaim (and absolve) French sins. At the same time, against the backdrop of such a political culture, the Restoration monarchs patronized Napoleonic Egyptological works from the beginning, despite the links of these works to the previous regime. The first volume of the *Description de l'Egypte* appeared in 1810, but the massive project was only partially complete when the Bourbons returned to power. Louis XVIII continued its publication with only a

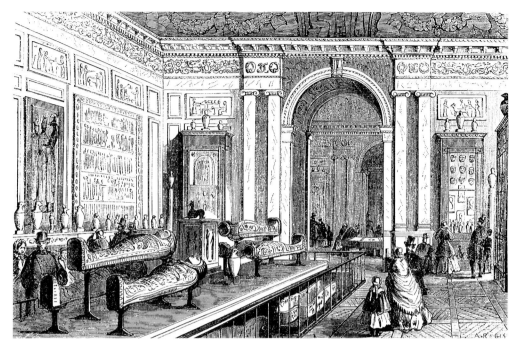

Fig. 42. A. Régis, *Musée Charles X. Salle égyptienne,* 1863. Woodcut from Adolphe Joanne's *Paris Illustré* (Paris, 1879). Firestone Library, Princeton University, Princeton, New Jersey

few changes, such as the suppression of Bonaparte's name and the replacement of the imperial emblem on the title page by a Bourbon insignia.[2] The project was even expanded. A twenty-four volume octavo set, dedicated to Louis XVIII, appeared from 1821 to 1829. The imprimatur of the sponsor of Egyptological works had changed, but the nature of the enterprise had not. The Napoleonic Egyptological project was continued and expanded not because it represented a neutral, disinterested, apolitical scholarly activity, but for precisely the opposite reason, because it was profoundly and multifariously political. The completion of the *Description,* as well as the establishment of France's first Egyptian museum, would continue the imperial aims of Napoleon's Egyptian campaign works and, at the same time, be enlisted to legitimate the restored monarchy.

The dual imperial and dynastic functions of the Musée d'Egypte are enunciated in its 1826 founding document. The director of Beaux-Arts in the Maison du Roi, the vicomte Sosthènes de La Rochefoucauld, linked the creation of the museum to the French military expedition to Egypt in 1798, which, he said, completely opened a new world to the zeal of the European intelligentsia, just as the might of England

had revealed the treasures of India. He explicitly linked the project to European imperialism, to the same European rivalry over control of the East that inspired the invasion of Egypt in 1798:

> *Thirty years ago, historical work on Greece, Rome, and ancient Europe seemed to be nearly exhausted, and the Orient appeared closed forever to the natural desires of scholars and artists. But soon England's power revealed the literary treasures of Hindustani, and a French expedition, completely military in its purpose, completely scientific in its results, revealed for meditation all of ancient Egypt.*

French imperial desire, which in 1798 was deflected from England to Egypt, is now deflected to the museological plane, where Egyptological studies and ancient objects could also bolster the legitimacy of the new regime:

> *As for the Egyptian monuments, conscientious erudition could only refute various assertions with conjectural deductions. The monuments carry within themselves the solution to so many difficulties, but the interpretation of hieroglyphic writings had remained the mystery that lasted for 1500 years. Suddenly everything changed with the discovery of the hieroglyphic alphabet, which has already been very useful for establishing the historic truth and affirming holy doctrine.*[3]

The Egyptian department would be a part of the new Musée Charles X. It would be comprised of nine rooms on the second floor of the Seine wing of the Cour Carrée. While four rooms were to contain Greek and Roman antiquities, for the first time in the history of the Louvre, four rooms would also be devoted to Egyptian antiquities, under the jurisdiction of Champollion.[4] For the ceilings the government commissioned nine paintings and an elaborate decorative program in order to celebrate—and justify—French stewardship of the arts and civilization. They operate as the official commentary on how the Restoration meant to manipulate Egypt for its own gain. In the words of the critic for the official *Moniteur universel,* the program was made up of "a series of interrelated compositions with a moral and philosophical conceit."[5] Their subjects were worked out in consultations among the vicomte de La Rochefoucauld in the Maison du Roi; Auguste de Forbin, director of the Louvre; the artists; and the brothers Champollion.[6] Several purposes emerge from a program that had the highest official approval: to legitimize the regime through the presentation of a reactionary historicism, to reinforce a sense of national identity based on French scientific exploits in Egypt, and to promote its reactionary foreign policy in Europe and its imperial

foreign policy vis à vis the Orient. This Musée d'Egypte program demonstrates the flexibility of the Oriental currency that had been inherited from the Empire and reveals how it was transformed in the Restoration to forge a continual, national, imperial culture and then how it was adapted again in the July Monarchy.

From its inception in 1826 to its definitive arrangement in 1834, the ceiling cycle underwent modifications that enable us to read it against various political and dynastic shifts. Most of the eight painters were contracted in the spring and summer of 1826, and most of the paintings were ready for the opening of the Salon in 1827.[7] In 1828, nine new rooms, distinct from the Musée d'Egypte, but part of the Musée Charles X, were commissioned and were to be inaugurated at the Salon of 1831.[8] The most coherent and last Restoration scheme survives only in the program of 1828, as there were changes yet again following the July Revolution of 1830. (Table 1 outlines the original commission and notes subsequent changes to the ensemble.)

Table 1. Musée Charles X ceiling paintings, the 1826 program and changes

1. Gros, *The King Giving the Musée Charles to the Arts* (in 1833 Gros replaced it with *The Genius of France Animating the Arts and Succoring Humanity*).

2. Vernet, *Julius II Giving Wreaths and According Honors to Michelangelo and Raphael* (in 1828 scheduled to be moved to southern aisle and replaced by an Egyptian subject by Couder; the July Revolution intervened and Vernet's painting remains in place).

3. Abel de Pujol, *Egypt Saved by Joseph* (1826 commission; remains in place).

4. Picot, *Study Crowned with Laurels and the Genius of the Arts Unveiling Ancient Egypt for Greece* (1826 commission; remains in place).

5. Gros, *True Glory Resting on Truth.* In the other two panels of this larger and central room: *Time Raising Truth to the Steps of the Throne; Wisdom Taking It under His Wing;* and *Mars Crowned by Victory, Listening to Moderation* (1826 commission; remains in place).

6. Fragonard, *Francis I Receiving the Pictures and Statues Brought from Italy by Primaticcio* (in 1828 scheduled to be removed; replaced in 1831 by Picot's *Cybele Opposing Vesuvius to Protect the Cities of Stabia, Herculaneum, Pompeii, and Resina which the Fires Seem to Condemn to Complete Destruction*).

7. Meynier, *The Nymphs of Parthenope Carry the Penates and Are Driven by Minerva to the Banks of the Seine* (1826 commission; remains in place).

8. Heim, *Vesuvius Receiving from Jupiter the Fire that Will Consume Herculaneum, Pompeii, and Stabia* (1826 commission; remains in place).

9. Ingres, *The Apotheosis of Homer* (1826 commission; replaced by a copy by Balze in 1856).

The revisions to the Musée d'Egypte contributed to a want of thoughtful criticism about the decorative program itself. The cycle was not completely ready for the opening of the 1827 Salon, and when it was unveiled a month later, one of Gros's paintings was still only a sketch. Few of the Salon's critics considered the suite as a whole; most pointed to this or that picture as good or passable based on the critic's partisanship in the *bataille Romantique*. Those who did address the paintings as a group were preoccupied with their relative failure as ceiling paintings and with the obtuseness of the allegories. The retrograde bombast of the works, which surely continues to contribute to their obscurity, was captured by the Salon critic in *Le Figaro*. "As for the ceilings," he wrote, "the subjects are cold, tasteless, or ridiculous. It is what you would expect. We should be over with these Frances in coats covered with fleur-de-lys, with Arts holding palettes or lyres, these temples to the glory of victory, and all this silly obsequiousness that the courtesans with their shrunken brains tell us: the reign of allegories is over."[9] However witty the critic may seem and however much we may agree with his assessments of some of the inflated allegories, leaving the Musée d'Egypte to critics and art historians who view it only in terms of the development of Romantic painting, or to leave it exclusively to antiquarians, who may seek only to marvel at this seminal chapter in the formation of Egyptology, is to risk missing the point.

LEGITIMACY

Rambling though it may be, the program of the Musée d'Egypte is unambiguous. Like the reequestrification of the Place Royale, the Place des Victoires, the Ecole Militaire, and the Place Louis XV, the Musée Charles X affirmed a "royalty reestablished" against the ideas and events of the French Revolution.[10] To this end the ceiling paintings represent enthroned power in every case. In the first room (figure 43), Charles X points the way to the imaginary portico of the Musée d'Egypte, leading on to the other enthroned figures, which include Julius II, personifications of Egypt, Vesuvius, and Homer (figure 44).[11] Only Meynier's *Nymphs of Parthenope Carry the Penates and Are Driven by Minerva to the Banks of the Seine* (figure 45) does not show an enthroned figure

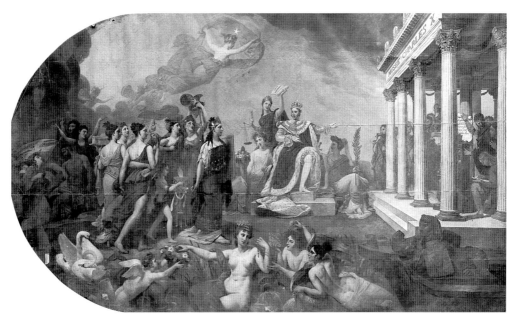

Fig. 43. Antoine-Jean Gros, *The King Giving the Musée Charles X to the Arts,* 1827. Oil on canvas, 19 ft. ⅜ in. x 30 ft. 6⅛ in. (580 x 930 cm). Musée National du Château, Versailles

as an actor in the historical or allegorical subject. Instead, it represents a statuette, an enthroned Jupiter. Personifications of Genius bring the arts to the banks of the Seine under the patronage of Charles X, who is present in a medallion at the lower left. With the museum's temple facade visible in the background, monarchic power is symbolized by the possession and presentation of artifacts from the past. France is the heir and caretaker of civilization in its movement from Egypt to Greece, from Greece to Rome, from ancient Rome to Italy, and, finally, to Restoration France. The pivotal and historiographically innovative link in the chain of civilization is Picot's *Study Crowned with Laurels and the Genius of the Arts Unveiling Ancient Egypt for Greece* (figure 46). A hinge between the Egyptian and Greco-Roman rooms, Picot's picture diagrams the transfer of the authority of the most ancient civilization.

Winged allegories of Genius and Study have led Minerva, patron of Athens and embodiment of wisdom, to the banks of the Nile. With the help of four cherubic genii, a shroud is lifted, revealing, for the first time since antiquity, Egypt, in all her splendor. She is nude, and her throne sits against the Nile river god and amidst the fruits of Egyptian civilization—scientific, military, and utilitarian objects, as well as sculp-

Fig. 44. Details from the nine ceiling paintings of the Musée du Louvre's Musée d'Egypte:
Charles X, Julius II, the pharaoh, Egypt, Truth and Glory, Cybele, Jupiter, Jupiter, and Homer

Fig. 45. Charles Meynier, *The Nymphs of Parthenope
Carry the Penates and Are Driven by Minerva to the
Banks of the Seine,* 1827. Oil on canvas, mounted on
ceiling. Musée du Louvre, Paris

ture, pyramids, and an obelisk. In his Salon review of 1828, Auguste Jal breathlessly described the excitement of this art historical borrowing that is at the heart of the Musée d'Egypte:

> *He {Picot} has envisioned Egypt covered by Time in a mysterious veil that super-natural powers alone could raise. He gave to the Nymph of Hellas the love of science, the desire for peaceable conquests on the ground of antique civilization, and he led her to the land of the Nile, guided by Study and Genius. Carried on the clouds, illuminated by the flame of the spirit of discoveries and supported by Study, Greece arrived at the foot of the Pyramids; beside the ruins she perceives the vast shroud, which hides from all eyes the immortal daughter of the Pharaohs. At the command of her celestial guides, several little genii raise the drapery revealing Egypt, surprised as if softly awakened from a deep sleep.*[12]

Fig. 46. François-Edouard Picot, *Study Crowned with Laurels and the Genius of the Arts Unveiling Ancient Egypt for Greece,* 1827. Oil on canvas, mounted on ceiling. Musée du Louvre, Paris

The painting's subject is, as Delécluze wrote, "the transfer of Egyptian civilization to the Greeks."[13] Minerva's trip to the Nile represents a voyage back in time, an antedating of civilization. Argued in official publications, consecrated in museum policy, and enshrined in the program of the museum's painting cycle, this is the new wrinkle and central assertion of the Musée d'Egypte. It permitted the Restoration to bypass the Greco-Roman basis of Western civilization for a more ancient and authoritarian basis of kingship, monotheism, and order.

When Louis XVIII passed an ordinance maintaining the Louvre as a museum on 22 July 1816, the Bourbon monarchy resumed control of the royal palace, which had been usurped by the regicides of 1793. Since the mid-eighteenth century, philosophers and writers proposed exhibiting the royal collection in the Louvre, which had symbolized French cultural supremacy since 1665 when Louis XIV solicited and then refused Bernini's designs. In the 1790s, the royal palace became the museum that was often envisioned in the ancien régime. As it was organized in the same month as the vote to execute Louis XVI, and scheduled to open on the second anniversary of the vote, 10 August 1794, it became a celebration of the Revolution's triumph over the monarchy. A major tool of Revolutionary propaganda, a demonstration of France's intellectual advancement, and a trophy case of Revolutionary war spoils, the Louvre attested to the triumph over tyrants and enemies of the fatherland.[14]

To enter the Louvre in the 1790s was to reenact and reaffirm the Revolution, to knock down the doors of the kings, to pay homage to the Revolutionary order's basis in antiquity and in the Enlightenment, and to become a better citizen through communion with the relics of the classical past.[15] The museum's installation presented a history of progress, its spokesman proclaimed, "a continuous and uninterrupted sequence revealing the progress of the arts and the degrees of perfection attained by various nations that have cultivated them."[16] The basis of this historical cycle was ancient Greece and Rome, its culmination, Revolutionary France.

In this history of art, progress, and civilization, there was no place for Egypt. In 1795 Egyptian artifacts were kept in the Medals Department of the Bibliothèque Nationale alongside other curiosities, including stuffed muskrats. The Musée des Antiquités du Louvre of 1800 displayed only a few Egyptian objects, and they were of dubious origin. Spoils from the Egyptian campaign had been forcibly surrendered to the British in 1801. It was not until 1818 that the Restoration's Musée Royale presented the first room devoted to Egypt, the Salle d'Isis, which centered on a Roman imperial colossal statue of Isis amid an ensemble of two dozen objects relating to Egypt: ancient Roman, Egyptianizing, and even eighteenth-century Egyptoid ob-

jects. Academic doctrine still maintained that Egyptian art was a dead end, its value strictly historic.[17] In 1823 Drovetti, the former French ambassador to Egypt and colonel in the Egyptian campaign, offered his collection to the government, and it was refused.

In 1824, when Champollion went to Turin to study the Drovetti collection, which was purchased by the king of Savoy, he wrote to journals in Paris, fighting the entrenched bias against Egyptian art.[18] Vigorous and unprecedented acquisitions followed the ascension of Charles X in 1824, when the Royal Museum was subjugated to the Minister of the Maison du Roi, where the Champollion brothers were much better connected. The government purchased the 2500-object Durand collection in November 1824. The Salt collection's 1400 pieces followed in October 1826. Monumental objects entered the collection in 1827 with the purchase of Drovetti's second collection.[19] This change in acquisition policy marks a reversal of Revolutionary, Napoleonic, and royal policy on Egyptian art. To elevate the status of Egyptian art was to deemphasize Greece and Rome, to reverse the Revolutionary thinking in which the Apollo Belvedere was sought not only for its general fame but also because it was a vital link to classical civilization, the fountainhead of the Enlightenment and Revolution.[20]

The Musée d'Egypte represented the official consecration of a history of civilization that was controversial, political, and some time in the making. The *Description de l'Egypte* declared Egypt the cradle of civilization: "This country, which was visited by the most illustrious philosophers of antiquity, was the source from which Greece drew the principles of law, arts, and the sciences."[21] Champollion concurred vehemently. His research trip to Egypt confirmed his strongly held belief in Egypt's generative role. His nearly frenzied letter to his brother in 1829 (published soon thereafter) indicates the tenacity of his belief that "the arts began in Greece as a servile imitation of the arts of Egypt. . . . Without Egypt, Greece would probably have not at all become the classic land of the fine arts."[22]

Indeed, the most striking impression of the Musée d'Egypte painting cycle is the demotion of Greco-Roman antiquity. Egypt is rediscovered in one end, while Greece and Rome are buried in the other. In *Vesuvius Receiving from Jupiter the Fire that Will Consume Herculaneum, Pompeii, and Stabia* (figure 47), François-Joseph Heim depicts Jupiter's passing bolts of lightning to Vesuvius, as Minerva watches ineffectually. The vaults show scenes of the destruction in long rectangular panels, framed by golden medallions in which genies of the arts rescue *objets d'art*. Cities are destroyed, only tiny objects survive. In the next room, Charles Meynier's painted *The Nymphs of Parthenope Carry the Penates and Are Driven by Minerva to the Banks of the Seine* after Vesu-

Fig. 47. François-Joseph Heim, *Vesuvius Receiving from Jupiter the Fire that Will Consume Herculaneum, Pompeii, and Stabia,* 1827. Oil on canvas, mounted on ceiling. Musée du Louvre, Paris

vius had engulfed the neighboring towns (figure 45).[23] The cataclysm was continued in the fourth room in Picot's *Cybele Opposing Vesuvius to Protect the Cities of Stabia, Herculaneum, Pompeii, and Resina, Which the Fires Seem to Condemn to Complete Destruction* (figure 48).[24] Like Denon in the satiric caricature, the Restoration took its turn kneeling before the Egyptian gods, and Greece and Rome were relegated to the periphery.

In a museum dedicated to the collection and display of antiquities, the ambivalent treatment of classical antiquity is at least paradoxical. A prelude to the Greco-Roman galleries, Jean-Baptiste Mauzaisse's *Time Displaying the Ruins that He Creates and the Masterpieces He Leaves to Discover* (figure 49) is dominated by the formidable and scythe-wielding figure of Father Time who gestures to fragments of classical antiquities he has permitted to survive: the Belvedere Torso, the Venus de Milo (recently acquired), and remnants of a column, an architrave, and an obelisk. Commissioned in 1821, the painting's meaning was given a cyclical underpinning by the addition in 1828 of painted friezes representing the four seasons.[25] Mauzaisse's oil sketch (figure 50) suggests his interest in the powerful and gloomy effects Father Time has wreaked

Fig. 48. François-Edouard Picot, *Cybele Opposing Vesuvius to Protect the Cities of Stabia, Herculaneum, Pompeii, and Resina, Which the Fires Seem to Condemn to Complete Destruction,* 1831. Oil on canvas, mounted on ceiling. Musée du Louvre, Paris

on preceding civilizations. In the place where we find the Venus de Milo, the Belvedere Torso, and the fragment of an obelisk and a column in the final picture, the preparatory study includes a bust of Napoleon amongst the ruins. For the artist in the final work to have exchanged more antique fragments for the bust of Napoleon suggests that the ruins occupy the space of that which has been outmoded. The Bourbons replaced Napoleon, Egypt supplants Greece and Rome.

Greece and Rome were certainly present in the Musée Charles X; they occupied half of the Musée d'Egypte's galleries. In a reversal of the Revolutionary and Napoleonic Louvres, Greece and Rome, however, were eviscerated of their Enlightenment associations. This is made clear by the most famous picture from the cycle, Ingres's *Apothe-*

osis of Homer (figure 51). The artist presents a colossal and authoritative Homer, surrounded by carriers of the classical tradition, which includes, with the exception of Mozart, not a single eighteenth-century figure.[26] In this way, Greece and Rome were present in the Musée Charles X, but they were made part of a reactionary, not revolutionary, history.

Ultimately, the payoff from the demotion and destruction of Greco-Roman antiquity was to institutionalize a reactionary source for French society. Champollion's work provided the link to the origins of monarchy, a convincing chronology of Egyptian kings and a demonstration of the piety and munificence of the pharaohs.[27] Since at least the middle of the seventeenth century, Egypt had been claimed as the origin of monotheism, which was confirmed again by Jacques-Joseph Champollion-Figeac and by Félicité de Lamennais, the arch-Catholic theologian.[28] Moreover, the Egyptian model was desirable for this regime as it was for other post-Revolutionary regimes, because, as Champollion-Figeac had written, it was a nation said to be like no other, "essentially interested in the conservation of order."[29]

In the rooms below and beside Picot's *Genius Unveiling Ancient Egypt,* France was shown to possess the most lasting sign of the stability of Egyptian civilization: its monuments. The *Description de l'Egypte* asserted that the immobility and hieratic nature of Egyptian art not only symbolized permanence but also actively contributed to the stability of Pharaonic Egypt. "The Egyptians considered their religion and their government somewhat eternal," it said. "[They] were supported in this thought by the enduring aspect of great public monuments that always seemed to look the same and that appeared to resist the effects of time. Their legislators had judged that this moral impression would con-

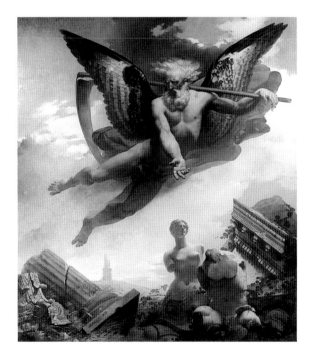

Fig. 49. Jean-Baptiste Mauzaisse, *Time Displaying the Ruins that He Creates and the Masterpieces He Leaves to Discover,* 1821. Oil on canvas, mounted on ceiling. Musée du Louvre, Paris

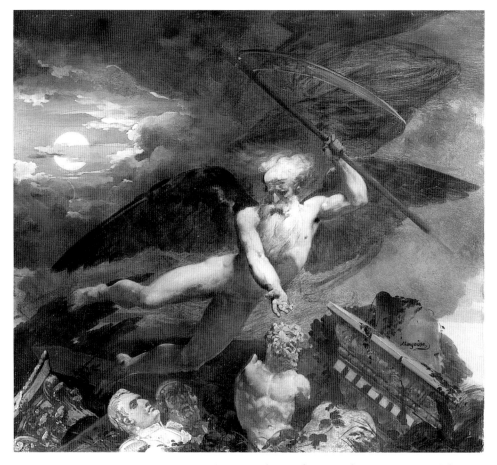

Fig. 50. Jean-Baptiste Mauzaisse, *Time Displaying the Ruins that He Creates and the Masterpieces He Leaves to Discover,* 1821. Oil on canvas, 20⅛ x 22⅛ in. (51 x 56 cm). Musée du Louvre, Paris

tribute to the stability of their empire."[30] In the *Description* and the Musée d'Egypte, the evident survival of such old objects served political and Romantic longings. They were relics of an enviable and immutable order, extant because of their very embodiment of permanence. Now ruined and plucked from their context, they testified to the constancy of Pharaonic Egypt and to its unbridgeable distance in the past.

NATIONAL IDENTITY

The presence of these monuments eroded one of the most durable Orientalist clichés, that ancient Egypt was shrouded in mysterious veils. Indeed, in Picot's *Genius Unveiling Ancient Egypt* the paradigm is undone, for Genius and Study bring Minerva to the

banks of the Nile to unveil the once mysterious glory of Egypt. The recent unveiling that Picot's painting evokes is Champollion's 1822 decipherment of Egyptian hieroglyphs. The critic in the *Annales de la littérature et des arts* proclaimed the conceit of the painting "becomes completely monumental for the happy discovery of M. Champollion."[31] The decipherment was one of the central reasons for the creation of the Musée d'Egypte and one of the many themes of its painting cycle.

The celebration of Champollion extended beyond Picot's allegory. In the easternmost room, decorated by Gros's *The King Giving the Musée Charles X to the Arts* (figure 43), the visitor saw Champollion teaching hieroglyphs to students standing beneath the portico of the museum, and by 1831, he also appeared in a portrait by Cogniet hung in this first room of the Egyptian sanctuary.[32] The curator is thematized in the very museum that he organizes. In 1828, the two contiguous rooms were also programmed, suggesting that the decipherment might have become the predominant theme had the July Revolution not intervened. Couder was to paint an Egyptian sub-

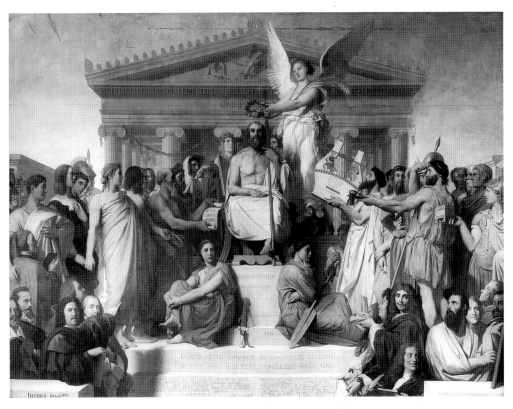

Fig. 51. Jean-Auguste-Dominique Ingres, *The Apotheosis of Homer,* 1827. Oil on canvas, 12 ft. 8 in. x 16 ft. 9⅝ in. (386 x 512 cm). Musée du Louvre, Paris

ject, and Cogniet was hired to paint what was described as "a modern subject having to do with Egypt." This room housed papyruses, Champollion's office, and a reception area. Slow in executing the ceiling painting, Cogniet wrote his patrons about his project in which "allegory plays the principal role."[33] That project must allude to the painted oil sketch in Orléans (figure 52) that depicts an enthroned personification of glory distributing laurel crowns to both a winged warrior and a winged genius who unveils Egypt. The latter points to the subjugated peoples of Egypt, who are kneeling and huddled like the groups of captives in Guérin and Gros's paintings of the Empire. If Egypt was the "theater of Napoleon's glory," in the Empire's *Description,* as in its Salons, the Restoration presented Egypt and the Musée d'Egypte as the theater of a nationalized, allegorized French scientific genius.

There is tantalizing evidence suggesting that Champollion was honored elsewhere in the Salon of 1827–28. If Ingres's late entry to the Salon, his *Oedipus and the Sphinx,* referred to the Egyptologist, the implications would have been rich and the timing precipitous (figure 53). In the first, 1808, exhibition of the picture, Ingres intended to honor artistic genius, which lay beyond looking at the surface, and, thus, to align himself with the geniuses of antiquity.[34] Repainted, increased in size, and submitted late to the Salon in 1828, the painting might have been an homage to Champollion's solution to Egyptian writing, the most vexing of ancient riddles. Oedipus's facial features correspond only vaguely to Cogniet's portrait of Champollion

Fig. 52. Léon Cogniet, *Glory Distributing Laurels to War and Science,* ca. 1828–30. Oil on canvas, 8¾ x 13⅞ in. (22.3 x 35.2 cm). Musée des Beaux-Arts, Orléans

(figure 54), and certainly the body did not match that of the corpulent curator.[35] Still, the theme is compelling. In a *Caricature of Egyptology* of 1858 (figure 55), the Egyptologist in question, F.-J. Chabas, strikes the pose of Ingres's Oedipus, and he triumphantly thumbs his nose at the sphinx. In the caricature, the threat of the power and intractability of the sphinx and of ancient Egypt is met with a juvenile gesture and defiance.

In the ceiling cycle of the Musée d'Egypte, as well as in its installation, France's scientific acumen was presented soberly and augustly as a national attribute of France. It was the museum, itself, according to Champollion-Figeac, which proved that the "mystery is finally unveiled."[36] The decipherment made possible the new kind of installation that insisted less on the beauty of the objects than on the historical significance revealed by their inscriptions. Critics responded accordingly, hailing the museum as a rigorous demonstration of Champollion's science, the "application of his handsome system," the product of this "indefatigable intellectual," apparent to "even the most ignorant man, as well as the most frivolous."[37]

Champollion's system broke with previous systems of museology. He did not adhere to the material organization created by the Revolutionary museum, for instance, which was divided between paintings and antiquities (later called statues). Nor did he opt for a picturesque system, nor did he seek to flatter the eyes.[38] Those who sought the picturesque and who criticized Champollion's historical approach for neglecting the aes-

Fig. 53. Jean-Auguste-Dominique Ingres, *Oedipus and the Sphinx,* 1808 and 1828. Oil on canvas, 74⅜ x 56¾ in. (189 x 144 cm). Musée du Louvre, Paris

Fig. 54. Léon Cogniet, *Jean-François Champollion,* 1831. Oil on canvas, 28⅞ x 23⅝ in. (73.5 x 60 cm). Musée du Louvre, Paris

thetic, for showing "l'art sans l'art," recognized that what was left in place of art was science. Friend or foe, his critics confirmed the science of his enterprise. At the end of the nineteenth century, his system was changed for the first time, reproached by his successor as an "ideological classification" that "took no account of form."[39]

Champollion's installation and printed guide were suffused with the rhetoric of scientific classification. The Egyptologist Nestor L'Hôte explained how the catalogue makes the museum accessible to everyone and demonstrates the brilliance of Champollion's research. "It will serve as a guide for all those who visit the Musée Charles X," he wrote, "and will make visitors see at the same time that if the research of Monsieur

Fig. 55. Jules Chevrier, *Caricature of Egyptology,* 1858. Musée Denon, Châlon-sur-Saône

Champollion has already made such a great step for Egyptian archaeology, we have the right to hope completely for further research from this indefatigable intellectual."[40] Entering the museum beneath Gros's *The King Giving the Musée Charles X to the Arts,* the visitor encountered here, as throughout, mostly small objects in windowed cabinets, but also mummies and coffins. In rooms designated Salle Funéraire, Salle Civile, a second Salle Funéraire, and Salle des Dieux,[41] objects were classified by subject and site. Each received a letter and sometimes a subnumber, so that, for instance, all the statuettes, figurines, and amulets representing the kings of Egypt would be found in the Salle Civile under the letter "D." The objects without legends were labelled "D1," and those with names and legends of the Egyptian race or pharaohs were called "D2." Thus, Champollion's display and catalogue were structured along the lines of an open-ended Enlightenment encyclopedia, installed, at the same time, beneath the ceilings that promoted the reactionary historicism of the regime into which he had been enlisted.

Champollion's appointment, his work as curator, and his apotheosis at the Salon of 1827 were neither neutral nor inevitable. In the Musée d'Egypte, Egyptology

was not so much invented as it was fabricated, bit by complicated bit, its boundaries and its function established by these actors, its domain reserved for antiquarians and archaeologists, its scientific authority meant to embody the superiority of a nation. The government's order that created the museum also identified Champollion's achievements and scientific genius as national attributes of France. It boasted that science propelled France to the zenith of its historical destiny, and that Champollion's intellectual achievements contributed to the intellectual progress that makes France dominant in the modern world.[42] French science was unveiling a society that could be the basis for Restoration kingship and religion and had, in its day, also been the embodiment of scientific and commercial acumen, an image that France continued to seek for itself.[43]

The conflation of French identity and Champollion's genius should set us to wonder. Since the Terror, but especially during the Restoration, changes of coat by politicians who survived from regime to regime were satirized in bitter caricatures. In these works, survivors like Talleyrand, to name the most notorious, appeared with weather vanes on their heads, populating France with more and more "girouettes." Champollion, however, escaped such comparisons, despite his deep ties to the previous regime and his canny success in the next. His education and early achievements were closely associated with the scholars of Napoleon's Egyptian campaign. Astonishingly accomplished and appropriately connected at a young age, he rose swiftly during the Empire. Fourier, who had been permanent secretary of the Institut d'Egypte and author of the *Description de l'Egypte*'s "Préface Historique," became prefect of Champollion's *département,* facilitated the young Champollion's studies, and hired his brother (Champollion-Figeac) as a private secretary. With the support of his brother and Fourier, Champollion went to Paris to study with leading Orientalists, among them Denon and Silvestre de Sacy.[44] At the age of nineteen (in 1809), he became adjunct professor of history and professor of Hebraic languages at Grenoble.[45] Two years later he published his introduction to *L'Egypte sous les Pharaons,* and two more volumes appeared in 1814. His crowning achievement was the 1822 decipherment of hieroglyphs, published in his *Lettre à M. Dacier,* which snubbed the king in its dedication.

Politically, Champollion worked at some danger to undermine the monarchy. He was a rabble-rouser, an active conspirator, and a visible celebrant of Napoleon's return, via Grenoble, from Elba.[46] A March 1816 intelligence report on political agitators lists him as a "dangerous man, entirely devoted to the usurper's government."[47] After Waterloo, Champollion called for the reestablishment of the Republic and thus was dismissed from his teaching position for treason. In Grenoble, he operated in and

against a repressive political climate in which even porcelain vases with representa-
tions of Bonaparte were suppressed, in which the prefect of the Isère saw to the surveil-
lance, imprisonment, expulsion, and execution of dissidents.[48] Champollion, how-
ever, remained active into the early 1820s, using the pretext of the May 1820 visit of
the duc d'Angoûleme to stir opposition both in Grenoble and in Paris with his anony-
mously published pamphlet *Attention!* It hit antiroyalist hot-button issues, railing
against taxes on bread, the neglect of veterans, and the suppression of political dis-
course.[49] In a March 1821 rebellion, Champollion helped to raise the tricolor over
Grenoble's citadel, and soon he found himself taking refuge in Paris after having only
been restored to his professorship in 1818. His political activities cost him jobs and
forced him to move among Grenoble, his natal Figeac, and Paris. At the Academy he
was known as "le Jacobin enragé," and "le Robespierre de Grenoble."[50]

After years of governmental coercion, Champollion began in the 1820s to lend
support to the regime and to censor his own work. Together the archaeologist and
the government declared his work free of dissident politics, indeed free of politics al-
together. They instated his work into the supposedly disinterested realms of science
and the history of art and archaeology. Still, he recognized the political and theolog-
ical questions born from his work. When in Turin in 1824, Champollion followed the
instructions of his financial backer, the ultraroyalist duc de Blacas, by suppressing the
lists of pharaonic reigns that would have undermined the official teachings of the
faith.[51] In Rome in 1825, he designed a temporary obelisk for a French celebration of
the coronation of Charles X (figure 56),[52] which won him a private audience with the
pope and proved the dynastic flexibility of the fabricated obelisk. The hieroglyphic
texts that he composed herald the legitimacy and succession of the Bourbon king,
which would have been to the maker of the anti-Denon print an unimaginable al-
liance of the Bourbons and Egypt. Champollion's participation seemed to make these
political bedfellows even stranger.

Scholars do us no favors when they gloss over the details of how ancient and con-
temporary Egypt came to be the site for cooperation between Champollion and the
Restoration, and among the Empire, Restoration, and July Monarchy. Annotating
Champollion's letters about his design of the Charles X coronation obelisk, his most
important biographer says that Champollion's purpose was not political, that he
wanted only "to revive ancient Egypt and thus enlarge greatly the domain of ancient
history."[53] Champollion, himself, had a more nuanced view of the situation. At times,
he seemed to wrestle to be free of the contemporary political milieu, declaring a dis-
interested and determined scholarly pursuit. He railed against the way Ultra jour-
nalists were using his discoveries for their own purposes. These "vile reptiles," he wrote

Fig. 56. Jean-François Champollion, *Obélisque érigé à Rome en l'honneur du sacre de Charles X*, 1825. From *Lettres de Champollion le jeune*, vol. 1, *Lettres écrites d'Italie* (Paris, 1909)

a friend, were trying to make him into a "Father of the Church," but he rejected the "odor of sanctity that the devoted are beginning to give me, as if I had no other goal in working over the last fifteen years than the discovery of my alphabet for the glory of God."[54] Meanwhile, however, when he wrote his brother that he was suppressing his discovery of the pharaonic reigns that predated official sacred chronology, he said that one day he would publish them and that he would do so "with gloves of a certain color."[55] Champollion knew the potential uses and implications of his findings, so he withheld and revealed his work carefully, according to the political touch that he saw fit.

He knew what he was doing: when his nomination to curate the Egyptian de-

partment was threatened by complaints that he had plotted against the monarchy, the duc de Doudeauville investigated and was able to secure and justify the nomination. He noted that Champollion and his brother had had "errors of opinion," but that this should not prevent the monarchy from employing them as "savants." In this way, the duke separated Champollion's politics from his scholarship and announced him cleansed. That having been said, Doudeauville immediately followed by stating that Champollion's work buttressed the politics of the regime. Their discoveries, he wrote to the Director of Public Security in May of 1826, serve to "reestablish the holy doctrines, destroying the fabulous antiquity that is opposed to the holy Scripture."[56]

If Champollion's cooperation with the government cannot be explained away (à la Louis-Philippe) by saying that it was apolitical, to what can it be attributed? Judging from his personal letters, Champollion's cooperation was based on a potent mixture of careerism and despair. While preparing the Musée d'Egypte, he wrote to a confidante, distancing himself from his old oppositional political activity, saying that it had been guided by delusional "dreams of infinite social perfection." Rebutting the police report of 1816, he measured the distance between his antagonism toward the early Restoration and his later work at the Musée d'Egypte: "I am not at all hostile to the government; my work can honor my country. I am now completely devoted to my affections and my studies. I am thus no longer a dangerous man."[57] Champollion appreciated that this new field he helped establish would absorb, or siphon off, we might say, his intellectual energy. Ancient Egypt was both "sufficiently vast," as he said, and sufficiently flexible so as to provide a vast screen that could accommodate his fantasies of finding a better world in the past, while the monarchy used him to promote its own image of Egyptian history as a reactionary model for France.[58] Egypt was distant and desirable, the Revolution was close and vexing. For the government the Musée d'Egypte was created to overthrow the logic of the Revolution, while Champollion sought compensation for his abandoned revolutionary dreams.

Imperialism before 1830

Even before the Luxor obelisk came to the Place de la Concorde, the Restoration's Musée d'Egypte fulfilled one of the fantasies of the Egyptian campaign—to bring to life (and to Paris) the glory of Pharaonic Egypt. "Amongst all these corpses," Délécluze reported from the galleries, "these coffins and these Egyptian tools, before these

vases from the earliest days of Greece, even the man deprived of all instruction stops himself; antiquity appears to him to be almost alive."[59] With modern France allied with Pharaonic Egypt, the two could be set off against the Islamic East. As the Restoration introduction to the *Description de l'Egypte* had it, the scientific prowess of France would soon end the period in which Islamic dominance separated France from the glory of Egyptian antiquity: "Abandoned successively by the effect of political and religious revolutions, these monuments have not become more accessible to European travelers since the establishment of the Muhammadan religion."[60] The glory of Pharaonic Egypt, the degeneracy of the Islamic East, and the triumphs of modern France comprised a cycle of civilization put forward by the museum, a model of history that served to explain, justify, and promote modern French imperialism in the Near East. These practical applications and implications of French scientific glory are conveyed in a series of allusions to Restoration foreign policy in the Musée Charles X program.

In Gros's *The King Giving the Musée Charles X to the Arts* (figure 43), the first figural group at the left shows Greece being succored by Mars who, one critic recognized, "has come to lift the yoke of the oppressors."[61] This reference of aid to an oppressed Greece called attention to the Greek uprising, which began in 1821 against hundreds of years of Ottoman rule. The Greek war was a cause célèbre among Romantics, inspired by Lord Byron, and among liberals, fired by a restaging of the Revolutionary wars with the Ottoman Empire cast as the ancien régime. The role of French artists in support of the Greeks is now well known. Philhellenic works such as Delacroix's *Greece on the Ruins of Missolonghi* implicitly criticized the government's refusal to intervene. By 1826 when Delacroix and others held the "Exposition au profit des Grecs," support for the Greek cause was a major liberal tenet used against the Ultras who denounced it as a trap concealing 1793-style liberty.[62] On 6 July 1827, however, the government reversed its policy. It signed the Triple Alliance, joining England and Russia in pledging to liberate Greece.[63] The government effectively coopted the liberals' issue. Whereas from the beginning the Musée d'Egypte posited Egypt to legitimize Bourbon rule, along the way the government used the museum to unite, not divide, political factions. In Greece the central question of the Restoration, the validity of the French Revolution, could be submerged: the left could relive the Revolution and the right could relive the Crusades. They could agree because both factions had their reasons that could also be subsumed under the broader and more agreeable question of civilization (the Greeks) fighting the barbarians (the Turks). This is precisely why cultural and political policy regarding the Orient could be the point of agree-

ment of left and right, the continuing thread from regime to regime that wove the fabric of post-Revolutionary national identity.

The most important picture in the Musée d'Egypte for rationalizing French intervention in the East was Abel de Pujol's 1827 *Egypt Saved by Joseph* (figure 57). If Picot's *Genius Unveiling Ancient Egypt for Greece* rendered France's affinities to ancient Egypt in order to bolster the legitimacy of the regime, Pujol's picture refined the comparison, distancing Egypt from France by conjuring a series of cultural antitheses that, in Europe in general during the nineteenth century, supported colonial policies.[64] These cultural antitheses served to rationalize and promote French intervention in the Orient, thereby affirming the same sense of national identity and purpose recommended by the Egyptian campaign pictures and drawing more sharply the alien face of other groups against which sentiments of solidarity were established.

Pujol's painting is the only Biblical subject in the Musée Charles X. It allegorically represents an episode in the life of the Old Testament patriarch (Genesis 37–50), a popular story from the Constantinian era forward, usually recounted in a series of episodic, narrative pictures.[65] Joseph's brothers sell him into Egyptian slavery, he is framed by the wife of the pharaoh, and he is thrown into jail, where he interprets the pharaoh's recurring dream of seven years of plenty followed by seven of famine. For that the pharaoh entrusts Joseph with the management of the agro-economy, and the former slave becomes viceroy of Egypt.

Pujol kept the subject on the usual narrative level in the four grisaille vaults below *Egypt Saved by Joseph,* which tell of Joseph guarding his flock, being sold by his brothers, explaining the pharaoh's dreams, and receiving the authority to govern. In the ceiling painting, the artist introduces an innovation into the treatment of the subject: he allegorizes Joseph's investiture with power. Joseph protects a nubile personification of Egypt from seven wizened personifications of famine, who themselves are driven by a hound breathing flames of drought.[66] An authoritative male figure, Joseph saves the distressed, collapsing, and half-nude female personification of Egypt. In this respect, his Egypt is importantly linked to Picot's in the adjacent room, where a reclining, bare-chested Egypt is vulnerable to the gaze of the columnar and austere Athena and to the regard of the viewer. As the critic in *La Pandore* commented, Picot's Egypt exudes a calm majesty, which does not prohibit "a sort of voluptuous languor."[67] In one room Egypt waits passively to be uncovered, in the next she runs desperately to be rescued.

This inflates Joseph's stature. Moreover, his youth, heroism, and virility eclipse the distant, flattened, retiring figure of the pharaoh. Abel de Pujol's pharaoh is enthroned, placed frontally and at the center, but he is diminutive and nearly obscured.

Fig. 57. Alexandre-Denis Abel de Pujol, *Egypt Saved by Joseph,* 1827. Oil on canvas, mounted on ceiling. Musée du Louvre, Paris

He raises his left hand and cedes power to the young Joseph. The pharaoh's inferior position was noted by the critics of the Salon of 1827. Jal complained that Pujol's pharaoh is a mere, tranquil spectator, "so effaced in the half-light where he is sheltered!"[68] Another, more contented critic recognized that the pharaoh's role was to admire and defer to Joseph, "the genius-liberator of his kingdom."[69] The pharaoh is a symbol, flat and iconic. Joseph stands, turns in space. He is vigorous and strong. He supports Egypt in his arms, protecting her from the scourge of drought and famine. In short, Joseph's gendered actions, defined in opposition to Egypt and the pharaoh, reiterate the old saw that the West is a powerful male force that can save, possess, and know the passive, powerless East.

The second opposition that Pujol introduces is racial. Joseph's clean-shaven face is decidedly white, even pinkish. His features are not classical but resolutely French. He saves an Egypt who embodies, one critic wrote, "the national physiognomy of Egypt."[70] In this way, the Musée d'Egypte participates in the early-nineteenth century whitening of the origins of Egyptian and Western civilization. In the mid-eighteenth century, *philosophes* turned to Egypt as the origin of Western civilization, following Herodotus, who contended that ancient Egypt was the origin of civilization and that the ancient Egyptians were black. By the early nineteenth century, scholars in various fields were backtracking on the unified origins of humanity.[71] While Champollion's history of Egypt, written for the pasha in 1828, gives a black origin to ancient Egypt, by 1840 Champollion-Figeac posited a white Pharaonic Egypt and blamed his brother's misstep on the Enlightenment and Volney.[72] Pujol's picture conjures up a racial divide and insists on a white salvation of Egypt.

The third cultural antithesis is religious. Joseph had long been treated as an antitype of Christ, and the comparison remained current.[73] In fact, the year before Pujol proposed his subject, a book called *Essai sur les rapports entre le saint patriarche Joseph et Notre Seigneur Jésus-Christ* repeated the typology. It lists the facts of Joseph's life in one column and the analogous episodes in Christ's life in the next. Equated with the pharaoh's naming Joseph viceroy of Egypt, the theme of Pujol's picture, is God's promise to Christ of authority over every corner of the earth: "I will give to you, says God the Father to Jesus Christ, the nations for heritage, and, for your possession, the extremities of the earth."[74] White, virile, and Christian *avant la lettre,* Joseph receives divine sanction for universal domination. Thus, Joseph's Christianity combines with his sexuality and race to offer an antitype for the French presence in Egypt. If Picot's painting is an allegory of the intellectual discovery, possession, and control of ancient Egypt, then Abel de Pujol's *Egypt Saved by Joseph* completes the familiar, bivalent, and

imperialistic view of an exotic culture discovered, known, and then, in this painting, managed (figure 58).

The promise of Joseph's—and France's—control of Egyptian agriculture is displayed below the ceiling. Eleven grisaille panels represent the civil life of Egyptians in a range of agricultural activities: planting, hunting, fishing, wine-making, selling milk, and harvesting (figure 59). In the frieze, sixteen genii of the Nile hold garlands of fruit. Agriculture, the foundation science of the cradle of civilization, transformed nomads into the first Egyptians, so Champollion wrote in his 1829 "Notice sommaire sur l'Histoire d'Egypte."[75] To recapture the glory of ancient Egypt, France, the new Joseph, would manage the Egyptian agro-economy.

In this way the Restoration's Musée d'Egypte effectively nationalizes what had been a Napoleonic imperial project. According to the *Description de l'Egypte,* Egypt might "be considered an enormous garden" for France to plant, a garden capable of supporting varied and valuable agricultural yields and the key to the success of a potential French colony, if not province, in Egypt.[76] In the Restoration's Musée d'Egypte, Joseph, the "genius-liberator," offered both a precedent and a rationale through analogy for Restoration activity in Egypt, where France acted "almost as a tutor."[77] Thus, when in the July Monarchy, private business interests pushed for the expansion of French influence in Egypt and Algeria,[78] they were not only laying the foundations for the modern French empire, but they were also building those foundations with the culture—the military, economic, scientific, and ideological experience—that was developed under the Empire and Restoration.

That the imperial aspect of the program could be cultivated and the reactionary program made yet more virulent is evident in the changes ordered in 1828. The never-realized program of 1828 celebrated the Restoration's interventionist and fervently Catholic foreign policy in two additional commissions: from Steuben, a work called "Modern Subject: France under Clovis, or Catholic France," and from Alaux, a "Modern Subject: The Century of Charles X. The Triple Alliance: France, England, and Russia Succoring Tearful Greece." The functional use of being civilization's proper heir and steward is enunciated: to act in international relations as the civilizing force. The paintings by Abel de Pujol and the proposed picture by Alaux recommend the French management of Egypt and the expulsion of the infidel from Greece. The projected 1828 painting cycle recommended the fight against the Orient or at least the submission of it to the tradition that began in Egypt and then endowed Greece, Rome, and, finally, Restoration France.

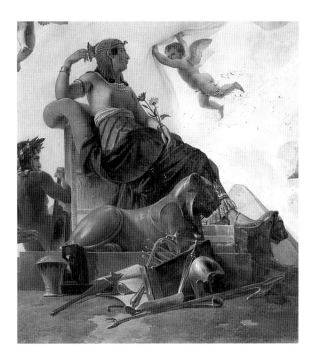

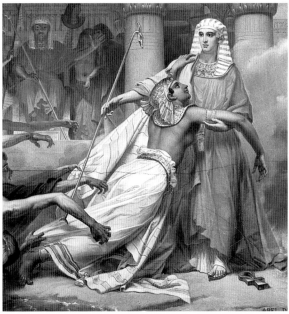

Fig. 58. Details showing the allegorical figure of Egypt: *(top)* François-Edouard Picot, *Study Crowned with Laurels and the Genius of the Arts Unveiling Ancient Egypt for Greece* (fig. 46), and *(bottom)* Alexandre-Denis Abel de Pujol, *Egypt Saved by Joseph* (fig. 57)

Fig. 59. Alexandre-Denis Abel de Pujol, *Daily Life of the Egyptians: The Harvest,* 1827.
Oil on canvas, mounted on wall. Musée du Louvre, Paris

IMPERIALISM AFTER 1830

After the July Revolution, the decoration of the galleries was adjusted for the new
regime. Fontaine, who fifteen years before removed Napoleonic bees and imperial ea-
gles, found himself eliminating Bourbon insignia and the monogram of Charles X in
favor of Phrygian caps and revolutionary fasces. In the ceiling cycle, the Bourbon
figures and the aggressive Catholicism in the program did not survive the transition.
Slated in 1828, Alaux's and Steuben's pictures were never executed. And, of course,
Gros's dynastic and introductory painting to the Musée d'Egypte, *The King Giving the
Musée Charles X to the Arts,* was taken down. The reactionary monarchic theme was
suppressed, but the imperialist agenda not only survived but was further elaborated.
In place of Charles X, Gros painted *The Genius of France Animating the Arts and Suc-
coring Humanity* (figure 60).[79] Here Humanity guards a black figure representative of
Egypt and the Orient, while embracing and protecting a Greek boy and girl. She
pleads to an enthroned Europe, while the Genius of France comes to her aid. Thus,
Gros celebrates France's continued support of both Greece and of Muhammad Ali's
Egypt in their struggles against the Ottoman Empire. France continued friendly re-
lations with Egypt in order to try to extend its sphere of influence.[80]

———————

At the Salon of 1834, Cogniet's *Egyptian Expedition under the Orders of Bonaparte* (figure
61) finally appeared. The July Monarchy addition to the museum revealed what had
been implicit in the Restoration's sponsorship of Egyptology: France's cultural and
scientific success came on the wings of military power. Whereas in his Restoration oil
sketch Cogniet was general and allegorical about the military's role in French Egyp-
tology, here he is direct and historical. With the French troops fighting in the The-

Fig. 60. Antoine-Jean Gros, *The Genius of France Animating the Arts and Succoring Humanity,* 1833. Oil on canvas, 15 ft. 11¾ in. x 32 ft. 9¾ in. (487 x 1000 cm). Musée du Louvre, Paris

ban plain, Bonaparte directs the work of the intellectuals of the campaign. He is surrounded by Kléber, Monge, Berthollet, and Denon. A mummy is hauled up to the platform; water is carried by a fellah; and the savants plot their work, guarded by soldiers in the foreground. The cycle of civilizations is intoned by the surrounding medallions representing antique Egypt, "the cradle of human understanding," and modern Egypt, where the genius of France rekindles the flame of civilization. Names of ancient Egyptian cities are juxtaposed with the sites of the French campaign battles, and the names of the generals and the intellectuals are inscribed in grisaille plaques. Proof of the success of the mission and of France's possession of ancient Egypt is demon-

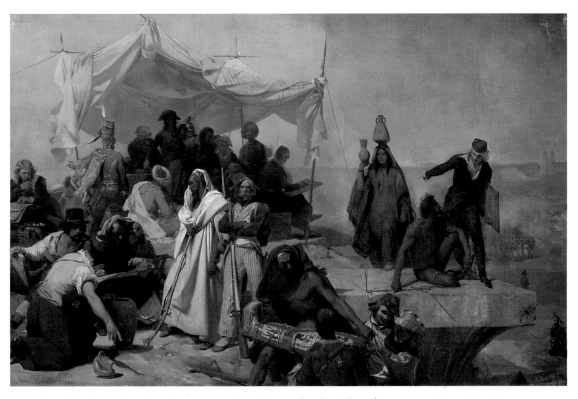

Fig. 61. Léon Cogniet, *The Egyptian Expedition under the Orders of Bonaparte,* 1834. Oil on canvas, mounted on ceiling. Musée du Louvre, Paris

strated in the depictions of objects like the Dynasty XXII sarcophagus being hoisted to the platform, and the canopic vase on the left, objects that could be found in the galleries of the Musée d'Egypte.[81]

The appearance of Bonaparte in Cogniet's painting has traditionally been understood in relationship to Louis-Philippe's own Napoleonic revival. However, the July Monarchy was not unique in this regard.[82] The Restoration's sponsorship of Egyptological projects reveals that when it came to building France's imperial culture, these regimes could carry on the work of their predecessors. Recognition of the military role in the rediscovery of ancient Egypt is evident in the Restoration too, as conveyed in the 1826 medal struck to mark the Restoration publication of the *Description.* In Barré's *Victorious Gaul Rediscovering Ancient Egypt* (figure 62), as in Picot's ceiling painting, a placid female personification of ancient Egypt is surrounded by the signs and symbols of the land of the pharaohs. Here, however, instead of Study and Genius lifting the veil of mystery, it is a warrior, "Victorious Gaul," a pre–ancien régime national symbol. As the official *Moniteur universel* described, the medal "shows the military genius of France."[83] Picot's painting and Barré's medal use the same metaphors

Fig. 62. Jean-Jacques Barré, *Victorious Gaul Rediscovering
Ancient Egypt,* 1826. Medal, diam. 2⅝ in. (6.8 cm).
Hillwood Art Museum, Brookville, New York

to present scientific and military prowess as the key to the "rediscovery" of ancient Egypt.

Both the *Description de l'Egypte* and the Musée d'Egypte would seem, then, to be trophies of war, but they are not. As we have seen, spoils of the Egyptian campaign were surrendered to the British in 1801, and acquisitions began only in 1824. The Egyptian campaign, in the end, was not a victory, no matter how hard the cultural artifacts of the Empire, Restoration, and July Monarchy may insist. The memories of the Egyptian campaign could, however, be fabricated, relished, polished, and enlisted as a model for French paternalism in Egypt and the Near East. The Musée d'Egypte did not so much reflect a secure empire as it cultivated imperial desire. In the July Monarchy, Thiers made clear that France could build on such historical fantasies to redeem and extend the Egyptian campaign through the Restoration and July Monarchy's invasion, occupation, and eventual conquest of Algeria. The Musée d'Egypte is the Restoration's, but not uniquely the Restoration's, contribution to the culture of empire.

As for Cogniet's picture, it not only participated in the institutionalization of Egyptology, but it also helped forge the tradition of Orientalist painting. Running beneath the ceiling is a grisaille frieze by Cogniet which quotes four great paintings of the Empire: Gros's *Battle of Aboukir* and *Pesthouse at Jaffa* (figure 63), Girodet's *Revolt of Cairo,* and Guérin's *Bonaparte Pardoning the Rebels in Cairo.* Cogniet cites and then expands on the stylistic examples set by his predecessors, evoking a creamy atmospheric light that is refracted through thin clouds of dust, rendering the fellah's dress transparent and playing variously on both the top and bottom side of the tent. Critics responded by echoing the reception of the same battle paintings when they were first exhibited three decades before. They proclaimed that Cogniet had successfully depicted the true light, color, and atmosphere of Egypt. Tardieu pointed out the soldier just above the mummy's feet as a masterpiece of the natural.[84] For Peisse the use of local color was particularly notable.[85] And the *Magasin Pittoresque*'s description of the atmosphere would become a cliché of Orientalist painting: "the color is full of heat, a sparkling light circulates in all the parts of the canvas."[86]

Cogniet's naturalizing technique serves to authenticate the heroizing narrative of French science in Egypt. That Cogniet succeeded in adapting and advancing a set of conventions and purposes for Orientalist painting is evident from Léon Bonnat's 1883 eulogy, written in homage to his teacher, whose seat at the Academy he was prepared to assume. For Bonnat, who painted his own share of Orientalist pictures for

Fig. 63. Léon Cogniet, grisaille evoking Gros's *General Bonaparte
Visiting the Pesthouse at Jaffa,* 1834. Musée du Louvre, Paris

the celebrations in honor of the opening of the Suez Canal, Cogniet's Louvre ceiling
was a masterpiece for its local color and true effects of Oriental atmosphere. "His ar-
dent love for nature made of him a sort of reformer, a precursor," Bonnat wrote. "It
is as early as 1831 and here he is in his most beautiful, most important work, *Bona-
parte in Egypt,* a work so personal and so French, in which he passionately pursues lo-
cal color, seeks the true effect, and dedicates himself to rendering the sun and the bril-
liance of the Orient. The truth of the setting in which the subject occurs, this truth
almost unknown before him in history painting, becomes in the master one of the most
prominent aspects of his art."[87] The conventions of Orientalist painting are in place
in the work that Bonnat calls "si française": fidelity to setting, local color, and the
true effect of the light of the Orient. These traits were found elsewhere at the Salon
of 1834—in Delacroix's *Women of Algiers*—which would seem to be more indepen-
dent of governmental interests than Cogniet's ceiling. Delacroix's painting certainly
made for one of the most enduringly influential and complex exemplars of the Ori-
entalist tradition.

4

The Women of Algiers

Eugène Delacroix's *Death of Sardanapalus* (figure 64), a Byronic scene of the impending suicide of the Assyrian king Sardanapalus and his murder and destruction of his favorite harem women, slaves, and material possessions, offended nearly everyone at the Salon of 1827–28. Even his former supporters mustered admiration only for his audacity.[1] The critics said that Delacroix showed bad taste, abused his talent, could not draw, knew only how to fill a canvas with corpses, trafficked in the bizarre and ugly, and brazenly violated the artistic tradition of Michaelangelo, Raphael, and Gros; in short, Delacroix was ruining "le beau idéal."[2]

In front of the enormous canvas, the viewer is faced with vertiginous perspective, nightmarish color, and extravagant elongations of form—violation after violation of all standards of painting in Delacroix's day. Viewers are forced to work their way up and over all this "bad painting," all this chaos and mayhem, until reaching the figure of Sardanapalus, positioned high on the canvas. Sardanapalus, on the other hand, looks coolly at the scene that he has set in motion, and for him everything is in order. The chaos and destruction are just what he planned.

At the same 1827–28 Salon in which the Musée d'Egypte's ceiling paintings allegorized Western hegemony in a fallen East, Delacroix undertook a subject that traditionally reinforced notions of Oriental cruelty and tyranny, and he identified with the murderer. Sardanapalus set in motion the violent destruction of beautiful women, animals, and other possessions, and Delacroix was recognized for destroying all civilized standards of painting. Delacroix affirmed that he, the artist, was responsible for the corruption typically associated with the Orient. By identifying with his Oriental antihero, by taking responsibility for the iconoclasm of the painting and its sub-

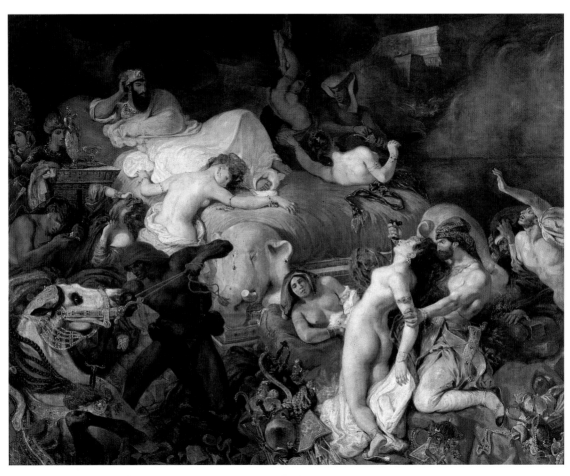

Fig. 64. Eugène Delacroix, *The Death of Sardanapalus,* 1827. Oil on canvas,
12 ft. 11⅜ in. x 16 ft. 2¾ in. (395 x 495 cm). Musée du Louvre, Paris

ject, Delacroix revealed that the pleasure in this mayhem was his, that the violent and sadistic fantasies about the Orient were the creator's own.

The Restoration's art administrators held a private meeting with Delacroix to admonish him, and his official commissions ground to a halt. For there to be a stable post-Revolutionary order, public life could no longer be acted out in the incendiary terms of the Revolution. Delacroix never again asserted his individual liberty with such iconoclasm. The harsh attacks of 1828, Delacroix later said, resulted in his own "retreat from Moscow," suggesting a bloodied withdrawal from a most ambitious and megalomaniacal project.

After an ambiguous success in the 1831 Salon with *The 28th of July, Liberty Leading the People,* purchased by the government of Louis-Philippe and quickly put in storage, Delacroix's next major canvas was displayed at the Salon of 1834, his *Femmes d'Algiers dans leur appartement* (*The Women of Algiers*) (figure 65). Whereas *Sardanapalus* is colossal in scale, *The Women of Algiers* is large but less grandiose. In *Sardanapalus* the imaginary color serves expressive ends; in *The Women of Algiers* the tints were judged "dazzling" by critics but were also considered balanced and harmonious. The figures sit logically in their space, accessible to both artist and viewer. Delacroix has, in the words of the critics, returned to the "imitation of nature"—or nature as they understood it.[3] *The Women of Algiers* was purchased at the Salon of 1834, greatly improving the artist's critical and financial fortunes. Official commissions resumed and Delacroix never really returned to the leading edge of Romanticism that he had occupied in 1828. Orientalist subjects remained a staple in his repertoire, but revolutionary politics and iconoclastic aesthetics were left behind. When the Revolution of 1848 came, there were rumors that Delacroix was preparing a pendant to *Liberty Leading the People* for this revolution, an *Equality Leading the People.* But he did not. Instead he withdrew, and in addition to his flamboyant still lifes, in which he seems to be painting out the world, he returned to and repeated *The Women of Algiers,* this time as a more distant memory (figure 66).[4] In words that echo Champollion's declaration of himself as "no longer a dangerous man," Delacroix said, "I have buried the man of former days, with his hopes and his dreams of the future, and at present I walk to and fro with a certain appearance of calm—as if it concerned somebody else—on the grave in which I have buried all that."[5] Instead, in the Orient Delacroix had found a productive career, a safe haven from the harsh critical attacks based on his most Romantic works, and a refuge in the uncontroversial realm of imperial justification.

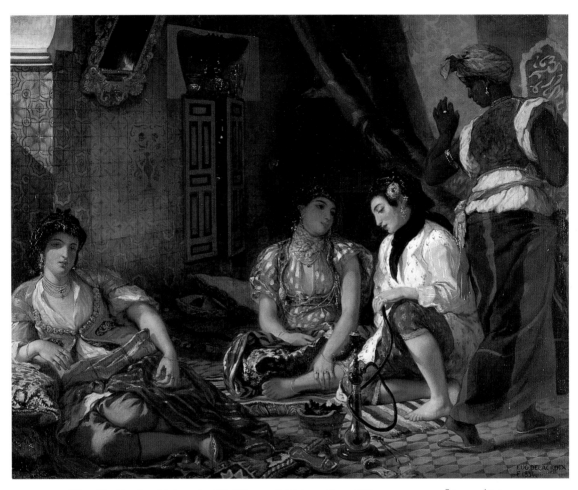

Fig. 65. Eugène Delacroix, *The Women of Algiers,* 1834. Oil on canvas, 70⅞ x 90⅛ in.
(180 x 229 cm). Musée du Louvre, Paris

THE ARTIST AS DOCUMENTER

The Women of Algiers has long been posited as the first true Orientalist painting. Like the paintings of Gros, for instance, which have been considered forerunners of Orientalism, *The Women of Algiers* has been accepted as an actual eyewitness account, based on Delacroix's 1832 trip to the *proche Orient*. Thus, the painting evinces the definitive quality of Orientalism—reportage.[6] Moreover, it has been accepted as a document of the artist's visit to a Muslim harem in Algiers, the quintessential Orientalist subject. Its reputation has been in the making since the Salon of 1834.

Critics considered Delacroix's *Women of Algiers* one of the most important paintings of that year's exhibition. It received a correspondingly esteemed hanging position in the Salon Carré.[7] An ambitious genre scene, it was fully without the rhetorical pomposity of the heavily loaded allegories of the Musée Charles X. Unlike Cogniet's

Fig. 66. Eugène Delacroix, *The Women of Algiers,* ca. 1848. Oil on canvas, 33⅛ x 43¾ in. (84 x 111 cm). Musée Fabre, Montpellier

history painting (figure 61), Delacroix's picture represented a personal account, according to one critic, "a fragment of his journey."[8] The year's capital production by the leader of the Romantic school, Delacroix's picture appeared to be free from political vagaries like those that dictated the changes Cogniet made to his Musée d'Egypte project after the July Revolution. That the Orientalist tradition in painting is often drawn back to this picture owes in part to the shift in genres from history painting. *The Women of Algiers* does have precedents in the *grandes machines* of the Empire but as a genre scene, albeit a large one, it can pass as historically innocent.

The Women of Algiers offered one point of agreement for critics regardless of their political and aesthetic allegiances. They all agreed that Delacroix's work was authentic, true to nature, even scientific.[9] According to their loyalty in the *bataille Romantique,* critics judged this "truth" positively or negatively. Romantics like Gustave Planche and Alexandre Decamps were whole-hearted supporters. Classicists—supporters of Ingres, who had contributed the *Martyrdom of St. Symphorian* (figure 67)— complained that the picture was too real, that it was impoverished by its reality. Even for a partisan of Paul Delaroche's *juste-milieu* and painstaking *Execution of Lady Jane Grey* (figure 68), a critic whose motto was *"La verité avant tout,"* Delacroix showed too much nature, "too much of these voluptuous and lazy creatures."[10] Thus, while they may have fought over the appropriateness of Delacroix's picture, no one disputed its authenticity.

Over the years, *The Women of Algiers* has continued to be construed as scientific, scrupulous in its portrayal of the physiognomies, mores, costumes, and living conditions of an exotic people. In the 1880s, the Realist critic Philippe Burty placed

Fig. 67. Jean-Auguste-Dominique Ingres, *Martyrdom of Saint Symphorian,* 1834. Oil on canvas, 13 ft. 4 in. x 11 ft. 1 in. (407 x 339 cm). Musée d'Autun

Fig. 68. Paul Delaroche, *Execution of Lady Jane Grey,* 1834. Oil on canvas, 96⅞ in. x
9 ft. 8⅞ in. (246 x 297 cm). National Gallery, London

The Women of Algiers first in what he called "the modern ethnographic school."[11] In the
1930s, as if to corroborate this assessment of the previous century, the Musée Ethno-
graphique du Bardo in Algiers displayed a three-dimensional re-creation of Delacroix's
painting.[12]

Delacroix's artistic practice has contributed to a convincing narrative about his fidelity
to nature. In contrast to the more expressive *Death of Sardanapalus, The Women of Al-
giers* is more of a descriptive painting. Three women sit in the foreground of a shal-
low space, a low and cramped interior. Accompanied by a striding black slave to the
right, they are gathered around a water pipe in a circle. Space and access are left to

the viewer. Light floods in from the upper left, illuminating the costumes, objects, habits, and physiognomies. The play of light in the foreground is contrasted against the deep shadows of the back of the room, which correspond to the smokey gazes and sultry comportment of the harem women.

The painting is based on drawings that Delacroix made in Algeria.[13] The two huddled figures derive from the sheet in which two women are seated on the floor, which is indicated in a light brown wash (figure 69). Before them is a hookah and its implements. Some watercolor is applied for the figures' hair and clothing, but other areas are left uncolored. Written notes tell what the colors will be: gold and green for the vest of the figure at right and "white with flowers" for her shirt. In his Paris studio the artist worked out the pose and costume of the figure on the left and the facial features and posture of the figure on the right, as he returned to his 1820s habit of drawing after Oriental costumes.

Fig. 69. Eugène Delacroix, *A Harem in Algiers,* 1832, from Delacroix's Moroccan sketchbook.
Pencil with watercolor, 4¼ x 5⅜ in. (10.7 x 13.8 cm). Musée du Louvre, Paris

In North Africa, Delacroix filled at least seven notebooks, three of which survive intact.[14] He drew in pencil and watercolor, frequently the choice of documenters of nature and illustrators of travel.[15] His drawings suggest an artist with eyes open, pencil in hand, ready to record everything that came before him. Small enough to have been carried anywhere, the notebooks read like a verbal and pictorial diary of the unfolding expedition. Made on the approach to Meknès for an ambassadorial reception, one page from the notebooks (figure 70) shows Delacroix's typical intermingling of words and pictures. He has drawn five vignettes in pencil, heightened with watercolor. They seem to move with Delacroix through time and space: studies of Arab figures; cavaliers descending toward the city in the background; cavaliers carrying flags closer to the town; a closer view of the gate of the city; and a look down a path along the ramparts of the city. The accompanying verbal description is similarly paratactic. The artist writes in an abbreviated style to record events as they happen before his eyes, as at the upper left on the page, where he writes:

> *Made boring promenade. Continual races to our left, to right shots of guns of the infantry. From time to time we would arrive at circles formed by seated men who would rise at our approach and shoot at our noses. Preceded by music. head of Sardanapalus. walking behind the flags. descended to the left. Meknès presented this aspect. One of the ancestors of the current emp{eror} prolonged the wall which passes the two sides on the bridge. white spots on that hill. faces of all kinds. the white always dominating.*[16]

Delacroix's verbal descriptions confirm what his pictorial language tells us: these pictures are "artless" reminders of what he encountered. He was in too alien an environment to manipulate his visual records. "I made my sketches on the fly because of Islamic hostility," he explained, "and with a lot of difficulty due to the prejudice of the Muslims against images."[17] Some twenty years later, he continued to assert the documentary nature of his pictures from North Africa: "I was pursued by the love of exactitude," he wrote, "which most people take for the truth."[18] Exactitude and fidelity were among his conscious goals, as evidenced by a color triangle that he inscribed in the back of the Chantilly sketchbook. Taken from Mérimée's *De la peinture à l'huile*, it was accompanied by an explanation of how to depict accurately light and color:

> *Primary colors draw from the three binaries. If to the binary tone you add the primary tone which is opposed to it, you annihilate it, you produce from it the necessary half-tint. . . . Thus, to add some black is not to add the half-tint, it is to dirty the tone in which the true half-tint finds itself in the opposite tone.*[19]

Fig. 70. Eugène Delacroix, *The Approach to Meknès,* 1832, from Delacroix's Moroccan
sketchbook. Pencil with watercolor, 7⅝ x 10 in. (19.3 x 25.4 cm). Musée du Louvre, Paris

Is it fair, then, to conclude that in *The Women of Algiers* Delacroix was fulfilling the role of the eighteenth- and early nineteenth-century artist-voyager, who struggled "to find an innocent mode of literary and visual expression" that would convincingly do justice to the novelty of the material circumstances encountered? To what extent did Delacroix's *Women of Algiers* serve the function of the scientific travel account, that of "accurately impressing nature in the mind, instead of the mind ignorantly propelling itself outward or fantastically receding inward"?[20]

LA PEINTURE ORIENTALE

The Women of Algiers is the culmination of artistic and critical practices applied to representations of the East during the first third of the nineteenth century. The curtain is opened, less on the beginning of Orientalist painting than on its achievement—habits of perception, production, and reception, translated through various media and endeavors, transferrable again to still other venues. The Orientalist narrative about the artist, his experience, and his picture had been in formation for some forty years. Delacroix and his critics reenacted and enshrined it.

The epithet "true to nature" was given to *The Women of Algiers* due to the artist's presence in Algiers and then to the way in which he translated his observations, especially through fidelity to local color and light. Planche, who called *The Women of Algiers* "a fragment of his voyage," said that Delacroix demonstrated a brilliant and vigorous color, an expansive light on the ensemble, and a remarkable value given to the half-tints, rendered with a finesse and a truth previously unknown.[21] These expectations for a document of an event set in the Orient had already been established, first, we may recall, from the battlefields of the Egyptian campaign. We saw these expectations come into play in the commission, production, and reception of Gros's *Battle of Nazareth*. Napoleon's draftsmen also set the model for veracity in draftsmanship. Delacroix's explanation of the haste in which he made his drawings recalls Lejeune's posturing in the portrait by Chassaignac (figure 35) and echos the work (and words) of Denon, who said he made his drawings on the fly, most often on his knee, standing, or on horseback. Destabilized by the dangerous and alien land, the artist's cool-headed determination, like that which characterized the French army on the plains of the Pyramids, prevails and gains authenticity for his pictures.

From as early as 1817 Delacroix studied, drew, and painted pictures, weapons, costumes, objects, and people from the East.[22] His interests followed the French imperial trajectory—from Egypt to Greece to Algeria and Morocco. In the early 1820s,

he made dozens of small-scale paintings, mostly figure and costume studies of Greeks, Indians, and Turks, in which the artist luxuriated in the ostensible foreignness of the colors, habits, and vices of his subjects. Then in the Salon of 1824 he exhibited *Scenes from the Massacres of Chios* (figure 71), his first large-scale contemporary history painting, inspired by the Greek War of Independence against the Ottoman Empire and based on journalistic accounts and interviews with a participating officer.[23]

Delacroix and the young Romantics esteemed the paintings of Gros, in particular, among Napoleon's painters. At the Salon of 1824, the *Massacres of Chios* was measured against battle paintings of the Egyptian campaign. Gros himself led the attack, calling it "the massacre of painting," despite the fact that, or perhaps because, it descends from Gros's 1804 *General Bonaparte Visiting the Pesthouse at Jaffa* (figure 27). Delacroix followed the established artist's lead in the exotic and murderous subject and in the handling of paint, although one critic quipped that Delacroix had used Gros's old palette without washing it.[24] The critics were correct in identifying Delacroix's sources

Fig. 71. Eugène Delacroix, *Scenes from the Massacres of Chios,*
1824. Oil on canvas, 13 ft. 8⅛ in. x 11 ft. 7⅞ in.
(417 x 354 cm). Musée du Louvre, Paris

in the paintings of the Egyptian campaign: his journals of 1824 are filled with admiration for Gros's *Pesthouse at Jaffa* and Girodet's *Revolt of Cairo* (figure 36).[25] In fact, he said much later that his first idea for the 1824 picture came while admiring the *Pesthouse at Jaffa.*[26]

By the time of Victor Hugo's 1829 preface to his *Les Orientales,* exotic color becomes the ultimate signifier of the Orient, a vehicle to connote any Oriental ethnicity:

> *The Orient, whether as image or as concept, has become for the mind as much as for the imagination a sort of general preoccupation, which the author of this book has followed perhaps without knowing it. Oriental colors themselves have become imprinted in all his thoughts and dreams, and these dreams and these thoughts become by turn, and almost involuntarily, Hebraic, Turkish, Greek, Persian, Arab, and even Spanish, because already with Spain the Orient begins.*[27]

A year later, the tendency in painting was sufficiently established—no doubt through the works of Gros, Delacroix, Decamps, Champmartin, and others—that a satire could be launched against it. An eight-page anonymous pamphlet of 1830 features a dialogue between two young girls in which Nathalie teaches her friend *"La Peinture Orientale, Manière de Peindre."* Already the technique has a formula: the girls learn how to paint flowers and decorate pots, screens, and the like. The essential process rests on following patterns to make the forms and using colors, not black, to make the shadows. The author suggests that any child can reproduce the formula of *La Peinture Orientale,* which respects neither draftsmanship nor artistic imagination. It can be learned in a night, taken up like a game of connect-the-dots. *La Peinture Orientale* has an artistic rival, Davidian classicism, which goes unnamed, but its displacement is rued by the author. And the technique has a source, an uncle who brought *La Peinture Orientale* home from the army.

The myth that the Western artist is overtaken by the novel experience of the Orient, and thus automatically and innocently records it, occludes the relationship that Delacroix's painting had to precedents by painters like Gros and to the illustrated travel accounts that he had seen before his trip. Delacroix conformed to what he already knew about the Orient and to what and how observer-artists were supposed to respond. When it came to the Orient, or to *The Women of Algiers* at least, Delacroix and his public were "thinking textually."[28] That is to say, his education gained in advance of his trip influenced both his real experience and his artistic relation of that experience on his return. Pictorial and verbal descriptions inform each other, helping to set the conventions and meaning of conventions for the representation and reception of the East.

Delacroix's technique and iconography echo the work of other artist-voyagers that he knew before his departure. Like Rosset in his *Moeurs et Coutumes Turques et Orientales: dessinés dans le pays en 1790,* Delacroix used watercolor, was specific in the description of costume, and rendered a palpable atmosphere.[29] In his sketchbooks, he repeated Rosset's iconographic concerns, rendering city views, costume studies, portraits, and scenes of daily life.

Delacroix's methods and their significance are earlier set down in books like Sir Robert Ker Porter's 1821–22 *Travels in Georgia, Persia, Armenia, Ancient Babylonia, etc., etc. during the years 1817, 1818, 1819, and 1820.*[30] In a preface to this book, which Delacroix knew before his voyage, the editor lays out Porter's task: "During three years traveling in the East, he kept a regular journal of all he saw worthy [of] observation, and he wrote his remarks with the impressions of the moment." Later he arranged the subjects "without altering their language to give it literary grace." And his editor adds, "Hence, as he lays claim to nothing of what is commonly called style, in writing, he trusts in the candor of his reader to judge him by his pretensions alone, truth in what he relates, and fidelity in what he copies."[31] Like Porter, Delacroix knew how to paint the East, and his audience knew how to read it.

The presence of the color triangle in Delacroix's African sketchbook shows the artist's consultation of accepted scientific principles to achieve verisimilitude. Delacroix's own established documentary approach to Orientalist subjects and his position on the mission suggest that this verisimilitude, whether in light, costume, or subject, was his practice and his job. Below the triangle Delacroix noted an example of how he observed the effect described by Mérimée: "The heads of the two little peasants, that which was yellow had violet shadows, that which was more sanguine and more rouge, green shadows."[32] Once in North Africa, Delacroix's scientific learning affected what he saw, or, at least, how he understood what he saw.

WOMEN OF ALGIERS

Delacroix's voyage to North Africa and the expectations for his work there cannot be completely divorced from the imperial context. Louis-Philippe, having continued and extended the Restoration's imperial policy toward Algeria, sought help from neighboring Morocco. With bilateral relations deteriorating in 1831, however, Charles Edgar de Mornay was sent as a special ambassador to curry favor with the Sultan of Morocco.[33] Mornay in turn invited Delacroix to join him. It is usually said that Delacroix was invited because, as their mutual friend the actress Mlle Mars (Anne Boutet) ex-

plained, he would make a good traveling companion. But Mlle Mars went on to mention that Mornay had first invited Isabey *fils,* who "having been in Algiers and not possessed by the demon of curiosity, refused."[34] Isabey had been part of the Algerian campaign team and had published lithographs for the 1830 *Précis historique et administratif de la Campagne d'Afrique,* the Algerian campaign's version of the *Description de l'Egypte.*[35] In asking Isabey and then Delacroix, Mornay sought artists who were proven documenters of the Orient.

It was thanks to the French military in Algiers that Delacroix is reputed to have gained access to a Muslim harem during his three-day stay in Algiers. Through the intervention of a certain Poirel who administered the port of the French-occupied city, Delacroix was able to violate Muslim rule. This offense is the central conceit behind his painting of 1834. The French presence in Algiers facilitated access to the harem, an institution that in the eyes of Westerners embodied the moral corruption of the East. Delacroix's rendering of this institution was presented in the very year that the July Monarchy decided to colonize all of Algeria, to secure what it called its "African Possessions."[36]

Reports of Delacroix's visit to the harem say that it was his hope, expectation and "strongest desire to get in a Muslim interior," which was strictly forbidden to Christians.[37] Both Delacroix and Poirel's descriptions of what they saw were not particularly erotic; but Delacroix had so warmly anticipated the encounter that, according to Poirel, "Delacroix spent a day, then another in this harem, a prey to an exaltation which translated itself into a fever that was hardly calmed by sherbet and fruits."[38] Delacroix's hyperthermia must have been incubated during his previous literary and artistic experience of the East. For the armchair connoisseur of the ethnicity, toilette, costume, and sexuality of Oriental women, entering a Muslim harem of Algerian women was especially desirable. According to one of Delacroix's confidants, the women had a special reputation:

> *The women of Algiers are, according to the Orientals, the prettiest from the Barbary Coast. They know how to complement their beauty with rich silk fabrics and velvets, embroidered in gold. Their complexion is remarkably white. If their hair is blond, they dye it black, and those who already have that nuance are dyed with a henna preparation. Natural flowers, roses and jasmine ordinarily accompany their elegant hair.*[39]

For the vicarious connoisseur of harem women, the women of Algiers represented the most desirable fruit. Poirel described Delacroix's excited entry into the harem:

When, after having crossed through some dark hallway, one penetrates the part which is reserved for them; the eye is truly dazzled by the sparkling light, by the fresh faces of women and children, appearing suddenly in the midst of this mass of silk and gold. For a painter there is a moment of fascination and of strange happiness. That must have been the impression felt by Delacroix, and it is that which he transmitted to us in his painting The Women of Algiers.[40]

Delacroix's painting does make it seem as if the curtain has been pulled back to reveal the Muslim harem. Once in North Africa, however, it was Delacroix's Orientalist learning that seems to have guided his hand and his eye, as well as his body temperature.

The composition, postures, and some of the props in *The Women of Algiers* were already familiar to the amateurs of the Orient, including Delacroix. His three seated figures closely resemble the central grouping in Rosset's *Turk with His Wives* (figure 72), which he also knew. Even the slippers in *The Women of Algiers* first appear in the left of Rosset's picture. As Delacroix's pictures called up these images, they also seemed to reaffirm the accompanying moralizing texts. Like the obelisk at the Place de la Concorde, the harem came with a meaning already inscribed. The audience at the Salon may have never been inside a Muslim harem, nor even perhaps had Delacroix. But they knew what it meant. By the eighteenth century, the visit to the harem, whether in Racine, Mozart, or Guardi, was the *topos obligé* of the Eastern excursion, and it stood for Eastern despotism.[41] The representation of the harem, like the re-presentation of the obelisk, the testaments of the battles, and the display of the Egyptian collection, inspired opposing characterizations of East and West, which posited the superiority of the latter.

Among the texts that Delacroix

Fig. 72. Rosset, *Turk with His Wives,* 1720. Watercolor. Bibliothèque Nationale, Paris

knew before his departure, Antoine-Ignace Melling's 1819 *Voyage Pittoresque de Constantinople et des rives du Bosphore* includes four pictures of the sultan's harem. In one, Melling provides an architectural cutaway diagraming the interior and its workings (figure 73). The distant and objectifying viewpoint helps authenticate the picture and invites the reader to "penetrate" the harem. While Delacroix's technique is sensual and colorist, not linear and architectural, both images serve up access to the harem in naturalizing, information-conveying styles. The moralizing posture associated with objective views of the harem is made clear in Melling's text. The harem, which he so scrupulously details in pictures, signifies the lubricity of Oriental societies, their "denatured law," and the hazards of lesbian love.[42] Meanwhile, the viewer's eye is able to survey the entire subject, to have access to a place where Westerners and all men, except the sultan, are forbidden. Thus, Melling could be both titillating and contemptuous while appearing to be, superficially at least, merely informative.

Linking Melling and Delacroix's project more closely and underlying much Orientalist production of the nineteenth century, is the political position of the observer to the observed. Melling's unprecedented access to the royal harem is attributed to

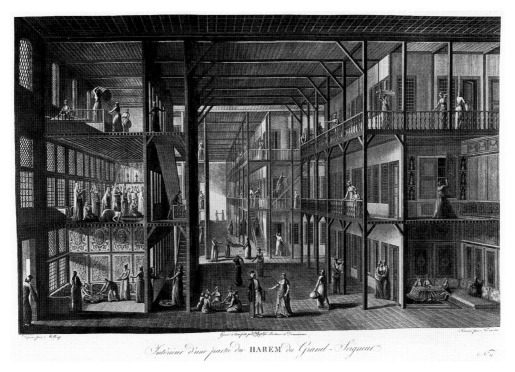

Fig. 73. Antoine-Ignace Melling, *Interior of a Part of the Harem of the Grand-Seigneur,* 1819. Engraving. Bibliothèque Nationale, Paris

his practice as a physician, which he opposes to the backwardness and innate tyranny of the rulers of the Ottoman Empire, "now crumbling under the weight of its vices."[43] In both harem scenes, the implied science and objectivity of the Western author stand in contrast to the depravity of the social structures represented. We will see in the afterword how Delacroix's painting is essential to the history of Western images of Oriental women as it establishes a paradigm of function and purpose that is viable well into the twentieth century—presenting a contrived reality to satisfy preconceived expectations. *The Women of Algiers* passes for objective or scientific fact, and, at the same time, it provokes a long-standing, moralizing cant about the depravity of the East. The Orient of *The Women of Algiers* is an Orient that was a creation of Delacroix's culture, the culture that informed his experience in North Africa, his artistic production on his return, and then the reception of the picture at the Salon of 1834. Accounts of the harem varied in tone and quality, as did the texts surrounding the obelisk at the Place de la Concorde, but they consistently offered contrasts of French progress and moral rectitude as opposed to Eastern backwardness and moral laxity, contrasts that reinforced the cultural stereotyping in Pujol and Picot's Egypt, which in turn complemented the irrational, animal ferocity ascribed to France's Muslim opponents on the battlefield.

Part of the success of *The Women of Algiers* and its progeny is that it evoked both desire for the harem women and repulsion at the Orient's inferior social and political systems. At the Salon of 1834, critics of all types maintained that Delacroix's penetration of the harem was unprecedented and, yet, they knew what they saw. For Delécluze, a classicist, Delacroix's figures were repellent; for the Romantic Tardieu they were the "finest delicacies." The "truth" that Decamps and his cohorts recognized in the painting of 1834 served as an index of the social corruption and the political decline of the Orient. The critic Gabriel Laviron wrote, "In seeing this picture, one really understands the boring life of these women who do not have a serious idea, nor a useful occupation to distract themselves from the eternal monotony of this prison in which they are enclosed."[44] That Delacroix's eyewitness and moralizing posture concerned a fact that seemed so undebatable contributed to the apolitical appearance of *The Women of Algiers.* One critic went so far as to say that it did not even have a subject. What that meant was played out in an exchange between two critics. After having discussed the subject, Planche maintained that Delacroix's subject could be dismissed, for Delacroix, he wrote, offered a subject that could not be interpreted in a thousand ways. Subsequent biographers have used this statement to say that *The Women of Algiers* contributes to the development of "pure painting, art for art's sake."[45] Critic

and Orientalist painter Alexandre Decamps objected. Delacroix's most expansive and sympathetic critic that year, Decamps took a literal stance to very interesting ends. He said he disagreed with people who have said that *The Women of Algiers* has no subject. No, he said, the subject has a moral character that is not inferior to the execution. The poses "of these Africans [have] a sentiment of indolence," Decamps said, and "in their heads an expression of idleness and insouciance."[46] He remarked on the heads that express "all the insipidity and inaction of these ignorant minds of the Levant," and the nonchalant poses that characterize "these sedentary women, fattened for pleasure."[47] All Decamps has done here is to echo Planche's characterization of the moralizing subject and then underline the fact that this is indeed a subject.

Even if *The Women of Algiers* had been a conscious attempt by Delacroix to paint a sympathetic picture of his Algerian subject by, for instance, insisting on the women's cleanliness, it would not have mattered to his public. Gustave Planche, who like all the other commentators, repeated clichés about the harem, saw the figures full of "sluggishness and nonchalance." While proclaiming that Delacroix's rendition was truthful, he also thanked the artist for omitting the women's dirty fingernails.[48] The critics' previously informed knowledge about the Orient stepped in to insure the moralizing "truth" about the picture, even when the artist had not offered it. There is here a will to authenticate on the part of Delacroix's public that was a fundamental aspect of the reception of Orientalist pictures since 1798. The relation of Delacroix's artistic production to his knowledge of Orientalism illustrates the textual constrictions on perception, presentation, and reception of ideas about the East.

LES FRUITS DE LA VICTOIRE

The Women of Algiers was produced and received in an artistic, intellectual, political, and military culture that was a legacy of the Egyptian campaign, a culture that then supported the Algerian conquests of the 1830s, and which could be refitted again to serve later incursions into Morocco and beyond. In his writings, Delacroix identified North Africans with the beautiful and august figures of antiquity. Like Benjamin West in Rome before the Apollo Belvedere ("Oh, how like a Mohawk warrior!"), Delacroix in North Africa proclaimed himself in touch with a living antiquity.

> *The physiognomy of this country will always remain in my eyes; the characteristics of that strong race will stir in my memory as long as I live; it is in them that I truly rediscovered antique beauty.*[49]

Delacroix shifted the ground under French painting, displacing and reassessing antiquity. His most expansive statement was well placed, sent to his friend, the critic Auguste Jal.

> *Your newspapers, your cholera, your politics, all these things unfortunately detract from the pleasure of going home. If you knew how peacefully men live here under the scimitar of tyrants; above all, how little they are concerned about all the vanities that fret our minds! Fame, here, is a meaningless word; everything inclines one to delightful indolence; nothing suggests that this is not the most desirable state in the world. Beauty lies everywhere about one. . . . I have Romans and Greeks on my doorstep: it makes me laugh heartily at David's Greeks, apart, of course, from his sublime skill as a painter. I know now what they were really like; their marbles tell the exact truth, but one has to know how to interpret them, and to our wretched modern artists they are mere hieroglyphs. If painting schools persist in setting Priam's family and the Atrides as subjects to the nurslings of the Muses, I am convinced, and you will agree with me, that they would gain far more from being sent off as cabin boys on the first boat bound for the Barbary Coast than from spending any more time wearing out the classical soil of Rome. Rome is no longer to be found in Rome.*[50]

The Catos and Brutuses that Delacroix said were at his doorstep were awarded none of the moral or philosophical connotations that made Greece and Rome the basis of the Davidian Revolutionary order or the lodestar of the Revolutionary Louvre. To his friend Villot, Delacroix wrote, "This place is made for painters. Economists and Saint-Simonians might find much to criticize as regards human rights and equality before the law, but beauty abounds here; not the over-praised beauty of fashionable paintings. The heroes of David and Co. with their rose-pink limbs would cut a sorry figure beside these children of the sun, who moreover wear the dress of classical antiquity with a nobler air, I dare assert."[51] Delacroix has rejected Davidian or French classicism and associated it with futile work and ambition, revolution, and disease. In turn, he heralds Oriental indolence, tyranny, and beauty shorn of its Enlightenment associations with truth and virtue. Rome is no longer in Rome.

Fearful of political and social change at home, Delacroix reiterates the familiar association of the East with tyranny and the West with technology and responsive government, and then he trumpets the pleasures of life under the sword of the tyrant. He sets out a vision for the regeneration of art based on a passage through "Barbary." And he luxuriates in his temporary respite from France, "a more advanced civilization" but at its end. The following appeared in his journal:

*We notice a thousand things in which they are lacking, but their ignorance is the
foundation of their peace and happiness. Can it be we have reached the end of what
a more advanced civilization can produce?*

*They are closer to nature in a thousand ways: their clothes and the shape of their
shoes. Also there is beauty in everything they do. But we, with our corsets, narrow
shoes, our ridiculous wrapping, are pitiful. Grace takes revenge on our science.*[52]

Delacroix's tenuous elevation of contemporary North Africa is inextricably bound to
his disgust with his own society, which, like ancient Rome, is exhausted. The con-
tempt that he felt for French society could easily be projected on to the Orient, and
when it came to official commissions, he did just that.

Just after his return from North Africa, Delacroix received a commission to paint
the Throne Room at the Palais Bourbon.[53] After its completion, he solicited all the
work on the entrance hall, conference room, and library. These proposals demonstrate
his understanding of the French civilizing mission and offer a comprehensive, histori-
cist view of France's rightful role. Delacroix proposed that the Grande Salle d'Entrée
be "consecrated to express the power of France, especially in the civilizing aspect":
the defeat of the Moors by Charles Martel at Poitiers, "at the moment where they
were in the heart of France and at the point of overthrowing our nationality." This
was no ordinary victory: "It saved our Christian and Western civilization, and with-
out doubt that of all of Europe."[54]

For the vaults he envisioned caryatid-like figures representing "the peoples sub-
mitted to our arms or civilized by our laws"; they would separate six principal subjects:

1. Charlemagne receives the homage of the emperors of the Orient, Science and
 the Arts introduced in France under his auspices.

2. The Conquest of Italy by Charles VIII, the Renaissance of Letters.

3. Clovis defeats the *Alamans* at Tolbiac, the first step in French national unity.

4. Louis XIV receiving the submission of the Doge of Genoa, the apogee of
 French influence in Europe.

5. Egypt submitted, France goes to the origins of civilization, the antique cradle
 of human knowledge, and it leaves seeds of emancipation in this land that
 had fallen into barbarism.

6. Finally, the Conquest of Algiers, our French laws established in the place of
 brutal despotism.[55]

For Delacroix, then, who claimed enjoyment under the sword of the tyrant and who

invited the viewer to enjoy access to the harem, the conquest of Algiers was expressed as the culmination of and contribution to France's civilizing mission, which promoted Christian and Western civilization against the Islamic Orient and which was a consequence and fulfillment of Bonaparte's Egyptian campaign.[56]

The success of Delacroix's *Women of Algiers* lay in part in its eschewal of the allegorical language demanded by official decorative commissions like those at the Palais Bourbon. At the same time, Delacroix's 1834 painting crystallized a series of pictorial and thematic conventions that were transferrable to and from a variety of media and endeavors and that promoted French imperialism in the *proche Orient*. Delacroix created his *Women of Algiers* in the same years as the invention of ethnography and with the same assumptions about scientific observation and the relative merits of Algerian and French life. The actual term, *ethnographie* was coined in 1831, the very year of his departure. This new science was consecrated in the 1831 founding of the Musée Ethnographique in Paris. Its curator defined its mission: to know "in an exact and positive (scientific) manner the degree of civilization of the peoples barely advanced on the social ladder," with the expectation that science and commerce should benefit from Africa's opening by the conquest of Algiers, now a "place of power of the French army."[57] At the time, *ethnographie* was defined as the study of the distinction of human races by understanding idioms, physiognomies, and social status. It was seen as a step toward the gradual diffusion of European civilization.

In popular art, Delacroix was preceded in the harems of Algiers. The conceit of his painting, his violation of the Muslim harem, was used before by cartoonists who equated the 1830 conquest of Algiers with the penetration of the Sultan's harem and the possession or rape of its women (figure 74). One print depicts French soldiers raping Algerian women—*Les Fruits de la Victoire,* the title says (figure 75). In image after image, triumphant French soldiers enter the great harem and cart off and rape the favorite of the ruler. Even the nincompoop Jean-Jean, a French version of Sad Sack, is rewarded with a woman simply because he is a French soldier (figure 76).[58] As in Delacroix's painting, penetration of the Algerian harem becomes a sign and result of French imperial power, a strategy that is expandable like the imperial trajectory itself, from Egypt, to Algeria, to Morocco and beyond.

A decade after *The Women of Algiers,* the lithograph *An Oriental Delight* appeared as a takeoff on Delacroix's painting (figure 77). The subject, viewpoint, composition, hookah, and curtain recall Delacroix's painting, but here the harem woman is grossly caricaturized. The soldier sits down to the pipe with "the charming Aïcha" and says suggestively: "I am available for your use. . . . I had at first the intention to French you but, I find it really sweeter for you to Bedouinise me!" Tastefully kept out of the

Fig. 74. A. Meniet, *Rape of the Sultan's Favorite,* 1830. Lithograph.
Musées de la Ville de Paris

Fig. 75. Adolphe Richard, *The Fruits of Victory,* 1830. Lithograph by C. Souchay.
Bibliothèque Nationale, Paris

Fig. 76. Charles, *Jean-Jean at the Seraglio of Algiers,* 1830. Lithograph by Fonrouge. Musée Carnavalet, Paris

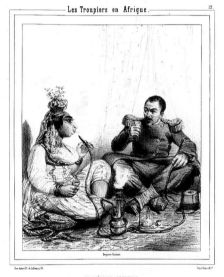

Les Troupiers en Afrique. 12.

UN BONHEUR ORIENTAL.

Saprebleu, charmante Aicha... je me fais à vos usages ... j'avais d'abord l'intention de vous franciser mais je trouve bien plus doux de me bédouiniser !

Fig. 77. Benjamin Roubaud, *An Oriental Delight,* 1844–45. Lithograph. Musée Carnavalet, Paris

frame of Delacroix's painting, the French military presence materializes just in time to celebrate the extension of French conquests from Algeria to Morocco.[59] Rape, access to the women of Algiers, and the penetration of the harem are the fruits of the conquest of Algeria, the prerogative of the military, and trophies of victory. French military power and ambition were always implied in and by Delacroix's picture. They made possible his trip to North Africa and gained him access to the forbidden harem; and the picture, in turn, promoted the rationale for the extension of France's imperial role in the Near East.

Part of the power of imperial culture and part of its elusiveness to the discipline of art history is that its visual and thematic conventions do not respect the boundaries of specific media. Look at the similarities between *Rape of the Sultan's Favorite* (figure 74) and another ostensibly comic work, Dantan's 1836 sculpture of Lebas (figure 78). In Dantan's caricature, the engineer of the obelisk's transportation merrily carries the obelisk away from Egypt.[60] The statuette's humor, of course, comes from the discrepancy in scale. Impressive distances, weights, and measures, which were recalled in the obelisk publications and on its pedestal, are overcome despite Lebas's unimpressiveness as a mechanical device. In his own memoirs, Lebas tells how he visited the Pasha of Egypt, who sophomorically teased him, wondering how this short man was going to move his big obelisk.[61] The joke was on the Pasha, of course, for it was French in-

tellect that was going to make the needle dance.

In possession of their foreign booty, Lebas struts and Meniet's soldiers struggle. French scientific and military power take control of the Eastern artifact, the obelisk symbolic of ancient grandeur, the harem of contemporary decrepitude. In this imperial culture, France takes possession of objects, of images that, in contrast to its military or scientific might, evoke the historical, technological, moral, in short, civilizational failings of contemporary Egypt and Algeria.

A deadly sense of ambivalence fuels the humor in these pieces. Jean-Jean and his fellow soldiers do not look all that heroic compared to their victims, and Lebas seems ridiculously proud of his accomplishment. This ambivalence rises to the surface now and again. It may be expressed in the desire to erase France's revolutionary history, as at the Place de la Concorde or the Musée d'Egypte, or it may be expressed in the projection of

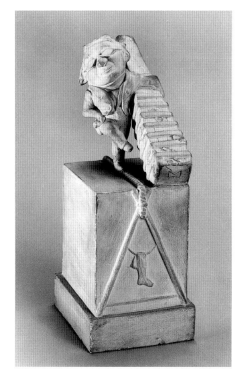

Fig. 78. Jean-Pierre Dantan, *Jean-Baptiste-Apollinaire Lebas,* 1835. Plaster with terra-cotta patina, h. 13 in. (33 cm). Musée Carnavalet, Paris

French atrocities onto its victims, as in the paintings of the Egyptian campaign. This ambivalence helps give imperial culture its endurance and its aggressive edge.

Afterword

In these closing pages, I would like to make some comments about the ongoing importance of the imperial culture that I have described in this book. I have examined an imperial culture in a foundational period, 1798–1836, when it became official, standard orthodoxy, and, not coincidentally, when France founded its modern empire. However contested, the culture was not quickly dismantled. While postcolonial studies may now be accepted in the Anglo-American academy, this is a long way from saying that imperial art and ideology have gone away.

Over the last ten years, some scholars have investigated anti-imperialists, particularly of the high imperial period, in a sympathetic effort to identify a tradition of resistance. (Such studies notably avoid the early nineteenth century.) What impresses me about the period following the 1830s and 1840s is not, unfortunately, the withering away but the persistence of the artistic, art critical, and political strategies that were developed in the early nineteenth century. Like the artists we will visit at the end, we must keep the tradition firmly in sight as a vehicle for critiques of both the past and the present.

Later in the nineteenth century, imperial expansion, tourism, and the reproductive picture-making industry flooded Europe with photographs, postcards, and prints of Oriental scenes, many of which followed the kinds of strategies that we have investigated. The image of the Oriental woman was perhaps the most widely diffused of all the picture types, and so I will conclude with a few remarks on the theme. Postcards like *6596 SCENES ET TYPES — The Cracked Jug* (figure 79) presented the Oriental woman bare-breasted, frankly and amiably addressing the viewer. The postcard employs a convention made most famous in Jean-Baptiste Greuze's 1780 painting, *The*

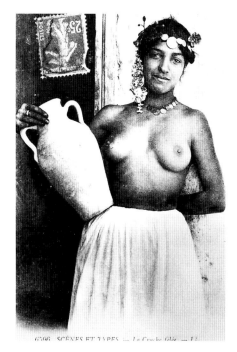

Fig. 79. Unknown photographer,
The Cracked Jug, ca. 1900. Postcard.
Collection of Malek Alloula

Broken Pitcher (Musée du Louvre, Paris), in which the artist indicates that the jug is cracked, ruined. Greuze's bedraggled girl, tattered, post-coital and clutching a broken pitcher, is meant to titillate the viewer and blithely teach a lesson on sexual virtue. In the post-card, on the other hand, the vessel is pristine; what is broken is the sexually (and continually) available Oriental woman.

While relying on the high art tradition of moralists like Greuze and Orientalists like Delacroix, *The Cracked Jug* functions on other levels as well. The photographer is anonymous. His picture is numbered and titled—*6596 SCENES ET TYPES*—suggesting that this figure is one specimen among many. The creation and marketing of the postcard operate in a more frankly commercial vein than the Salon painting. Once purchased in the East, the card becomes a personal message carrier, and the messages are typically banal, having nothing to do with the content of the image, except in the most important geopolitical way—the sender is in the East as a result of Western power, and the image conveys the corruption of Eastern people, which justifies the imperial presence.[1] While one side of the card may comment on the weather, the other visually reminds the correspondents of the rationale and purpose of their political role in the world.

As if this contrast were not strong enough, the postcard's stamp makes it clear that the image of a particular North African woman was understood as a representative, ethnic, or national type. The "République Française," conversely, is represented by the striding, idealized, Greco-Roman-inspired figure of Marianne, wearing the Phrygian bonnet, symbol of the freed slave and the French Revolution—the antithesis of the fleshy, erotic, earthy, available, and completely real (we are told) Oriental woman. This conjunction of Marianne and the Oriental nude brings together the symbol of the ostensibly liberty-loving French with the symbolism of the despotism inherent in Oriental self-rule. Imperial rule is justified, and the correspondents can go about their business.

The tradition of true, or modern, Orientalism is usually said to end a century after Delacroix's *Women of Algiers*. A figure like Henri Matisse is seen as making frankly undocumentary pictures, interested in Oriental subjects only as a pretext for abstract investigations into painting. While it may be fair to think that Matisse was trying only to replicate familiar motifs in a personal and innovative style, his works, like those of Delacroix, functioned in ways beyond the aesthetic. He might have hoped that his pictures were strictly escapist, aesthetic fantasies, that they operated out of the realm of quotidian political concerns, but his paintings of Oriental women are patent proof of the impossibility of such a project.[2]

Matisse was devoted to the Orient early in his career, traveling to Algeria in 1906, visiting Munich in 1910 to see a major Islamic art exhibition, and Morocco in the winters of 1911–12 and 1912–13. His works from Morocco combine a typical litany of Orientalist subjects with his most important abstract innovations in painting. These aspects are found to a lesser extent in works made well after his Oriental excursion, such as in his *Odalisque in Red Trousers* of 1921–22 (figure 80). In the decor around the central figure, we see the fruits of Matisse's Fauvism of the first decade of the century: unmodeled expanses of vibrant color and flat patterning. Yet, the subject and the classical draftsmanship used in rendering the volumetric torso of the reclining nude recall the grand tradition in painting, from Titian to Delacroix, to Ingres and Renoir. Matisse's stylistic synthesis makes the subject of the Oriental woman modern, acceptable, and august.

The strategy paid off, as Delacroix's had in the previous century. *Odalisque in Red Trousers* was the first Matisse purchased by the French government for a Parisian Museum. Léonce Bénédite, curator of the Luxembourg Museum and president of the Society of Orientalist Painters, made the acquisition. In a tamed modernist language, Matisse had updated the discourse about Oriental women in time to help celebrate France's extension of its empire during World War I. The purchase of the painting preceded by just three weeks the opening of the massive Exposition Coloniale (April–November 1922), intended to glorify, justify, and expand the French empire.[3]

Odalisque in Red Trousers also succeeded by contributing to a general backlash against modernist abstraction, including Fauvism, which Matisse himself had helped invent. This "return to order" meant the official marginalization of work that was too individualistic, too open to interpretation and enigma. *Odalisque in Red Trousers* worked because it conformed to both the classical (read "idealized and generalized") tradition

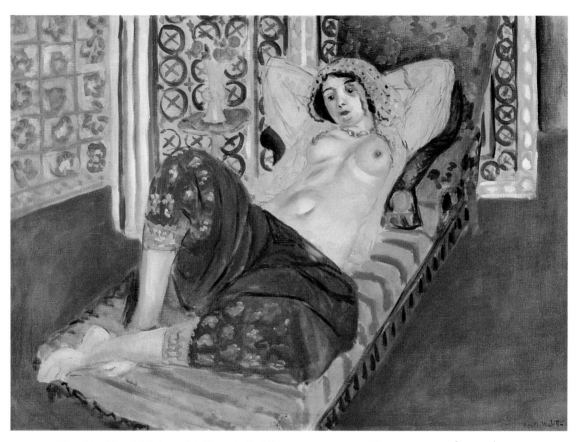

Fig. 80. Henri Matisse, *Odalisque in Red Trousers,* 1921–22. Oil on canvas, $25\frac{5}{8}$ x $35\frac{1}{2}$ in. (65 x 90 cm). Musée National d'Art Moderne, Centre Georges Pompidou, Paris

of draftsmanship and repeated the now clichéd subject of the Oriental woman. Achieving the zenith of its modern empire after the war, France sought to reshape its national identity, investing yet more of its prestige into the image of a great imperial power.[4] Far from moribund, Orientalism provided a clear and stable tradition that could unite the French, as it had in Delacroix's day, suppressing political differences at home while reasserting the moral and sexual chasm that separated them from their colonized peoples.

Western representations of Oriental women were only severely tested with the onset of decolonization following World War II. In December 1954, only six weeks after both the beginning of the Algerian Revolution and the death of Matisse, Picasso began a series of drawings, fifteen paintings, and a suite of lithographs on the theme of Delacroix's *Women of Algiers*. Picasso was well aware that the picture of the Oriental woman had become a canonical theme of the grand tradition in Western painting, and that Matisse's death had left him as the lone heir to that tradition. "When Matisse died," he said, "he left his odalisques to me as a legacy."[5] Yet, when Picasso's series was exhibited in 1955, the critic Charles Estienne of *France Observateur* wrote that with Picasso's contributions "one thinks above all, unfortunately, of a vulgar mockery (*chahutage*) of Matisse's odalisques."[6] Something was amiss.

Up until now I have been exclusively concerned with French representations of the East. It must be noted, however, that in Algeria itself the status and representation of Algerian women had been contested with the assertion of Arab feminism in the nineteenth century and that the controversy increased following the outbreak of the Algerian Revolution. Much of the debate centered on the veil. Once a traditional and occasional part of Islam, the veil became a screen for the political projections and goals of all parties. At different times in the Algerian Revolution, wearing or not wearing the veil helped women carry out military missions. Without the veil one might pass in the streets as a Western woman and gain access to important public locales. In other instances, the veil could serve as cover.[7]

A last-ditch effort by the French to control the representation of the Arab woman occurred on 13 May 1958, in a particularly chilling bit of political theater. Immediately following a military coup that ousted French civilian authorities in Algeria, the newly governing French military attempted to consolidate the support of its colonials. It assembled Algerian women on the steps in front of the Governor's Palace and stripped them of their veils. Cries of "Vive l'Algérie française!" rang out. Ostensibly,

the purpose was to demonstrate France's liberation of Algerian women.[8] Once again, the liberationist ideology was used to recall the old saw about Eastern despotism, symbolized in the veil. Algeria's women, however, were really a prop for the new military regime's reassertion of its power over Algerian life. The military's ceremonial unveiling of Algerian women carried out the dictum of the colonial administration, as described by Frantz Fanon: "If we want to destroy the structure of Algerian society, its capacity for resistance, we must first of all conquer the women; we must go and find them behind the veil."[9] In the last years of France's colonial regime, this event repeated and actualized the unveiling of the Oriental woman begun by the presentation of Delacroix's painting in 1834.

In the same years, Picasso's series on the *Women of Algiers* began to undermine the tradition from within. Although we do not have statements by Picasso on the outbreak of the Algerian Revolution, we do know that his sympathies lay on the left, with the opponents of an "Algérie française." His extensive series is encyclopedic in its references to Delacroix's and Matisse's works, but it is decidedly conflicted and ambivalent. Picasso does indeed follow the tradition in his presentation of nude and eroticized Oriental women in an interior; the debt to Delacroix is the starting point. However, the final picture of the series, *The Women of Algiers, "O"* (figure 81), for instance, is overtly aggressive and uninviting. Access to the harem is barred by the formidable figure on the left and the collapsed space, which is particularly blocked, on the right. Unlike Matisse's *Odalisque in Red Trousers,* the patterning here is not luxuriant and dreamy but collapsing and jarring, the colors harsh, not warm and sensual. In contrast to the convincingly illusionistic and enticing torso of Matisse's odalisque, the volumes of Picasso's figures are constricted by harsh, cubistic forms, like the volumetric passages in the nightmarish visions of Max Beckmann. Only one of Picasso's figures, the one at far left, sits still for the picture, and she is nearly regal and dignified in her posture, gaze, and enormous scale. In particular, the figure at lower right refers directly to Matisse's odalisques, especially in her recumbent posture and raised arms. Her legs, however, are neither relaxed nor inviting. Her body, and indeed the whole interior, is shot through with a violence that is reminiscent of *Guernica.* Whatever Picasso's own psychosexual proclivities and political affiliations, his women of Algiers are either self-possessed or completely given over to other forces. They are unlike Matisse's odalisques and unlike the tradition of the Orientalist's harem women. They are decidedly not complicit.

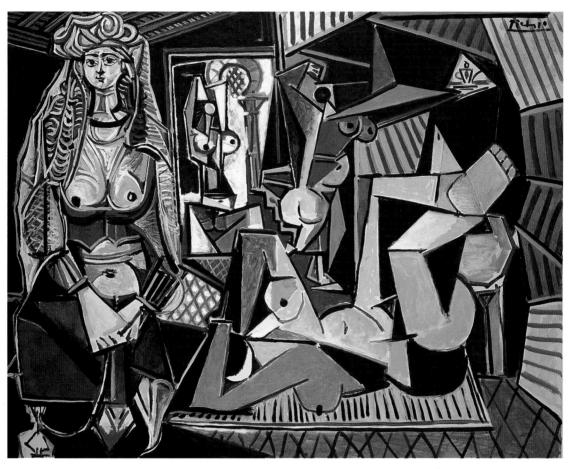

Fig. 81. Pablo Picasso, *The Women of Algiers, "O,"* 1955. Oil on canvas, 44⁷⁄₈ x 57¹⁄₂ in. (113.9 x 146 cm). Private collection

Since decolonization, *The Women of Algiers* has maintained for Algerian women artists and writers the allure of an imperial icon that invites exploration, criticism, and co-optation. The Algerian novelist and filmmaker Assia Djebar has addressed the cultural and political legacy of Western depictions of Oriental women. In her 1980 novel named for Delacroix's picture, *Les Femmes d'Alger dans leur appartement,* Djebar sees Delacroix in the role of "the thief, the spy, the voyeur."[10] She perceives the picture as a violation, the women as objects of a keyhole view, of the gaze of the artist, and she implies that the picture both actively oppresses Oriental women and accurately depicts their oppression. This allows her to discuss the painting's current relevance, for she uses it to warn that Algerian women are "once again with ankles shackled," now under the thumb of a new oppressor.[11] Djebar offers her view of the status of Arab women in the postcolonial era: "For a few decades—as each nationalism triumphs here and there—we have been able to realize that within this Orient that has been delivered unto itself, the image of woman is still perceived no differently, be it by the father, by the husband, and, more troublesome still, by the brother and the son."[12] In Picasso's *Women of Algiers,* she finds an image of freedom that has yet to be attained. "Picasso reverses the malediction, causes misfortune to burst loose, inscribes in audacious lines a totally new happiness," she writes, "a foreknowledge that should guide us in our everyday life."[13] Whether in reference to Delacroix or Picasso, Djebar's work turns the Western Orientalist tradition on itself and on any other claimants to that patriarchal throne.

The paintings of Houria Niati join Djebar in rethinking the Orientalist tradition. An Algerian artist who grew up during the Algerian Revolution, Niati was imprisoned for her actions in the Revolution. Her 1982–83 work *No to Torture* (figure 82) brings Delacroix's *Women of Algiers* directly to mind. Niati's "new" women of Algiers are now seen against a darkened background. She will not replicate the luxury and splendor of Delacroix's interior or of Delacroix's handling of paint. The figures float in darkness, their feet in shackles, their heads in cages. The series is strong and direct. The pictures both unmask the power dynamics associated with Delacroix's picture, while in no way confining their relevance to the oppression of the colonial past.

Finally, the persistence of the Orientalist tradition is confronted by the characters of Leïla Sebbar's 1982 novel *Sherazade.* This coming of age story, set in contemporary Paris, brings together two lovers, the Algerian-born Sherazade and Julien, formerly a French colonial. The two get together despite, or perhaps because of, their differences. Julien is passionate about nineteenth-century Orientalist painting, and on their first outing the couple visits the Louvre, where they spend time in front of

Fig. 82. Houria Niati, *No to Torture,* 1982–83. Oil on canvas, 71½ x 108½ in.
(28.1 x 42.6 cm). Collection of the artist

Delacroix's *Women of Algiers*. Later, Julien explains the conventions of Western images of Oriental women: "They're always reclining languidly," he says, "gazing vacantly, almost asleep. . . . They suggest for Western artists the indolence, the depraved allure of Oriental women."[14] By the end of the novel, Sherazade has learned enough.

Although still in love with Julien, she leaves him, and her thoughts turn instantly to her working-class and immigrant friends who would hate paintings in museums, "rotten bourgeois culture, the decadent West, old, played out, dead." While reading in the library of the Beaubourg,[15] she happens by Matisse's *Odalisque with Red Trousers* (figure 80). At that moment she decides to return to Algeria, but before she departs, she buys a postcard of the painting and writes a farewell: "It's on account of her that I'm going."[16] This is Sherazade's—and Sebbar's—decisive response to the long legacy of an imperial culture.

Notes

ABBREVIATIONS

ADI Archives Départementales de l'Isère
AL Archives du Louvre
AMBAN Archives, Musée des Beaux-Arts, Nantes
AN Archives Nationales
BMG Bibliothèque Municipale de Grenoble
BN Bibliothèque Nationale, Paris
HAK Historisches Archiv. der Stadt Köln

INTRODUCTION

1. Jean Meyer et al., *Histoire de la France coloniale* (Paris: Armand Colin, 1990–91), 1:197, 296, 311–12, 314, 324, 329, 340, 347.

2. Max Weber, "The Nation," in *Nationalism,* ed. John Hutchinson and Anthony D. Smith (Oxford: Oxford University Press, 1994), 21–25. Originally published in Max Weber, "The Nation," in *Essays in Sociology,* trans. H. H. Gerthe and C. Wright-Mills (London: Routledge and Kegan Paul, 1948) 171–77, 179.

3. Meyer et al., *Histoire de la France coloniale,* 1:333. See also John Laffey, "Les Racines de l'impérialisme français en Extrême-Orient," *Revue d'Histoire Moderne et Contemporaine,* 16 (April–June 1969): 282–300 and "Roots of French Imperialism in the Nineteenth Century: The Case of Lyon," *French Historical Studies,* 6 (Spring 1969): 78–93; and Sanford Elwitt, *The Making of the Third Republic: Class and Politics in France, 1868–1884* (Baton Rouge: Louisiana State University Press, 1975), 274. According to Elwitt, Laffey "demolished the argument for prestige and glory as motivations for French imperial expansion." As a result, historical inquiry has turned away from the early nineteenth century, although it was the Directory that sent

Bonaparte to invade Egypt, the Consulate and Empire that celebrated the exploits, the Restoration that intervened in Ottoman Greece and blockaded and invaded Algiers, and the July Monarchy that extended the conquest.

 See also Maurice Agulhon, "Politics, Images, and Symbols in Post-Revolutionary France," in *Rites of Power: Symbolism, Ritual and Politics since the Middle Ages,* ed. Sean Wilentz (Philadelphia: University of Pennsylvania Press, 1985), 177. According to Agulhon, one of the basic functions of the major signs and emblems of a political power is to "translate clearly the principles upheld by that power (for instance, the hammer and sickle: the union of workers and farmers)." I am arguing the opposite: that the works of art celebrating France's nascent imperial power mask the particular economic interests of, for example, Marseille merchants and Lyon manufacturers. In that sense, a sympathetic and parallel study to mine is Loren Kruger, "Attending (to) the National Spectacle: Instituting National (Popular) Theater in England and France," in *Macropolitics of Nineteenth-Century Literature: Nationalism, Exoticism, Imperialism,* ed. Jonathan Arac and Harriet Ritvo (Philadelphia: University of Pennsylvania Press, 1991), 243–67. This study focuses on the end of the nineteenth century and illustrates how imperialists used the theater to unify a country through an imperial identity and to mask internal fissures at home.

4. Alexis de Tocqueville, "Intervention dans le premier bureau de la Chambre des députés sur la question de l'adresse le 10 novembre 1840," *Oeuvres complètes,* ed. Jacob Peter Mayer, vol. 3, part 2, *Ecrits et discours politiques* (Paris: Gallimard, 1985), 284; quoted in Henry Laurens, *Le Royaume impossible: La France et la genèse du monde arabe* (Paris: Armand Colin, 1990), 104–5. On Tocqueville on Algeria, see André Jardin, *Tocqueville: A Biography,* trans. Lydia Davis and Robert Hemenway (New York: Farrar, Straus, and Giroux, 1988), 308–42. And for an examination of Tocqueville's particular kind of liberalism in the field of foreign affairs, see Tzvetan Todorov's introductory essay, "Tocqueville et la doctrine coloniale," in Alexis de Tocqueville, *De la colonie en Algérie,* ed. Tzvetan Todorov (Brussels: Editions Complexe, 1988), 9–33.

5. "Il ne rappelera aucun événement politique." Letter from Louis-Philippe to Rambuteau, quoted in Georges Lequin, ed., *Mémoires du Comte de Rambuteau* (Paris: Calmann-Lévy, 1905), 388.

6. Alfred Cobban, *A History of Modern France,* vol. 2, *From the First Empire to the Second Empire, 1799–1871* (London: Penguin Books, 1965), 131.

7. See Marcel Merle, *L'Anticolonialisme européen de Las Casas à Karl Marx* (Paris: Armand Colin, 1969). Editing an anthology of anticolonial texts, Merle concludes that among his dozens of representative thinkers, critics, and reformers of French empire, none made governmental policy and none called for the empire to be dismantled. Opposition to the empire was mitigated and ineffective.

 Antiracists of the period like the Abbé Grégoire have been enlisted as foundational figures by post–World War II groups like the Movement Against Racism and Friendship between Peoples. See Cathie Lloyd, "Antiracist Ideas in France: Myths of Origin," *The European Legacy* 1, no. 1 (March 1996): 126–31.

8. See, for example, Michel Laclotte, ed., *Petit Larousse de la peinture* (Paris: Larousse, 1979), 1329–30; Musée Cantini, *L'Orient en question, 1825–1875: De Missolonghi à Suez ou l'Oriental-isme de Delacroix à Flaubert,* exh. cat. (Marseille: Musée Cantini, 1975); Musée Borély, *L'Orient des Provençaux dans l'histoire: Orient réel et mythique,* exh. cat. (Marseille: Musée Borély, 1982–83); Mary Anne Stevens, "Western Art and Its Encounter with the Islamic World, 1798–1914," in National Gallery of Art, *The Orientalists: Delacroix to Matisse. The Allure of North Africa and the Near East,* exh. cat. (Washington, D. C.: National Gallery of Art, 1984), 15–23; Lynne Thornton, "La Renaissance des Orientales," *Connaissance des Arts* 329 (July 1979): 77–84; and Michelle Verrier, *Les Peintres orientalistes* (Paris: Flammarion, 1979).

 In the modernist canon of a hermetic, stylistic evolution from Neoclassicism to Abstraction, the "documentary" approach of the artist is deemed decisive because, and only insofar as, the accurate evocation of Eastern light and colors advanced the aesthetic trajectory of Western painting and contributed to the formation of Impressionism or Abstraction.

9. See Edward W. Said, *Orientalism* (New York: Random House, 1978); Linda Nochlin, "The Imaginary Orient," *Art in America* (May 1983): 119–31, 187–91. Nochlin argues that the traditional approach to Orientalist painting has obfuscated the forces of political domination and ideology in which the pictures operated. She suggested that an Orientalist picture would be better viewed as "a visual document of nineteenth-century colonialist ideology, an iconic distillation of the Oriental couched in the language of would-be transparent naturalism." In addition to Said, she cites as precedent Kenneth Paul Bendiner, "The Portrayal of the Middle East in British Painting, 1835–1860" (Ph.D. diss., Columbia University, 1979). He focuses on the artistic, social, and intellectual factors of British portrayals of the Middle East.

 Among the art historical responses, Stevens emphatically restates the traditional view of Orientalism (National Gallery of Art, *The Orientalists,* pp. 12–26). She argues that the Orientalist was involved in a dialogue with the Orient, not a discourse. Although she does not say what the Oriental said in this dialogue, she does claim that the experience of going to the Orient had a profound effect on the Orientalist, leading artists to an ever increasing realism and generating inventions central to the evolution of modern painting. Her text, however, does not sustain the claim. She uses different Orientalists to illustrate the major stylistic trends in modern painting, a task that could illustrate the point that she is trying to oppose: experiences of Orientalists in the Orient were dominated by the civilization they took with them, rather than by life they encountered in the East. This traditional view remains current in works like Rachid Boudjedra, *Peindre l'Orient* (Cadeilhan: Zulma, 1996); John M. MacKenzie, *Orientalism: History, Theory and the Arts* (Manchester: Manchester University Press, 1995), which offers a rich and severe critique of Said and Nochlin; Thomas R. Metcalf, *An Imperial Vision: Indian Architecture and Britain's Raj* (Berkeley: University of California Press, 1989); *L'Orient: Concept et images,* Fifteenth Colloquium of the Institut de Recherches sur les Civilisations de l'Occident Moderne, Civilisations, no. 15 (Paris, 1987); John Sweetman, *The Oriental Obsession: Islamic Inspiration in British and American Art and Architecture, 1500–1920* (Cambridge: Cambridge University Press, 1988).

A quote from Said begins the wide-ranging catalogue for the 1990 Berlin exhibition *Europa und der Orient, 800–1900.* The catalogue is meant to follow Said and avoid using art about the Orient to condemn the Oriental. Its fifteen essays and dozens of entries follow two paths: Europe's rediscovery of the ancient Orient and the many cultural contacts between Europe and the Islamic Orient between 800 and 1900. See Martin-Gropius-Bau, *Europa und der Orient, 800–1900,* exh. cat. (Gütersloh and Munich: Bertelsmann, 1989), 15.

Works that are more sympathetic to the approaches of Nochlin and Said and to mine in historical and art historical methods include Julia Ballerini, "Photography Conscripted: Horace Vernet, Gérard de Nerval, and Maxime Du Camp in Egypt" (Ph.D. diss., City University of New York, 1987); and Çeylan Tawadros, "Foreign Bodies: Art History and the Discourse of Nineteenth-Century Art," *Third Text* 3–4 (Spring–Summer 1988) 51–67. More theoretical works that insist on heterogeneity and resistance in Orientalism are Reina Lewis, *Gendering Orientalism: Race, Femininity, and Representation* (London: Routledge, 1996); and Lisa Lowe, *Critical Terrains: French and British Orientalisms* (Ithaca and London: Cornell University Press, 1991).

10. Standard accounts of European fascination with Egypt, or Egyptomania, try to maintain the tautology that Egypt was a subject of fascination because it was so inherently fascinating. This is an organizing assumption of the useful catalogue by Jean-Marcel Humbert, Michael Pantazzi, and Christiane Ziegler, *Egyptomania, L'Egypte dans l'art occidental, 1730–1930,* exh. cat. (Paris: Réunion des Musées Nationaux, 1994), 38. This catalogue, however, provides contradictory evidence regarding the political use of Egyptian monuments. It mentions (and then skips over) the 1716 plans for the first-ever museological installation of Egyptian sculpture on the Capitoline Hill, for which an official poem both proposed a symbolic link to the defeat of the Turks at Belgrade and compared Pope Clement XI's acquisition of Pharaonic Egyptian monuments to the Roman emperors' gathering of imperial booty in their conquests of Egypt.

11. Petit Palais, *Exposition du centenaire de la conquête de l'Algérie 1830–1930,* exh. cat. (Paris: Petit Palais, 1930), vii. Musée des Arts Décoratifs, Palais du Louvre, *Exposition artistique de l'Afrique française,* exh. cat. (Paris: Musée des Arts Décoratifs, 1935), iv–v. In these exhibitions Orientalist art was seen, as it will be seen here, as depicting and promoting France's civilizing mission in the Near East. A wider variety of media is considered than one finds in recent studies of Orientalism, the insistence on reportage and formal values is muted, and the actions and individuals that created the French Empire are considered alongside the art.

Chapter 1

The obelisk brought back to Paris from the Luxor temple in Egypt inspired an outpouring of reactions among French commentators, many of which will be explored in this chapter: "Il est le premier monument qui frappe les regards à la plus belle entrée de la capitale. C'est après avoir lu sur l'arc-de-triomphe les noms d'Aboukir, d'Héliopolis, des Pyramides, qu'on l'aperçoit. L'étranger l'admire long-temps [*sic*] avant de l'atteindre, et quand il est arrivé au

pied, tous les souvenirs de science et de gloire qui s'y rattachent, ont ajouté leur puissance à la première impression.

En rappelant nos anciens triomphes, il devient un nouvel honneur pour notre époque, puisqu'il témoigne que nous avons exécuté à notre tour ce que le peuple romain seul avait fait avant nous." Edme Miel, "Sur L'Obélisque de Louqsor, Et les Embellissements de la Place de la Concorde et des Champs-Elysées," *Le Constitutionnel* (18 and 26 November, 14 December 1834): 21.

"Sur la plus grande, la plus belle de nos places où l'on ne devrait chercher à rappeler que de glorieux souvenirs." Alexandre-Louis-Joseph de Laborde, *Description des obélisques de Louqsor, figurés sur les places de la Concorde et des Invalides, . . .* (Paris: Bohaire, 1832), 14.

"C'est au nom de la science et du progrès que la plupart de ces crimes sont consumés. C'est la science qui parcourt l'univers, une pioche ou une hache à la main, qui va spoliant Thèbes de ses ruines imposantes." Pétrus Borel, *L'Obélisque de Louqsor* (Paris: Marchands de Nouveautés, 1836), 6–7.

1. "La Concorde dessine une sorte d'image de France." Maurice Agulhon, "Paris: La traversée d'est en ouest," in *Les Lieux de mémoire,* ed. Pierre Nora, vol. 3, *Les France,* part 3, *De l'archive à l'emblème,* 883–84 (Paris: Gallimard, 1992). According to Agulhon, the Place de la Concorde is neutralized by the obelisk and by the July Monarchy's programming of liberal-secular-republican values in the East and of military-authoritarian values in the West.

 Historians have illuminated various aspects of the Place's history while generally ignoring the function of the obelisk. For a thorough treatment and an essential starting point, see Solange Granet, *Images de Paris: La Place de la Concorde,* Revue Géographique et Industrielle de France, n.s. 26 (Paris, 1963).

 Donald David Schneider focuses on the embellishments and finds the obelisk "apolitical." Schneider concludes "that national unity (and hence the survival of the monuments in the Place) is achievable and can be maintained principally through the triumph of technical/commercial/agricultural progress." Donald David Schneider, *The Works and Doctrine of Jacques-Ignace Hittorff, 1792–1867,* 3 vols. (New York: Garland, 1977), 1:409–10.

 Other essential contributions have been made by two Musée Carnavalet (Paris) exhibitions: *Hittorff: Un Architecte du XIX^{ème}* (1986–87), and *De la Place Louis XV à la Place de la Concorde* (1982).

 Menu's *L'Obélisque de la Concorde* offers a highly illustrated and uncritical overview, while Kemp's "Der Obelisk" is one of the rare treatments of the obelisk in light of corresponding monuments in the Paris cityscape. See Bernadette Menu, *L'Obélisque de la Concorde* (Paris: Edition de Lunx, 1987) and Wolfgang Kemp, "Der Obelisk auf der Place de la Concorde," *Kritische Berichte* 7, nos. 2–3 (1979): 19–29.

2. Thiers was Under Secretary, Department of Finance (1830–31); Minister of Commerce and Public Works (1832–34); Minister of the Interior (1832, 1834–36); and both President of the Council of Ministers and Minster of Foreign Affairs (1836, 1840).

The only controversy surrounding the obelisk was over its placement in Paris. The arguments were aesthetic, archaeological, and esoteric. Hittorff erected simulacra of the obelisk around Paris to commemorate the third anniversary of the July Revolution, which precipitated the controversy. See Jean-Marcel Humbert, "Les Obélisques de Paris, projets et réalisations," *Revue de l'Art* 23 (1974): 20–21.

Some argued for an archaeologically correct placement of the obelisk in front of one of Paris's temples. Viator, *Sur l'Emplacement de l'Obélisque de Louqsor* (Paris: Decourchant, 1833) 13–14. Some wanted a museologically useful location in the courtyard of the Louvre, adjacent to the Musée d'Egypte. See Miel, "Sur L'Obélisque de Louqsor," 17; Gau letter to the administration, 11 October 1834, AN ms. F13 1230; and Augustin Bernard, "Les Obélisques de Louqsor et La Mission Taylor," *L'Académie des Sciences Coloniales* 8–9 (1926–27): 438. Others argued for a papal-Roman urbanistic usage in the center of one of the city's squares. Champollion criticized that proposal. AN ms. F13 1230, dossier 365. As late as July 1836, other critics weighed in on the subject, even while Thiers was requesting more money from the parliament to erect the obelisk. AN ms. F13 1230, 1836 June and July.

However, Hittorff said that from the beginning of the July Monarchy, he worked under the assumption that the obelisk would be placed at the center of the Place de la Concorde. See Miel, "Sur L'Obélisque de Louqsor," ii.

3. "Vous pourriez y voir quelque jour un monument expiatoire ou une statue de la Liberté." Letter from Louis-Philippe to Rambuteau, quoted in Lequin, *Rambuteau,* 388; also quoted in Louis Hautecoeur, *L'Histoire de l'architecture classique en France,* vol. 6, *La Restauration et le Gouvernement de Juillet, 1815–1848* (Paris: A. et J. Picard, 1955), 66. On Louis-Philippe's art politics as they pertain to painting, the Revolution, Napoleon, and July Monarchy domestic politics, see Michael Marrinan, *Painting Politics for Louis-Philippe: Art and Ideology in Orléanist France, 1830–1848* (New Haven: Yale University Press, 1988).

4. On societal centers as the "realm of values and beliefs," see Edward Shils, *Center and Periphery: Essays in Macrosociology* (Chicago: University of Chicago Press, 1975), 3. For a discussion of both the difficulty and necessity of mustering the political authority to fill and control a sacred center, see Clifford Geertz, "Centers, Kings, and Charisma: Reflections on the Symbolics of Power," in *Culture and Its Creators: Essays in Honor of Edward Shils,* ed. Joseph Ben-David and Terry Nichols Clark (Chicago: University of Chicago Press, 1977), 167–68.

5. "Mais le roi, voulant éviter le bouleversement de quartiers marchands et populeux, fit don du vaste terrain qui était situé entre le pont-tournant du jardin des Tuileries et l'avenue des Champs-Elysées." Alphonse Roserot, "La Statue de Louis XV par Bouchardon," *Gazette des Beaux-Arts* 17 (1897): 197.

For an analysis and summary of the architecture and development of the Place Louis XV, see Bernard de Montgolfier, "La Place Louis XV," *Monuments Historiques* 120 (April 1982): 38–41; and Jean Ducros, "La Place de Louis XV," in *Les Gabriel,* ed. Michel Gallet and Yves Bottineau (Paris: Picard, 1982), 254–76. For a discussion of eighteenth-century royal squares and their monuments, see James A. Leith, *Space and Revolution: Projects for Monuments, Squares,*

and Public Buildings in France, 1789–1799 (Montreal: McGill-Queen's University Press, 1991).

6. Quoted in Stanley J. Idzerda, "Iconoclasm during the French Revolution," *American Historical Review* 60, no. 1 (October 1954): 16.

7. "Sur les débris existants du piédestal de la tyrannie, serait élevée la statue de la Liberté dont l'inauguration se ferait avec solennité." *Ordre de marche et détails des cérémonies pour la Fédération du 10 août,* S.I. 3. Procès verbaux de la Convention, S.I. 6; quoted in Granet, *Images de Paris, Place de la Concorde,* 78.

8. In theory, whether it was the head of the king or of other state criminals, the monument "annexes royal privileges to itself, transforms them into Republican virtues, to a rational universal system." Daniel Arasse, *The Guillotine and the Terror,* trans. Christopher Miller (Paris: Flammarion, 1987), 54–55.

9. Ibid., 5. On the symbolic function of the guillotine, see also Regina Janes, "Beheadings," *Representations* 35 (Summer 1991): 29; Lynn Hunt, *Politics, Culture, and Class in the French Revolution* (Berkeley: University of California Press, 1984), 31; and Michael Walzer, *Regicide and Revolution: Speeches at the Trial of Louis XVI,* trans. Marian Rothstein (Cambridge: Cambridge University Press, 1974), 13.

 In Freudian terms, this decapitation of Louis Capet signifies a political castration carried out by the guillotine, which has traditionally been feminized in name from Guillotin to guillotine and in popular culture, where it was characterized as a *vagina dentata.* On the endowment of the guillotine with female attributes, from the Renaissance to the twentieth century, see Camille Naish, *Death Comes to the Maiden: Sex and Execution, 1431–1933* (London: Routledge, 1991), 106.

10. Janes, "Beheadings," 35.

11. "Fils de saint Louis, montez au ciel!" Quoted in Musée Carnavalet, *De la Place Louis XV à la Place de la Concorde,* 85. See also Robert Anchel, "La Commémoration des rois de France à Paris pendant la Restauration," *Mémoires de la Société de l'Histoire de Paris et de l'Ile-de-France* 47 (1924): 185–86, 205–8; and Pierre-François-Léonard Fontaine, *Journal, 1799–1853,* 2 vols. (Paris: Ecole Nationale Supérieure des Beaux-Arts, 1987), 1:563. Chaudonneret discusses different artistic responses to the Revolution across the regimes of the nineteenth century: Marie-Claude Chaudonneret, "Historicism and 'Heritage' in the Louvre, 1820–40: From the Musée Charles X to the Galerie d'Apollon," *Art History* 14, no. 4 (December 1991): 488–520.

12. Philipon responded that "it [the proposed monument] would be at most a provocation to make marmalade." Robert Justin Goldstein, *Censorship of Political Caricature in Nineteenth-Century France* (Kent, Ohio: Kent State University Press, 1989), 128; Sandy Petrey, "Pears in History," *Representations* 35 (Summer 1991): 56. Examining the government's point of view, Cuno explains that, "by suggesting sodomy and castration, 'La Poire' called for violent revolution, a wresting from the King his power in the most obscene manner." James Bash Cuno, "Charles Philipon and La Maison Aubert: The Business, Politics, and Public of Caricature in Paris, 1820–1840" (Ph.D. diss., Harvard University, 1985), 257–58.

13. "Peu touché des honneurs qu'en différents temps j'ai vu les partis vainqueurs exiger des vain-

cus, peu certain de la durée de ces constructions que la passion élève, et qu'une autre passion détruit." Fontaine, *Journal,* 2:895, entry of 6 May 1831. With the advent of the July Monarchy, Fontaine effaces the emblems of Charles X in the architectural decoration of the Louvre's Musée d'Egypte, in favor of republican symbols. The dynastic variances of the Louvre's antiquities collection will be treated in chapter 3.

Agulhon has discussed the nineteenth century as nothing less than a civil war "between the tenants of the regimes which wanted to align France with the principles of the Revolution . . . and those who wanted to align themselves spiritually with the counterrevolution." Maurice Agulhon, "Imagerie civique et décor urbain dans la France du XIXᵉ siècle," *Ethnologie Française* 5 (1975): 36.

Bergdoll seeks to nuance Agulhon's work by saying that each site is not just a trophy won by a particular regime but an opportunity to refine the shifting politics of a regime. Barry Bergdoll, "Le Panthéon/Sainte-Geneviève au XIXᵉ siècle. La Monumentalité à l'épreuve des révolutions idéologiques," in *Le Panthéon: Symbole des révolutions. De l'Eglise de la Nation au Temple des grands hommes,* Centre Canadien d'Architecture (Paris: Picard, 1989), 176. Such a gambit is also described in McWilliam's article on the shifting iconography and the political and critical fortunes of David d'Angers's Pantheon pediment (of 1830–37). Neil McWilliam, "David d'Angers and the Panthéon Commission: Politics and Public Works under the July Monarchy," *Art History* 5, no. 4 (December 1982): 426–46.

14. Albert Boime, *Hollow Icons: The Politics of Sculpture in Nineteenth-Century France* (Kent, Ohio: Kent State University Press, 1987), 5. For the center of the Place de la Concorde, Baltard (*L'Artiste* 1 [1835]: 147) proposed a column to be dedicated to Louis-Philippe but flexible enough to be changed according to each subsequent change in regime; cited in Granet, *Images de Paris, Place de la Concorde,* 106.

15. François René Chateaubriand, "Lettre sur les Tuileries," *L'Artiste* 1, no. 1 (1831): 133. "Mais si nous ne possédons qu'un seul de ces monumens [obélisques] et il faudra toujours deux ans pour se procurer le second, où pourrait-il être mieux aperçu, mieux étudié que sur la plus grande, la plus belle du nos places où l'on ne devrait chercher à rappeler que de glorieux souvenirs." From Laborde, *Description des obélisques de Louqsor,* 14. Laborde was a politician, intellectual, and writer, who served in the administrations of the Empire, Restoration, and July Monarchy, where he was an advisor and supporter of Louis-Philippe.

Mirolli mentions that the obelisk was enlisted to obliterate memory. See Jane Van Nimmen and Ruth Mirolli, *Nineteenth-Century French Sculpture: Monuments for the Middle Class,* exh. cat. (Louisville: Speed Art Museum, 1971), 13. Bataille talks about the obelisk at the Place de la Concorde as an "apparently meaningless image." Georges Bataille, "The Obelisk," in *Visions of Excess. Selected Writings, 1927–1939,* ed. and trans. Allan Stoekl (Minneapolis: University of Minnesota Press, 1985): 221. See also Boime, *Hollow Icons,* 55.

In other contexts, Louis-Philippe sought to avoid the contentiousness of the past by trying to impose a collective amnesia. See J. Whiteley, "The King's Pictures," *Oxford Art Journal* 12, no. 1 (1989): 57; Thomas Gaehtgens, "Versailles: Monument national," in *Saloni, gal-*

lerie, musei e loro influenza sullo sviluppo dell'arte dei secoli XIX e XX, ed. Francis Haskell (Bologna: CLUEB, 1981), 55–61.

By the time of the July Monarchy and increased development of the west of Paris, the Place de la Concorde was fast becoming the city's center. Granet, *Images de Paris, Place de la Concorde,* 107.

According to a Saint-Simonian observer of the 1840s: "That square is one of the most sacred of sites, the most mysterious on the earth. It is there, at the center of that square, that the world of the Middle Ages just expired, immolated on the scaffolding of the Revolution." From Fonds Enfantin et Fonds d'Eichthal, Bibliothèque de l'Arsenal, ms. 7826, 4; quoted in Jacques de Caso, *David d'Angers: L'Avenir de la mémoire. Etude sur l'art signalétique à l'époque romantique* (Paris: Flammarion, 1988), 54.

16. Patrick H. Hutton, "The Role of Memory in the Historiography of the French Revolution," *History and Theory* 30, no. 1 (1991): 56–69. The obelisk works like the screen described by Sturken, who writes on the Washington, D.C. Vietnam Veterans Memorial. It offers flat faces for projection, while "hiding something from view," as in Freud's screen memory which hides highly emotional material from view. Marita Sturken, "The Wall, the Screen, and the Image: The Vietnam Veterans Memorial," *Representations* 35 (Summer 1991): 118–19.

Hollier has a useful if short account of unofficial opponents of the obelisk as a monument of forgetting. See Denis Hollier, "1836, 25 October," in *A New History of French Literature,* ed. Denis Hollier (Cambridge: Harvard University Press, 1994), 672–75.

17. According to Agulhon, "Jusque-là disputée et incertaine, perçue encore un peu comme excentrique et incomplètement aménagée, la place va recevoir désormais son sort définitif, qui sera politiquement neutre. Au centre, en effet, s'érigera l'obélisque de Louxor, cadeau opportunément arrivé d'Egypte." Agulhon, "Paris: Traversée d'est en ouest," 883.

Schneider starts from the premise that "the obelisk was apolitical iconographically," and describes a Place in which all the meaning is carried by the subsidiary embellishments. The obelisk serves a dramatic function in his narrative, as it appears from an exotic land to first challenge, then resolve the conflict of the protagonist. Schneider, *Jacques-Ignace Hittorff,* 1:386.

Muhammed Ali appears to have been persuaded that his gift of the obelisk would gain him French help in Westernizing Egypt. He wrote a French diplomat: "I did nothing for France that France did not do for me. If I gave it some debris of an old civilization, it was in exchange for the seeds of a new civilization that it had planted in the Orient. May the obelisk of Thebes arrive happily in Paris and serve eternally as a link between these two cities." ("Je n'ai rien fait pour la France que la France n'ait fait pour moi. Si je lui donne un débris d'une vieille civilisation, c'est en échange de la civilisation nouvelle dont elle a jeté les germes en Orient. Puisse l'obélisque de Thèbes arriver heureusement à Paris et servir éternellement de lien entre ces deux villes.") Quoted in C. Desroches Noblecourt, "Préface," in Menu, *L'Obélisque de la Concorde,* 13.

18. In the earliest widely disseminated publication from the campaign, Denon coveted the Luxor obelisks. See Dominique-Vivant Denon, *Voyage dans la Basse et Haute Egypte pendant les cam-*

pagnes du général Bonaparte, 2 vols. (Paris: Didot, l'aîné, year X [1802]), 1:224. The association of the Place de la Concorde obelisk with Napoleon and the Egyptian campaign remained current in the July Monarchy. See for instance, "Transport en France et érection de l'obélisque de Luxor," *Magasin Pittoresque* 1 (1837): 3. English sources concurred: "The Obelisk of Luxor," *The Penny Magazine of the Society for the Diffusion of Useful Knowledge* 3 (15 February 1834): 61.

During the Restoration, the Egyptians promised a second Alexandrian obelisk to England. See Bernard, "Les Obélisques de Louqsor," 425. Also see J. Vidal's epilogue, "L'absent de l'obélisque," in Jean Lacouture, *Champollion: Une vie de lumières* (Paris: Bernard Grasset, 1988), 475–76.

Champollion's role can be followed in his Egyptian letters; it is described by Hermine Hartleben in Jean-François Champollion, *Lettres de M. Champollion le jeune,* ed. Hermine Hartleben, vol. 2, *Lettres et journaux écrits pendant le voyage d'Egypte en 1828 et 1829,* Bibliothèque Egyptologique, vol. 31 (Paris: Ernest Leroux, 1909), 424. Baron Taylor followed Champollion as an official emissary and finalized the arrangement. On 7 October 1830, Taylor wrote the Département de la Marine et des Colonies that he had reminded the Egyptians that the obelisk was promised not to the chief of state but to the country. The Pasha followed with a letter, assuring the French that the obelisk was officially theirs on 29 and 30 November 1830. Taylor hoped that Europe would get all the obelisks so that Egypt's oppressive barbarism would not destroy them. BN ms. NAFR 9444, no. 412.

19. Viator, *Sur L'Emplacement de l'Obélisque,* 4. These sentiments are echoed in *Mémoires de l'Obélisque de Louqsor, écrits par lui-même, et dédiés aux Parisiens* (Paris, 1836), 2; Laborde, *Description des obélisques de Louqsor,* 3; Auguste Barthélemy, *L'obélisque de Luxor* (Paris: Everat, 1833), 7; and *Erection de l'Obélisque* (Paris: Paul Dupont, 1836), 1.

A historiography of the age of the obelisk was outlined in Jacques-Joseph Champollion-Figeac, *L'Obélisque de Louqsor, transporté à Paris, notice historique descriptive et archéologique sur ce monument* (Paris: Firmin Didot Frères, 1833), 9.

20. "C'est que dans ses longs jours de calme et d'harmonie / Jamais des factions le désastreux génie / N'agiter ses sages enfans." Barthélemy, *L'obélisque de Luxor,* 3, 25–26.

During the Second Republic, Hugo criticized the statue of the Republic as superficial and passing, like the regime itself, and he opposed it to the permanence of the obelisk. In an 1851 poem, Gautier also saw political stability in the obelisk. See Nichola A. Haxell, "Hugo, Gautier and the Obelisk of Luxor (Place de la Concorde) during the Second Republic," *Nineteenth-Century French Studies* 18, nos. 1–2 (Fall–Winter 1990): 68–69.

21. "Ces monuments parurent aux Romains le plus noble trophée qu'ils puissent apporter de l'Egypte." Joseph-Jérome Siméon, "Dépôt du rapport sur le projet de loi concernant les monuments de la Capitale," *Archives Parlementaires* 105b (10 June 1836): 175.

Egyptologists and critics also recalled the Roman precedent. See for instance: Champollion-Figeac, *Obélisque de Louqsor, transporté à Paris,* 12; Laborde, *Description des obélisques de Louqsor,* 15; Nestor L'Hôte, *Notice historique sur les Obélisques et en particulier sur l'obélisque de Louqsor* (Paris: Leleux, 1836), 8; and "Transport en France," 6.

See, too, Rudolf Wittkower, *The Impact of Non-European Civilizations on the Art of the West* (Cambridge: Cambridge University Press, 1989), 72.

22. M. C. [Michel Chevalier] "L'Obélisque," *Journal des débats* (11 October 1836): 2; Fontaine, *Journal,* 2:900–901; Miel, *Sur l'Obélisque de Louqsor,* 20; L'Hôte, *Notice historique sur les Obélisques,* 17; "Transport en France," 6; and Viator, *Sur l'Emplacement de l'Obélisque,* 14. Schneider noted that Hittorff's facsimile obelisk created in 1833 recalled the Baltard scheme. Schneider, *Jacques-Ignace Hittorff,* 1:86–87.

Thiers requested the reference to St. Peter's, as seen in Hittorff's letters and designs sent to the Director of Public Works on 12 October 1833. HAK, Legs Hittorff, A 1053, vol. 8, 29–29b.

On papal Roman usage, see J.-J. Gloton, "Les Obélisques romains de la renaissance au néo-classicisme," *Mélanges d'Archéologie et d'Histoire* 73 (1961): 437–69.

At the Place des Victoires, an obelisk first replaced the royal equestrian; it was replaced in 1800 by a maquette of an Egyptian temple in honor of Desaix and Kléber, heroes of the Egyptian campaign, which, in turn, was replaced by the statue of General Desaix. The pedestal of the Place des Victoires monument was to carry reliefs illustrating the battles for Upper and Lower Egypt. Inaugurated in August of 1810, the Desaix monument survived into the Restoration through prints and memories. Desaix's nudity in Dejoux's monument was deemed inappropriate for a new, bourgeois neighborhood. In 1812, Denon proposed replacing it with the obelisk at the Piazza del Popolo. On the Desaix Place des Victoires monument and Pont Neuf obelisk proposal, see Humbert in Humbert et al., *Egyptomania,* 213–19. For a critical analysis of that catalogue and exhibition, see Todd B. Porterfield, "Egyptomania," *Art in America* 82, no. 11 (November 1994): 84–91, 149.

The association was actually tripled in the post-decipherment era, when the obelisks evoked Egyptian triumphs. Erudite and popular writers alike came to recognize that obelisks had functioned as "signs of victory" under the pharaohs. At the Place de la Concorde, the three historical uses of Egyptian obelisks recalled Egypt's glory under the pharaohs, subjugation under the Roman Empire, and slide into Muslim barbarism.

23. "Cette attention [attention publique] s'accroîtra encore quand l'obélisque sera exposé à tous les regards, à ceux surtout des personnes capables d'apprécier les rares mérites que réunit ce monument colossal de l'art des anciens, qui est en même temps une de ses pages primitives de leur histoire." Champollion-Figeac, *Obélisque de Louqsor, transporté à Paris,* vii, 14–15.

In Angelin's terms, obelisks were recognized as "great signs" at the entries of temples. J.-P. Angelin, *Expédition du Louxor* (Paris: Thomine, 1833), 4.

While one anonymous writer continued the outmoded mystification of hieroglyphs ("Obélisque de Louqsor," *France Industrielle* 4 [July 1834]: 141), L'Hôte, an Egyptologist and disciple of Champollion, refuted this, discussing the historiography on obelisk use and the various views regarding the philosophical, religious, or commemorative functions of the earliest obelisks. L'Hôte, *Notice historique sur les Obélisques,* 4.

24. "Parlera dans les lieux que le peuple fréquente / A Paris, tous les soirs, comme un vieillard conteur." Barthélemy, *L'obélisque de Luxor,* 20.

25. For instance, there was the plan to construct an obelisk out of the stones of the Bastille and engrave it with the Declaration of the Rights of Man. Humbert, "Les Obélisques de Paris," 11. On the other hand, Champollion composed hieroglyphic inscriptions for the temporary obelisk erected in Rome to celebrate the coronation of Charles X in 1825. Jean-François Champollion, *Lettres de Champollion le jeune*, ed. Hermine Hartleben, vol. 1 *Lettres écrites d'Italie*, Bibliothèque Egyptologique, vol. 30 (Paris: Ernest Leroux, 1909), letters of 5 June and 17 June 1825, 219–25. The political considerations involved in Champollion's Roman obelisk will be discussed in chapter three.

 In eighteenth-century England, obelisks are said to have functioned as "iconological voids." Richard Hewlings, "Ripon's Forum Populi," *Architectural History* 24 (1981): 40–41.

26. G. W. F. Hegel, *The Philosophy of Fine Art*, 4 vols., trans. F. P. B. Osmaston (London: G. Bell and Sons, 1920), 14. Hemphill's account of Renaissance obelisks concurs: the obelisk is blank to the point that it takes on its meaning from what is done to it; it is the ultimate work of art for which context is everything. Richard Hemphill, "Le Transport de l'obélisque du Vatican," *Etudes Françaises* 26, no. 3 (Winter 1990): 111–17.

27. Barthélemy, *L'obélisque de Luxor*, 3; *Description De l'Embellissement de la Place de la Concorde, au milieu de laquelle doit s'élever le Monument* (Paris: Chassaignon, 1836) n.p.; and *Nouvelle Description des Obélisques de Luxor* (Paris: Mme Veuve Boissay, 1833), 3.

28. Barthélemy, *L'obélisque de Luxor*, 9; Borel, *L'Obélisque de Louqsor*, 15–16; *Description de L'Obélisque de Luxor, Avec L'histoire de son voyage, . . .* (Paris, 1836); *Embellissemens de la Place de la Concorde* (Paris: Gauthier, 1833 and 1839), 5; *Erection de l'Obélisque* (Paris: Paul Dupont, 1836), 1–2; C.-E. Guay, *La Gloire des monuments. Ode au Roi, sur l'achèvement des monuments de l'Empire à propos de l'inauguration de l'arc de triomphe de l'Etoile (Juillet 1836)* (Versailles: Montalant-Bougleux, 1838), 9. *Mémoires de l'obélisque*, 4–5; *Nouvelle Description des Obélisques*, 6; "Obélisque de Louqsor," *France Industrielle* 4 (July 1834): 141; and "Transport en France," 3–7.

29. *Mémoires de l'obélisque*, 1; *L'obélisque de Luxor au terre-plein du pont neuf* (Paris: C. L. F. Panckoucke, 1833), 1.

30. Barthélemy, *L'obélisque de Luxor*, 9; Guay, *La Gloire des monuments*, 7; "Méhémet-Ali et les antiquités de l'Egypte," *L'Artiste* 1 (1836): 19; *Nouvelle Description des Obélisques*, 22; *Obélisque de Luxor au terre-plein*, 2; S——, "Campagne pittoresque du Luxor par M. Léon de Joannis," *L'Artiste* 1 (1835): 199; "Transport en France," 3.

31. "Joindre l'éclat de votre nom à la splendeur des monuments d'Egypte, c'est rattacher les fastes glorieux de notre siècle aux temps fabuleux de l'histoire; c'est réchauffer les cendres de Sésostris et des Mendès, comme vous conquérants, comme vous bienfaiteurs." Denon, *Voyage* (1802), n.p. (dedication), see also 163–64.

32. "Ici fleurit jadis une ville opulente. Ici fut le siège d'un empire puissant. . . . Ils ne verraient plus épars çà et là que quelques hommes indolens et abrutis par le despotisme." *Description de l'Egypte ou Recueil des observations et des recherches qui ont été faites en Egypte pendant l'expédition de l'armée française*, 2nd ed. in 24 vols. (Paris: C. L. F. Panckoucke, 1821–29), 2:1, 37. The

view of the Luxor temple published in Denon's *Voyage* was actually engraved by J.-B. Lepère, who became Hittorff's father-in-law.

33. "Il ne s'est formé, dans l'Occident ou dans l'Asie, aucune puissance considérable qui n'ait porté ses vues sur l'Egypte, et ne l'ait regardée, en quelque sorte, comme son apanage naturel." Jean-Baptiste-Joseph Fourier, "Préface Historique" in *Description de l'Egypte ou Recueil des observations et des recherches qui ont été faites en Egypte pendant l'expédition de l'armée française,* 1st ed. in 21 vols. (Paris: Imprimerie Impériale and Imprimerie Royale, 1809–28), i. See also Edward W. Said, *Orientalism* (New York: Random House, 1978), 84–87.

34. "Sous le rapport historique, ce sont des monumens élevés à la gloire du plus célèbre des conquérans Egyptiens, Sésostris. . . . Il serait beau que de tels obélisques devinssent, dans Paris, des monumens commémoratifs de nos Victoires en Egypte." Champollion, "Rapport sur les obélisques.—en 1830 à M. le Ministre de la Marine." AN, ms. F13 1230, dossier 365.

35. "[Ramses] le plus célèbre des Pharaons, le conquérant de l'Afrique et d'une portion de l'Asie." Jean-François Champollion, *Lettres à M. le Duc de Blacas d'Aulps, premier gentilhomme de la chambre, pair de France . . .* (Paris: Firmin Didot, Père et Fils, 1824), 80. A parallel use of past monuments is found in French literature, where "summoning figures associated with the past of a specific ruin constitutes the particular contribution of the French romantics to the development of the motif (of ruins)." Ingrid G. Daemmrich, "The Ruins Motif as Aesthetic Device in French Literature," *Journal of Aesthetics and Art Criticism* 31 (Fall 1972): 35.

36. "C'est à lui qu'on attribue la première idée du canal de jonction du Nil à la mer Rouge. . . . C'est sous le règne de Rhamsès le Grand, ou *Sésostris,* que l'Egype arriva au plus haut point de puissance politique et de splendeur intérieure." Jean-François Champollion, *Lettres et journaux ecrits pendant le voyage d'Egypte,* ed. Hermine Hartleben (Paris: Christian Bourgois, 1986), 433–34. This cycle of civilizations had already been delineated in other Egyptological works growing out of the Egyptian campaign, including Gau's 1822 *Antiquités de la Nubie,* which Hittorff himself owned. Hittorff's own copy of Gau is kept with his papers in Cologne (HAK).

Champollion's followers and fellow Egyptologists reinforced, in both scholarly and popular publications, this cyclical history of civilization and recommended the obelisk as an Egyptian campaign monument; see, for instance, Jacques-Joseph Champollion-Figeac, *Obélisques Egyptiens de Paris, d'après les dessins faits à Louqsor en 1828 par Champollion le Jeune* (Paris: n.p., 1836); L'Hôte, *Notice historique sur les Obélisques,* 3; and François Salvolini, *Traduction et analyse grammaticale des Inscriptions sculptées sur l'obélisque égyptien de Paris* (Paris: Dondey-Dupré, 1837), i.

37. "Je propose (mais ma faible voix ne sera pas entendue) que, par une loi, l'obélisque soit élevé en mémoire de l'expédition française en Egypte, la plus mémorable enterprise des temps modernes, par son objet, ses moyens, l'illustration des noms qui s'y rattachent et par ses nombreux résultats, les uns déjà si utiles à la prospérité de la France, au retour des peuples du levant vers la civilisation." Champollion-Figeac (*Obélisque de Louqsor, transporté à Paris,* ix–x) proposed "one inscription, simple, precise, and intelligible to all": A L'ARMEE D'ORIENT / QUI OCCUPA / L'EGYPTE ET LA SYRIE / EN 1798, 1799, 1800 ET 1801."

Baron Taylor recommended an inscribed dedication to the "Campagne d'Egypte," and to

the "Great Captain of Modern Times." He wrote on 15 August 1833 to the Director of Public Works and called the obelisk a "trophy for conserving the immortal campaign of Napoleon and the French in the Orient." AN F13 1230, dossier 571.

38. Musée Carnavalet, *Hittorff,* 98–99; and Humbert, "Les Obélisques de Paris," 22.

39. A project called for by Said but rarely done. Said, *Orientalism,* 6, 20, 176.

40. "L'Egypte, depuis dix siècles, était retombée dans la barbarie, et à peine quelques voyageurs pouvaient-ils pénétrer sur cette terre où Pythagore et Platon étaient allés demander des inspirations au génie des sciences lorsqu'un grand homme entreprit de lui rendre l'existence et la gloire. Son armée triomphante, après avoir salué par une victoire les Pyramides, s'avança vers Thèbes, mais là s'arrêta tout-à-coup, et battit les mains à la vue des admirables monumens qu'elle aperçut. Dans son enthousiasme, elle aurait voulu pouvoir les transporter tous dans la capitale avec les drapeaux des ennemis qu'elle venait de vaincre. . . Ce fut une idée heureuse d'offrir aux regards des obélisques de Sésostris en même temps que d'inaugurer la colonne de Napoléon; d'honorer ainsi la mémoire des deux plus grands guerriers des temps anciens et modernes." Laborde, *Description des obélisques de Louqsor,* 3, 7–8, 10–11, 16.

41. "Je veux donc mettre fin à ces scandaleux abus, et pour vous prouver en même temps ma gratitude vous raconter moi-même mon histoire. J'ai 3,416 ans bien sonnés. . . . Hélas! tout est problème et mystère en Egypte; cette aïeule décrépite du genre humain, s'est couverte avec pruderie d'un voile plus impénétrable que celui d'une fraîche odalisque. . . . Sans votre érudit M. Champollion (que je vous demande la permission d'appeler mon parrain), j'ignorerais encore que j'ai reçu le jour 1,580 ans-avant-Jésus-Christ." *Mémoires de l'Obélisque,* 1–5, 9.

42. Although it takes the same view as Denon, the journal's print is cruder and shows a restored Luxor temple. "Obélisque de Louqsor," *Magasin Pittoresque* (21 December 1833): 393–94. The obelisk's function, to "eternalize" the memory of the Egyptian campaign, is echoed again in the subsequent 1837 *Magasin Pittoresque* article, "Transport en France et érection de l'obélisque de Luxor."

A decade after the elevation of the obelisk, the discourse remained unchanged. In Pigeory's 1847 book on the monuments of Paris, the author repeats the model of civilization that infused the obelisk with meaning. He understands the obelisk as a war spoil, comparing it to the horses of San Marco, themselves once Napoleonic trophies: "It [the obelisk] recalled the triumphant victors from Rome and Byzantium, who, upon each of their victories, acknowledged the conquered cities and ornamented the mother country with the spoils." ("Il se rappelait ces triomphateurs de Rome et de Byzance qui, à chacune de leurs victoires, rançonnaient des villes conquises et ornaient la mère patrie de leurs dépouilles.") Félix Pigeory, *Les Monuments de Paris . . . sous le règne du Roi Louis-Philippe* (Paris: A. Hermitte, 1847) 38–51. Pigeory recognized that, like France's imperial ambitions, the French project to acquire and elevate the obelisk was advanced not only by Napoleon and Louis-Philippe but, by Louis XVIII and Charles X as well—in short, by all the post-Revolutionary governments.

On the bronze horses of San Marco and the subject of *translation imperii,* see André Corboz, "Walks Around the Horses," *Oppositions* 25 (Fall 1982): 84–101.

43. Inscription on print: "From the Tuileries Gardens, it was seen that in times of war the statue would be partially concealed; two ornamental iron gates let the people see the pedestal of Louis XV, mutilated and broken, an allegory which signifies that Concorde is raised triumphantly on the ruins caused by the division of the Citizens." ("Il est vu du Jardin des Tuileries, en tems de guerre la statue serait ainsi Voilée, deux portes grillées laissent voir au peuple le piédestal de Louis XV, Mutilé et brisé, allégorie qui signifie que la Concorde s'élève triomphante, sur les ruines Causées par la division des Citoyens.") Included in Claudine de Vaulchier, "Iconographie des décors révolutionnaires," in *Les Architectes de la Liberté, 1789–1799,* ed. Annie Jacques and Jean-Pierre Mouilleseaux (Paris: Ecole Nationale Supérieure des Beaux-Arts, 1989–90), 266.

 This use of the ruined monument departs from the traditional reuse of disposed monuments, as when bronzes are melted to make new statues. It also departs from the revolutionary custom of subsuming visible fragments of discredited monuments in a new whole dedicated to the succeeding and triumphant ideology.

44. Pliny, *Natural History,* trans. D. E. Eicholz, vol. 10 (Cambridge: Harvard University Press, 1962), 55. The poet and novelist Joseph Méry called for France to do the same. "Le Luxor à Toulon," 2–3, as transcribed in BN Est. Ub209/Pet fol.

45. AN F13 1230, dossier 365. In the same letter he declared France the new Egypt.

46. In 1787, Volney argued that scientists rather than missionaries should lead France's colonizing efforts in Egypt. Nicole Dhombres and Jean Dhombres, *Naissance d'un pouvoir: Sciences et savants en France (1793–1824)* (Paris: Payot, 1989), 106.

47. For texts laden with dimensions, weights, and other details, see, for instance, Angelin, *Expédition du Louxor,* 3; Champollion-Figeac, *Obélisque de Louqsor, transporté à Paris,* 51–55; *Description de L'Obélisque de Luxor,* 4; E., "Egypte. L'Obélisque de Louqsor," *Journal La Paix* 1194 (16 October 1836): 7; *Erection de l'Obélisque,* 2; Léon de Joannis, *Campagne Pittoresque du Luxor,* (Paris: Mme Huzard, 1835), 8–10; Apollinaire Lebas, *L'Obélisque de Luxor, Histoire de sa translation à Paris . . .* (Paris: Carilian-Goeury et Dalmont, 1839); Héricourt de Thury, "Note sur l'obélisque de Louqsor, lue à l'Académie des Sciences dans sa Séance du 20 Janvier 1834," *Moniteur du Commerce* 253 (22 January 1834): 3; Pigeory, *Les Monuments de Paris,* 50; "Transport en France," 16.

48. "Mon dieu! quelle manie de prendre et de transporter! Ne pouvez-vous donc laisser à chaque latitude, à chaque zone sa gloire et ses ornements?" Borel, *L'Obélisque de Louqsor,* 6–7. In this 1836 publication, the young Borel (born Joseph Pétrus in 1809) is in his contrarian, Romantic mode. A writer who had trained in Paris as an architect, he went on to be an inspector of colonization in Algeria from 1845 to 1856. His 1845 article, "Alger et son avenir littéraire," for *L'Artiste* boasted of the superiority of French colonialism (as opposed to the British) and detailed Oriental influences on Occidental writers. On his career in Algeria, see Gabriel Esquer, "La vie algérienne de Pétrus Borel, le lycanthrope," *Simoun* 4, no. 15 (Oran, 1955): 1–72. On Borel's literary output, see Victor Brombert, "Pétrus Borel: Prison and the Gothic Tradition," 49–61, in *The Romantic Prison: The French Tradition* (Princeton: Princeton University Press, 1978).

49. "Cette conquête faite par la science sur la barbarie. . . . Un pays jadis florissant aujourd'hui morne, abandonné. Là quelques hommes presque nus, dégradés par l'esclavage, rongés par la détresse, rampent plutôt qu'ils ne marchent sur des ruines antiques, stériles monuments de la splendeur de leurs pères. . . . Notre succès leur parut comme miraculeux, et à nous s'écrièrent à l'envie: 'Il n'y a que des Français qui soient capables d'une entreprise aussi hardie.'" Angelin, *Expédition du Louxor,* dedication (n.p.), 1, and 16. Similarly, in his account of his own scientific exploits, Lebas digresses into a description of the depraved morals of the Egyptians. Lebas, *L'Obélisque de Luxor,* 59–60. He insists on the hostility of the climate for his team, which felt "transported to another nature" (p. 3). The theme is repeated in "Transport en France"; and it continues into our epoch with Dibner, who describes the lowering of the obelisk occurring "after a period of intense training in which the primitive natives had to be taught the use of the simplest of tools." Bern Dibner, *Moving the Obelisks* (Norwalk, Conn.: Burndy Library, 1952), 57.

50. "Groups of men and women of all ages would surround us immediately," Joannis recounts, "and were amusing us as much by their original questions as by their grotesque faces and clothing." ("Des groupes d'hommes et de femmes de tout âge nous entouraient aussitôt, et nous amuseraient autant par leurs questions originales que par leurs figures et leurs vêtements grotesques.") Joannis, *Campagne Pittoresque du Luxor,* 26.

51. "'Barra el hhamice (à bas la chemise),' tel fut le commandement préliminaire de M. Vessière, et à l'instant, les deux grandes chemises bleues et les voiles blanches laissèrent voir les corps fins des deux jeunes filles." Ibid., 27–28, 93–95. That the indecent dance by Oriental women is a trope of the Orientalist travel account is evident from Fredrik Hasselquist's *Voyages dans le Levant dans les années 1749, 50, 51 et 52,* trans. M.-A. Eidars (Paris: Saugrain le jeune, 1769). Quoted in Henry Laurens, *Les Origines intellectuelles de l'expédition d'Egypte: L'Orientalisme Islamisant en France (1698–1798)* (Istanbul, Paris: Editions Isis, 1987), 115.

52. Hunt, *Politics, Culture, and Class,* 31.

53. "Thèbes! ce nom seul réveille le souvenir de toutes les gloires; Thèbes, le berceau des arts et des sciences, où commandèrent pendant des siècles les puissants rois de l'Egypte, Thèbes est aujourd'hui couchée dans la poussière. . . .

 Erigé sur une de nos places, il sera là comme l'héritage d'une ville déchue, recueilli par une ville florissante." (Angelin, *Expédition du Louxor,* 2, 119–20)

54. "Gloire à l'ingénieur!" Joseph Méry, "Le Luxor à Toulon. A M. Barthélemy. Toulon, ce 3 Juin 1833," *Journal de Paris* 2128 (1 July 1833): 2. On Méry's popular celebrations of the Algerian campaign and his influential role in the Napoleonic revival, see Esquer, "Les Poètes et l'expédition d'Alger, 'La Baricade' de Barthélemy et Mery," *Revue Africaine* 60 (Algiers, 1919): 112–45.

55. Letter from Lebas to the Minister of Commerce and Public Works, 23 September 1833. AN F13 1230, dossier 346. Lebas went on to discuss the plan in *L'Obélisque de Luxor,* 155–56. Siméon and Thiers discussed the plan before the parliament. See Siméon, "Dépôt du rapport," 175; Adolphe Thiers, "Discussion du projet de loi concernant l'achèvement de divers

Monuments Publics de la Capitale," *Archives Parlementaires* 105 (16 June 1836): 447. In the press, the plan was received favorably. See *Description de L'Obélisque de Luxor,* 12.

56. Michael Adas, *Machines as the Measure of Men: Science, Technology, and Ideologies of Western Dominance* (Ithaca: Cornell University Press, 1989), 221. In his discussion of European imperialism in sub-Saharan Africa later in the century, Adas talks about a similar trope that has Africans responding in awe "to even the simplest mechanical devices." Ibid., 159.

Even after the plan's rejection, it was seen as "a great and beautiful idea that would thus associate one of the most powerful inventions of modern times with one of the greatest products of the antique arts." ("C'était une grande et belle idée que celle d'associer ainsi l'une des plus puissantes inventions des temps modernes à l'un des plus grands produits des arts antiques.") *Erection de l'Obélisque,* 3.

Even without the steam engine, the felling, transportation, and raising of the obelisk were widely discussed as having surpassed the achievements of both ancient and papal Rome, linking France and ancient Egypt in their scientific authority, and proving the superiority of both to contemporary Egypt. See Angelin, *Expédition de Luxor,* 6; Laborde, *Description des obélisques de Luxor,* 5–6; E., "Egypt. L'Obélisque de Louqsor," 7–8; *Erection de l'Obélisque,* 3; L'Hôte, *Notice historique sur les Obélisques,* 14; and *Nouvelle Description des Obélisques,* 15–16.

The project spawned another technological proposal, as seen in a 28 September 1836 letter from a certain Gové to the Minister of Public Works. The writer proposed topping the obelisk with a globe illuminated by gas to make the Place de la Concorde visible from a great distance. AN F13 1230.

In 1833, French diplomats were considering introducing the steam engine into Egypt in order to accustom the local population to the fruits of modern civilization. Laurens, *Royaume impossible,* 40–42.

On the use of science in the control and exploitation of Algeria in the July Monarchy, see Maxine Taylor, "French Scientific Expeditions in Africa during the July Monarchy," *Proceedings for the Annual Meeting of the Western Society for French History* 16 (1989): 243–52.

57. Agreement to use this subject on the pedestal can be followed in Hittorff's letters to the Director of Public Works. HAK, 1053, no. 8, 15b–16 and 54–55. Some of these documents are quoted in Musée Carnavalet, *Hittorff,* 83–84. A letter from the Director of Public Monuments to the Minister of Public Works suggests that it was Hittorff's idea to show the means employed to move the obelisk. AN F21 1575.

In August 1833, Hittorff was consulting with Champollion-Figeac about the inscriptions for the pedestal. See Letter from Hittorff to Champollion-Figeac, BMG, vol. 39, letter 116.

On engineering drawings, see Eugene S. Ferguson, *Engineering and the Mind's Eye* (Cambridge: MIT Press, 1992).

58. *Description de L'Obélisque de Luxor,* 14. Kemp posits that it is a mistake to read the obelisk as an endpoint of the urban program, that instead it stands at the intersection of Paris's bourgeois and royal axes, emanating respectively from the Chamber of Deputies and the Tuileries Palace. Kemp, "Der Obelisk," 19.

59. Champollion-Figeac, *Obélisques Egyptiens de Paris*. Schneider recognized the shift but did not explain it; Schneider, *Jacques-Ignace Hittorff*, 1:404. Granet (*Images de Paris, Place de la Concorde*, 141, note 19) and Humbert ("Les Obélisques de Paris," 28, note 87) cite the shift but do not recognize any meaning in it.

 For the hieroglyphic texts, see Champollion-Figeac, *Obélisque de Louqsor, transporté à Paris*, 59; L'Hôte, *Notice historique sur les Obélisques*, 58–59, 94–95; Salvolini, *Traduction et analyse*, 90.

60. "Il avait l'habitude de dire: *le canon de l'Algérie ne retintit pas en Europe.*" Pierre Guiral, *Adolphe Thiers ou De la nécessité en politique* (Paris: Fayard, 1986), 132. See also H. A. C. Collingham, *The July Monarchy: A Political History of France, 1830–1848* (London: Longman, 1988), 222, 246–49.

61. Adolphe Thiers, "Discours sur le budget de l'Algérie, prononcé le 9 juin 1836 à la Chambre des Députés," in *Discours parlementaires de M. Thiers*, ed. M. Calmon, vol. 3 (Paris: Calmann Lévy, 1879), 507–8, 512–16. Discussed also in J. P. T. Bury and R. P. Tombs, *Thiers 1797–1877: A Political Life* (London: Allen and Unwin, 1986), 25. See also Thiers, "Discussion du budget d'Alger et des autres possessions françaises," 154–59.

CHAPTER 2

1. See Henry Laurens, *L'Expédition d'Egypte, 1798–1801* (Paris: Armand Colin, 1989); *Origines intellectuelles de l'expédition;* and *Royaume impossible.*

2. Alain Silvera, "Egypt and the French Revolution: 1798–1801," *Revue Française d'Histoire d'Outre-mer* 69, no. 257 (1982): 311. This fine article cites new documents and pinpoints this exchange of the Revolution for modern imperialism.

 On the Directory's attempt to consign the Revolution to history, see Ewa Lajer-Burcharth, "David's *Sabine Women*: Body, Gender and Republican Culture under the Directory," *Art History* 14, no. 3 (September 1991): 397–430.

3. On the Directory's decision to launch the Egyptian campaign, and on Bonaparte and Talleyrand's use of eighteenth-century histories, travel accounts, and political philosophy, see Laurens, *Expédition d'Egypte*, 11–30, and *Origines intellectuelles de l'expédition.*

 In discussing Bonaparte's Orientalist learning, Said calls his plans "the first in a long series of European encounters with the Orient in which the Orientalist's special expertise was put directly to functional colonial use." Said, *Orientalism*, 80.

4. Quoted in Albert Soboul, *A Short History of the French Revolution, 1789–1799*, trans. Geoffrey Symcox (Berkeley: University of California Press, 1977), 152. Stewart Woolf points out, "If Brumaire marked the end of Revolution, it was that of the political revolution of popular sovereignty and diffusion of power, not the initial ideal of the possibility of cancelling the past and creating a new society, nor the driving conviction of France's mission as the vector of civilization." Stewart Woolf, "The Construction of a European World-View in the Revolutionary-Napoleonic Years," *Past and Present* 137 (November 1992): 95.

5. The day after the occupation of Alexandria, Bonaparte issued a proclamation in Arabic on a

press taken from the Vatican's Office for the Propagation of the Faith. France came as liberator from the Turkish oppressor, protector of commerce, defender and friend of Islam, and facilitator of popular government.

6. Piussi discusses the confusion over the precise number of savants who accompanied Napoleon. Anna Ruth Piussi, "Images of Egypt during the French Expedition (1798–1801): Sketches of a Historical Colony" (Ph.D. diss., St. Antony's College, Oxford University, 1992), 39.

 Because of its combination of military and intellectual endeavors, Said sees the invasion as the "keynote of the relationship . . . for the Near East and Europe . . . [which was] in many ways the very model of a truly scientific appropriation of one culture by another apparently stronger one. For with Napoleon's occupation of Egypt processes were set in motion between East and West that still dominate our contemporary cultural and political perspectives." Said, *Orientalism*, 42.

7. In Max Weber's definition, nationalism is built through fostering a sense of solidarity in opposition to a recognized "other," based on a sense of mission "through the very cultivation of the peculiarity of the group set off as a nation." Weber, "The Nation," 24.

8. Susan Locke Siegfried, "Naked History: The Rhetoric of Military Painting in Postrevolutionary France," *Art Bulletin* 75, no. 2 (June 1993): 242. This excellent article compares Gros's *Battle of Nazareth* to Lejeune's *Battle of Marengo*, detailing the administration of the Nazareth program and the presentation and reception of the pictures in light of changes in battle painting following the Revolution's transformations in military ideology. She identifies Gros's inclusion of a number of discrete incidents in the manner of the Revolutionary *traits de courage et d'humanité*, whose origin and function she outlines. Ibid., 251–54.

 Crow says that most critics were disappointed that Gros won the competition, and that they faulted him for a lack of a clear center of action; one saw Rococo revival in his color. Thomas Crow, *Emulation: Making Artists for Revolutionary France* (New Haven: Yale University Press, 1995), 242. See also Norman Schlenoff, "Baron Gros and Napoleon's Egyptian Campaign," in *Essays in Honor of Walter Friedlaender* (New York: Institute of Fine Arts, 1965), 162; and Manfred Heinrich Brunner, "Antoine-Jean Gros. Die Napoleonischen Historienbilder" (Ph.D. diss., Rheinischen Friedrich-Wilhelms Universität, Bonn, 1979), 124–25, 355–56.

 As early as 1800, the Consulate's Minister of the Interior had commissioned medals celebrating the victories in Egypt (and Bavaria); these were distributed to generals, officers, and noncommissioned soldiers in the campaign and may have had a wider distribution. For an overview of Napoleonic propaganda, see Robert B. Holtman, *Napoleonic Propaganda* (Baton Rouge: Louisiana State University Press, 1950), 162.

9. "A gauche s'élève le mont Tabor, célèbre par le miracle de la Transfiguration, et par sa position près des lieux tels que Nazareth, Kana, etc., qui furent le berceau du christianisme." "Un officier découvre une pierre gothique aux armes de France, qui rappelle les croisades de Louis IX." Lejeune, "Salon de l'an IX," *La Gazette nationale {ou} Le Moniteur universel* (6 vendémiaire, year X): 21–22; reprinted in H. W. Janson, ed., *Catalogue of the Paris Salon, 1673 to 1881*, 60 vols. (New York: Garland, 1977), 55.

10. "La valeur française y porte son empreinte particulière, le calme qui la caractérise, contraste avec l'aveugle impetuosité des Musulmans." "Salon de l'an IX," 21–22.

11. "Deux ou trois groupes non prescrits donc introduits pour caractériser les deux nations. . . . En opposition la coutume barbare des Turcs de couper la tête d'un ennemi à terre avec la loyauté française qui, dans cette situation, ne voit qu'un prisonnier doit faire respecter." Antoine-Jean Gros, "Extrait du Programme," 1801, AMBAN.

12. "A peu de distance de cette scène où la barbarie des Orientaux est peinte, et par un contraste parfaitement seul, un dragon sauve la vie d'un Turc qui se rend, et que poursuivait un soldat français." From "Salon de l'an IX," 21.

13. C. La Jonquière, *L'Expédition d'Egypte, 1798–1801,* 5 vols. (Paris: H. Charles Lavauzelle, 1899–1907), 4:381. Useful here is White's distinction between the historical discourse that narrates, or rather adopts, a perspective that looks out on the world and reports it, and a discourse that narrativizes, one that "feigns to make the world speak itself and speaks itself a story." Hayden White, "The Value of Narrativity in the Representation of Reality," in *On Narrative,* ed. W. J. T. Mitchell (Chicago: University of Chicago Press, 1981), 2–3. *The Battle of Nazareth* sets an important precedent for it is read as reportage, while it actually narrativizes, "speaks itself a story."

14. "Les Turcs qui étaient retranchés dans la presqu'île d'Aboukir, avaient repoussé la première attaque des Français, dirigée sur la redoute qui défendait la droite de leur position; ils sortent de leur retranchemens pour couper les têtes des Français restés morts ou blessés sur le champ de bataille." Gros's Salon *livret* text is borrowed directly by Pierre-Jean-Baptiste-Publicole Chaussard, *Le Pausanias Français: Etat des Arts du Dessin en France à l'ouverture du XIXᵉ siècle: Salon de 1806* (Paris: F. Buisson, 1806): 71–72.

15. "Le calme de la supériorité, la valeur éclairée, et de l'autre, le brutal emportement, la férocité stupide et le courage aveugle; comme s'il avait voulu indiquer qu'il s'agissait du triomphe des lumières et de la civilisation sur les ténèbres et la barbarie." Chaussard, *Pausanius Français,* 74.

16. All three are discussed and illustrated in Siegfried, "Naked History," 242–45.

17. Gros, "Extrait du programme," AMBAN.

18. "Voyons jusqu'à quel point les auteurs se sont rapprochés du site et de la vérité de l'action." Lejeune, "Salon de l'an IX," 21. In Gros's sketch, this commentator found the local tone bright but doubted that it was characteristic of the country. However, anecdotalists subsequently told how Gros used refracted light in his studio to simulate the light of that particular day and place. Letter of unknown origin, AMBAN.

Like *The Battle of Nazareth,* Gros's *Battle of Aboukir* was praised for the same sort of evocation in an 1806 Salon review: "All of the foreground of Gros's picture is admirable regarding color and effect. All of the objects reflect a striking light, which makes recognizable the sun of Egypt, and even the shadows have a transparency that reveals all the details." Chaussard, *Pausanius Français,* 600.

19. Schlenoff, "Baron Gros," 152; Hugh Honour, *Romanticism* (New York: Harper and Row, 1979),

47–90; and Walter Friedlaender, *David to Delacroix,* trans. Robert Goldwater (Cambridge: Harvard University Press, 1952), 63–65, 101, 112. In "Modernism and Imperialism," Jameson proposes a different link between imperialism and modernism, "the dynamic of capitalism proper." Terry Eagelton, Frederic Jameson, and Edward W. Said, *Nationalism, Colonialism, and Literature* (Minneapolis: University of Minnesota Press, 1990), 43–66.

In Alexandre's late nineteenth-century history of battle paintings, Gros is the greatest military painter of all time and "truly the father of the modern school and of the Romanticism which issued from him." Alexandre's discussion of Gros's superlativeness is dominated by the Near Eastern paintings, *The Battle of Nazareth, The Battle of the Pyramids,* and *Pesthouse at Jaffa,* which, according to this writer, represented "his best painting." Gros broke from classical formulae in the observed and uncalculated appearance of pictures set in the contemporary Orient. His anticlassicism is attributed to his never having won the Prix de Rome, so that he never learned the stilted classics that *Pesthouse at Jaffa* so boldly left behind. Arsène Alexandre, *Histoire de la Peinture Militaire en France* (Paris: Renouard, 1880), 131, 140–46, 158.

One should not overestimate the importance of the Egyptian campaign pictures. Alexandre calls Gros's *Battle of Eylau* the culmination of his reputation. There is, however, a discernable moral difference assigned to the pictures. *Battle of Eylau* is seen as depicting the horrors of war, whereas *Pesthouse at Jaffa* is credited with a moral grandeur. Although the anticlassical character of the picture can be exaggerated, the critical disassociation of these paintings from the classical tradition is very pregnant in the context of paintings of the Egyptian campaign. For there is a connection here between the artistic divergence from the classicizing artistic tradition of the Enlightenment on the one hand, and, on the other, the political purpose of the Egyptian campaign itself: to suspend the Revolution.

Whereas I am examining Gros's *Pesthouse at Jaffa* in the launching and workings of an imperial discourse, Grigsby evaluates the painting as a masterpiece in its "capacity to accommodate the instability of conflicting interpretations," specifically regarding classicism, masculinity, and contagion. Darcy Grimaldo Grigsby, "Rumor, Contagion, and Colonization in Gros's *Plague-Stricken at Jaffa* (1804)," *Representations* 51 (Summer 1995): 4.

20. "L'artiste qui n'a pas le courage de faire justice des trois quarts de la pièce d'éloquence descriptive, produit une esquisse divisée par virgules, points et paragraphes, précisément comme un programme." Jean-Baptiste Boutard, "Salon de l'an IX," *Journal des débats* (2 vendémiaire, year X): 2. Boutard liked Taunay's picture because that artist rejected modern costumes. Siegfried notes that Chaussard was suspicious of the administration of the competition and disliked the fact that none of the competitors had witnessed the battle. Siegfried, "Naked History," 246.

21. In the formation of a new discourse, topoi are forged to convey moral judgements to serve a new era. See Hayden White, *Tropics of Discourse: Essays in Cultural Criticism* (Baltimore: The Johns Hopkins University Press, 1978), 2–5.

22. Later a French soldier described the "horrible massacre; the streets were blocked with cadavers;

children, their throats slit, were seen in the arms of their mothers." ("Il y eut un massacre horrible, les rues étaient encombrées de cadavres, on voyait des enfants égorgés dans les bras de leurs mères.") J. Brossollet and H. Mollaret, "A propos des 'Pestiférés de Jaffa' de A. J. Gros," *Koninklijk Museum voor schone Kunsten* (1968): 280.

23. Ibid., 281–83; René N. Desgenettes, *Histoire médicale de l'armée d'Orient* (Paris: Croullebois, 1802), 49. Larrey, who returned to Egypt before reaching Jaffa, said that the soldiers were accustomed to all manner of emotional impact. D. J. Larrey, *Relation historique et chirurgicale de l'expédition de l'armée d'Orient, en Egypte et en Syrie* (Paris: Demonville et Soeurs, 1803), 136.
 Of the 4,500 French men who died during the Egyptian campaign, 4,100 died from illness. Dhombres and Dhombres, *Naissance d'un pouvoir,* 123.

24. Brossollet and Mollaret, "A propos des 'Pestiférés de Jaffa,'" 281.

25. Pierre Lelièvre, "Gros, peintre d'histoire," *Gazette des Beaux-Arts* (May 1936): 293.

26. "Se trouvant dans une chambre étroite et très encombrée, il aida à soulever le cadavre hideux d'un soldat dont les habits en lambeaux étoient souillés par l'ouverture d'un bubon abscédé." Desgenettes, *Histoire médicale,* 49–50.

27. Walter Friedlaender, "Napoleon as 'Roi Thaumaturge,'" *Journal of the Warburg and Courtauld Institutes* 4, nos. 3–4 (April–July 1941): 140.

28. Brossollet and Mollaret, "A propos des 'Pestiférés de Jaffa,'" 292.

29. Religion was always a factor during the Egyptian campaign despite Bonaparte's pronouncement of religious neutrality. Dhombres and Dhombres, *Naissance d'un pouvoir,* 111.

30. D. D., "Salon de l'an XIII," *Nouvelles des Arts* 3 (year XIII): 373; and *Annales des sciences, de la littérature et des arts commencées le 24 juillet 1804,* 330.

31. Brossollet and Mollaret propose one of Denon's plates from a mosque in Alexandria as the source for Gros's architecture. There seem to be, however, many significant differences among the architectural elements. Brossollet and Mollaret, "A propos des 'Pestiférés de Jaffa,'" 292. The pointed arches may recall Denon's recognition of the debt of French Gothic to Islamic architecture incurred during the Crusades, a point of view mentioned in Pierre Lelièvre, *Vivant Denon: Directeur des Beaux-Arts de Napoléon* (Paris: Floury, 1942), 95.

32. "L'Europe savante ne saurait voir avec indifférence la jouissance des sciences appliquées à un pays où elle sont ramenées par la sagesse armée et l'amour de l'humanité, après avoir été longtemps exilées par la barbarie et la fureur religieuse." *La Décade Egyptienne* 1 (year VII): 15; quoted in Dhombres and Dhombres, *Naissance d'un pouvoir,* 114. Dhombres and Dhombres also provide a twenty-entry table of medical memoirs on the Egyptian expedition. Ibid., 819–20.

33. Gunther E. Rothenberg, *The Art of Warfare in the Age of Napoleon* (Bloomington: Indiana University Press, 1978), 227–31.

34. Larrey, *Relation historique et chirurgicale,* 87. Brossollet and Mollaret identify the camel as a field ambulance but do not interest themselves in the modernity of the inclusion. Brossollet and Mollaret, "A propos des 'Pestiférés de Jaffa,'" 303.
 Other paintings from the campaign champion French medical expertise. In Desfontaine's 1802 *Battle of Mount Tabor,* the artist included the ambulances arriving on the heels of the

army. Larrey is featured in Lejeune's 1804 *Battle of Aboukir* (Versailles, Musée National du Château), and medical paraphernalia is carefully described. And the whole of Desoria's Salon *livret* entry for the *Arrival of the French Army at the Port of Tentoura in Syria* (Salon of 1810) recounts the story that after a triumph, Bonaparte jettisoned the Turkish arms booty, and the army walked in order to provide horses to evacuate the sick and injured: "Not a single Frenchman was left behind."

Said observes that many early English Orientalists were medical men; he quotes Edgar Quinet's aphorism, "Asia has the prophets; Europe has the doctors." See Said, *Orientalism,* 79.

35. "[Desgenettes est] le médecin en chef de l'armée, aussi célèbre pour ses connaissances que pour son courage." Charles Paul Landon, *Annales du Musée,* vol. 1 (Paris: Pillet aîné, 1832): 122. Schlenoff said that perhaps the picture is a tribute to Desgenettes. Schlenoff, "Baron Gros," 159. In a related drawing, Gros sketched Desgenettes innoculating himself against the plague. The vaccine was an invention of the campaign's medical team.

36. For instance, the critic D. D. thought that Desgenettes's gesture and his facial traits suggest inquietude. D. D., "Salon de l'an XIII," 373.

37. Brossollet and Mollaret use the gesture to offer a brief Freemason interpretation of the painting. Brossollet and Mollaret, "A propos des 'Pestiférés de Jaffa,'" 305–7. Schlenoff noted that in 1805 the government insisted on the invention of the vaccine in their ongoing competition with England. Schlenoff, "Baron Gros," 159.

38. "[Gros] avait voulu trop indiquer, trop prouver. Il avait cherché à montrer, dans les différentes figures, toutes les phases de la maladie contagieuse; ce qui pouvait intéresser sans doute les médecins, mais ce que le public n'aurait pas saisi." Alexandre, *Histoire de la Peinture Militaire,* 140. Alexandre notes that Gros's painting interests doctors because of its factual description.

39. "Au dire des gens de l'art et ceux qui ont eu occasion d'observer les effets de la peste le peintre en a rendu fidèlement les symptômes et les progrès dans ces divers malades." Boutard, "Salon de l'an XII," *Journal des débats* (25 September 1804): 3.

40. D. D., "Salon de l'an XIII," 373. Furthermore, Landon wrote, "The artist consecrated the other part of the picture to expressing the symptoms and cruel effects of the plague of the Levant." ("L'artiste a consacré l'autre partie du tableau à exprimer les symptômes et les effets cruels de la peste du Levant.") Landon, *Annales,* 123.

41. "Tous ses membres contractés annoncent l'excès de son souffrances." Ibid., 123. Grasping a column and pulling himself into the picture space, a blindfolded soldier suffers from ophthalmia, which made it impossible to stand bright light; the symptoms are described in Larrey, *Relation historique et chirurgicale,* 19.

42. "[Les corps] attaqués d'accès convulsifs." Boutard, "Salon de l'an XII," (25 September 1804): 3.

43. "Les yeux sont ouverts, semblent sortir de l'orbite et restent fixes. La peau du visage se décolore, l'individu se contourne sur lui-même, jette des cris lugubres, et expire tout-à-coup." Larrey, *Relation historique et chirurgicale,* 126. The figure with the 32nd regiment's indication on his head covering may recall Larrey's description: "I saw a sergeant major of the 32nd half-brigade, aged 23 years, of a robust constitution, die after only six hours of the sickness (J'ai

vu un sergent-major de la 32ᵉ demi-brigade, âgé de 23 ans, d'une constitution robuste, périr après six heures de maladie seulement.)" Ibid., 125.

44. "Au fond de la plaine que le Nil inonde tous les ans, s'élèvent les pyramides. . . . Les bataillons carrés du fond, sont celui du général Regnier à droite, celui du général Desaix. . . . Les Mamelouks et Arabes sont en désordre autour de ces bataillons." From the 1806 Salon *livret*, p. 63.

45. "[Les] ruées cavalerie fondent en desordre sur l'infanterie française qui les attend de pied ferme." Frédéric de Clarac, "Lettre sur le Salon de 1806," *Journal des Archives de Littérature, d'Histoire et de Philosophie* 12 (1806): 478; in Bibliothèque Nationale, Collection Deloynes, vol. 38, no. 1047, 247.

46. "Quelques Turcs courent pêle-mêle dans ces vastes plaines, massacrant nos blessés." Jean-Baptiste Boutard, "Salon de l'an 1806," *Journal de l'Empire* (10 October 1806): 3. There are others who write essentially the same thing, including the writer signing himself "C." who says: "We love to see the beautiful order and the tranquil courage of the French army in opposition with the trouble and blind fury of the Turks." C., "Salon de 1806," *Mercure de France* 25 (September 1806): 601.

47. "La réponse est facile: la supériorité de notre Tactique tient à cela même. Le plus grand obstacle que le Français avait eu jusqu'ici à vaincre, était sa propre impétuosité. C'est au Génie qui les conduit à la Victoire que nos Guerriers doivent cette assurance froide et cette espèce d'impassibilité au milieu des extrêmes périls." Chaussard, *Pausanias Français,* 219.

48. "La vue des Pyramides ne laisse aucun doute sur le sujet que le peintre a choisi: la symétrie qui, le plus souvent, nuit aux effets pittoresques, leus [*sic*] prête ici un nouveau secours.

L'oeil se promène avec plaisir sur ces bataillons carrés qu'affronte vainement la témérité des Mamelouks." "Salon de 1806," *Le Publiciste* (10 October 1806): 3.

49. "Son Ordre admirable" versus "le tumulte, l'effroi, la rage et le désespoire des Barbares." Chaussard, *Pausanias Français,* 208. Other critics lodge the same complaint with Hennequin. See: C., "Salon de 1806," 600; and Clarac, "Lettre sur le Salon de 1806," 486. One critic said that the public did not hesitate in awarding its sentiment to Lejeune's picture over that of Hennequin's. ("Salon de 1806," 3.) Hennequin, however, posited a fundamental meeting of opposites in his Salon *livret,* where he concludes by saying: "Few of the French perished in that memorable battle: everyone stayed in their rows. (Peu de Français périrent dans cette mémorable bataille: tous restèrent dans leurs rangs.)" Quoted in Chaussard, *Pausanias Français,* 206.

Hennequin had taken over Vincent's 1800 commission, as the latter had fallen ill. See Philippe-Auguste Hennequin, *Mémoires de Philippe-Auguste Hennequin,* ed. Jenny Hennequin (Paris: Calmann-Lévy, 1933), 223–24.

After viewing Gros's entry (*Battle of Aboukir*) in the same Salon, Chaussard was compelled to credit France's success to a long tradition of French rationalism, to the French character, which is opposite the Oriental character: "Corneille, this profound genius, expressed in a single verse all the character of heroism: 'Valor is only valor as long as it is calm.'" Chaussard, *Pausanias Français,* 76.

50. "Les tableaux de cet artiste [Lejeune] sont moins des compositions pittoresques que les

représentations exactes des faits d'armée, tels qu'ils se sont passés, et auxquels le peintre a le plus souvent pris part lui-même." Boutard, "Salon de l'an 1806," 2. See also, for instance, C., "Salon de 1806," 601; and Clarac, "Lettre sur le Salon de 1806," 484.

51. "Lejeune, chef de bataillon au corps impérial du génie, élève de M. Valenciennes." This position is continued in recent publications, such as Marguerite Gaston, "Le Général baron Lejeune (1775–1845)," *Bulletin du Musée Bernadotte* (Pau) 20 (December 1975): 25–26.

52. "Il est aisé de reconnaître qu'il a eu les camps pour ateliers et les champs de batailles pour modèles." D. B., "Salon de l'an XII," *Le Publiciste* (16 October 1804): 1–2.

53. "Ce n'est sans doute pas sans y avoir pensé que l'auteur a sacrifié ici les intérêts de l'art à ceux de l'histoire." Boutard, "Salon de l'an XII," *Journal des débats* (3 October 1804): 2–3.

54. Gaston, "Le Général baron Lejeune (1775–1845)," 21–22; Louis Sonolet, "Le Général baron Lejeune," *Gazette des Beaux-Arts* 33 (1905): 282–88; Fournier-Sarlovèze, *Le Général Lejeune* (Paris: Librairie de l'art ancien et moderne, 1902), 24. Also, see Siegfried on Lejeune's military-artistic profile and his use of conventions of scientific drawing. Siegfried, "Naked History," 235–58.

55. "Le beau portrait que nous reproduisons au début de cette étude explique admirablement l'oeuvre de Lejeune. L'ensemble du personnage est d'une distinction raffinée et qui n'est pas exempte de recherche. Le front vaste, sous les cheveux qui s'envolent au vent des balles, révèle l'imagination, l'esprit précis et sûr. Autour de l'imprudent artiste, la bataille gronde, mais l'oeil clair, scrutateur, souriant, n'en continue pas moins à observer et la main à dessiner. Devant cette allure martiale et décidée, on devine qu'il peint comme il se battait: à la française." Sonolet, "Le Général baron Lejeune," 302. The Chassaignac painting is said to be a copy after an 1810 Salon miniature by Guérin, which seems to have passed to the sitter's family and possibly been destroyed in a fire. Other variants are kept at Versailles and the Ecole des Beaux-Arts, Toulouse.

56. "J'ai déjà été récompensé de l'abandon que j'ai fait de cet amour-propre par la complaisante curiosité que vous avez mise, citoyens, à observer avidement le nombre immense des dessins que j'ai rapportés; dessins que j'ai faits le plus souvent sur mon genou, ou debout, ou même à cheval: je n'ai jamais pu en terminer un seul à ma volonté." Denon, *Voyage* (1802) 1:iv, 2.

Appositely, Stafford places Denon at the end of an Enlightenment tradition, in the humanist tradition of a scientific or predominantly factual voyage that signified a new golden age of humanitarian interests united with science in the noblest occupation—to explore distant parts of the globe. Barbara Maria Stafford, *Voyage into Substance: Art, Science, Nature, and the Illustrated Travel Account, 1760–1840* (Cambridge: MIT Press, 1984), 25. In the line of works she describes, including Denon's, "art could again serve a practical purpose; it could be a vehicle for knowledge without stigma." Ibid., 29. For Stafford, Denon provides the image of an artist in hot pursuit of novel images, riding across an unexplored desert. Ibid., 50.

Denon belongs with the scholars of the Egyptian campaign whom Said considers inaugural heroes of Orientalism, who put Orientalism on a scientific and rational basis through scrupulous observation in the face of Eastern perils. Said, *Orientalism,* 122.

Bendiner remarked on the critical importance of amateur and scientific draftsmen to the early British Orientalists. Bendiner, "Portrayal of the Middle East in British Painting," 2, 9.

57. See Siegfried, "Naked History," 236.

58. In 1810, Napoleon chose Guérin's picture and ten others to be translated into tapestries. Fernand Calmettes, *Etat général des tapisseries de la manufacture des Gobelins depuis son origine jusqu'à nos jours, 1600–1900,* ed. Maurice Fenaille, vol. 5: *1794–1900* (Paris: Imprimerie Nationale, 1912), 220, 237.

59. "L'armée se range en colonnes mobiles." This is repeated by an anonymous critic; see *L'Observateur au Museum ou Revue critique des ouvrages de peinture, sculpture et gravure exposés au musée Napoléon en l'an 1810* (Paris: Aubry, n.d.), 12.

60. Napoleonic clemency in Egypt is the subject of other pictures such as Rigo's *The Clemency of His Majesty the Emperor toward the Divan in Egypt* and *The Clemency of His Majesty the Emperor toward an Arab Family,* both of the Salon of 1806; as well as Colson's *Entry of General Bonaparte in Alexandria* (Salon of 1812; Musée National du Château, Versailles), in which Bonaparte grants clemency to a pleading, fawning family as French troops enter the city.

61. "Un trophée précieux à ces barbares; . . . [mais à laisser substituer sur ce visage ce que] la beauté, la jeunesse, la majesté des traits, ce qu'un certain caractère de douceur et de noblesse, attributs ordinaires d'une vie prospère, doivent exciter de regret et de pitié sur une mort cruelle." Boutard, "Salon de 1810," *Journal de l'Empire* (21 December 1810): 2–3.

62. Brown University, *All the Banners Wave: Art and War in the Romantic Era, 1792–1851,* exh. cat. (Providence: Brown University, 1982), 52.

63. Betts wrote: "Indeed, it has been argued that all colonial enterprises in the nineteenth century required the establishment of cultural antitheses, without which the ideologies of liberalism and democracy would have seemed moral contradictions to an imperialism fundamentally based on force and domination." R. F. Betts, "The French Colonial Empire and the French World-View," in *Racism and Colonialism: Essays on Ideology and Social Structure,* ed. R. Ross (Dordrecht: Martinus Nijhoff, 1982), 68.

Weber wrote about the myth of a national, providential mission:

> *Another element of the early idea was the notion that this mission was facilitated solely through the very cultivation of the peculiarity of the group set off as a nation. Therewith, in so far as its self-justification is sought in the value of its content, this mission can consistently be thought of only as a specific "cultural" mission. The significance of the "nation" is usually anchored in the superiority, or at least the irreplaceability, of the culture values that are to be preserved and developed only through the cultivation of the peculiarity of the group. It therefore goes without saying that the intellectuals, as we have in a preliminary fashion called them, are to a specific degree predestined to propagate the "national idea," just as those who wield power in the polity provoke the idea of the state.* (Weber, "The Nation," 24–25)

64. "Une émeute populaire dans une ville conquise, une entreprise restée sans résultats, la révolte inutile d'une poignée de barbares." Boutard, "Salon de 1810" (21 December 1810): 1.

For a discussion of the disinclination in the field of art history to examine the homoerotics

of Girodet's paintings, see James Smalls, "Making Trouble for Art History: The Queer Case of Girodet," *Art Journal* 55, no. 4 (Winter 1996): 20–27.

65. "L'Empereur, élevé sur un tertre, vient de pardonner aux révoltés du Caire: sa figure exprime la fermeté et l'indulgence." *Observations sur le Salon de l'an 1808* (Paris: Ve Gueffier, Delaunay, 1808), 16.

66. "Ces malheureux ont imploré la clémence du vainqueur, et le pardon a été accordé; quelques-uns sont encore prosternés en attitude de suppliants et déjà plusieurs lèvent au ciel leurs mains dégagées des fers." Boutard, "Salon de 1808," *Journal de l'Empire* (22 October 1808): 2.

67. "La vengeance est empreinte dans leurs regards: ce sont des tigres altérés de sang." *Examen critique et raisonné des tableaux des peintres vivants formant l'exposition de 1808* (Paris: Ve. Hocquart, 1808), 29.

68. For an overview of Freudian views of projection, see Jean Laplanche and J. B. Pontalis, *The Language of Psychoanalysis,* trans. Donald Nicholson-Smith (New York: Norton, 1973), 349–52.

69. Boutard recognized Guérin's gambit as a fashion among French painters but did not feel that it had succeeded: "Afin de profiter du ciel brillant de l'Egypte, et de ménager des accidens de jour, M. Guérin a fait venir la lumière du fond du tableau: pratique dangeureuse, que de grandes scènes ont mis en vogue dans notre école, mais qui ne réussit point toujours également bien. Ainsi l'effet est ici peu satisfaisant." Boutard, "Salon de 1808," 3. One critic does find the light too divided, not focused enough like baroque lighting. *Examen critique des tableaux de 1808,* 30.

70. "On demeure étonné du génie singulier de l'auteur pour inventer la figure . . . selon son tempérament, sa profession, ses habitudes nationales." Boutard, "Salon de 1810" (21 December 1810): 3.

71. Denon's written description of the plate refers to the abject state of the Mameluke who can never move up a grade in society. Denon, *Voyage,* 2:33. Schlenoff reproduces a similar plate and says that studies like this "found their way into Gros's painting." Schlenoff, "Baron Gros," 154, figure 1.

The stereotype was first an invention in printing technology announced in 1798 by Didot. Within a few decades, the word gained its current usage as in "a stereotyped expression." See introduction in Sander L. Gilman, *Difference and Pathology: Stereotypes of Sexuality, Race, and Madness* (Ithaca and London: Cornell University Press, 1985), 15–36.

72. The influence of Gros's *Battle of Nazareth* is undisputed: Monsieur Auguste, Théodore Géricault, and Horace Vernet copied it, and Eugène Delacroix proclaimed his fealty. Stevens, *The Orientalists,* 163; Detroit Institute of Arts, *French Painting 1774–1830: The Age of Revolution,* exh. cat. (Detroit: Wayne State University Press, 1975), 468–70.

73. George Levitine, *Girodet-Trioson: An Iconographical Study* (New York: Garland, 1978), 278a.

74. Woolf says that the statement was recorded during Napoleon's first exile at St. Helena, and this may be apocryphal. Woolf, "The Construction of a European World-View," 86n. 34. Indeed it may be, but it antedates St. Helena. Gros printed it in the Salon *livret.* Laurens maintains that the original quote was, "Allez, et pensez que du haut de ces monuments quarante

siècles nous observent," and that through usage in the nineteenth century it became known as "Du haut de ces Pyramides, quarante siècles vous contemplent." Laurens, *L'Expédition d'Egypte,* 88.

Brunner says that the picture's subject came from Denon in a letter to Napoleon. Brunner, "Antoine-Jean Gros," 291.

The historical greatness of Egypt is intoned by the looming pyramids in paintings of the Battle of the Pyramids, such as those by F. Watteau, 1799 (Musée des Beaux-Arts, Valenciennes); Vincent, 1800–1806, figure 33; and Lejeune, 1806, figure 32.

In 1809, Gros's painting was commissioned for the Imperial Senate. Originally its format was vertical. In 1835, Louis-Philippe hired Gros and his studio to enlarge the canvas horizontally, thereby achieving its current state. The Cleveland Museum of Art posesses two full-sized preparatory oil paintings for the addition, generally thought to be by Gros's hand. After Gros's suicide, his assistant Auguste-Hyacinthe Debray completed the additions to the canvas, and it went first to the Salon of 1806 and then to the July Monarchy's Galerie historique at Versailles, where it is found today. See Alisa Luxenberg, *"General Kléber* and *Egyptian Family,"* in *Catalogue of Nineteenth-Century European Painting,* ed. Louise d'Argencourt (Cleveland: Cleveland Museum of Art, 1998).

75. The canvas is soundly attributed to Jean-Pierre Franque (1774–1860) and not his brother Joseph. Detroit Institute of Arts, *French Painting 1774–1830,* 421–22.

76. "On voit sur le devant, à gauche du tableau, trois guerriers, un Turc, un Arabe et un Africain mortellement blessés. Ce groupe, d'un bon effet pittoresque, est allégorique; il représente les nations vaincues dans la guerre d'Egypte." Boutard, "Salon de 1810," *Journal de l'Empire* (23 November 1810), 1. Boutard also credited Gros's transparent color as true in all parts of the picture. Ibid., 2.

It should be noted that parts of the left and right of the painting, including Kléber on the rearing brown horse and the Arab family, were added for the 1836 reexhibition of the picture. Schlenoff, "Baron Gros," 156–57.

77. Matthew Smith Anderson, *The Great Powers and the Near East 1774–1923* (London: Edward Arnold, 1970), 28–55.

78. Nina Athanassoglou-Kallmyer, *French Images from the Greek War of Independence, 1821–1830: Art and Politics under the Restoration* (New Haven: Yale University Press, 1989), 39–41. Woolf is interested in the Egyptian campaign for examining how France could use it to unite Europe. Woolf, "Construction of a European World-View," 86. In this regard, see the circulation of the Sèvres Egyptian service among European capitols in Porterfield, "Egyptomania," 87–88.

79. "Les tableaux dont nous parlons sont contemporains d'un siècle déjà bien loin de nous." Alfred de Musset, "Exposition au Profit des Blessés dans La Galerie du Luxembourg," in *Oeuvres complètes de Alfred de Musset,* ed. Edmond Biré, vol. 7, *La Confession d'un enfant du siècle* (Paris: Garnier Frères, 1975), 249–51. Originally published in *Le Temps* (27 October 1830).

80. See Michael Marrinan, "Shadowboxing Napoleon's Glory: The Orléanist Revival of Imperial

Imagery," Part 4, in *Painting Politics for Louis-Philippe: Art and Ideology in Orléanist France, 1830–1848* (New Haven: Yale University Press, 1988), 141–200. He discusses Louis-Philippe's use of Gros's *Battle of Aboukir* in the Salle du Sacre at Versailles in terms of Louis-Philippe's personal political advancement but not in terms of his foreign policy. Ibid., 150–54.

CHAPTER 3

1. Denon is identified through the pun, "de nom." The print is reproduced in Humbert et al., *Egyptomania,* 316. In discussing a wallpaper design of 1818 that depicts General Kléber in Egypt, Humbert apparently shares the opinion of the anti-Denon printmaker, as he finds it "peu conforme à l'esprit de la Restauration." Ibid., 318.

2. The foreword of the Restoration's first volume in the grand folio edition says only that recent political events delayed the publication and that Louis's high esteem for the arts and sciences naturally compelled him to insure its continuation. See this "Avertissement" in *Description de l'Egypte,* 1st ed., vol. 4 (1817).

 The Restoration's own edition attributes the opportunity to acquire an exact knowledge of Egypt to the victorious French army. See Siméon's short introductory essay in *Description de l'Egypte,* 2nd ed., 1:n.p.

 In the first volume of the grand folio edition, a second and later frontispiece, drawn by Louis Lafitte (1770–1828), has been inserted in the example in the Département des Cartes et Planches of the Bibliothèque Nationale, Paris. Below a bust of Louis XVIII, a cartouche declares: "His Majesty Louis XVIII ordains that the *Description de l'Egypte* be continued and that its editions be multiplied." Lafitte's drawing seems to be a model for an engraving. It has not, to my knowledge, been previously published, although it was exhibited at the Bibliothèque Nationale in the "Exposition de 1875. Congrès International des Sciences géographiques," where it was the forty-sixth item.

 Piussi's valuable and synthetic (but not critical) historical account, "Images of Egypt during the French Expedition (1798–1801)," distinguishes between the pure science of the work of the savants and the political work made of it by politicians, beginning with Napoleon. She says, "The publication itself was not overtly Napoleonic, apart from the frontispiece and the Preface." Piussi, "Images of Egypt during the French Expedition," 169. She cites Jomard's letter to the Minister of Interior of the first Restoration (Ibid, 166–67), in which he proclaims the *Description* nonpartisan, reasoning that it has its origins in the Enlightenment of the ancien régime and that the study of Egypt dates to antiquity. BN, NAF 3580, 26 July 1814, 21–23.

3. "Il y a trente ans, les travaux historiques sur la Grèce, Rome et l'ancienne Europe semblaient près d'être épuisés, et l'Orient paraissait fermé pour toujours aux justes désirs des savans et des artistes. Mais bientôt la puissance anglaise leur révéla les trésors littéraires de l'Industan. Une expédition, toute militaire dans son but, toute scientifique dans ses résultats, livra à leur méditation l'antique Egypte toute entière." La Rochefoucauld went on to write, "Relative-

ment aux monuments d'Egypte, une érudition consciencieuse ne pouvait opposer que des déductions conjecturales aux assertions diverses. Les monuments portaient en eux-mêmes la solution de tant de difficultés: mais l'interprétation des écritures hiéroglyphiques était encore un mystère qui durait quinze cents ans. Tout fut subitement changé par la découverte de l'alphabet des hiéroglyphes, dont l'application a déjà été très utile à la vérité de l'histoire et à l'affermissement des saintes doctrines." AN O3 1276, 15 May 1826. The objectives for this new division of the Louvre and for its first curator were stated clearly: to acquire and study, to facilitate historical research, and to enlighten the public. Champollion was required to teach a free and public course each season on Egyptian archaeology, emphasizing systems of writing.

A brief history is offered in Christiane Ziegler, "Le Musée égyptien de Champollion," *La Revue du Louvre* 4 (1990): 264–66.

4. In addition, Champollion won space on the first floor for the heaviest objects. Pierre Quoniam, "Champollion et le Musée du Louvre," *Bulletin de la Société Française d'Egyptologie* 95 (October 1982): 47–49.

The term "Musée d'Egypte" was always used to mean at least the rooms curated by Champollion and decorated by Gros, Vernet, Pujol, and Picot. It also came to include the Salle des Papyrus. Contemporaries sometimes called the Musée d'Egypte the Musée Charles X and vice versa. These nine rooms comprised the Musée Charles X from their conception in 1825 to the commissions of 1828, which launched the decorative program for the southern aisle intended to complete the Musée Charles X.

The Egyptian and the Greek and Roman collections are mediated by the largest room, number 5, the Salle des Colonnes.

5. He signed his articles "Ch" and was apparently Champollion-Figeac. "Beaux-Arts.—Salon, Sixième Article," *Le Moniteur universel* 29 (29 January 1828): 112.

6. The documents suggest that Forbin chose the artists and that there was consultation among all the parties regarding subject and execution, although La Rochefoucauld had the preponderant influence on the political meaning of the cycle.

Aulanier wrote that La Rochefoucauld suggested Ingres's subject. Christiane Aulanier, *Le Musée Charles X et le Département des Antiquités Egyptiennes* (Paris: Editions des Musées Nationaux, 1961), 36.

La Rochefoucauld referred to the Musée Charles X as "my work." Sosthènes de La Rochefoucauld, *Mémoires,* 11 vols. (Paris: Michel Lévy Frères, 1862–63), 9:493. Judging from his politics and job, I am inclined to think that the 1828 plan was his assertion of power, remaking the plan after the Triple Alliance was signed. In certain letters, however, Forbin writes La Rochefoucauld asking only for approval of subjects already conceived. AL P6 dossier 118, letter of 4 May 1827.

In another instance, the painter, this time Pujol, wrote Forbin, revoking his earlier subject and suggesting an alternative. At first, Pujol had projected painting the triumph of Paul-Emile. A week later he wrote back to Forbin that he would paint a story from the life of

Joseph, as it would conform better to the majority of subjects that occur in Egypt and as this room was to receive Egyptian objects. AL P30 Pujol, 30 July and 5 August 1826.

Champollion-Figeac also consulted with Picot on the subject of his picture. The former wrote his brother in Italy on 15 May 1826, "M. Picot habile artiste et chargé des peintures de plafond, s'est concerté avec moi pour le sujet: une allégorie représentant le génie de la France relevant et dévoilant d'une main l'antique Egypte, assise, appuyée auprès d'un vieux temple orné de cartouches des plus grands rois, montrant de l'autre main et dans le lointain Paris avec les tours de Notre-Dame, quelques vestiges et un obélisque en honneur de Charles X. Ce sujet a plu au peintre mais nous devons en reparler. Si tu as quelque idée à cet égard, marque-le-moi et bien vite." Quoted in Monique Kanawaty, "Les Principes muséologiques de Champollion," in *Akten des Vierten Internationalen Ägyptologen Kongresses, München 1985,* ed. Sylvia Schoske (Hamburg: Helmut Buske, 1988), 57.

7. Heim was notified by 28 May 1826 (AN O3 1423); Gros by 7 July 1826 (AL P30 Gros); Abel de Pujol by 30 July 1826 (AL P30 Abel de Pujol); Ingres learned sometime in 1826, according to a payment of 6 January 1827 (AL P30 Ingres). See also Nicole Munich, "Les Plafonds peints du Musée du Louvre: Inventaire des documents d'Archives," *Archives de l'Art Français* 26 (1984): 135–42. Picot knew by 9 August 1826. Two documents antedate those that Munich lists. See AN O3 1421; and AL 2DD11, "Commandes Règne de Charles X," 17.

Before the artists had begun their paintings, the framework for the collections and the ceiling paintings along with the walls, moldings, furniture, and decorative sculpture—in short, the décor—had to be determined. Champollion proposed Egyptianizing and didactic interiors, representing, for example, different types of Egyptian columns. However, the court architect Pierre Fontaine's proposal, sumptuous and generally classicizing, was followed. Champollion ended his studies early in Italy because of this dispute with Forbin and Fontaine (letter of 4 October 1826). He shuddered at the thought of Egyptian objects in what he derided as a Gothic setting. Louis de Blacas, "Inventaire analytique de quelques lettres nouvelles de Champollion le jeune," in *Recueil d'études égyptologiques dédiées à la mémoire de Jean-François Champollion à l'occasion du centenaire de la lettre à M. Dacier* (Paris: Librairie Ancienne Honoré Champion, Edouard Champion, 1922), 9.

Fontaine's decisive role is confirmed in Auguste Jal, *Esquisses, Croquis, Pochades ou Tout ce qu'on voudra, sur le Salon de 1827* (Paris: Ambroise Dupont, 1828), 195.

8. In a letter of 14 November 1828, Alphonse de Cailleux, Forbin's second in the administration of the Royal Museum, sent the vicomte de La Rochefoucauld a plan of the new program and explained that the changes would achieve a new thematic unity and thus better accord with the purpose of these galleries of antiquities. Alphonse de Cailleux, Paris, to the vicomte de La Rochefoucauld, 14 November 1828, AN O3 1423, dossier 764.

There is a draft of this plan in the Archives du Louvre, T16, dossier 1832. The program was still in effect 18 November 1829, when Forbin sent La Rochefoucauld a list of recent commissions and scheduled payments. AN O3 1426, dossier 962. The plan and letter reveal that Vernet's *Julius II Giving Wreaths and According Honors to Michelangelo and Raphael* was slated

to be moved to the other aisle to be replaced by "an Egyptian subject" by Couder. "Le pla-
fond [celui de Vernet] est déjà exécuté dans la salle no. 2. M. Couder qui a reçu une com-
mande sera chargé de son remplacement qui représentera un sujet Egyptien." Forbin to the
vicomte de La Rochefoucauld, 18 November 1829, AN O3 1426, dossier 962.

Additionally, A.-E. Fragonard's *Francis I Receiving the Pictures and Statues Brought from Italy
by Primaticcio* was to be moved to the new aisle and replaced by a second painting commis-
sioned from Picot.

This series, for the new Galerie Campana aisle, was more like a group of giant troubadour
paintings in contrast to the heavily allegorical and loaded historical ensembles of the more
neoclassical pictures in the north aisle, which are of greater concern here.

A good overview is provided by Chaudonneret, "Historicism and 'Heritage' in the Louvre,"
488–520.

9. "Quant aux plafonds, les sujets sont froids, fades, ou ridicules: c'est dans l'ordre. On devrait
bien en finir avec ces Frances en manteau fleurdelis avec les arts tenant la palette ou la lyre,
ces temples de la gloire, de la victoire, et toutes ces niaises flagorneries qu'imaginent des
courtisans au cerveau rétréci: le règne des allégories est passé." [Vergnaud], "Figaro au Sa-
lon. Les nouvelles salles," *Le Figaro* 432 (18 December 1827): 927.

The *bataille Romantique*'s hold on critics is exemplified in Ary Scheffer, "Salon de 1827,"
Revue Française 1 (1828): 206–7. "Dans cette suite nombreuse de plafonds et de tableaux, la
marche distincte des deux écoles est bien sensible."

10. Anchel, "La Commémoration des rois de France." M. C. Sahut noted that the cycle is dedi-
cated to the glory of royal patronage. See M. C. Sahut's *"Les Nymphes de Parthénope,"* in Jacques
Foucart, ed., *Nouvelles acquisitions du Département des Peintures 1983–86,* exh. cat. (Paris: Réunion
des Musées Nationaux, 1987), 172.

11. In the central Salle des Colonnes, six rectangular ceiling panels provided a lineage of princely
patrons: Pericles, Louis XIV, Augustus, Francis I, Leo X, and the culmination of these princely
patrons, Charles X. Below was a sculpted portrait bust of the king by Pradier. See E. J. Delé-
cluze [signed D.], "Musée Charles X," *Journal des débats* (16 December 1827): 2. The 1828
commission would have added to the southern aisle depictions of Clovis, Charlemagne, Fran-
cis I, Henri IV, Louis XIII, and Louis XIV.

12. "Il a supposé l'Egypte couverte par le Temps d'un voile mystérieux que des puissances sur-
naturelles pouvaient seules soulever. Il a donné à la Nymphe d'Hellas l'amour de la science,
le désir des paisibles conquêtes sur la terre de l'antique civilisation, et il l'a fait voyager aux
contrées du Nil, guidée par l'Etude et le Génie. Portée sur des nuages, éclairée par le flam-
beau de l'Esprit des découvertes, et soutenue par l'Etude, la Grèce est arrivée au-dessus des
Pyramides; auprès de leurs ruines, elle aperçoit le vaste linceul qui cache à tous les yeux l'imor-
telle des Pharaons. Aux ordres de ces célèstes guides, plusieurs petites filles Génies lèvent
la draperie qui laisse voir l'Egypte, étonnée et comme rappelée doucement d'un sommeil pro-
fond." Jal, *Esquisses . . . sur le salon de 1827,* 215–16. François Picot (1786–1868), a student of
Vincent, shared the Grand Prix de Peinture in the competition for the Prix de Rome in 1813

for a now lost painting of an Egyptian subject, *The Death of Jacob*. He was awarded the Legion of Honor in 1824. Philippe Grunchec, *Le Grand Prix de Peinture: Les Concours des Prix de Rome de 1797 à 1863* (Paris: Ecole Normale Supérieure des Beaux-Arts, 1983), 154–55.

The ceiling painting was exhibited at the Salons of 1827 and 1833. Picot painted the vaults. Vinchon and Gosse painted the eight antique scenes imitating bas reliefs, painted in grisaille. The subjects are a Greek sculptor copying an Egyptian Isis; Phidias sculpting after nature; Apelles choosing his models; the origin of drawing; the origin of the Corinthian capital; Orpheus singing; a tragic poet rehearsing a role with an actor; and the barbarians overthrowing the monuments of Greece. Picot's ceiling painting has been discussed by Sahut in a catalogue entry on the preparatory oil sketch, *"L'Etude et le Génie dévoilent l'antique Egypte,"* in Foucart, ed., *Nouvelles acquisitions du Département des Peintures,* 174–75.

13. "Le sujet du plafond indique la transition de la civilisation égyptienne à la grecque." Delécluze, "Musée Charles X," 2.

The figure of Egypt is based on the goddess Neith, "the Egyptian Athena," from Jean-François Champollion, *Le Panthéon Egyptien, Collection des Personnages Mythologiques de l'ancienne Egypte, d'après les monuments* (Paris: Firmin Didot, 1823), 6.

As Gossman has written, "in the period between 1815 and 1848 the task of providing a convincing foundation for the postrevolutionary regimes was taken up by philosophers, lawyers, and historians alike." The Romantic historian tried to unveil a history that would reveal continuity between remotest origins and the present, between the other and the self, in order to ground the social and political order. Lionel Gossman, *Between History and Literature* (Cambridge: Harvard University Press, 1990), 257–58.

14. Andrew McClellan, "The Musée du Louvre as Revolutionary Metaphor during the Terror," *Art Bulletin* 70, no. 2 (June 1988): 300, 303–4.

15. Ozouf observed, "There is no end to the list of spatial metaphors associated with the Republic or with Revolutionary France: from the beginning of the Revolution a native connivance linked rediscovered liberty with reconquered space. The beating down of gates, the crossing of castle moats, walking at one's ease in places where one was once forbidden to enter: the appropriation of a certain space which had to be opened and broken into, was the first delight of the Revolution." Mona Ozouf, *La Fête révolutionnaire, 1789–1799* (Paris: Gallimard, 1976), 205.

McClellan explains: "Inside the museum, the feeling of Revolutionary conquest was unequivocal. The works of art on display had been prized from their pre-Revolutionary settings and returned to their 'rightful' owners: the people." McClellan also discusses the shift from a republican to an imperial Louvre with the arrival of the Italian spoils. Andrew McClellan, *Inventing the Louvre: Art, Politics, and the Origins of the Modern Museum in Eighteenth-Century Paris* (Cambridge: Cambridge University Press, 1994), 98, 120–23.

16. "Que la galerie offirra une suite noninterrompue des progrès de l'art et des degrés de perfection où les ont portés tous les peuples qui les ont successivement cultivés." Casimir Varon, *Rapport du Conservatoire du Muséum national des arts* (Paris, 1794); reprinted in Yveline Cantarel-

Besson, ed., *La Naissance du Musée du Louvre*, 2 vols. (Paris: Réunion des Musées Nationaux, 1981), 2: 226–29; quoted in McClellan, *Inventing the Louvre*, 113.

17. Antoine-Chrysostome Quatremère de Quincy, *De l'Architecture Egyptienne, considérée dans son origine, ses principes et son goût, et comparée sous les mêmes rapports à l'Architecture Grecque* (Paris: Barrois l'aîné et fils, 1803), 2, 11.

When the Zodiac of Denderah was acquired in 1822 and placed in the Cabinet des Médailles, Quatremère said it had only historical value. Monique Kanawaty, "Les Acquisitions du Musée Charles X," *Bulletin de la Société Française d'Egyptologie* 104 (October 1985): 33–34. See also Monique Kanawaty, "Vers une politique d'acquisitions: Drovetti, Durand, Salt et encore Drovetti," *La Revue du Louvre* 4 (1990): 267–72.

18. The duc de Blacas in turn published extracts in the *Moniteur universel* and other periodicals, which helped turn the tide. Kanawaty, "Acquisitions du Musée Charles X," 34. On an important precursor to the Musée d'Egypte, Turin's Museo Egitto, see Silvio Curto, "Jean-François Champollion et l'Italie," *Bulletin de la Société Française d'Egyptologie* 65 (October 1972): 13.

19. Other acquisitions included fifteen Egyptian antiquities from Brindeau in 1827; the Egyptian treasures from Denon's estate after his death in 1827; a gift from Muhammad Ali of thirty pieces of jewelry; and the Caillaud collection in 1830. Kanawaty, "Acquisitions du Musée Charles X," 34–40.

One of the motivations for the collection of Egyptian objects was compensatory. In recommending the purchase of the Durand collection, Forbin told the vicomte de La Rochefoucauld who told the king that the collection would fill the lacuna left from the hazards of war that despoiled the Musée Royal of its own war trophies. AN O3 1422, dossier 602, 19 November 1824; and AN O3 1276, dossier 42, 26 November 1824.

One critic suggested that the new acquisitions would replace and compensate for the Greco-Roman antiquities surrendered in the humiliating treaty of Vienna: "The new Museum, the Musée Charles X, displays for our eyes a mass of riches carrying all the interest that attaches itself to the least debris of Etruscan and Egyptian antiquity. At the sight of the new rooms, magnificent depot of so much learned and laborious conquests from the remote ages, one is consoled for the losses that the vicissitudes of fate have cost France." ("Le nouveau Musée, le Musée Charles X, étale à nos yeux une masse de richesses portant avec elles tout l'intérêt qui s'attache aux moindres débris des antiquités étrusques et égyptiennes. A l'aspect de ces nouvelles salles, magnifique dépôt de tant de savantes et laborieuses conquêtes sur les âges écoulés, on est consolé des pertes que les vicissitudes de la fortune ont coûté à la France.") Alphonse Rabbe, "Exposition de 1827. Restitution du Salon carré et ouverture du nouveau Musée," *Courrier Français* 351 (17 December 1827): 4.

20. Martin Rosenberg, "Raphael's Transfiguration and Napoleon's Cultural Politics," *Eighteenth-Century Studies* 19, no. 2 (Winter 1985–86): 182.

Supporting the demotion of Greece and Rome as societal models, Merle urged French artists to follow the classics only as aesthetic guides. J. T. Merle [signed P.], "Sur le Salon de 1827," *La Quotidienne* 115 (24 April 1828): 3–4.

21. "Ce pays, que visitèrent les plus illustres philosophes de l'antiquité, fut la source où les grecs puisèrent les principes des lois, des arts, et des sciences." From unsigned essay added at the beginning of the Restoration edition of the *Description de l'Egypte,* 2nd ed., 1: n.p.

 On the previous proposals for Egypt as the forerunner of Greek classicism, see Syndram, "Das Erbe der Pharaonen zur Ikonographie Ägyptens in Europa," in Martin-Gropius-Bau, *Europa und der Orient,* 18–55; see, too, his entry on the comte de Caylus in the same catalogue, pp. 401–2.

 On Winckelmann's followers, who continued to support the primacy of Greece and Rome, see Robert Maricha, "Champollion et l'Académie," *Bulletin de la Société Française d'Egyptologie* 95 (October 1982): 24.

22. "Les arts ont commencé en Grèce par une imitation servile des arts de l'Egypte. . . . Sans l'Egypte, la Grèce ne serait probablement point devenue la terre classique des beaux-arts." Champollion, *Lettres et journaux ecrits pendant le voyage d'Egypte,* 335–36.

23. Coupin objected to this subject, protesting that Naples is not a desert, that the arts still are cultivated there. Coupin [signed P. A.], "Beaux-Arts. Exposition des tableaux en 1827," *Revue Encyclopédique* 37 (January 1828): 307.

 Editor-in-chief of the *Journal des Artistes* from 1827 to 1835, Farcy observed the unseemliness of the destruction of antiquity in an antiquities museum: "Est-ce au dix-neuvième siècle," he asks, "qu'il convient de représenter le maître de l'univers s'amusant à détruire deux ou trois villes charmantes qui n'avaient rien fait pour mériter un tel châtiment, et prêtant le feu sacré, à l'un de ses agens, pour opérer cette belle oeuvre!" Charles Farcy, "Musée Royal. Exposition de 1827. Musée Charles X," *Journal des Artistes* 11 (13 January 1828): 18.

24. Picot's second painting for the cycle was commissioned in 1828 to replace A.-E. Fragonard's painting.

 On scenes of the destruction of Pompeii, see University of Michigan Museum of Art, *Pompeii as Source and Inspiration: Reflections in Eighteenth- and Nineteenth-Century Art,* exh. cat. (Ann Arbor: University of Michigan Museum of Art, 1977); and Jean Seznec, "Herculaneum and Pompeii in French Literature of the Eighteenth Century," *Archaeology* 3, no. 7 (Autumn 1949): 150–58. Two especially relevant images in this context are Forbin's *La Mort de Pline,* exhibited in the Salon and reproduced in his *Portefeuille du Comte de Forbin,* 49; and Joseph Franque's *Scene during the Eruption of Vesuvius,* which was exhibited in the last month of the 1827–1828 Salon. On the latter, see Donald A. Rosenthal, "Joseph Franque's *Scene during the Eruption of Vesuvius,*" *Philadelphia Museum of Art Bulletin* 75, no. 324 (March 1979): 2–15.

25. The documents are listed in Munich, "Les Plafonds peint du Musée du Louvre," 132.

 Mauzaisse's Father Time comes full circle in the July Monarchy. In *Le Code Napoléon couronné par le Temps* (1833, Malmaison), Time has put down his scythe to crown Napoleon, who is recording what came to be known as the Napoleonic Code.

 This reactionary and deep ambivalence toward Greco-Roman antiquity is found also in the Nazarene Philip Veit's *Colosseum Restored,* a lunette fresco decorating the Galleria Chiaramonti in the Vatican Museum. The Galleria Chiaramonti may have been an influence on the

creation of the Musée Charles X and its decorative program. Canova organized and commissioned the Italian analogue in 1816 to celebrate the restitution of works from Paris and to pay homage to Pius VII for the development of Rome as center for the study and production of the fine arts. Nine artists painted fifteen lunettes to glorify specific acts of papal patronage, including the restoration of ancient monuments in Rome. It was mostly complete in 1818 and definitively in 1821. Ulrich Hiesinger, "Canova and the Frescoes of the Galleria Chiaramonti," *Burlington Magazine* 120, no. 907 (October 1978): 655.

Veit's picture is singular in the Italian cycle. Rather than emphasizing the restoration of the Colosseum as an act of archaeological preservation, as one of his colleagues did, the deeply Catholic Veit showed it as an act of piety, an obligation to Christian principles to memorialize the Christians martyred there. In the center of the Colosseum sits an allegory of Religion, holding a cross and palm amidst instruments of martyrdom and an overturned pagan altar. (Ibid., 659–61.) Religion, quite literally, has filled the void of antiquity.

26. Donat de Chapeaurouge, "Ingres' 'Apotheose Homers' und der griechische Freiheitskampf," in *Kunst als Bedeutungsträger: Gedenkschrift für Günther Bandmaan,* ed. Werner Busch, Reiner Haussherr, and Eduard Trier (Berlin: Mann, 1977), 367–68. Chapeaurouge concludes from the lack of eighteenth-century figures that the painting was apolitical. Forbin was apparently critical of Ingres for showing only the authoritarian aspect of Greece and not its struggle for independence in *The Apotheosis of Homer.* Ibid., 376.

Nochlin also discusses the painting as a hieratic equivalent of political domination: "In *The Apotheosis of Homer,* history is transformed by the allegorical impulse into an enabling myth of origins under the aegis of the classical, ordered by static symmetry into a permanent emblem of the pedigree and permanence of power. Aesthetic control in Ingres's work is overtly equated with a politics of domination." Sarah Faunce and Linda Nochlin, *Courbet Reconsidered* (New Haven: Yale University Press, 1988), 23.

27. Champollion, *Lettres à Blacas,* 53–54.

Liberal historians argued that liberty is ancient, while conservatives promoted the myth of French history as "fourteen centuries of unbroken order." Ultraconservative historians deemed the Revolution a crime and recommended the punishment of its advocates and the reversal of history. The lesson of the Revolution for conservatives was that religion is a critical buttress for the monarchy. Stanley Mellon, *The Political Uses of History: A Study of Historians in the French Restoration* (Stanford: Stanford University Press, 1958), 8, 80, 90.

28. Theories, such as Kircher's, maintained that Egypt was the birthplace of a monotheistic philosophy. See Jean Yoyotte, "Champollion et le Panthéon Egyptien," *Bulletin de la Société Française d'Egyptologie* 95 (October 1982): 93.

Lamennais, writing in 1824, posited the passing down of religious traditions from Egypt to Greece. Félicité de Lamennais, *Oeuvres complètes,* 10 vols. (Paris: Pagnerre, 1843–44), 2: 1–11.

Champollion-Figeac wrote that "the Egyptian religion had for its base the existence of God and the immortality of the spirit." Jacques-Joseph Champollion-Figeac, *Fourier et Napoléon:*

l'Egypte et les Cent jours: Mémoires et Documents inédits (Paris: Firmin Didot Frères, 1844), 97.

29. "[L'Egypte est] essentiellement intéressée à la conservation de l'ordre." Jacques-Joseph Champollion-Figeac, "Description de l'Egypte . . . Première Livraison," *Magasin Encyclopédique* 5 (1811): 429–30.

30. "Les Egyptiens considéraient en quelque sorte comme éternel ce qui appartenait à leur religion et à leur gouvernement; ils étaient entretenus dans cette pensée par l'aspect continuel des grands monuments publics, qui demeuraient toujours les mêmes et qui paraissent n'être plus soumis à l'action du temps. Leurs législateurs avaient jugé que cette impression morale contribuerait à la stabilité de leur empire." Fourier, "Préface Historique," *Description de l'Egypte,* 1st ed., 1:xc.

31. "Elle [la pensée] devient tout-à-fait monumentale pour l'heureuse découverte de M. de Champollion [*sic*]." "Musée Charles X," *Annales de la Littérature et des Arts* 7, no. 31 (1828): 122.

 Sahut notes that the discovery is suggested in the picture but that no critic made the connection. Sahut, "*L'Etude et le Génie dévoilent l'antique Egypte*," in Foucart, ed., *Nouvelles acquisition du Département des Peintures,* 175.

 However, Jal's Salon review begins with a quote from Chateaubriand, extolling the solution to the ancient mystery: "The obelisk of the desert presented its mysterious characters, and he has read them (L'obélisque du désert a présenté ses caractères mystérieux, et on les a déchiffrés)." Jal, *Esquisses . . . sur le salon de 1827,* 214.

32. AL P30. See Charles Boreux, *Antiquités égyptiennes (Catalogue-guide),* 2 vols. (Paris: Musée du Louvre, 1932), 2:291; and also Edmond Henrotin, "Autographes des deux Champollion," *Chronique d'Egypte* 47, no. 96 (Brussels, 1973): 266–75.

33. The circa 1828–30 oil sketch is reproduced with a catalogue entry and some related preparatory works in Ojalvo and Demange. Ojalvo does not associate the alteration with the change of regimes but with the painter's dissatisfaction with the subject. David Ojalvo and Françoise Demange, *Léon Cogniet, 1794–1880,* exh. cat. (Orléans: Musée des Beaux-Arts, 1990), 142–56.

 The final ceiling painting's subject has habitually been dated to the Restoration despite its depiction of Bonaparte. See Chaudonneret, "Historicism and 'Heritage' in the Louvre," 488–520; and Elisabeth Foucart-Walter, "*L'Expédition d'Egypte sous les ordres de Bonaparte,*" in Foucart, ed., *Nouvelles acquisitions du Département des Peintures,* 151.

 The documents, however, strongly suggest that the change in subject corresponded to the change in regimes. It is well known that Cogniet's work dragged on for seven years; he was slowed by other commissions and by a seriously ill relative for whom he cared. When he wrote the administration on 14 June 1829, he described himself as not far along, "peu avancé." Cogniet to Alphonse de Cailleux, 14 June 1829, AL P6 Cogniet.

 In the many references to the painting before July 1830, the subject is described only generally as a modern subject having to do with Egypt. (The plan of 1828 calls it a "sujet moderne ayant rapport à l'Egypte.") There is one significant exception. On 22 May 1829, Cogniet wrote his patrons and revealed that he had been asked to make allegory play the principal role: "I have not yet achieved something which is acceptable; I hope, meanwhile, that next

Thursday or Friday I can bring you a project in the manner that you suggested where allegory plays the principal role (Je ne suis pas parvenu encore à arrêter quelque chose de passable; j'espère pourtant jeudi ou vendredi prochain pouvoir vous porter un projet dans le sens que vous m'avez indiqué et où l'allégorie jouerait le rôle principal)." Cogniet to Alphonse de Cailleux, 22 May 1829 (AL P6 Cogniet).

It would be difficult to claim that allegory plays the principal role in the 1834 painting as it was supposed to have in 1829. The first dated description of a historical subject for the room is found in the document of 2 December 1830, the "Designation des sujets," which records the changes made after the July Revolution. For the first time we have a record that accords closely with the finished picture: "M. Cogniet. Les travaux des savans français lors de l'expédition d'Egypte en 1798." ["Designation des sujets," 2 December 1830 (AL T16 1830).] The title, "Les français en Egypte à l'époque de l'expédition de 1798," is given in the post–July 1830 plan (figure 41; AL T16). Therefore, it is more plausible that the project took on its definitive form after the July Revolution and that Cogniet followed the general dynastic political culture of both regimes, omitting Napoleon in the Restoration and reinstating him in the July Monarchy.

Cogniet was born 29 August 1794. He was enrolled at the Ecole des Beaux-Arts beginning in 1812 when he entered Guérin's studio. He won second place in the Grand Prix de Rome contest in 1815 and first place in 1817. He exhibited at the Salon from 1817 to 1855 and taught at the Ecole Polytechnique and the Ecole des Beaux-Arts.

34. James Henry Rubin, "Ingres's *Vision of Oedipus and the Sphinx*: The Riddle Solved?" *Arts Magazine* 54, no. 2 (October 1979): 133.

On the different versions of Ingres's picture, see "Oedipus and the Sphinx," in Speed Art Museum, *Ingres, In Pursuit of Perfection: The Art of J. A. D. Ingres,* exh. cat. (Louisville: Speed Art Museum, 1983–84).

Michelet called the historian "an intrepid Oedipus." See Gossman, *Between History and Literature,* 154.

35. The engraving included in Viard's review of the Salon of 1828 strengthens the affinity through the depiction of sideburns, which correspond more closely to the Champollion of the Cogniet portrait.

36. "Le mystère est enfin dévoilé." Jacques-Joseph Champollion-Figeac, "Beaux-Arts.—Salon. Cinquième Article," *Le Moniteur universel* 16 (16 January 1828): 63. He goes on to say, "The new discoveries about the graphic system of old Egypt have cast, nonetheless, enough light to submit these varied monuments to a rigorous and methodical classification, which will be confirmed more and more by future discoveries. The current state of studies of the three types of Egyptian writing is sufficiently advanced to have taken advantage of the inscriptions that decorate almost all products of Egyptian art, indicating the subject and purpose." ("Les nouvelles découvertes sur le système graphique de la vieille Egypte ont fourni néanmoins des lumières suffisantes, pour soumettre ces monumens si variés à une classification rigoureusement méthodique et que les découvertes futures confirmeront de plus en plus. L'état actuel des

études sur les trois sortes d'écriture égyptiennes, est en effet assez avancé pour qu'on ait profité avec avantage des inscriptions qui, décorant presque tous les produits de l'art Egyptien, en indiquent expressément le sujet et la destination.") Champollion had declared his scientific approach in his 1824 published letters to the duc de Blacas. He distanced himself from Winckelmann, for instance, who had founded his notions about Egyptian art on too narrow a selection of works. Champollion, *Lettres à Blacas,* 11.

37. Lenoir proclaimed that science was demonstrated in Champollion's organization of the museum. Alexandre Lenoir, *Examen Mythologique, Historique et Critique de la Collection des Antiquités Egyptiennes du Louvre, réuniées dans la Galerie, dite 'Charles X'* (Paris, 1829), 5.

According to Champollion-Figeac, "[le Musée d'Egypte est] l'application de son beau système." Champollion-Figeac, "Beaux-Arts.—Salon. Cinquième Article," 63. L'Hôte described Champollion as "l'infatigable savant." Nestor L'Hôte, *"Notice descriptive des monumens égyptiens du Musée Charles X; par M. Champollion, le jeune," Revue Encyclopédique* 36 (1827): 785.

Delécluze wrote that "even the most ignorant man, as well as the most frivolous, cannot distract himself from that systematic succession of Egyptian and Greek antiquities which engage the eye and solicit reflection." ("L'homme le plus ignorant, comme le plus frivole, ne peut se soustraire à cette succession systématique d'antiquités égyptiennes et grecques, qui interrogent l'oeil, et sollicitent la refléxion.") E.-J. Delécluze [signed D.], "Beaux-Arts. Fondation du Musée Charles X," *Journal des débats* (17 January 1828): 1.

Champollion won the minds of artists and savants who saw that he had "opened a new mine of historical facts." Hermine Hartleben, *Champollion: Sa vie et son oeuvre, 1790–1832,* trans. Denise Meunier (Paris: Pygmalion, 1983), 364–65.

Grandet noted that Champollion's organization was ethnographic and historic and, thus, far ahead of its time. Pierre Grandet, "La Méthode de Champollion," *L'Histoire* 106 (December 1987): 24.

38. When the Musée des Antiquités was formed in 1795, the museum was divided into two sections, paintings and antiquities, later to be "statues." The museological division, material rather than historical, remained (with the added drawings section) until the historicizing sections were created under Charles X. Quoniam, "Champollion et le Musée du Louvre," 47–48.

L'Hôte recognized that Champollion's "first object is to instruct and not to flatter the eyes." ("[Il] doit avoir pour premier objet d'instruire et non de flatter les regards.") Champollion, L'Hôte testified, remained faithful to the principle of sacrificing "all concessions to taste in the necessity of a rigorous classification method; each monument must have its place according to the subject that it represents and its particular destination, without regard to size or material." ([Champollion,] fidèle à ce principe, devait sacrifier toute convenance de goût à la nécessité d'une classification rigoureusement méthodique; chaque monument devait prendre sa place d'après le sujet qu'il représentait et d'après sa destination spéciale sans égard aux proportions ou à la matière.") L'Hôte, *"Monumens égyptiens du Musée Charles X,"* 784.

Champollion, writing in the *Bulletin Universel des Sciences et de l'Industrie* (February 1825), also contrasted his method to those made "pour les yeux," in which monuments were placed

for maximum "effet pittoresque." Cited in Ziegler, "Le Musée égyptien de Champollion," 266n. 30.

For a discussion of the museological models of Lenoir and Du Sommerard, see Stephen Bann, *The Clothing of Clio* (Cambridge: Cambridge University Press, 1984), 77–92.

39. "La mise en valeur de nos richesses exigeait la refonte complète du plan de Champollion. Il ne pouvait plus être question d'un classement idéologique, ne tenant compte de la forme." Georges Bénédite, "La Formation du Musée Egyptien au Louvre," *Revue de l'Art Ancien et Moderne* 43 (January–May 1923): 281. In 1895, Bénédite was the first curator to transform significantly Champollion's system. He was resolutely opposed to what he considered Champollion's bric-a-brac and resolved to exhibit what he thought to be the most beautiful objects of real importance. Boreux, *Antiquités Egyptiennes,* 1:11–13.

40. "Il servira de guide à tous ceux qui visiteront le Musée Charles X, et fera voir en même temps que si les recherches de M. Chapollion ont déjà fait faire un si grand pas à l'archéologie égyptienne, nous avons droit de tout espérer des recherches ultérieures de cet infatigable savant." L'Hôte, *"Monumens égyptiens du Musée Charles X,"* 785; and Nestor L'Hôte, "Beaux-Arts.— Ouverture du Musée d'antiquités égyptiennes au Louvre," *Revue Encyclopédique* 36 (1827): 829–30.

41. Jean-François Champollion, *Notice Descriptive des Monumens Egyptiens du Musée Charles X* (Paris: Crapelet, 1827), iv, 1, 38, 49, 60, 111, 132.

Champollion wrote a friend in September 1827 about his installation: "Ce sera une véritable encyclopédie égyptienne par ordre de matières, religion, gouvernement, moeurs, usages, costumes, etc. Tout passera successivement sous les yeux des spectateurs et chaque objet mis en relation avec ceux d'une même classe, en prendra un nouvel intérêt." Quoted in Kanawaty, "Principes muséologiques de Champollion," 58.

At the same time, however, Champollion-Figeac scrupulously pointed out that the reunion of the monuments addressed themes dear to the Restoration Bourbons: the religious, royal, and utilitarian. "This is finally the reunion of the monuments relating to religion, the history of kings, and daily life of these people, neighbors of the cradle of civilization." Champollion-Figeac, "Beaux-Arts.—Salon. Cinquième Article," 63.

42. Sosthènes de La Rochefoucauld, "Etablissement du Musée Royal Egyptien de Paris.—Rapport du Roi," *Bulletin des Sciences Historiques, Antiquités, Philologie* 6 (1826): 31–33.

43. This is the essential view of Egypt in Champollion, *L'Egypte sous les Pharaons*. In his review of the museum, L'Hôte explained that Egypt was the birthplace of everything necessary and useful, guided by stable and wise government, so that it had sketched out everything France would become. L'Hôte, "Ouverture du Musée d'antiquités égyptiennes," 827–28.

44. See Ahmed Fakhry, "Champollion in Egypt," in *A la mémoire de Champollion* (Cairo: L'Institut au Caire, 1973), 12–48; and Maricha, "Champollion et l'Académie," 12–31.

Champollion's brother, Jacques-Joseph, took the name Champollion-Figeac, adding the name of their natal town, to distinguish himself from his more famous brother. During the Empire, Champollion-Figeac was editor of the *Journal administratif du département de l'Isère*

and professor and librarian of the city of Grenoble. See Léon Grasilier, "Les Frères Champollion et la politique," *Nouvelle Revue* (1 August 1922): 275.

J.-B. Fourier was also an important physicist and a leader of the French occupying force in Egypt. See Dhombres and Dhombres, *Naissance d'un pouvoir,* 132–42.

45. Jean Leclant, "Champollion et le Collège de France," *Bulletin de la Société Française d'Egyptologie* 95 (October 1982): 37. See also Jean Paquet, "Les Deux Champollion dans le milieu universitaire grenoblois," *Bulletin Mensuel de l'Académie Delphinale* 12, no. 1 (1973): 29–43.

Normally, the letter to Dacier would have been dedicated to Louis XVIII, had there not been such animosity between its author and the regime. Quoniam, "Champollion et le Musée du Louvre," 52.

46. Grasilier, "Frères Champollion et la Politique," 278–79.

Champollion's grammar and dictionary of Egypt were accepted by Napoleon on 18 March 1815, during his stay in Grenoble; it was then rejected after the Hundred Days and was not published until after Champollion's death. P. Vaillant, "Champollion et les origines du déchiffrement des hiéroglyphes," *Bulletin Mensuel de l'Académie Delphinale* 12, no. 1 (1973): 27.

47. "Un homme dangereux, entièrement dévoué au gouvernement de l'usurpateur." ADI 52M16, March 1816, "Correspondance générale du Cabinet du Préfet. Etats des Condamnés et surveillés en 1816." See also Grasilier, "Frères Champollion et la Politique," 279.

48. The suppression of oppositional politics in Grenoble and the Isère can be followed in ADI DI 52M16 and ADI 52M24 (File no. 180, "Vases en porcelaine représentant Bonaparte. 1822").

For an overview of national politics in Grenoble in the turn to the Restoration, see Robert Avezou, "Les Cent Jours dans l'Isère," *Bulletin de la Société Dauphinoise d'Ethnologie et d'Archéologie* 27, no. 206 (1951): 30–36.

49. Jean-François Champollion, *Attention!* (Paris: Chez Corréard, 1820) BMG P2887. The author of *Attention!* suggests that he led the cries of "Vive la charte!" which greeted the duke and which were treated by the police as "un cri séditieux." On the attribution to Champollion, see Jeannot Kettel, *Jean-François Champollion le jeune. Répertoire de bibliographie analytique, 1806–1989,* Mémoires de l'Académie des Inscriptions et Belles-Lettres, n.s. 10 (Paris: Institut de France, 1990), 7.

On liberal and republican opposition to the Restoration from the Grenoble perspective, see Joseph Rey, "Notice historique sur les Sociétés secrètes qui ont existé en France pendant la Restauration," *Le Patriote des Alpes* 12, no. 1772 (26 October 1847): 1–2.

50. Maricha, "Champollion et l'Academie," 16, 19. Also see Paquet, "Les Deux Champollion," 41.

The Baron d'Haussez, the prefect, wrote the mayors of the Isère the day after the 1821 uprising and described "le bruit d'une révolution à la suite de laquelle le Roi aurait abdiqué." BMG 1MI17R, vol. 10, fol. 693, p. 1.

Livchitz discusses Champollion's 1827 election to the Academy of Science of St. Petersberg and the controversy over this "Robespierre de Grenoble." I. G. Livchitz, "Nouveaux documents sur l'histoire de l'égyptologie," *Cahiers d'Histoire Mondiale* 6, no. 3 (Neuchatel, 1961): 606–7.

51. Champollion, *Lettres de Champollion le jeune,* 1:229–32.

Champollion's work on the zodiac of Denderah served to support Biblical dating, thus garnering him Ultra support. After the July Revolution, he published his actual conclusions about the Egyptian calendar and effectively antedated Egyptian civilization. See Martin Bernal, *Black Athena: The Afroasiatic Roots of Classical Civilization,* 2 vols. (New Brunswick: Rutgers University Press, 1987), 1:250–57.

In Alexandria in 1829, Champollion gave his honest dating of the Pyramids to the viceroy of Egypt, while he suppressed them at home so as not to offend the Restoration clergy. Champollion, *Lettres et journaux ecrits pendant le voyage d'Egypte,* 424.

52. "Intérieur. Paris, le 7 juillet," *Le Moniteur universel* 189 (8 July 1825): 1017.

53. "Il était avant tout *historien,* et chez lui le philologue et l'archéologue ne devaient qu'ouvrir à cet historien les chemins de l'histoire." Champollion, *Lettres de Champollion le jeune,* 1:229.

Grasilier dismisses the issue by saying that the Champollions were much more successful with their science than their politics. Léon Grasilier, "Les Frères Champollion et la police," *L'Intermédiaire des chercheurs et curieux* 85, no. 1567 (20–30 October 1922): cols. 805–8.

54. "Est-il arrivé que, si l'on veut en croire la bonne vieille *Gazette des France,* je suis consideré par le parti dévot comme un *Père de l'Eglise,* un vrai père de la foi, défenseur de la Religion et des bonnes doctrines chronologiques. . . . Heureusement que les coassements de ces vils reptiles se perdent dans le concert d'approbation que donnent aussi à mes travaux des personnes pour l'esprit et le bon sens desquelles je professe la plus haute estime. . . . Enfin, je suis tenté de dire à la bonne *Gazette*: 'Ma vieille, taisez-vous; car je n'ai mérité, ni cet excès d'honneur, ni cette indignité,' tant je suis las de cette odeur de sainteté que les dévots commencent à me trouver, comme si je n'eusse eu pour but en travaillant pendant quinze ans à la découverte de mon alphabet que la gloire de Dieu." Champollion, *Lettres de Champollion le jeune,* 1:230. He acknowledged the criticism he incited from both the *philosophes* and devout Catholics who were displeased with his dating of Egyptian documents, which thwarted their cosmology. Jean-François Champollion, *Lettres à Zelmire* (Paris: L'Asiathèque, 1978), 44.

Champollion said that history-writing seeks at its best the Truth but is the work of men. ("Elle participe de leur imperfection.") From his first lesson, "De l'histoire en général et de ses bases, la chronologie et la géographie comparée," published in J. de Crozals, "Deux leçons d'Histoire professées à la Faculté des Lettres de Grenoble, en 1818," *Annales de l'Université de Grenoble* 9 (1897): 525.

55. "[Il le ferait] avec des gants d'une certaine couleur." Champollion, *Lettres de Champollion le jeune,* 1:231. In an only half-facetious study of the "Physiologie du gant," Guenot-Lecointe analyzes the symbolics of gloves for, as he says, "The color of one's gloves is an almost certain indicator of his personal mores," and "one can recognize the nobility of a man by the shade of his gloves." ("La couleur des gants est un indice presque certain des moeurs intimes de leur propriétaire" [et] "on reconnaît la distinction d'un homme à la nuance de ses gants.") See G. Guenot-Lecointe, *Physiologie du gant* (Paris: Desloges, 1841), 85, 110.

56. "Ce qui ne doit pas empêcher de les employer comme savants, principalement dans les découvertes importantes qu'ils ont faites et qu'ils n'ont fait servir jusqu'à présent, qu'à rétablir

les saintes doctrines et en détruisant la fabuleuse antiquité qu'on opposait à l'Ecriture sainte." Grasilier, "Frères Champollion et la police," cols. 805–8; Grasilier, "Frères Champollion et la politique," 282.

The duke's son, the vicomte Sosthènes de La Rochefoucauld (1785–1864), who headed Beaux-Arts section of the Maison du Roi, produced Champollion's birth certificate to quell rumors that Champollion had been a leader in the Terror, when he would have been three years old. Hartleben, *Champollion,* 354–55.

On the intervention of Champollion's friend and frequent publisher, the baron de Férussac, see Kanawaty, "Acquisitions du Musée Charles X," 37.

57. "Je ne suis point hostile contre le gouvernement; mes travaux peuvent honorer mon pays. Je suis tout entier à mes affections et à mes études. Je ne suis donc plus un homme dangereux." Champollion, *Lettres à Zelmire,* 68, letter of 15 June 1827.

58. Champollion, *Lettres à Zelmire,* 18–19, 93–94; letters of September 1826 and 16 January 1828.

Inspired by Jean Racine's *Bajazet,* which had opened the French classical stage to the Eastern subject, Champollion wrote a play of the same name in Grenoble and performed it on Mardi Gras, 1814. Roxanne may have voiced his sentiments in her monologue at the beginning of the play: "Oublions, s'il se peut, les soins de notre empire; / Pour égayer le temps, amusons nous à lire; / Depuis que les combats retiennent mon époux / La lecture remplit mes moments les plus doux." BMG 1MI17–R38.

Champollion's sentiment is like that attributed to Royer-Collard after the fall of the Decazes ministry: "Write, gentlemen, publish books; there is nothing else we can do at this point." Cited in Gossman, *Between History and Literature,* 86. Gossman discusses the growth of Romantic history writing and Augustin Thierry's idea that the full flowering of the historical school was the result of the "diversion of revolutionary fervor" (especially around 1821–22) into thinking and writing.

59. "Au milieu de ces morts, de ces cercueils et de ces ustensiles égyptiens; devant ces vases des premiers temps de la Grèce, l'homme privé de toute instruction, s'arrête; l'antiquité lui apparoît presque vivante." E.-J. Delécluze [signed D.], "Beaux-Arts. Salon de 1827," *Journal des débats* (2 January 1828): 1.

60. "Abandonnés successivement par l'effet des révolutions politiques et religieuses, ces monuments n'en étaient pas devenus plus accessibles aux voyageurs européens depuis l'établissement de la religion mahométane." *Description de l'Egypte* 2nd. ed., 1:n.p.

61. "Grèce secourue par Mars vient implorer les moyens de secouer entièrement le joug de ses oppresseurs." Charles Farcy, "Exposition de 1827. Musée Charles X," *Journal des Artistes* 26 (23 December 1827): 809. While Farcy referred to the figure helping Greece as Mars, Athanassoglou-Kallmyer suggests it is Hercules. Athanassoglou-Kallmyer, *French Images from the Greek War of Independence,* 124.

The revanchist foreign policy of the early Restoration was detected by Jal, who saw in Gros's *Mars Crowned by Victory, Listening to Moderation* a reference to the Restoration's 1823

Spanish campaign in which France intervened to restore the absolutist monarchy and continued to occupy the country until 1828. Mars's features recall those of the Dauphin who led the campaign; Moderation refers to the ordinance of Andujar, which sought protection for the opponents of the monarchy; and the messengers refer to the conquerors of Trocadero. Jal, *Esquisses . . . sur le salon de 1827,* 212.

For the liberal Jal, Meynier's allegory, *The Nymphes of Parthenope* was an opportunity to lament the reestablishment in Naples of absolutism by Austrian troops in 1821, which squelched the ephemeral Carbonari revolution. Ibid., 206–9. Also cited by Sahut, *"Les Nymphes de Parthénope,"* in Foucart, ed., *Nouvelles acquisitions du Département des Peintures,* 172.

Naples had been liberalized when its king was forced to accept the Spanish constitution of 1812, but absolutism was restored by Austrian troops in 1821. The French government, with the Russian, wanted to reconcile Ferdinand I with a constitutional regime, but France would not act independently of the continental powers. The Naples affair was a negative object lesson for the remainder of the Restoration, for the government was criticized by the right for France's loss of prestige and by the left for failure to support the Italian constitutionalists. André Jardin and André-Jean Tudesq, *Restoration and Reaction, 1815–1848,* trans. Elborg Forster (Cambridge: Cambridge University Press, 1988), 49–50.

For liberals, the Spanish campaign was unpardonable because it put France on the side of the Holy Alliance, France's enemy in the Revolution. The Spanish campaign, however, was meant to appeal on a broader, national level, as it was meant to be an easy victory, "a military promenade." It ended France's isolation in Europe after the Napoleonic wars, and it restored glory to the military. Mellon, *Political Uses of History,* 44.

62. Athanassoglou-Kallmyer, *French Images from the Greek War of Independence,* 87–91, 100–101.

63. Louis de Viel-Castel, *Histoire de la Restauration,* 20 vols. (Paris: Calmann-Lévy, 1860–80), 16:664–65. The Alliance vowed to end the bloody war, to deliver Greece from anarchy, and to resume European commerce.

 In February 1825, Villèle wrote Polignac that France was not strong enough to fight on the continent but that "finally the affair of the Orient could lead on the Continent to an appropriate scenario that would give to us the highest importance." Comte de Villèle, *Mémoires et Correspondance,* 5 vols. (Paris: Perrin, 1888–90), 5:153–55.

64. See Betts, "French Colonial Empire," 68.

 According to Gossman, "In Romantic historiography, nature, the Orient, woman, the people, and the hidden past itself are almost metaphors of each other and of the oppressed and the repressed in general—figurations of the Other of reason and bourgeois order." Gossman, *Between History and Literature,* 259.

 Pujol's painting was commissioned by 30 July 1826 but the subject was not set until 5 August 1826. See Munich, "Les Plafonds peints du Musée du Louvre," 141–42. Alexandre-Denis Abel de Pujol (1785–1861) was admitted at age 12 to the Ecole des Beaux-Arts of his natal city, Valenciennes. He then went to Paris and became a student of David; he won second prize for painting in 1810 and in 1811 won the Grand Prix with his *Lycurgue présente aux*

Lacédémoniens l'héritier du trône (Paris, Ecole des Beaux-Arts). He spent one year in Rome, 1811–12, studying at the Villa Medici. See "Abel de Pujol," in Detroit Institute of Arts, *French Painting 1774–1830: The Age of Revolution.*

65. Pierre Fabre, "Le Développement de l'Histoire de Joseph dans la littérature et dans l'art au cours des douze premiers siècles," *Mélanges d'Archéologie et d'Histoire* 39 (1921–22) 193–211. See also Anne-Marie Didier-Lamboray, "Les Vitraux de l'Histoire de Joseph à l'église Saint-Antoine de Liège et leurs modèles," *Bulletin de l'Institut Royal du Patrimoine Artistique* 8 (Brussels, 1965): 201–22.

 Pujol followed the traditional narrative approach in his previous paintings of Joseph, *The Children of Joseph Blessed by Jacob* (Salon of 1810) and *Joseph Interpreting the Dreams of the Pharaoh's Butler and Baker* (Salon of 1822).

 In the Musée Charles X, Pujol departed both from his great predecessors at the Vatican and his German contemporaries, the Nazarenes, who in 1816–17 painted a fresco cycle in Rome, at the Casa Bartholdy, on the life of Joseph. By December 1816 the leading artists in Rome, including Canova, had acclaimed the frescoes. The French ambassador, the duc de Blacas, had encouraged academicians to visit these works. The broadcast of the frescoes continued in an 1819 exhibition of four cartoons in the Palazzo Caffarelli exhibition. See Robert Eastburn McVaugh, "The Casa Bartholdy Frescoes and Nazarene Theory in Rome, 1816–1817," (Ph.D. diss., Princeton University, 1981), 64–81.

66. Frédéric de Clarac, *Musée de Sculpture Antique et Moderne ou Description historique et graphique du Louvre et de Toutes ses parties* (Paris: Imprimerie Royale, 1841), 574–75.

67. "[L'Egypte] est caractérisée par une majesté calme qui n'exclut pas une sorte de langueur voluptueuse." "Clôture du Salon," *La Pandore* 1802 (27 April 1828): 3.

68. "Pharaon, tranquille spectateur de cette scène, est sur son trône au second plan. Nous blâmerons la présence ici du roi égyptien; il est tout-à-fait inutile au sujet; et comme il y est inutile, il y nuit. . . . Il est si petit, si effacé dans la demi-teinte où il est blotti!" Jal, *Esquisses . . . sur le salon de 1827,* 218–19.

69. "[Pharaon] semble admirer dans Joseph le génie libérateur de son royaume." L'Hôte, "Ouverture du musée d'antiquités égyptiennes," 829–30.

70. "Nous avons admiré le talent avec lequel l'artiste a rendu la physionomie nationale de l'Egypte personnifiée, et l'abandon mêlé d'espoir avec lequel elle se jette dans les bras de Joseph; les traits de ce dernier et la fraîcheur de sa carnation le font peut-être participer un peu trop du sexe féminin." Ibid., 830.

71. The source or origin of ancient wisdom was shifted to Africa during the Enlightenment. In his 1787 travel account, Volney gazes at the Sphinx and recalls Herodotus's observation that the ancient Egyptians were black. In the same decade others were denying the optimistic belief in the unity of humankind and replacing it with a firm intellectual commitment to the doctrine of innate racial characteristics and a natural hierarchy of ideas. See D. S. Wiesen, "Herodotus and the Modern Debate over Race and Slavery," *Ancient World* 3, no. 1 (April 1980): 3–6.

72. Jean Leclant, "La Modification d'un regard (1787–1826): Du *Voyage en Syrie et en Egypte* de Volney au Louvre de Champollion," *Académie des Inscriptions & Belles-Lettres* (November–December 1987): 709–29. Leclant dismisses the idea of a black, Egyptian origin. Ibid., 715.

73. Meyer Schapiro, "The Joseph Scenes on the Maximianus Throne in Ravenna," *Gazette des Beaux-Arts* (July 1952): 27–28.

74. "Je vous donnerai, dit le Seigneur à Jésus-Christ, les nations pour héritage et pour votre possession les extrémités de la terre." See L.-H. Caron, *Essai sur les rapports entre le saint patriarche Joseph et Notre Seigneur Jésus-Christ* (Abbeville: Boulanger-Vion, 1825), 3, 37.

75. Champollion, *Lettres et journaux écrits pendant le voyage d'Egypte*, 428. Lenoir also said that agriculture was the first of the sciences in the cradle of civilization. Lenoir, *Examen Mythologique, Historique et Critique*, 5.

76. Fourier in Préface, *Description de l'Egypte*, 1st ed. Champollion-Figeac, *Fourier et Napoléon*, 116–24. These commercial plans for Egypt recalled the practical genius of Bonaparte, Fourier wrote, and were also associated with his proposed re-creation of the Suez Canal (118, 123).

 Chabrol wrote in the *Description* that agriculture was the original cause of Egypt's prosperity and the principal element in its contemporary commerce and industry. "Essai sur les moeurs des habitans modernes de l'Egypte," in *Description de l'Egypte* 2nd ed., 18:313.

 On the Roman precedent of viewing Egypt as the granary of Italy, see Laurens, *Origines intellectuelles de l'expédition d'Egypte*, 98.

 In the session of the Institut d'Egypte of 12 brumaire, an VII (3 November 1798), Bonaparte proposed a commission to study wheat production in Egypt. Four memoirs on agriculture were produced in the three years of the occupation of Egypt. See Dhombres and Dhombres, *Naissance d'un pouvoir*, 120, 823.

77. "French engineers planned major public works projects, French instructors trained the army, and French dry-docks built ships." Jardin and Tudesq, *Restoration and Reaction*, 142.

 France's role as "tutor" is probably more a French than an Egyptian viewpoint. During the Restoration, the Egyptian ruler Muhammad Ali invited French technocrats to Egypt. Many Saint Simonians were inspired to come to Egypt by Muhammad Ali's invitation. For them, Egypt was a tabula rasa, void of the obstacles of liberalism, individualism, and a disobedient work force; there they could erect modern, technological pyramids. Muhammad Ali had his own plans as a mercantilist formed under the Ottoman Empire. The French who were hired to train Egyptians in technology, to train the army along Western lines, and to establish factories were cogs in a mercantile machine envisioned first by Ali Bey in the eighteenth century and then by Muhammad Ali who saw the French presence as useful and temporary. See Alaf Lutfi Al-Sayyid Marsot, *Egypt in the Reign of Muhammad Ali* (Cambridge: Cambridge University Press, 1984), 19–21, 77, 168.

78. The Napoleonic dream of Egypt as an enormous garden continued to be promoted by private interests who may have stood to benefit, as seen in the Marseille merchant Julliany's *Essai sur le commerce de Marseille* (Paris, 1842), 2:311; quoted in Marsot, *Egypt in the Reign of Muhammad Ali*, 18–21.

In 1848, authors of a booklet promoting a steam-powered clearing machine promised profits after twenty years of war and French sacrifices in Algeria. "Of all the questions that have most vividly occupied the minds of contemporary economists," they wrote, "the most essential question today is the use of agriculture in the colonization of French Africa." ("De toutes les questions qui ont le plus vivement occupé l'esprit des économistes contemporains, la plus essentielle, la plus importante dans son actualité est l'emploi de l'agriculture à la colonisation de l'Afrique française.") Barrat and Delol jeune, *Colonisation de l'Afrique française par l'emploi de la machine à défricher* (Bordeaux: Emile Crugy, 1848), 1–2.

79. Aulanier avoids the politics of the situation, claiming the Revolution offered a pretext to replace a failed work. Aulanier, *Le Musée Charles X,* 41, 46, 49–50.

In an equally courtly manner, Forbin reported the following in his post–July Revolution assessment of Restoration work: "Gros avait commencé le plafond de cette salle, cet ouvrage représentant Charles X donnant aux Arts un nouveau musée, dont il n'y avait encore que l'ébauche à l'époque du dernier salon; il avait été cependant mis provisoirement en place. Gros ayant reconnu que cet ouvrage avait été exécuté dans des dimensions peu convenables, changea la dimension et le sujet." Forbin to the Commissaire de la Liste Civile, 28 August 1830. AL T16, 28 August 1830.

During the 1830 July Revolution, the Egyptian collection was despoiled by a nearly systematic pillaging of ancient Egyptian jewelry. Then when Champollion died in March of 1832, the Egyptian collection was abandoned, the objects ignored and damaged by traffic. Champollion's colleague and rival, Clarac, survived him and reported in 1834 on "this poor Egyptian Museum, [a] space which seems like a hospital for Egyptian sculpture and which will become its tomb." ("Ce pauvre Musée égyptien, secteur qui semble l'hôpital de la sculpture égyptienne et qui en deviendra le tombeau.") Kanawaty, "Acquisitions du Musée Charles X," 43.

80. Athanassoglou-Kallmyer, *French Images from the Greek War of Independence,* 124–26.

81. Foucart-Walter, *"L'Expédition d'Egypte sous les ordres de Bonaparte,* esquisse," in Foucart, ed., *Nouvelles acquisitions du Département des Peintures,* 152. See also, Aulanier, *Le Musée Charles X,* 63.

82. While Cogniet's painting is indeed in keeping with Louis-Philippe's cultural politics, it is important to specify the restraint of the Bonapartism presented here. In some preparatory sketches, Cogniet considered employing the dramatic and dashing Bonaparte of Gros's *Bonaparte at Arcole.* In the final picture, Bonaparte is at the summit of the composition, but he is small and obscured by shadow. He wears the bicorn hat suggestive of the "little corporal," an image that Bonapartists invoked as the unassuming friend of the common soldier. Foucart-Walter noted this change in the sketches in ibid., 151.

For a discussion of "petit caporal" imagery, see Marrinan, *Painting Politics for Louis-Philippe,* 158–64.

83. "La face de la médaille montre le génie militaire de la France, portant de la main gauche, l'enseigne gauloise et l'olivier de la paix, et soulevant de la droite le voile qui enveloppait l'Egypte." See "Médaille égyptienne," *Le Moniteur universel* 336 (2 December 1826): 1617–18.

The medal was proposed by Champollion-Figeac and commissioned by the editor Panckoucke under the order of Louis XVIII. One side carried the name and title of each subscriber and the other showed Egypt unveiled by Gaul; an inscription read, "Gallia Victice Aegyptus Rediviva." Hartleben, *Champollion,* 353–54. Also noted in Ballerini, "Photography Conscripted," 241.

Another project for a medal commemorating the opening of the Musée Charles X was designed by L. Lafitte; it is reproduced in a gallery advertisement in *La Revue du Louvre et des Musées de France* 3 (1989). It features Charles X directing allegories of the arts to the arched entrance of the Musée Charles X; a few ancient objects, including a kneeling Egyptian figure, decorate the middle ground.

Champollion was well aware that he followed in the footsteps of both the scholars and the soldiers of the Egyptian campaign. On his return from the Nile in 1829, he published his journals and reported on his "vivid emotions" when he slept in the same alcove where Kléber, "the conqueror of Heliopolis had slept." ("Ce n'est point sans émotion que je me suis couché dans l'alcôve où a dormi le vainqueur d'Héliopolis.") Jean-François Champollion, *Lettres de M. Champollion le jeune, écrites pendant son voyage en Egypte en 1828 et 1829* (Paris: Firmin Didot, 1829), letter of 23 August 1828, 5. Also in Champollion, *Lettres et journaux écrits pendant le voyage d'Egypte,* 33.

84. A. Tardieu, "Salon de 1834. (Septième article)," *Courrier Français* 89 (30 March 1834): 2.

85. Louis Peisse, "Salon de 1834.—(Quatrième article)," *Le National* (11 March 1834): 1.

86. "Le coloris est plein de chaleur, une lumière étincelante circule dans toutes les parties de la toile." "*Expédition de Bonaparte en Egypte.* Commission et Institut d'Egypte," *Magasin Pittoresque* 4 (November 1836): 354.

87. "Son amour ardent pour la nature fit de lui une sorte de réformateur, de précurseur. Dès 1831, le voilà dans sa plus belle oeuvre, dans son oeuvre la plus importante, *Bonaparte en Egypte,* oeuvre si personnelle et si française, poursuivant avec passion la couleur locale, cherchant l'effet vrai, s'efforçant de rendre le soleil et l'éclat de l'orient. La vérité de la mise en scène, du milieu dans lequel se mue le sujet qu'il représente cette vérité presque inconnue avant lui dans la peinture d'histoire, devient chez le maître un des côtés les plus saillants de son art." Léon Bonnat, "Notice sur M. Léon Cogniet," *Chronique des Arts et de la Curiosité* 8 (24 February 1883): 60.

Similarly, in Henri Delaborde's narrative on Cogniet's life, the artist's fidelity to nature overcomes the influence of Greco-Roman art, even while the artist was studying in Rome. Henri Delaborde, *Notice sur la Vie et les Ouvrages de M. Léon Cogniet* (Paris: Firmin-Didot, 1881), 8–10.

CHAPTER 4

1. See [Vergnaud], "Figaro au Salon. MM. Champmartin, Steuben, et Delacroix," *Le Figaro* 3, no. 49 (18 February 1828): 2; and his article "Figaro au Salon," *Le Figaro* 429 (15 December 1827): 914–15.

2. See Champollion-Figeac [signed Ch.], "Beaux-Arts.—Salon. Septième Article," *Le Moniteur universel* 58 (27 February 1828): 234; Coupin [signed P. A.], "Beaux-Arts. Exposition des tableaux en 1827," *Revue Encyclopédique* 37 (February 1828): 582; "Croquis," *Observateur des Beaux-Arts* (April 1828): 16; "Résumé du Salon de 1828," *Observateur des Beaux-Arts* (8 May 1828): 33; "Salon de 1827. M. Gudin—M. Delacroix," *France chrétienne* 3, no. 46 (22 February 1828): 3–4; "Salon de 1827. La Nouvelle Ecole," *La Pandore* 1649 (24 November 1827): 2; "Salon de 1827. La salle des séances," *Journal du Commerce* (14 January 1828): 2; "Salon de 1827. Troisième Exposition—Revue," *Journal du Commerce* 2959 (7 February 1828): 2; "Salon de 1828," *La Pandore* (9 February 1828): 2; L. Vitet [signed L. V.], "Beaux-Arts," *Le Globe* 6, no. 39 (8 March 1828): 253. For a monograph on the painting, see Jack J. Spector, *Delacroix: The Death of Sardanapalus,* Art in Context, ed. John Fleming and Hugh Honour (New York: Viking Press, 1974).

 In an article entitled "Fashion/Orientalism/the Body," Wollen identifies a frenzied and voluptuous side of early twentieth-century modernism, and he posits the *Death of Sardanapalus* as a forerunner. Peter Wollen, "Fashion/Orientalism/the Body," *New Formations* 1 (Spring 1987): 5–33.

3. [A. D.] Vergnaud, *Examen du Salon de 1834* (Paris: Delaunay, 1834), 15.

4. On Delacroix and the Revolution of 1848, see T. J. Clark, *The Absolute Bourgeois: Artists and Politics in France, 1848–1851* (Princeton: Princeton University Press, 1982), 126–41. On the reprise of *The Women of Algiers,* ca. 1848, see Frank Anderson Trapp, *The Attainment of Delacroix* (Baltimore: The Johns Hopkins University Press, 1971); and T. Bajou and V. Bajou, *Chefs d'oeuvre de la peinture (du Musée Fabre à Montpellier)*, exh. cat. (Montpellier: Musée Fabre, 1988), 154.

5. Quoted in Clark, *Absolute Bourgeois,* 130.

6. See, for instance, Stevens, *The Orientalists,* 15–23.

 Many people have commented that Delacroix may have actually entered a Jewish, not a Muslim, harem in Algiers. See, for instance, Sarah Graham-Brown, *Images of Women: The Portrayal of Women in Photography of the Middle East, 1860–1950* (New York: Columbia University Press, 1988), 70. The presumption at the Salon of 1834, however, was that he was representing a Muslim harem that he had visited.

7. E.-J. Delécluze, "Salon de 1834. Troisième Article," *Journal des débats* (8 March 1834): 1; Gustave Planche, "De l'Ecole Française au Salon de 1834," *Revue des Deux-Mondes* (1 April 1834): 58; A. Tardieu, "Salon de 1834. (Deuxième article)," *Courrier Français* 63 (4 March 1834): 1–2. Delacroix exhibited four other paintings at the Salon of 1834: a battle scene, a historical portrait, a street scene from Meknès, and a view of the interior of a convent in Madrid.

8. Planche, "De l'Ecole Française," 60–61.

9. Laviron praised *The Women of Algiers* for the science in its color. Gabriel Laviron, *Le Salon de 1834* (Paris: Louis Janet, 1834), 88. Lenormant saw Delacroix as faithful to nature, displaying the "poetry of truth." Charles Lenormant, "Salon de 1834.—Deuxième article," *Le Temps, Journal des Progrès* 2, no. 1690 (6 March 1834): 2. Another critic recognized a certain finesse

and freshness of tone, description of "local physiognomy," "certain truths," in short, that did not redeem the poverty of the artist's "choice of nature," which evidently disgusted the critic. W., "Salon de 1834.—Sixième article," *Le Constitutionnel* 101 (11 April 1834): 1.

10. "Il y a trop de nature dans cette production, trop de vie dans ces voluptueuses et molles créatures." Hilaire-Léon Sazerac, *Lettres sur le Salon de 1834* (Paris: Delaunay, 1834), 143; W., "Salon de 1834. (Sixième article)," 1.

11. "Ce tableau est un de ceux qui tiennent le pas dans l'oeuvre du maître et dans toute l'école ethnographe moderne." Philippe Burty, "Eugène Delacroix à Alger," *L'Art* 32, no. 1 (1883): 76.

12. Georges Marçais, *Le Costume Musulman d'Alger* (Paris: Plon, 1930), 121–23. The ethnographic function and value of Delacroix's Orientalist paintings was reasserted by the Institut du Monde Arabe's installation of its 1994 exhibition, *Delacroix: Le Voyage au Maroc,* in which some of Delacroix's pictures of Oriental themes were installed on one floor, and actual North African objects on the next: costumes, furniture, musical instruments, and the like, comparable to those that Delacroix depicted in his paintings.

13. The most exhaustive account of the preparatory drawings is in Lambert. Elie Lambert, *Delacroix et "Les Femmes d'Alger,"* (Paris: H. Laurens, 1937).

 The postures of the two figures sketched in the harem echo copies that Delacroix made from a Turkish manuscript, *Costumes Turcs de la cour et de la ville de Constantinople, en 1720,* about a decade before his voyage. According to Johnson, "when sketching Moslem women from life in 1832, he could come close to the conventions of pose and expression learnt before he set foot outside Europe. . . . The images of Islamic life, once experienced vicariously, now in the flesh, dovetail." Lee Johnson, "Towards Delacroix's Oriental Sources," *Burlington Magazine* 120, no. 900 (1978): 147.

14. Seven notebooks were sold after his death at a sale, 22–27 February 1864. One notebook is at the Musée Condé at Chantilly and the other two at the Louvre. The eighteen watercolors he made for Mornay were dispersed at a public sale of 19 March 1877. See Maurice Sérullaz, *Delacroix: Aquarelles du Maroc* (Paris: Fernand Hazan, 1951), 7.

15. Maurice Sérullaz, ed., *Dessins d'Eugène Delacroix, 1798–1863. Inventaire général des dessins. Ecole Française* (Paris: Réunion des Musées Nationaux, 1984), 15.

 Alazard insists on Delacroix's documentation: "Jamais on n'avait encore étudié l'Orient aussi directement: le milieu, les costumes, les attitudes étaient analysés par un peintre qui en avait saisi le caractère original." Jean Alazard, "Les Peintres de l'Algérie au XIXᵉ siècle," *Gazette des Beaux-Arts* 6, no. 3 (January–June 1930): 371.

16. Louvre sketchbook, RF 1712 bis, 17v–18r.

 Stafford discusses parataxis in relation to the illustrated travel account. Stafford, *Voyage into Substance,* 47.

 Delacroix's sketches demonstrate a variety of interests—landscape, costume, decorative arts, local customs, physiognomies, and architecture. The painter noted local habits, Arabic names for clothing, and his activities, memories of related texts and pictures, as well as gifts

for his friends at home. His impressions often triggered associations with books he knew or with the exploits of previous European conquerors such as those at Alcassar-El-Kebir: "Climbed a hill and entered in a pretty woods of green oaks; entered in the plain where the army of D. Sébastien had been defeated." Letter of 8 March 1832 in Eugène Delacroix, *Journal 1822–1863,* ed. André Joubin, new ed. (Paris: Plon, 1981), 101. He pays special attention to colors in verbal characterizations like the one above and, especially, in pictorial renderings.

17. "Je faisais mes croquis au vol et avec beaucoup de difficulté, à cause du préjugé des musulmans contre les images." Quoted in Théophile Silvestre, *Les Artistes français,* vol. 1, *Les Romantiques* (Paris: G. Crès, 1926), 30. Delacroix told a friend that "you mustn't consider the scraps of paper I shall bring back as things of commercial value but simply reminders of a country that you're fond of." Letter of 6 December 1831 from Delacroix to Royer-Collard in *Eugène Delacroix: Selected Letters, 1813–1863,* ed. and trans. Jean Stewart (London: Eyre and Spottiswoode, 1971), 178–79.

18. The quote begins as follows: "I did not begin to do anything passable from my North African journey until I had so far forgotten the small details as to recall only the striking and poetic aspects in my paintings. Up to then," In this passage, Delacroix claims exactitude for the North African subjects even as he was renouncing that exactitude. From Delacroix's 1853 journal, cited in Lee Johnson, "Delacroix's North African Pictures," *Canadian Art* 20, no. 1 (January–February 1963): 24.

19. In Delacroix's sketchbook (Musée Condé, Chantilly), the artist transcribed a passage from J. F. L. Mérimée, *De la peinture à l'huile: ou Des procédés materiels employés dans ce genre de peinture, depuis Hubert et Jan Van Eyck jusqu'à nos jours* (Paris: Mme Huzard, 1830), opposite page 272: "Des couleurs primitives se forment les trois binaires. Si au ton binaire vous ajoutez le ton primitif qui lui est opposé vous l'annihilez, vous en produisez la demi-teinte nécessaire. . . . Ainsi ajouter du noir n'est pas ajouter de la demi-teinte, c'est salir le ton dont la demi-teinte véritable se trouve dans le ton opposé que nous avons dit, de là les ombres vertes dans le rouge." The sketchbook was reprinted in Jean Guiffrey, *Le Voyage de Eugène Delacroix au Maroc, facsimile de l'album du Château de Chantilly* (Paris: Terquem and P. Lemare, 1913).

 Trapp writes that the principles of this device were well known and that Signac cited Delacroix's color triangle. Trapp, *Attainment of Delacroix,* 320.

 Some commentators do not see that Delacroix intentionally sought to render accurately the light and color of the Orient. Sérullaz described the experience as a product of revelation rather than deliberation: "The African light brought to him two capital revelations: for one, the vibrations between tints and the play of their reflections on the other, and this is a consequence of the modification of these tints in function of variations of the light Delacroix discovered." Maurice Sérullaz, *Delacroix* (Paris: F. Nathan, 1981), 161. Friedlaender discounted any scientific aspect to his "color atmosphere," based not on a reading of Delacroix's pictures or purpose but on his Romantic personality: he "had too much temperament for such an approach." Friedlaender, *David to Delacroix,* 118.

20. Stafford, *Voyage into Substance,* 28, 437. Stafford suggests that Fromentin and Delacroix are

alike in that their attitude toward nature and travel "is entirely dissimilar from the journal-
istic treatments of exotic inhabitants as practiced by Gérôme and the Orientalists." She goes
on to disagree with Said, who "would have it that such 'imperial' representations involve the
appropriation of one culture by another." Ibid., 554–55. I am proposing that Delacroix's
Women of Algiers was tied to the tradition of travel pictures, from which it gained some of its
authority.

21. Planche, "De l'Ecole Française," 60–61. Delacroix was seen as being faithful to nature in *The
Women of Algiers.* It has the "poetry of truth," Lenormant wrote. Lenormant, "Salon de 1834," 2.

22. Sérullaz, *Aquarelles du Maroc,* 4. See also Lee Johnson, "Two Sources of Oriental Motifs Copied
by Delacroix," *Gazette des Beaux-Arts* 65 (March 1965): 163–68; and Johnson, "Towards
Delacroix's Oriental Sources," 144–51.

 The artist's interest in Greece, Algeria, and Morocco was preceded by his interest in Egypt.
He had considered subjects from biblical Egypt at least as early as October 1822, and he
thought often about modern Egypt during the spring of 1824. He read, questioned travelers,
sought Mameluke arms, planned to learn Arabic, and he prayed, "God grant that I go there."
He also talked about painting Bonaparte's arrival with the army in Egypt. Delacroix, *Jour-
nal,* 27–28, 53, 68–69.

 Among Delacroix's earliest lithographs, dating from about 1819, are a pair depicting *The
Persian Ambassador* and *The Favorite Slave of the Persian Ambassador,* which were probably copied
from a Persian manuscript. Sérullaz, *Aquarelles du Maroc,* 4.

 In 1824, Delacroix reported buying "Oriental costumes and instruments of savages."
Delacroix, *Journal,* 76.

 Delacroix's brother Charles sent him Islamic manuscripts from Istanbul, and, in prepara-
tion for *The Death of Sardanapalus,* he requested a friend's "licentious paintings from Delhi."
Donald A. Rosenthal, "A Mughal Portrait Copied by Delacroix," *Burlington Magazine* 119,
no. 892 (July 1977): 505. The friend was Frédéric Leblond, a French customs official.

23. On *Scenes from the Massacres of Chios,* see Athanassoglou-Kallmyer, *French Images from the Greek
War of Independence,* 30–41, 92, 94, 95, 101, 139–40. *Scenes from the Massacres of Chios* reflects
Delacroix's ambivalent attitude toward the Orient. He has allowed himself, and he has forced
his audience, to savor the violence of his subject without recourse to an uplifting hero.
Delacroix and his critics, however, did use the picture as a vehicle to express outrage at the
plight of the Greeks at the hands of the Ottoman Empire. When Delacroix sent the picture
to the Galerie Lebrun for the 1826 exhibition to profit the Greek cause, he endorsed the same
interpretation.

 For Delacroix and his colleagues in the 1820s, the Oriental subject provided a vehicle for
explorations of Eastern vice. In the early to mid-1820s, he shared his interests, models, and
studio props with other young Romantics such as Théodore Géricault and Horace Vernet.
Delacroix and his colleagues borrowed exotic costumes, arms, and manuscripts from Jules-
Robert Auguste. On 30 June 1824, Delacroix reported visiting Auguste and coveting his
Greek, Persian, and Indian costumes. Auguste had won the Prix de Rome for sculpture in

1810, and went to Egypt, Greece, and Asia Minor in 1814. Géricault introduced him to Delacroix in 1817. Delacroix, *Journal*, 89.

For Delacroix's generation, captivated by Lord Byron's Orientalist works and by the story of his death in 1824 during the Greek War of Independence, the Orient provided a pretext for licentious and violent pleasures forbidden in the Western arena. This was a Romantic endeavor, undertaken in opposition to the official line of Davidian history painting that Gros, for instance, had lapsed into after the Empire.

Vernet made his first Byron-inspired print in 1819, and Géricault in 1820; Delacroix followed with his first Byronic subject in 1821. Trapp, *Attainment of Delacroix,* 63–64.

24. Sérullaz, *Delacroix* (1981), 31. Stendhal called it a plague scene converted into a massacre by newspaper accounts. Trapp, *Attainment of Delacroix,* 40–41.

25. Delacroix, *Journal* 86 (9 June 1824); and 63 (11 April 1824).

26. Trapp, *Attainment of Delacroix,* 40–41, 180–83. He eventually possessed Géricault's painted copy of Gros's *Battle of Nazareth.*

27. "Il résulte de tout cela que l'Orient, soit comme image, soit comme pensée, est devenu pour les intelligences autant que pour les imaginations une sorte de préoccupation générale à laquelle l'auteur de ce livre a obéi peut-être à son insu. Les couleurs orientales sont venues comme d'elles-mêmes empreindre toutes ses pensées, toutes ses rêveries; et ses rêveries et ses pensées se sont trouvées tour à tour, et presque sans l'avoir voulu, hébraïques, turques, grecques, persanes, arabes, espagnoles même, car l'Espagne c'est encore l'Orient." Victor Hugo, *Odes et ballades. Les Orientales* (Paris: Flammarion, 1968), 322.

28. The example Said gives is how a tourist's experience of Venice can be structured and given meaning by Baedecker's account at the expense of the real thing. Said, *Orientalism,* 92–93.

Citing Delacroix's predecessors who traveled in the East—Champmartin in 1827 and Decamps in 1828—Alazard notes, "Lorsque l'attention de l'opinion publique française est brusquement attirée par la question algérienne, en 1830, le pittoresque oriental est déjà à la mode depuis quelques années." Alazard, "Peintres de l'Algérie," 370.

Wein's fine, short article on Delacroix's *Street in Meknès* (1833, Albright-Knox Art Gallery, Buffalo) analyzes its documentary quality and treatment of the Oriental. Jo Ann Wein, "Delacroix's *Street in Meknès* and the Ideology of Orientalism," *Art Magazine* 83 (June 1983): 106–9.

29. Rosset's first name is not given; he is identified as a sculptor from Lyon. The book was included in the 1989 exhibition at the Bibliothèque Nationale, Paris, "1789: Le Patrimoine libéré." The author of the short catalogue entry notes that Rosset was a rival of Etienne Falconet and, in this book, produced a fantasy, despite the reportorial title. Bibliothèque Nationale, *1789: Le Patrimoine libéré,* exh. cat. (Paris: Bibliothèque Nationale, 1989), 87.

Johnson noted that Rosset's group of wash drawings may have served as a model for the folio Delacroix prepared for Mornay. See Johnson, "Towards Delacroix's Oriental Sources," 148. Johnson's interest is in finding direct sources. I am more concerned here with the similarity in attitude in these encounters with the Orient.

At a College Art Association session in February 1990, Nina Athanassoglou-Kallmyer demonstrated that Guardi, when painting a harem scene in 1740, relied on a 1715 illustrated travel-book harem scene by Van Mour. Then she pointed out that Delacroix's 1834 harem scene is not very different from both. I agree and would add that Delacroix was informed by these pictures and that his picture gained authenticity by the repetition of their imagery.

30. It has previously been demonstrated that Delacroix had consulted Porter's work and had borrowed from it architectural motifs for *The Death of Sardanapalus.* Johnson, "Towards Delacroix's Oriental Sources," 148.

31. Sir Robert Ker Porter, *Travels in Georgia, Persia, Armenia, Ancient Babylonia, etc., etc., during the years 1817, 1818, 1819, and 1820,* 2 vols. (London: Longman, Hurst, Rees, Orme, and Brown, 1821), 1:v, 144. Porter also devotes a section to the "Establishment of a Harem," 1:343ff. His "artless style" in addition to his attention to the harem would be traditions that Delacroix would follow on his own trip to the Orient.

32. "La tête de ses petits paysans, celui qui était jaune avait des ombres violettes; celui qui était plus sanguin et plus rouge, des ombres vertes." Delacroix, sketchbook, Musée Condée, Chantilly; reprinted in Guiffrey, *Voyage de Eugène Delacroix au Maroc,* n.p.

33. Maurice Regard, "Eugène Delacroix et le Comte de Mornay au Maroc (1832), (Documents Inédits)," *Etudes d'Art* 7 (1952): 31–33. The Sultan of Morocco had sent one of his lieutenants to support the Algerian Abd-el-Kadar against the French. In the Algerian province of Oran, the French occupying general, Boyer, had two Moroccans executed for treason; this provoked anti-French sentiment in Morocco, and so the French representative there telegraphed home that the French were in danger, and he demanded immediate intervention. "In the face of dangers so diverse and so pressing, the government of Louis-Philippe decided at the end of 1831 to send to Abd-ar-Rahman a special ambassador whose official mission would be to announce the accession of the King [Louis-Philippe], but who was charged above all with preventing the rupture toward which the conduct of the Emperor of Morocco . . . was leading infallibly." Ibid. This special ambassador, by an order of the Minister of Foreign Affairs of 8 December 1831, was the Count Charles Edgar de Mornay, who had been Gentilhomme de la chambre of Charles X. Soon after the return to France, the mission failed. Morocco continued to aid Algeria in its fight against the French imperial power.

34. "Mais celui-ci ayant été à Alger et n'étant plus possédé du démon de la curiosité a refusé." Eugène Delacroix, *Lettres intimes: Correspondance inédite,* ed. Alfred Dupont (Paris: Gallimard, 1954), 193–94n. 1. Delacroix and Mornay had met at the home of the director of the Opera, Duponchel. Delacroix's network of personal connections—the Bertins of the *Journal des débats,* Duponchel, and Mars, Mornay's lover—brought the two together.

35. Louis-Eugène-Gabriel Isabey (1803–1886) had wanted to be a soldier or a marine although he became an artist like other men in his family. See Atherton Curtis, *L'Oeuvre lithographié de Eugène Isabey* (Paris: Paul Prouté, 1939). Isabey was an acquaintance of Delacroix; together they went to Cornwall during Delacroix's sojourn in England. Trapp, *Attainment of Delacroix,* 53.

36. Jardin and Tudesq, *Restoration and Reaction,* 160.

37. "Delacroix n'avait pu pénétrer dans la maison arabe, sévèrement interdite aux chrétiens. Aussi, en arrivant à Alger son désir le plus vif était-il d'être introduit dans un intérieur mahométan." From a letter of Delacroix's contemporary Charles Cournault, cited in Burty, "Eugène Delacroix à Alger," 96. Also cited in Lambert, *Delacroix et "Les Femmes d'Alger,"* 10.

38. "Delacroix passa un jour, puis un autre dans ce harem, en proie à une exaltation qui se traduisait par une fièvre que calmaient à peine des sorbets et des fruits." Burty, "Eugène Delacroix à Alger," 96.

39. "Les femmes d'Alger passent chez les Orientaux pour êtres les plus jolies de la côte barbaresque. Elles savent relever leur beauté par de riches étoffes de soie et de velours, brodées en or. Leur teint est remarquablement blanc. Si leurs cheveux sont blonds, elles les rendent noirs par quelque teinture, et ceux qui ont déjà cette nuance sont colorés par une préparation de henné. Des fleurs naturelles, roses et jasmins, accompagnent ordinairement leur élégante chevelure." Cournault, quoted in Raymond Escholier, *Delacroix et les femmes* (Paris: Fayard, 1963), 81.

40. "Lorsque, après avoir traversé quelque couloir obscur, on pénètre dans la partie qui leur est réservée, l'oeil est vraiment ébloui par la vive lumière, par les frais visages des femmes et des enfants, apparaissant tout à coup au milieu de cet amas de soie et d'or. Il y a là pour un peintre un moment de fascination et d'étrange bonheur. Tel dut être l'impression que ressentit Delacroix et qu'il nous a transmise dans son tableau, *Femmes d'Alger.*" Ibid., 81–82.

41. Alain Grosrichard, *Structure du sérail. La Fiction du despotisme asiatique dans l'Occident classique* (Paris: Seuil, 1979), 8, 9, 165. Whether it was Rosset, Melling, or Delacroix, literary and artistic voyagers to the Orient obligingly reported on the seraglio. Each account purports to present a fresh and rare glimpse of a harem while actually repeating or inviting the standard refrain about the degeneracy of the Orient. The traveler's eyewitness posture gave authenticity to a moralizing refrain established before his perambulations. Typically, the tale "repeats itself, it copies itself (all in pretending each time that it is offering something new, unpublished), because the stereotypical image of the seraglio, composed at the beginning of the seventeenth century, responds without doubt exactly to what one expects of it." Ibid., 155–56.

 See, too, Malek Alloula, *Le Harem colonial: Images d'un sous-érotisme* (Paris: Garance, 1981), 51. Alloula writes, "In associating a political notion (despotism) with a sensual vision (the possession of women), the harem alone summarizes the essence of the Levant." Ibid., 57. Alloula is provocative and insightful but not historical. For a critique of Alloula and some related publications, see Annie E. Coombes and Steve Edwards, "Site Unseen: Photography in the Colonial Empire: Images of Subconscious Eroticism," *Art History* 12, no. 4 (December 1989): 510–16.

42. Antoine-Ignace Melling, *Voyage Pittoresque de Constantinople et des rives du Bosphore,* 2 vols. (Paris: P. Didot l'aîné, 1819), 1:n.p. In the preface, Melling's publishers boasted about the "authenticity" of the pictures and their "interest and the utility which characterize it (l'authenticité et le choix des matériaux qui le composent, l'interêt et l'utilité qui le caractérisent)."

43. Ibid., 1:1. Regarding one strategy to oppose East and West, Nochlin noted the absence of time and history in Gérôme's *Snake Charmer,* which is meant to suggest that the Orient has

been untouched by the West's historical forces and experience. Linda Nochlin, "The Imaginary Orient," *Art in America* (May 1983): 122. One of the strangest inclusions in *The Women of Algiers* is the watch supported by a coral pendant on the right breast of the figure in the center. One of the few references to the watch is in Marçais, *Le Costume Musulman d'Alger,* 122.

The watch was an agent and symbol of Western ideas of progress and industry, and it functioned as a Western representative in an East-West dialectic. In 1848, Louis-Philippe gave to the Pasha of Egypt a clock for a tower over the major courtyard of his mosque in exchange for the obelisk at the Place de la Concorde.

Jung summarized the signification of the watch, demonstrating the staying power of the notion that the Orient existed somewhere "backward in time," in a place fundamentally opposed to Western timekeeping: "While I was still caught up in this dream of a static, age-old existence, I suddenly thought of my pocket watch, the symbol of the European's accelerated tempo. . . . [The European] . . . will inevitably chop into the bits and pieces of days, hours, minutes, and seconds that duration which is still the closest thing to eternity. . . . The European is, to be sure, convinced that he is no longer what he was ages ago; but he does not know what he has since become. His watch tells him that since the 'Middle Ages' time and its synonym progress, have crept up on him and irrevocably taken something from him. . . . The deeper we penetrated into the Sahara, the more time slowed down for me; it even threatened to move backwards." C. G. Jung, *Memories, Dreams, Reflections,* ed. Aniela Jaffé, trans. Richard and Clara Winston (London: Fontana, 1986), 267–68.

44. "A la vue de ce tableau, on se rend bien compte de la vie ennuyée de ces femmes, qui n'ont pas une idée sérieuse, pas une occupation utile pour se distraire de l'éternelle monotonie de l'espèce de prison dans laquelle on les tient enfermées." Laviron, *Le Salon de 1834,* 88–89.

45. Planche, "De l'Ecole Française," 58–59. Wein quotes Planche's fingernail observation but attributes it to the class anxiety of the critic. Wein, "Delacroix's *Street in Meknès,*" 108. For Johnson, Planche's comment that the painting could not be interpreted in a thousand different ways shows that *The Women of Algiers* stands "as a development towards pure painting, art for art's sake." Lee Johnson, *The Paintings of Eugène Delacroix: A Critical Catalogue,* 4 vols. (Oxford: Clarendon Press, 1981–86), 3:139.

46. "Il y a dans la pose de ces Africains un sentiment d'indolence, dans leur tête une expression d'inoccupation, d'insouciance." Decamps, *Le Musée,* 57–58.

47. "Il [le public] n'y a pas vu le caractère de beauté des têtes qui expriment toute la fadeur et l'inaction des ces intelligences ignorantes du Levant; il n'y a pas de ces femmes sédentaires engraissés par le plaisir." Ibid., 58, 61.

As for the execution, the artist is praised for not repeating tired formulas, as Ingres does. Instead, Delacroix, "appears to be dominated by the motif (paraît être dominé par le motif)." Ibid., 60.

Evidently Decamps did not find the Orientalist formula tired at all. It is the classical and religious subjects that had become morally bankrupt. He pronounced: "The mystery is no longer accepted by anyone today. . . . When David was painting the Greeks and the Romans,

those were republican heroes that he was offering as models to his contemporaries who adored no other saints than the Brutuses, the Catos, the Cincinnatuses and the Gracchi." ("Quand David peignait les Grecs et les Romains, c'étaient des héros républicains qu'il offrait pour modèles à ses contemporains, qui n'adoraient plus alors d'autres saints que les Brutus, Caton, Cincinnatus et les Gracques.") Ibid., 22. As for religious painting, its problem is that "we no longer believe in anything! and we hardly believe in ourselves!" ("Mais nous ne croyons plus à rien! à peine croyons-nous à nous-mêmes!") Working in this critical void, Delacroix and the young "positivists' school" earned Decamps's accolades. Ibid., 18–22.

48. "Les attitudes sont pleines de mollesse et de nonchalance. . . . Je sais bon gré à l'auteur de nous avoir épargné les ongles noirs des femmes du pays." Planche, "De l'Ecole Française," 58.

49. "La physionomie de ce pays restera toujours dans mes yeux; les types de cette forte race s'agiteront tant que je vivrai dans ma mémoire; c'est en eux que j'ai vraiment retrouvé la beauté." Delacroix quoted in Silvestre, *Les Artistes français,* 1:30.

50. "Vos journaux, votre choléra, votre politique, tout cela, malheureusement, diminue un peu le plaisir du retour. Si vous saviez comme on vit paisiblement sous le cimeterre des tyrans; surtout comme on pense peu à toutes les vanités qui nous troublent la tête. La gloire est ici un mot vide de sens; tout y porte à une douce paresse: rien n'y dit que ce ne soit pas l'état le plus souhaitable de ce monde. Le beau court les rues. . . . [L]es Romains et les Grecs sont là à ma porte: j'ai bien ri des Grecs de David, à part, bien entendu, sa sublime brosse. Je les connais à présent; les marbres sont la vérité même, mais il faut y savoir lire, et nos pauvres modernes n'y ont vu que des hiéroglyphes. Si l'école de peinture persiste à proposer toujours pour sujets aux jeunes nourrissons des Muses la famille de Priam et d'Atrée, je suis convaincu, et vous serez de mon avis, qu'il vaudrait pour eux infiniment davantage être envoyés comme mousses en Barbarie sur le premier vaisseau, que de fatiguer plus longtemps la terre classique de Rome. Rome n'est plus dans Rome." Letter to Jal of 4 June 1832. Eugène Delacroix, *Correspondance générale d'Eugène Delacroix,* ed. André Joubin, 3 vols. (Paris: Plon, 1936), 1:329–30; translated in Delacroix, *Selected Letters,* 193–94.

51. "C'est un lieu tout pour les peintres. Les économistes et les saint-simoniens auraient fort à critiquer sous le rapport des droits de l'homme et de l'égalité devant la loi, mais le beau y abonde; non pas le beau si vanté des tableaux à la mode. Les héros de David et compagnie feraient une triste figure avec leurs membres couleur de rose auprès de ces fils du soleil: mais en revanche, le costume antique y est mieux porté, je m'en flatte." Letter to F. Villot, 29 February 1832. Delacroix, *Correspondance générale,* 1:316–17; translated in Delacroix, *Selected Letters,* 186.

52. "Nous nous apercevons de mille choses qui manquent à ces gens-ci. Leur ignorance fait leur calme et leur bonheur; nous-mêmes sommes-nous à bout de ce qu'une civilisation plus avancée peut produire?

"Il sont plus près de la nature de mille manières: leurs habits, la forme de leurs souliers. Aussi, la beauté s'unit à tout ce qu'ils font. Nous autres, dans nos corsets, nos souliers étroits, nos gaines ridicules, nous faisons pitié. La grâce se venge de notre science." Delacroix, *Journal,* 1:152, 28 April 1832.

53. Sérullaz, *Delacroix* (1981), 130. His chosen themes—Justice, Industry (he first thought of Commerce), War, and Agriculture—surrounded by the seas and rivers of France suggest some of the methods and purposes of French imperialism and anticipate some of the iconography at the Place de la Concorde. See also Maurice Sérullaz, *Les Peintures murales de Delacroix* (Paris: Editions du Temps, 1963), 28; and George L. Hersey, "Delacroix's Imagery in the Palais Bourbon Library," *Journal of the Warburg and Courtauld Institutes* 31 (1968): 383–403. Hersey wrote that the scheme combined the old basis of Bourbon power—land and justice—with the new constitutional monarchy's power of commerce and industry. Ibid., 385.

54. "La première salle pourrait être consacrée à exprimer la puissance de la France surtout dans le sens civilisateur. Ainsi le plafond principal serait occupé par: La défaite des Maures, que Charles Martel arrêta dans les plaines de Poitiers au moment où ils étaient au coeur de la France et sur le point de renverser notre nationalité. . . . Elle [notre victoire] a sauvé notre civilisation chrétienne et occidentale et sans doute celle de l'Europe entière, avec nos lois, nos moeurs, etc." Delacroix, AN F21 752; reprinted in Raymond Escholier, *Delacroix, peintre, graveur, écrivain,* 3 vols. (Paris: H. Floury, 1929), 3:26.

55. Delacroix's proposal for the vaults included these subjects:

 1. L'Empire de Charlemagne. Les hommages qui lui sont rendus par les empereurs d'orient; les sciences et les arts s'introduisant en France sous ses auspices.

 2. Conquête de l'Italie par Charles VIII. Nous avons dû à ces conquêtes peut-être téméraires la renaissance des lettres. L'introduction du mûrier date de ce moment.

 3. Clovis à Tolbiac défait les alamans et les chasse de l'Empire Franc. C'est le premier pas vers l'unité française.

 4. Louis XIV recevant les soumissions du doge de Gênes. Ce tableau exprimerait l'apogée de l'influence française.

 5. L'Egypte soumise. La France recevant la première à l'origine de toute civilisation dans cet antique berceau des connaissances humaines. De plus, elle dispose dans cette terre redevenue barbare après tant de siècles féconds de l'émancipation à laquelle sont appelés les peuples d'Orient.

 6. La conquête d'Alger. La vengeance d'un affront fait à notre dignité aura changé la face du nord de l'Afrique et établi l'empire de nos lois à la place d'un despotisme brutal.

 Delacroix, AN F21 752; reprinted in Escholier, *Delacroix, peintre, graveur, écrivain,* 3:27. According to Delacroix: "the revenge for an affront to our national dignity changed the face of North Africa and established the empire of our laws in the place of brutal despotism." Trapp, *Attainment of Delacroix,* 259. The program was not carried out.

 By 1822 Delacroix had his preconceptions well in hand about Turkish barbarism, judging by an 1822 journal entry: "When the Turks find the wounded on the field of battle or even prisoners, they say to them, 'Nay bos' ('do not be scared') and strike them in the face with the handle of their sword, causing them to lower their heads, which are sent flying." ("Quand les Turcs trouvent les blessés sur le champ de bataille ou même les prisonniers, ils

leur disent: 'Nay bos' ('N'ayez pas peur'), et leur donnant par le visage un coup de la poignée de leur sabre qui leur fait baisser la tête, ils la leur font voler.") Delacroix, *Journal,* 1:5, 5 September 1822; see also 1:29, 16 May 1823.

56. To underscore the point, I should mention that in 1858 Delacroix wrote the Municipal Council of Paris in support of a pavilion for Langlois, who in the style of Lejeune had painted panoramas, including one in 1849 of the Battle of the Pyramids. Delacroix recognized these as "spectacles faits pour moraliser et enflammer une nation," and he linked them to the obelisk of the Place de la Concorde. Delacroix, *Journal,* 3:186–88, letter of 14 April 1858.

57. "Ce but est essentiellement scientifique: il consiste principalement à faire connaître, d'une manière exacte et positive, le degré de civilisation des peuples peu avancés dans l'échelle sociale." Ernest-Théodore Hamy, *Les Origines du Musée Ethnographique: Histoire et Documents* (Paris: Ernest Leroux, 1890), 129. "Déjà même l'occupation d'Alger en a mis plusieurs de cette espèce au pouvoir de l'armée française." Ibid., 136.

58. Bernasconi discusses these prints in his thesis. Dominique Bernasconi, "L'image de l'Algérie dans l'iconographie française (1830–1871)," (Mémoire, Institut d'Etudes Politiques de l'Université de Paris, 1970), 21, 34.

59. The print was a part of B. Roubaud's 1844–45 series, *Les Troupiers en Afrique.* Ibid., 22.

60. Exhibited in Musée Carnavalet, *De la Place Louis XV à la Place de la Concorde,* 113–14; and Maison de Balzac, *Dantan jeune. Caricatures et portraits de la société romantique,* exh. cat. (Paris: Direction des Affaires Culturelles de la Ville de Paris, 1989), 169.

61. Lebas, *L'Obélisque de Luxor,* 28. In his foreword to Baudet, F. L. Baumer suggests that ambivalence is the hallmark of European's attitudes to non-Europeans during the era of imperialism. See Henri Baudet, *Paradise on Earth: Some Thoughts on European Images of Non-European Man,* trans. Elizabeth Wentholt (New Haven: Yale University Press, 1965), v. Homi K. Bhabha takes up the notion of ambivalence in "The Other Question: Difference, Discrimination and the Discourse of Colonialism," in *Literature, Politics and Theory,* ed. Francis Barker et al., Papers from the Essex Conference, 1976–84 (London and New York: Methuen, 1986), 148–49. He is, in turn, criticized by JanMohamed for avoiding the subject of "actual imperialist practices." Abdul R. JanMohamed, "The Economy of Manichean Allegory: The Function of Racial Difference in Colonialist Literature," *Critical Inquiry* 12, no. 1 (Autumn 1985): 59–87.

AFTERWORD

1. Alloula makes a psychoanalytic argument for the function of colonial postcards and reproduces this one. Alloula, *Harem colonial,* 115. In a chapter on the photographic essay, Mitchell discusses "voyeurism and exorcism" as they are treated in Alloula's book. W. J. T. Mitchell, *Picture Theory: Essays on Verbal and Visual Representation* (Chicago: University of Chicago Press, 1994), 307–12. The market for these images proved lucrative. By 1876, France's Bonfils family had not only a studio in Beirut but a mail-order business as well. Graham-Brown, *Images of Women,* 39.

2. A point wisely made in relation to recent Matisse exhibitions. See Roger Benjamin, "Matisse in Morocco: A Colonizing Esthetic?" *Art in America* (November 1990): 157–64, 211, 213; see also Linda Nochlin "'Matisse' and Its Other," *Art in America* (May 1993): 88–97.

3. Kenneth E. Silver, *Esprit de Corps: The Art of the Parisian Avant-Garde and First World War, 1914–1925* (Princeton: Princeton University Press, 1989), 264.

4. Kenneth E. Silver, "Matisse's Retour à l'ordre," *Art in America* (June 1987): 110–123. Regarding the more recent use of Matisse's Orientalism, Roger Benjamin notes how the 1990–91 exhibition *Matisse in Morocco,* sponsored by the United States and the Soviet Union, functioned as "an esthetic token for the resolution of political differences." He observed that the avoidance of the politics of Matisse's Orientalism in the catalogue corresponded to the show's obfuscation of the superpowers' own neocolonial posture vis-à-vis the Islamic world. Benjamin, "Matisse in Morocco," 159, 161.

5. Quoted in Marie-Laure Bernadac, "Picasso 1953–1972: Painting as Model," in *Late Picasso: Paintings, Sculpture, Drawings, Prints, 1953–1972,* exh. cat. (London: Tate Gallery, 1988), 55. On the formal development of the series, see the classic essay by Leo Steinberg, "The Algerian Women and Picasso at Large," in *Other Criteria: Confrontations with Twentieth-Century Art* (London: Oxford University Press, 1972).

6. Charles Estienne, "Picasso ou le Dernier Portrait," *France Observateur* (16 June 1955): 26; quoted in Kay Dian Kriz, "Picasso's Variations on Delacroix's 'Femmes d'Alger': The Grand Tradition, Desire and Colonialism (Again)" (Department of Fine Arts, University of British Columbia, Vancouver, 1987, photocopy), 15. I am indebted to Professor Kriz for her work on the Picasso series.

7. For an overview of Arab feminism, see the introduction to Margot Badran and Miriam Cooke, eds., *Opening the Gates: A Century of Arab Feminist Writing* (Bloomington: Indiana University Press, 1990). For a discussion of the veil in the Algerian Revolution, see Marie-Aimée Helie-Lucas, "Women, Nationalism and Religion in the Algerian Liberation Struggle," in Badran and Cooke, *Opening the Gates,* 105–14. See also chapter 8, "The Discourse of the Veil," in Leila Ahmed, *Women and Gender in Islam: Historical Roots of a Modern Debate* (New Haven: Yale University Press, 1992).

8. Marnia Lazreg, "Gender and Politics in Algeria: Unraveling the Religious Paradigm," *Signs* 15, no. 4 (Summer 1990): 755–80.

9. Frantz Fanon, *A Dying Colonialism,* trans. H. Chevalier (New York: Grove Weidenfeld, 1965), 37–38.

10. Assia Djebar, *Women of Algiers in Their Apartment,* trans. M. de Jager (Charlottesville: University of Virginia Press, 1992), 137.

11. Ibid., 2.

12. Ibid., 138.

13. Ibid., 149.

14. Leïla Sebbar, *Scherezade: Missing, Aged 17, Dark Curly Hair, Green Eyes,* trans. Dorothy S. Blair (London: Quartet, 1991), 203. Sebbar's mother was French and father Algerian. For an in-

formative article on writers Djebar and Sebbar, see Mildred Mortimer, "Language and Space in the Fiction of Assia Djebar and Leïla Sebbar," *Research in African Literature* 18 (Fall 1988): 301–11.

15. Musée National d'Art Moderne, Centre Georges Pompidou, Paris.
16. Sebbar, *Scherezade,* 272.

Bibliography

Titles of books and articles published in the nineteenth century retain their original spelling, capitalization, and punctuation.

Adas, Michael. *Machines as the Measure of Men: Science, Technology, and Ideologies of Western Dominance.* Ithaca: Cornell University Press, 1989.

Agulhon, Maurice. "Imagerie civique et décor urbain dans la France du XIXe siècle." *Ethnologie Française* 5 (1975): 33–56.

————. "Paris: La traversée d'est en ouest." In *Les Lieux de mémoire,* ed. Pierre Nora. Vol. 3, *Les France,* part 3, *De l'archive à l'emblème,* 883–84. Paris: Gallimard, 1992.

————. "Politics, Images, and Symbols in Post-Revolutionary France." In *Rites of Power: Symbolism, Ritual and Politics since the Middle Ages,* ed. Sean Wilentz, 177–205. Philadelphia: University of Pennsylvania Press, 1985.

Ahmed, Leila. *Women and Gender in Islam: Historical Roots of a Modern Debate.* New Haven: Yale University Press, 1992.

Alazard, Jean. "Les Peintres de l'Algérie au XIXe siècle." *Gazette des Beaux-Arts* 6, no. 3 (January–June 1930): 370–87.

Alexandre, Arsène. *Histoire de la Peinture Militaire en France.* Paris: Renouard, 1880.

Alloula, Malek. *Le Harem colonial: Images d'un sous-érotisme.* Paris: Garance, 1981.

Anchel, Robert. "La Commémoration des rois de France à Paris pendant la Restauration." *Mémoires de la Société de l'Histoire de Paris et de l'Ile-de-France* 47 (1924): 173–208.

Anderson, Matthew Smith. *The Great Powers and the Near East 1774–1923.* London: Edward Arnold, 1970.

Angelin, J.-P. *Expédition du Louxor.* Paris: Thomine, 1833.

Annales des sciences, de la littérature et des arts commencées le 24 juillet 1804.

Arac, Jonathan, and Harriet Ritvo, eds. *Macropolitics of Nineteenth-Century Literature: Nationalism, Exoticism, Imperialism.* Philadelphia: University of Pennsylvania Press, 1991.

Arasse, Daniel. *The Guillotine and the Terror.* Trans. Christopher Miller. Paris: Flammarion, 1987.

Art History Gallery of the University of Wisconsin–Milwaukee. *Napoleon in Egypt: Images from "The Description de l'Egypte."* Exh. cat. Milwaukee: Art History Gallery of the University of Wisconsin, 1987.

Athanassoglou-Kallmyer, Nina. *French Images from the Greek War of Independence, 1821–1830: Art and Politics under the Restoration.* New Haven: Yale University Press, 1989.

Aulanier, Christiane. *Le Musée Charles X et le Département des Antiquités Egyptiennes.* Paris: Editions des Musées Nationaux, 1961.

Avezou, Robert. "Les Cent Jours dans l'Isère." *Bulletin de la Société Dauphinoise d'Ethnologie et d'Archéologie* 27, no. 206 (1951): 30–36.

Badran, Margot, and Miriam Cooke, eds. *Opening the Gates: A Century of Arab Feminist Writing.* Bloomington: Indiana University Press, 1990.

Bajou, T., and V. Bajou. *Chefs d'oeuvre de la peinture (du Musée Fabre à Montpellier).* Exh. cat. Montpellier: Musée Fabre, 1988.

Ballerini, Julia. "Photography Conscripted: Horace Vernet, Gérard de Nerval, and Maxime Du Camp in Egypt." Ph.D. diss., City University of New York, 1987.

Bann, Stephen. *The Clothing of Clio.* Cambridge: Cambridge University Press, 1984.

Barker, Francis, Peter Hulme, and Margaret Iversen, eds. *Colonial Discourse/Postcolonial Theory.* The Essex Symposia, Literature/Politics/Theory. Manchester and New York: Manchester University Press, 1994.

Barker, Francis, et al. *Literature, Politics and Theory.* Papers from the Essex Conference, 1976–84. London and New York: Methuen, 1986.

Barrat and Delol jeune. *Colonisation de l'Afrique française par l'emploi de la machine à défricher.* Bordeaux: Emile Crugy, 1848.

Barthélemy, Auguste. *L'obélisque de Luxor.* Paris: Everat, 1833.

Bataille, Georges. "The Obelisk." In *Visions of Excess. Selected Writings, 1927–1939.* Ed. and trans. Allan Stoekl, 213–22. Minneapolis: University of Minnesota Press, 1985. First published in *Mesures* (15 April 1938): 35–50.

Baudet, Henri. *Paradise on Earth: Some Thoughts on European Images of Non-European Man.* Trans. Elizabeth Wentholt. New Haven: Yale University Press, 1965.

Bendiner, Kenneth Paul. "The Portrayal of the Middle East in British Painting, 1835–1860." Ph.D. diss., Columbia University, 1979.

Bénédite, Georges. "La Formation du Musée Egyptien au Louvre." *Revue de l'Art Ancien et Moderne* 43 (January–May 1923): 275–93.

Benjamin, Roger. "Matisse in Morocco: A Colonizing Esthetic?" *Art in America* (November 1990): 157–64, 211, 213.

Béraud, Antony. *Annales de l'Ecole Française des Beaux-Arts.* Paris: Pillet, 1827.

Bergdoll, Barry. "Le Panthéon/Sainte-Geneviève au XIX^e siècle. La Monumentalité à l'épreuve

des révolutions idéologiques." In *Le Panthéon: Symbole des révolutions. De l'Eglise de la Nation au Temple des grands hommes.* Centre Canadien d'Architecture, 175–233. Paris: Picard, 1989.

Bernadac, Marie-Laure. "Picasso 1953–1972: Painting as Model." In *Late Picasso: Paintings, Sculpture, Drawings, Prints, 1953–1972.* Exh. cat. London: Tate Gallery, 1988.

Bernal, Martin. *Black Athena: The Afroasiatic Roots of Classical Civilization.* 2 vols. New Brunswick: Rutgers University Press, 1987.

Bernard, Augustin. "Les Obélisques de Louqsor et la Mission Taylor." *L'Académie des Sciences Coloniales* 8–9 (1926–27): 425–40.

Bernasconi, Dominique. "L'Image de l'Algérie dans l'iconographie française (1830–1871)." Mémoire, Institut d'Etudes Politiques de l'Université de Paris, 1970.

Betts, R. F. "The French Colonial Empire and the French World-View." In *Racism and Colonialism: Essays on Ideology and Social Structure.* Ed. R. Ross. Dordrecht: Martinus Nijhoff, 1982.

Bhabha, Homi K. "The Other Question: Difference, Discrimination and the Discourse of Colonialism." In *Literature, Politics and Theory,* ed. Francis Barker et al., 148–72. Papers from the Essex Conference, 1976–84. London and New York: Methuen, 1986.

Bibliothèque Nationale de France, Paris. *Exposition de 1875. Congrès International des Sciences géographiques.* Exh. cat. Paris: Bibliothèque Nationale, 1875.

———. *1789: Le Patrimoine libéré.* Exh. cat. Paris: Bibliothèque Nationale, 1989.

Biver, Marie-Louise. "Documents sur Paris." In *Les Arts à l'Epoque Napoléonienne,* 31–36. Les Archives de l'Art Français. Paris: F. De Nobele, 1969.

Blacas, Louis de. "Inventaire analytique de quelques lettres nouvelles de Champollion le jeune." In *Recueil d'études égyptologiques dédiées à la mémoire de Jean-François Champollion à l'occasion du centenaire de la lettre à M. Dacier,* 3–20. Paris: Librairie Ancienne Honoré Champion, Edouard Champion, 1922.

Boime, Albert. *Hollow Icons: The Politics of Sculpture in Nineteenth-Century France.* Kent, Ohio: Kent State University Press, 1987.

Bonnat, Léon. "Notice sur M. Léon Cogniet." *Chronique des Arts et de la Curiosité* 8 (24 February 1883): 59–61.

Borel, Pétrus. *L'Obélisque de Louqsor.* Paris: Marchands de Nouveautés, 1836.

Boreux, Charles. *Antiquités égyptiennes.* Catalogue-guide. 2 vols. Paris: Musée du Louvre, 1932.

Boudjedra, Rachid. *Peindre l'Orient.* Cadeilhan: Zulma, 1996.

Boutard, Jean-Baptiste. "Salon de l'an IX." *Journal des débats* (2 vendémiaire, year X): 2–4.

———. "Salon de l'an XII." *Journal des débats* (25 September 1804): 2–4.

———. "Salon de l'an XII." *Journal des débats* (3 October 1804): 1–4.

———. "Salon de l'an 1806." *Journal de l'Empire* (10 October 1806): 1–4.

———. "Salon de 1808." *Journal de l'Empire* (22 October 1808): 1–4.

———. "Salon de 1810." *Journal de l'Empire* (23 November 1810): 1–4.

———. "Salon de 1810." *Journal de l'Empire* (21 December 1810): 1–4.

Brière, L. de la. *Champollion inconnu. Lettres inédites.* Paris: Plon, 1897.

Brombert, Victor. *The Romantic Prison: The French Tradition.* Princeton: Princeton University Press, 1978.

Brossollet, J., and H. Mollaret. "A propos des 'Pestiférés de Jaffa' de A. J. Gros." *Koninklijk Museum voor schone Kunsten* (1968): 263–308.

Brown University. *All the Banners Wave: Art and War in the Romantic Era, 1792–1851.* Exh. cat. Providence: Brown University, 1982.

Brunner, Manfred Heinrich. "Antoine-Jean Gros. Die Napoleonischen Historienbilder." Ph.D. diss., Rheinischen Friedrich-Wilhelms Universitat, Bonn, 1979.

Burty, Philippe. "Eugène Delacroix à Alger." *L'Art* 32, no. 1 (1883): 76–79, 94–98.

Bury, J. P. T., and R. P. Tombs. *Thiers, 1797–1877: A Political Life.* London: Allen and Unwin, 1986.

C. "Salon de 1806." *Mercure de France* 25 (September 1806): 596–602.

Calmettes, Fernand. *Etat général des tapisseries de la manufacture des Gobelins depuis son origine jusqu'à nos jours, 1600–1900.* Ed. Maurice Fenaille. Vol. 5, *1794–1900.* Paris: Imprimerie Nationale, 1912.

Cantarel-Besson, Yveline, ed. *La Naissance du Musée du Louvre.* 2 vols. Paris: Réunion des Musées Nationaux, 1981.

Caron, L.-H. *Essai sur les rapports entre le saint patriarche Joseph et Notre Seigneur Jésus-Christ.* Abbeville: Boulanger-Vion, 1825.

Carrott, Richard G. *The Egyptian Revival: Its Sources, Monuments, and Meaning, 1808–1858.* Berkeley: University of California Press, 1978.

Caso, Jacques de. *David d'Angers: L'Avenir de la mémoire. Etude sur l'art signalétique à l'époque romantique.* Paris: Flammarion, 1988.

Champollion, Jean-François. *Attention!* Paris: Chez Corréard, 1820.

———. *L'Egypte sous Les Pharaons, ou Recherches Sur la Géographie, la Religion, la Langue, les Ecritures et l'Histoire de l'Egypte avant l'invasion de Cambyse.* Paris: Bure Frères, 1814.

———. *Lettres à M. le duc de Blacas d'Aulps, premier gentilhomme de la chambre, pair de France, etc., Relative au Musée royal égyptien de Turin. Première Lettre. — Monuments Historiques.* Paris: Firmin Didot, Père et Fils, 1824.

———. *Lettres à Zelmire.* Paris: L'Asiathèque, 1978.

———. *Lettres de Champollion le jeune.* Ed. Hermine Hartleben. Vol. 1, *Lettres écrites d'Italie*; vol. 2, *Lettres et journaux écrits pendant le voyage d'Egypte en 1828 et 1829.* Bibliothèque Egyptologique, vols. 30 and 31. Paris: Ernest Leroux, 1909.

———. *Lettres de M. Champollion le jeune, écrites pendant son voyage en Egypte en 1828 et 1829.* Paris: Firmin Didot, 1829.

———. *Lettres et journaux écrits pendant le voyage d'Egypte.* Ed. Hermine Hartleben. Paris: Christian Bourgois, 1986.

———. *Notice Descriptive des Monumens Egyptiens du Musée Charles X.* Paris: Crapelet, 1827.

———. *Le Panthéon Egyptien, Collection des Personnages Mythologiques de l'ancienne Egypte, d'après les monuments.* Paris: Firmin Didot, 1823.

Champollion-Figeac, Jacques-Joseph. "Beaux-Arts.—Salon. Cinquième Article." *Le Moniteur universel* 16 (16 January 1828): 63–64.

———. "Beaux-Arts.—Salon. Sixième Article." *Le Moniteur universel* 29 (29 January 1828): 112.

———. "Beaux-Arts.—Salon. Septième Article." *Le Moniteur universel* 58 (27 February 1828): 233–34.

————. "Description de l'Egypte . . . Première Livraison." *Magasin Encyclopédique* 5 (1811): 426–37.

————. *Fourier et Napoléon: l'Egypte et les Cent jours: Mémoires et Documents inédits.* Paris: Firmin Didot Frères, 1844.

————. *L'Obélisque de Louqsor, transporté à Paris, notice historique, descriptive et archéologique sur ce monument.* Paris: Firmin Didot Frères, 1833.

————. *Obélisques Egyptiens de Paris, d'après les dessins faits à Louqsor en 1828 par Champollion le Jeune.* Paris, 1836.

Chapeaurouge, Donat de. "Ingres' 'Apotheose Homers' und der griechische Freiheitskampf." In *Kunst als Bedeutungsträger: Gedenkschrift für Günter Bandmaan,* ed. Werner Busch, Reiner Haussherr, and Eduard Trier, 367–78. Berlin: Mann, 1977.

Chateaubriand, François René. "Lettre sur les Tuileries." *L'Artiste* 1, no. 1 (1831): 133–34.

Chaudonneret, Marie-Claude. "Historicism and 'Heritage' in the Louvre, 1820–40: From the Musée Charles X to the Galerie d'Apollon." *Art History* 14, no. 4 (December 1991): 488–520.

————. "Le Mythe de la Révolution." In *Aux Armes et Aux Arts! Les Arts de la Révolution, 1789–1799,* ed. Philippe Bordes and Régis Michel, 312–40. Paris: Adam Biro, 1988.

————. "Permanence et innovation. Le Musée du Louvre dans les années 1820." In *Homage à Michel Laclotte: Etudes sur la peinture du Moyen Age et de la Renaissance.* Eds. Pierre Rosenberg, Cecile Scailliérez, and Dominique Thiébault, 532–37. Milan: Electa, and Paris: Réunion des Musées Nationaux, 1994.

Chaussard, Pierre-Jean-Baptiste-Publicole. *Le Pausanias Français; Etat des Arts du Dessin en France à l'ouverture du XIXᵉ siècle: Salon de 1806.* Paris: F. Buisson, 1806.

Chevalier, Michel [signed M. C.]. "L'Obélisque." *Journal des débats* (11 October 1836): 2.

Clarac, Frédéric de. "Lettre sur le Salon de 1806." *Journal des Archives de Littérature, d'Histoire et de Philosophie* 12 (1806); in Bibliothèque Nationale, Collection Deloynes, vol. 38, no. 1047, 247.

————. *Musée de Sculpture Antique et Moderne ou Description historique et graphique du Louvre et de Toutes ses parties.* Paris: Imprimerie Royale, 1841.

Clark, T. J. *The Absolute Bourgeois: Artists and Politics in France, 1848–1851.* Princeton: Princeton University Press, 1982.

Clifford, James. *The Predicament of Culture: Twentieth-Century Ethnography, Literature, and Art.* Cambridge: Harvard University Press, 1988.

"Clôture du Salon." *La Pandore* 1802 (27 April 1828): 2–3.

Cobban, Alfred. *From the First Empire to the Second Empire, 1799–1871.* Vol. 2 of *A History of Modern France.* London: Penguin Books, 1965.

Collingham, H. A. C. *The July Monarchy: A Political History of France, 1830–1848.* London: Longman, 1988.

Coombes, Annie E., and Steve Edwards. "Site Unseen: Photography in the Colonial Empire: Images of Subconscious Eroticism." *Art History* 12, no. 4 (December 1989): 510–16.

Corboz, André. "Walks Around the Horses." *Oppositions* 25 (Fall 1982): 84–101.

Coupin, P. A. "Beaux-Arts. Exposition des tableaux en 1827." *Revue Encyclopédique* 37 (January 1828): 302–16.

———. "Beaux-Arts. Exposition des tableaux en 1827." *Revue Encyclopédique* 37 (February 1828): 579–83.

Cournault, Charles. "La galerie Poirel au Musée de Nancy." *Courrier de l'Art* 2, 41 (12 October 1882): 483–86.

"Croquis." *Observateur des Beaux-Arts* (April 1828): 16.

Crow, Thomas. *Emulation: Making Artists for Revolutionary France.* New Haven: Yale University Press, 1995.

Crozals, J. de. "Deux leçons d'Histoire professées à la Faculté des Lettres de Grenoble, en 1818." *Annales de l'Université de Grenoble* 9 (1897): 534–56.

Cuno, James Bash. "Charles Philipon and La Maison Aubert: The Business, Politics, and Public of Caricature in Paris, 1820–1840." Ph.D. diss., Harvard University, 1985.

Curl, James Stevens. *The Egyptian Revival: An Introductory Study of a Recurring Theme in the History of Taste.* London: Allen and Unwin, 1982.

Curtis, Atherton. *L'Oeuvre lithographié d'Eugène Isabey.* Paris: Paul Prouté, 1939.

Curto, Silvio. "Jean-François Champollion et l'Italie." *Bulletin de la Société Française d'Egyptologie* 65 (Ocotober 1972): 13–24.

D. "Peinture: Considération sur le Romantisme." *Observateur des Beaux-Arts* (24 April 1828): 19.

D. B. "Salon de l'an XII." *Le Publiciste* (16 October 1804): 1–3.

D. D. "Salon de l'an XIII." *Nouvelles des Arts* 3 (year XIII): 372–74.

Daemmrich, Ingrid G. "The Ruins Motif as Aesthetic Device in French Literature." Parts 1, 2. *Journal of Aesthetics and Art Criticism* 30 (Summer 1972): 449–57; 31 (Fall 1972): 31–41.

Daniel, Norman. *Islam and the West: The Making of an Image.* Edinburgh: The University Press, 1960.

Decamps, Alexandre-Gabriel. *Le Musée—Revue du Salon de 1834.* Paris: Abel Ledoux, 1834.

Delaborde, Alexandre. *Description des Obélisques de Louqsor figurés sur les places de la Concorde et des Invalides.* Paris: Bohaire, 1833.

Delaborde, Henri. *Notice sur la Vie et les Ouvrages de M. Léon Cogniet.* Paris: Firmin-Didot, 1881.

Delacroix, Eugène. *Correspondance générale d'Eugène Delacroix.* Ed. André Joubin. 3 vols. Paris: Plon, 1936.

———. *Eugène Delacroix: Selected Letters, 1813–1863.* Ed. and trans. Jean Stewart. London: Eyre and Spottiswoode, 1971.

———. *Lettres intimes: Correspondance inédite.* Ed. Alfred Dupont. Paris: Gallimard, 1954.

———. *Journal, 1822–1863.* Ed. André Joubin. New ed. Paris: Plon, 1981.

"De la Machine à Vapeur Locomotive. Premier Chemin de Fer de Paris." *Magasin Pittoresque* 4 (January 1836): 35–38.

Delécluze, E.-J. [signed D.]. "Beaux-Arts. Salon de 1827." *Journal des débats* (2 January 1828): 1–3.

———. "Beaux-Arts. Fondation du Musée Charles X." *Journal des débats* (17 January 1828): 1–3.

———. "Musée Charles X." *Journal des débats* (16 December 1827): 1–3.

———. "Salon de 1834. Troisième Article." *Journal des débats* (8 March 1834): 1.

Denny, W. B. "Orientalism in European Art." *Muslim World* 73, nos. 3–4 (July–October 1983): 262–77.

Denon, Dominique-Vivant. *Voyage dans la Basse et Haute Egypte pendant les campagnes du général Bonaparte.* 2 vols. Paris: Didot, l'aîné, (year X) 1802.

———. *Voyage dans la Basse et Haute Egypte pendant les campagnes du génénral Bonaparte.* Paris: Pygmalion, 1990.

Description de l'Egypte ou Recueil des observations et des recherches qui ont été faites en Egypte pendant l'expédition de l'armée française. 1st ed. 21 vols. Paris: Imprimerie Impériale and Imprimerie Royale, 1809–28.

Description de l'Egypte ou Recueil des observations et des recherches qui ont été faites en Egypte pendant l'expédition de l'armée française. 2d ed. 24 vols. Paris: C. L. F. Panckoucke, 1821–29.

Description De l'Embellissement de la Place de la Concorde, au milieu de laquelle doit s'élever le Monument. Paris: Chassaignon, 1836.

Description de L'Obélisque de Luxor, Avec L'histoire de son voyage, l'explication des moyens mécaniques employés pour son embarquement, son débarquement et son érection sur la place de la Concorde. Paris, 1836.

Desgenettes, René N. *Histoire médicale de l'armée d'Orient.* Paris: Croullebois, 1802.

Detroit Institute of Arts. *French Painting 1774–1830: The Age of Revolution.* Exh. cat. Detroit: Wayne State University Press, 1975.

Dhombres, Nicole, and Jean Dhombres. *Naissance d'un pouvoir: Sciences et savants en France (1793–1824).* Paris: Payot, 1989.

Dibner, Bern. *Moving the Obelisks.* Norwalk, Conn.: Burndy Library, 1952.

Didier-Lamboray, Anne-Marie. "Les Vitraux de l'Histoire de Joseph à l'église Saint-Antoine de Liège et leurs modèles." *Bulletin de l'Institut Royal du Patrimoine Artistique* 8 (Brussels, 1965): 201–22.

Djebar, Assia. *Women of Algiers in Their Apartment.* Trans. M. de Jager. Charlottesville: University of Virginia Press, 1992.

Ducros, Jean. "La Place de Louis XV." In *Les Gabriel,* ed. Michel Gallet and Yves Bottineau, 254–76. Paris: Picard, 1982.

E. "Egypte. L'Obélisque de Louqsor." *Journal la Paix* 1194 (16 October 1836): 7.

Eagleton, Terry, Fredric Jameson, and Edward W. Said. *Nationalism, Colonialism, and Literature.* Introduction by Seamus Deane. Minneapolis: University of Minnesota Press, 1990.

Elwitt, Sanford. *The Making of the Third Republic: Class and Politics in France, 1868–1884.* Baton Rouge: Louisiana State University Press, 1975.

Embellissemens de la Place de la Concorde. Explication des monumens qui la décorent. New ed. Paris: Gauthier, 1839.

Embellissemens de la Place de la Concorde. Explication des Statues qui la décorent. Nouvelle édition, revue et augmentée de gravures; suivie d'une notice historique sur chaque ville. Paris: Gauthier, 1833.

"Erection de l'obélisque." *Le National* (26 October 1836): 3.

Erection de l'Obélisque. Paris: Paul Dupont, 1836.

Escholier, Raymond. *Delacroix et les femmes.* Paris: Fayard, 1963.

———. *Delacroix, peintre, graveur, écrivain.* 3 vols. Paris: H. Floury, 1929.

Esquer, Gabriel. "La Littérature algérienne en 1846 (première partie)." *L'Afrique Latine* 1 (Algiers, 15 December 1921): 24–34.

————. "La Littérature algérienne en 1846 (Suite et fin)." *L'Afrique Latine* 2 (Algiers, 15 January 1922): 77–86.

————. "Les Poètes et l'expédition d'Alger, 'La Bacriade' de Barthélemy et Méry." *Revue Africaine* 60 (Algiers, 1919): 112–45.

————. "La Vie algérienne de Pétrus Borel, le lycanthrope." *Simoun* 4, no. 15 (Oran, 1955): 1–72.

Estienne, Charles. "Picasso ou le Dernier Portrait." *France Observateur* (16 June 1955): 26.

Examen critique et raisonné des tableaux des peintres vivants formant l'exposition de 1808. Paris: Ve. Hocquart, 1808.

"*Expédition de Bonaparte en Egypte.* Commission et Institut d'Egypte." *Magasin Pittoresque* 4 (November 1836): 353–54.

Fabre, Pierre. "Le Développement de l'Histoire de Joseph dans la littérature et dans l'art au cours des douze premiers siècles." *Mélanges d'Archéologie et d'Histoire* 39 (1921–22): 193–211.

Fakhry, Ahmed. "Champollion in Egypt." In *A la mémoire de Champollion,* 12–48. Cairo: L'Institut au Caire, 1973.

Fanon, Frantz. *A Dying Colonialism.* Trans. H. Chevalier. New York: Grove Weidenfeld, 1965.

Farcy, Charles. "Exposition de 1827. Musée Charles X." *Journal des Artistes* 26 (23 December 1827): 809–16.

————. "Musée Royal. Exposition de 1827. Musée Charles X." *Journal des Artistes* 11 (13 January 1828): 17–20.

————. "Musée Royal. Exposition de 1827." *Journal des Artistes* 16 (20 April 1828): 241–46.

Faunce, Sarah, and Linda Nochlin. *Courbet Reconsidered.* New Haven: Yale University Press, 1988.

Ferguson, Eugene S. *Engineering and the Mind's Eye.* Cambridge: MIT Press, 1992.

Fontaine, Pierre-François-Léonard. *Journal, 1799–1853.* 2 vols. Paris: Ecole Nationale Supérieure des Beaux-Arts, 1987.

Forbin, Auguste. *Portefeuille du Comte de Forbin, directeur général des musées de France, contenat ses tableaux, dessins et esquisses les plus remarquables.* Ed. le comte de Marcellus. Paris: Challamel, 1843.

————. *Voyage dans le Levant en 1817 et 1818.* Paris: Imprimerie Royale, 1819.

Foucart, Jacques, ed. *Nouvelles acquisitions du Département des Peintures 1983–1986.* Exh. cat. Paris: Réunion des Musées Nationaux, 1987.

Fournier-Sarlovèze. *Le Général Lejeune.* Paris: Librairie de l'Art Ancient et Moderne, 1902.

Friedlaender, Walter. *David to Delacroix.* Trans. Robert Goldwater. Cambridge: Harvard University Press, 1952.

————. "Napoleon as 'Roi Thaumaturge.'" *Journal of the Warburg and Courtauld Institutes* 4, nos. 3–4 (April–July 1941): 139–41.

Gaehtgens, Thomas. "Versailles: Monument national." In *Saloni, gallerie, musei e loro influenza sullo sviluppo dell'arte dei secoli XIX e XX,* ed. Francis Haskell, 55–61. Bologna: CLUEB, 1981.

Gaston, Marguerite. "Le Général baron Lejeune (1775–1845)." *Bulletin du Musée Bernadotte* 20 (Pau, December 1975): 21–31.

Gautier, Théophile. "Salon de 1834." *France Industrielle* 1 (April 1834): 17–22.

Geertz, Clifford. "Centers, Kings, and Charisma: Reflections on the Symbolics of Power." In *Cul-*

ture and Its Creators: Essays in Honor of Edward Shils, ed. Joseph Ben-David and Terry Nichols Clark, 150–71. Chicago: University of Chicago Press, 1977.

Gilman, Sander L. *Difference and Pathology: Stereotypes of Sexuality, Race, and Madness.* Ithaca and London: Cornell University Press, 1985.

Gloton, J.-J. "Les Obélisques romains de la renaissance au néo-classicisme." *Mélanges d'Archéologie et d'Histoire* 73 (1961): 437–69.

Goldstein, Robert Justin. *Censorship of Political Caricature in Nineteenth-Century France.* Kent, Ohio: Kent State University Press, 1989.

Gorringe, Henry H. *Egyptian Obelisks.* New York: published by the author, 1882.

Gossman, Lionel. *Between History and Literature.* Cambridge: Harvard University Press, 1990.

Graham-Brown, Sarah. *Images of Women: The Portrayal of Women in Photography of the Middle East, 1860–1950.* New York: Columbia University Press, 1988.

Grandet, Pierre. "La Méthode de Champollion." *L'Histoire* 106 (December 1987): 18–26.

Granet, Solange. *Images de Paris: La Place de la Concorde.* Revue Géographique et Industrielle de France, n.s. 26 (Paris, 1963).

———. "Les Origines de la Place de la Concorde à Paris: Les Projets conservés aux Archives Nationales." *Gazette des Beaux-Arts* 53 (1959): 153–65.

Grasilier, Léon. "Les Frères Champollion et la police," *L'Intermédiare des Chercheurs et Curieux* 85, no. 1567 (20–30 October 1922): cols. 805–8.

———. "Les Frères Champollion et la politique." *Nouvelle Revue* (1 August 1922): 275–82.

Griener, Pascal. "L'Art de persuader par l'image sous le premier empire. A propos d'un concours officiel pour la représentation de *Napoléon sur le champ de bataille d'Eylau* (1807)." *L'Ecrit-Voir, Revue d'Histoire des Arts* 4 (1984): 9–21.

Grigsby, Darcy Grimaldo. "Rumor, Contagion, and Colonization in Gros's *Plague-Stricken at Jaffa* (1804)." *Representations* 51 (Summer 1995): 1–46.

Grosrichard, Alain. *Structure du sérail. La Fiction du despotisme asiatique dans l'Occident classique.* Paris: Seuil, 1979.

Grunchec, Philippe. *Le Grand Prix de Peinture: Les Concours des Prix de Rome de 1797 à 1863.* Paris: Ecole Normale Supérieure des Beaux-Arts, 1983.

Guay, C.-E. *La Gloire des monuments. Ode au Roi, sur l'achèvement des monuments de l'Empire à propos de l'inauguration de l'arc de triomphe de l'Etoile (Juillet 1836).* Versailles: Montalant-Bougleux, 1838.

Guenot-Lecointe, G. *Physiologie du gant.* Paris: Desloges, 1841.

Guiffrey, Jean. *Le Voyage de Eugène Delacroix au Maroc, facsimile de l'album du Château de Chantilly.* Paris: Terquem and P. Lemare, 1913.

Guiral, Pierre. *Adolphe Thiers, ou De la nécessité en politique.* Paris: Fayard, 1986.

Hamilton, George Heard. "Delacroix's Memorial to Byron." *Burlington Magazine* 94, no. 594 (September 1952): 257–61.

Hamy, Ernest-Théodore. *Les Origines du Musée Ethnographique: Histoire et Documents.* Paris: Ernest Leroux, 1890.

Hartleben, Hermine. *Champollion: Sa vie et son oeuvre, 1790–1832*. Trans. Denise Meunier. Paris: Pygmalion, 1983.

Hautecoeur, Louis. *L'Histoire de l'architecture classique en France*. Vol. 6, *La Restauration et le Gouvernement de Juillet, 1815–1848*. Paris: A. et J. Picard, 1955.

———. *Histoire du Louvre*. Paris: L'Illustration, 1929.

Haxell, Nichola A. "Hugo, Gautier and the Obelisk of Luxor (Place de la Concorde) during the Second Republic." *Nineteenth-Century French Studies* 18, nos. 1–2 (Fall–Winter 1990): 65–77.

Hegel, G. W. F. *The Philosophy of Fine Art*. 4 vols. Trans. F. P. B. Osmaston. London: G. Bell and Sons, 1920.

Hemphill, Richard. "Le Transport de l'obélisque du Vatican." *Etudes Françaises* 26, no. 3 (Winter 1990): 111–17.

Hennequin, Philippe-Auguste. *Mémoires de Philippe-Auguste Hennequin*. Ed. Jenny Hennequin. Paris: Calmann-Lévy, 1933.

Henrotin, Edmond. "Autographes des deux Champollion." *Chronique d'Egypte* 47, no. 96 (Brussels, 1973): 266–75.

Hersey, George L. "Delacroix's Imagery in the Palais Bourbon Library." *Journal of the Warburg and Courtauld Institutes* 31 (1968): 383–403.

Hewlings, Richard. "Ripon's Forum Populi." *Architectural History* 24 (1981): 39–52.

Hiesinger, Ulrich. "Canova and the Frescoes of the Galleria Chiaramonti." *Burlington Magazine* 120, no. 907 (October 1978): 654–65.

L'Histoire de Paris depuis 2000 ans. 2 vols. Paris: La Monnaie, 1950.

Hollier, Denis, ed. *A New History of French Literature*. Cambridge: Harvard University Press, 1994.

Holtman, Robert B. *Napoleonic Propaganda*. Baton Rouge: Louisiana State University Press, 1950.

Honour, Hugh. *Romanticism*. New York: Harper and Row, 1979.

Hugo, Victor. *Odes et ballades. Les Orientales*. Paris: Flammarion, 1968.

Humbert, Jean-Marcel. "L'Egyptomanie à Paris et dans la région parisienne de 1775 à 1825." Ph.D. diss., Paris, Sorbonne, 1975.

———. "Les Obélisques de Paris, projets et réalisations." *Revue de l'Art* 23 (1974): 9–29.

Humbert, Jean-Marcel, Michael Pantazzi, and Christiane Ziegler. *Egyptomania, L'Egypte dans l'art occidental, 1730–1930*. Exh. cat. Paris: Réunion des Musées Nationaux, 1994.

Hunt, Lynn. *Politics, Culture, and Class in the French Revolution*. Berkeley: University of California Press, 1984.

Hutton, Patrick H. "The Role of Memory in the Historiography of the French Revolution." *History and Theory* 30, no. 1 (1991): 56–69.

Idzerda, Stanley J. "Iconoclasm during the French Revolution." *American Historical Review* 60, no. 1 (October 1954): 13–26.

Institut du Monde Arabe. *Delacroix: Le Voyage au Maroc*. Exh. cat. Paris: Flammarion, 1994.

"Intérieur. Paris, le 7 juillet." *Le Moniteur universel* 189 (8 July 1825): 1017.

Jal, Auguste. *Esquisses, Croquis, Pochades ou Tout ce qu'on voudra, sur le Salon de 1827*. Paris: Ambroise Dupont, 1828.

Janes, Regina. "Beheadings." *Representations* 35 (Summer 1991): 21–51.

JanMohamed, Abdul R. "The Economy of Manichean Allegory: The Function of Racial Difference in Colonialist Literature." *Critical Inquiry* 12, no. 1 (Autumn 1985): 59–87.

Janson, H. W., ed. *Catalogue of the Paris Salon, 1673 to 1881.* 60 vols. New York: Garland, 1977.

Jardin, André. *Tocqueville: A Biography.* Trans. Lydia Davis and Robert Hemenway. New York: Farrar, Straus, and Giroux, 1988.

Jardin, André, and André-Jean Tudesq. *Restoration and Reaction, 1815–1848.* Trans. Elborg Forster. Cambridge: Cambridge University Press, 1988.

Joannides, Paul. "Colin, Delacroix, Byron and the Greek War of Independence." *Burlington Magazine* 125, no. 965 (August 1983): 495–500.

Joannis, Léon de. *Campagne Pittoresque du Luxor.* Paris: Mme Huzard, 1835.

Johnson, Lee. "Delacroix's North African Pictures." *Canadian Art* 20, no. 1 (January–February 1963): 20–24.

———. *The Paintings of Eugène Delacroix: A Critical Catalogue.* 4 vols. Oxford: Clarendon Press, 1981–86.

———. "Towards Delacroix's Oriental Sources." *Burlington Magazine* 120, no. 900 (1978): 144–51.

———. "Two Sources of Oriental Motifs Copied by Delacroix." *Gazette des Beaux-Arts* 65 (March 1965): 163–68.

Jung, C. G. *Memories, Dreams, Reflections.* Ed. Aniela Jaffé. Trans. Richard and Clara Winston. London: Fontana, 1986.

Kain, Roger. "Napoleon I and Urban Planning." *Connoisseur* (January 1978): 44–51.

Kanawaty, Monique. "Les Acquisitions du Musée Charles X." *Bulletin de la Société Française d'Egyptologie* 104 (October 1985): 31–49.

———. "Les Principes muséologiques de Champollion." In *Akten des Vierten Internationalen Ägyptologen Kongresses, München 1985,* ed. Sylvia Schoske, 53–62. Hamburg: Helmut Buske, 1988.

———. "Vers une politique d'acquisitions: Drovetti, Durand, Salt et encore Drovetti." *La Revue du Louvre* 4 (1990): 267–71.

Kemp, Wolfgang. "Der Obelisk auf der Place de la Concorde," *Kritische Berichte,* 7, nos. 2–3 (1979): 19–29.

Kettel, Jeannot. *Jean-François Champollion le jeune. Répertoire de bibliographie analytique, 1806–1989.* Mémoires de l'Académie des Inscriptions et Belles-Lettres, n.s. 10. Paris: Institut de France, 1990.

Kriz, Kay Dian. "Picasso's Variations on Delacroix's 'Femmes d'Alger': The Grand Tradition, Desire and Colonialism (Again)." Department of Fine Arts, University of British Columbia, Vancouver, 1987. Photocopy.

Kruger, Loren. "Attending (to) the National Spectacle: Instituting National (Popular) Theater in England and France." In *Macropolitics of Nineteenth-Century Literature: Nationalism, Exoticism, Imperialism,* ed. Jonathan Arac and Harriet Ritvo, 243–67. Philadelphia: University of Pennsylvania Press, 1991.

Laborde, Alexandre-Louis-Joseph de. *Description des obélisques de Louqsor, figurés sur les places de la Concorde et des Invalides, et précis des opérations relatives au transport d'un de ces monumens dans la capitale, lu à la séance publique de l'Institut.* Paris: Bohaire, 1832.

Laclotte, Michel, ed. *Petit Larousse de la peinture.* Paris: Larousse, 1979.

Lacouture, Jean. *Champollion: Une vie de lumières.* Paris: Bernard Grasset, 1988.

Laffey, John. "Les Racines de l'impérialisme français en Extrême-Orient." *Revue d'Histoire Moderne et Contemporaine* 16 (April–June 1969): 282–300.

———. "Roots of French Imperialism in the Nineteenth Century: The Case of Lyon." *French Historical Studies* 6 (Spring 1969): 78–93.

Lajer-Burcharth, Ewa. "David's *Sabine Women*: Body, Gender and Republican Culture under the Directory." *Art History* 14, no. 3 (September 1991): 397–430.

La Jonquière, C. *L'Expédition d'Egypte, 1798–1801.* 5 vols. Paris: H. Charles Lavauzelle, 1899–1907.

Lambert, Elie. *Delacroix et 'Les Femmes d'Alger.'* Paris: H. Laurens, 1937.

Lamennais, Félicité de. *Oeuvres complètes.* 10 vols. Paris: Pagnerre, 1843–44.

Landon, Charles Paul. *Annales du Musée.* Vol. 1. Paris: Pillet aîne, 1832.

Laplanche, Jean, and J. B. Pontalis. *The Language of Psychoanalysis.* Trans. Donald Nicholson-Smith. New York: Norton, 1973.

La Rochefoucauld, Sosthènes de. "Etablissement du Musée Royal Egyptien de Paris.—Rapport du Roi." *Bulletin des Sciences Historiques, Antiquités, Philologie* 6 (1826): 31–37.

———. *Mémoires.* 11 vols. Paris: Michel Lévy Frères, 1862–63.

Larrey, D. J. *Relation historique et chirurgicale de l'expédition de l'armée d'Orient, en Egypte et en Syrie.* Paris: Demonville et Soeurs, 1803.

Laurens, Henry. *L'Expédition d'Egypte, 1798–1801.* Paris: Armand Colin, 1989.

———. *Les Origines intellectuelles de l'expédition d'Egypte: L'Orientalisme Islamisant en France (1698–1798).* Istanbul and Paris: Editions Isis, 1987.

———. *Le Royaume impossible: La France et la genèse du monde arabe.* Paris: Armand Colin, 1990.

Lavedan, Pierre. *Histoire de l'Urbanisme.* Vol. 2, *Renaissance et Temps Modernes.* Paris: Henri Laurens, 1952.

Laviron, Gabriel. *Le Salon de 1834.* Paris: Louis Janet, 1834.

Lazreg, Marnia. "Gender and Politics in Algeria: Unraveling the Religious Paradigm." *Signs* 15, no. 4 (Summer 1990): 755–80.

Lebas, Apollinaire. *L'Obélisque de Luxor, Histoire de sa translation à Paris, description des travaux auquels il a donné lieu, avec un appendice sur des calculs des appareils d'abattage, d'embarquement, de halage et d'érection.* Paris: Carilian-Goeury et Dalmont, 1839.

Leclant, Jean. "Champollion et le Collège de France." *Bulletin de la Société Française d'Egyptologie* 95 (October 1982): 32–46.

———. "La Modification d'un regard (1787–1826): Du *Voyage en Syrie et en Egypte* de Volney au Louvre de Champollion." *Académie des Inscriptions & Belles-Lettres* (November–December 1987): 709–29.

Ledoux-Lebard, Guy. "Les Projets de Fontaines pour la place de la Bastille et la Fontaine à l'Elephant." In *Les Arts à l'Epoque Napoléonienne,* 37–56. Les Archives de l'Art Français, vol. 24. Paris: F. De Nobele, 1969.

Leith, James A. *Space and Revolution: Projects for Monuments, Squares, and Public Buildings in France, 1789–1799.* Montreal: McGill-Queen's University Press, 1991.

Lelièvre, Pierre. "Gros, peintre d'histoire." *Gazette des Beaux-Arts* (May 1936): 289–304.

————. *Vivant Denon: Directeur des Beaux-Arts de Napoléon.* Paris: Floury, 1942.

Lempriere, William. *A Tour Through the Dominions of the Emperor of Morocco, Including a Particular Account of the Royal Harem.* Newport, England, 1813.

Lenoir, Alexandre. *Examen Mythologique, Historique et Critique de la Collection des Antiquités Égyptiennes du Louvre, réunies dans la Galerie, dite 'Charles X.'* Paris, 1829.

Lenormant, Charles. "Salon de 1834.—Deuxième article." *Le Temps, Journal des Progrès* 2, no. 1690 (6 March 1834): 1–2.

Lequin, Georges, ed. *Mémoires du Comte de Rambuteau.* Paris: Calmann-Lévy, 1905.

Lettres impartiales sur les expositions de l'an 1806, par un amateur. Paris: Aubry, Petit, n.d.

Levitine, George. *Girodet-Trioson: An Iconographical Study.* New York: Garland, 1978.

Lewis, Reina. *Gendering Orientalism: Race, Femininity, and Representation.* London: Routledge, 1996.

L'Hôte, Nestor. "Beaux-Arts—Ouverture du Musée d'antiquités égyptiennes au Louvre." *Revue Encyclopédique* 36 (1827): 827–31.

————. "*Notice descriptive des monumens égyptiens du Musée Charles X;* par M. Champollion, le jeune." *Revue Encyclopédique* 36 (1827): 784–85.

————. *Notice historique sur les Obélisques Egyptiens, et en particulier sur l'obélisque de Louqsor.* Paris: Leleux, 1836.

Livchitz, I. G. "Nouveaux documents sur l'histoire de l'égyptologie." *Cahiers d'Histoire Mondiale* 6, no. 3 (Neuchatel, 1961): 605–27.

Lloyd, Cathie. "Antiracist Ideas in France: Myths of Origin." *The European Legacy* 1, no. 1 (March 1996): 126–31.

Lowe, Lisa. *Critical Terrains: French and British Orientalisms.* Ithaca and London: Cornell University Press, 1991.

Luxenberg, Alisa. "*General Kléber* and *Egyptian Family.*" In *Catalogue of Nineteenth-Century European Painting,* ed. Louise d'Argencourt. Cleveland: Cleveland Museum of Art, 1998.

McClellan, Andrew. *Inventing the Louvre: Art, Politics, and the Origins of the Modern Museum in Eighteenth-Century Paris.* Cambridge: Cambridge University Press, 1994.

————. "The Musée du Louvre as Revolutionary Metaphor during the Terror." *Art Bulletin* 70, no. 2 (June 1988): 300–313.

MacKenzie, John M. *Orientalism: History, Theory and the Arts.* Manchester: Manchester University Press, 1995.

McVaugh, Robert Eastburn. "The Casa Bartholdy Frescoes and Nazarene Theory in Rome, 1816–1817." Ph.D. diss., Princeton University, 1981.

McWilliam, Neil. "David d'Angers and the Panthéon Commission: Politics and Public Works under the July Monarchy." *Art History* 5, no. 4 (December 1982): 426–46.

Maison de Balzac, Paris. *Dantan jeune. Caricatures et portraits de la societé romantique.* Exh. cat. Paris: Direction des Affaires Culturelles de la Ville de Paris, 1989.

Marçais, Georges. *Le Costume Musulman d'Alger.* Paris: Plon, 1930.

Maricha, Robert. "Champollion et l'Académie." *Bulletin de la Société Française d'Egyptologie* 95 (October 1982): 12–31.

Markham, Felix. *Napoleon.* New York: New American Library, 1963.

Marrinan, Michael. *Painting Politics for Louis-Philippe: Art and Ideology in Orléanist France, 1830–1848.* New Haven: Yale University Press, 1988.

Marsot, Alaf Lutfi Al-Sayyid. *Egypt in the Reign of Muhammad Ali.* Cambridge: Cambridge University Press, 1984.

Martin-Gropius-Bau, Berlin. *Europa und der Orient, 800–1900.* Exh. cat. Gütersloh and Munich: Bertelsmann, 1989.

"Médaille égyptienne." *Le Moniteur universel* 336 (2 December 1826): 1617–18.

"Méhémet-Ali et les antiquités de l'Egypte." *L'Artiste* 1 (1836): 18–19.

Melling, Antoine-Ignace. *Voyage Pittoresque de Constantinople et des rives du Bosphore.* 2 vols. Paris: P. Didot l'aîné, 1819.

Mellon, Stanley. *The Political Uses of History: A Study of Historians in the French Restoration.* Stanford: Stanford University Press, 1958.

Mémoires de l'Obélisque de Louqsor, écrits par lui-même, et dédiés aux Parisiens. Paris, 1836.

Memorial Art Gallery of the University of Rochester. *Orientalism: The Near East in French Painting, 1800–1880.* Exh. cat. Rochester: Memorial Art Gallery of the University of Rochester, 1982.

Menu, Bernadette. *L'Obélisque de la Concorde.* Paris: Edition de Lunx, 1987.

Mérimée, J. F. L. *De la peinture à l'huile: ou Des procédés materiels employés dans ce genre de peinture, depuis Hubert et Jan Van Eyck jusqu'à nos jours.* Paris: Mme Huzard, 1830.

Merle, J. T. [signed P.]. "Sur le Salon de 1827." *La Quotidienne* 115 (24 April 1828): 3–4.

Merle, Marcel. *L'Anticolonialisme européen de Las Casas à Karl Marx.* Paris: Armand Colin, 1969.

Méry, Joseph. "Le Luxor à Toulon. A M. Barthélemy. Toulon, ce 3 Juin 1833." *Journal de Paris* 2128 (1 July 1833): 1–19.

Metcalf, Thomas R. *An Imperial Vision: Indian Architecture and Britain's Raj.* Berkeley: University of California Press, 1989.

Meyer, Jean, et al. *Histoire de la France coloniale.* 2 vols. Paris: Armand Colin, 1990–91.

Miel, Edme. "Sur L'Obélisque de Louqsor, Et les Embellissements de la Place de la Concorde et des Champs-Elysées." *Le Constitutionnel* (18 and 26 November, 14 December 1834).

Mitchell, W. J. T. *Picture Theory: Essays on Verbal and Visual Representation.* Chicago: University of Chicago Press, 1994.

Montgolfier, Bernard de. "La Place Louis XV." *Monuments Historiques* 120 (April 1982): 38–41.

Mortimer, Mildred. "Language and Space in the Fiction of Assia Djebar and Leïla Sebbar." *Research in African Literatures* 18 (Fall 1988): 301–11.

Munich, Nicole. "Les Plafonds peints du Musée du Louvre: Inventaire des documents d'Archives." *Archives de l'Art Français* 26 (1984): 107–63.

Musée des Arts Décoratifs, Palais du Louvre, Paris. *Exposition artistique de l'Afrique française.* Exh. cat. Paris: Musée des Arts Décoratifs, Palais du Louvre, 1935.

Musée des Arts et Traditions Populaires, Paris. *Le Fait divers.* Exh. cat. Paris: Réunion des Musées Nationaux, 1982–83.

Musée des Beaux-Arts, Pau. *Les Peintres Orientalistes (1850–1914).* Exh. cat. Pau: Musée des Beaux-Arts, 1983.

Musée Borély, Marseille. *L'Orient des Provençaux dans l'histoire: Orient réel et mythique.* Exh. cat. Marseille: Musée Borély, 1982–83.

Musée Cantini, Marseille. *L'Orient en question, 1825–1875: De Missolonghi à Suez ou l'Orientalisme de Delacroix à Flaubert.* Exh. cat. Marseille: Musée Cantini, 1975.

Musée Carnavalet, Paris. *De la Place Louis XV à la Place de la Concorde.* Exh. cat. Paris: Les Musées de la Ville de Paris, 1982.

———. *Hittorff: Un Architecte du XIX^{ème}.* Exh. cat. Paris: Les Musées de la Ville de Paris, 1986–87.

"Musée Charles X." *Annales de la Littérature et des Arts* 7, no. 31 (1828): 119–25.

Musée du Louvre, Paris. *Nouvelles acquisitions du Département des Peintures (1983–1986).* Exh. cat. Paris: Réunion des Musées Nationaux, 1987.

Musset, Alfred de. "Exposition au Profit des Blessés dans La Galerie du Luxembourg." In *Oeuvres complètes de Alfred de Musset,* ed. Edmond Biré, vol. 7, *La Confession d'un enfant du siècle,* 249–51. Paris: Garnier Frères, 1975. Originally published in *Le Temps,* 27 October 1830.

Naish, Camille. *Death Comes to the Maiden: Sex and Execution, 1431–1933.* London: Routledge, 1991.

Nicolle, Marcel. *Ville de Nantes. Musée Municipal des Beaux-Arts.* Nantes: Musée des Beaux-Arts, 1913.

Nochlin, Linda. "The Imaginary Orient." *Art in America* (May 1983): 119–31, 187–91.

———. "'Matisse' and Its Other." *Art in America* (May 1993): 88–97.

Nouvelle Description des Obélisques de Luxor. Paris: Mme Veuve Boissay, 1833.

Nowinski, Judith. *Baron Dominique Vivant Denon (1747–1825); Hedonist and Scholar in a Period of Transition.* Rutherford, N.J.: Farleigh Dickinson University Press, 1970.

"The Obelisk of Luxor." *The Penny Magazine of the Society for the Diffusion of Useful Knowledge* 3 (15 February 1834): 61–63.

"Obélisque de Louqsor." *France Industrielle* 4 (July 1834): 141.

"Obélisque de Louqsor." *Magasin Pittoresque* (21 December 1833): 393–94.

L'obélisque de Luxor au terre-plein du pont neuf. Paris: C. L. F. Panckoucke, 1833.

L'Observateur au Museum ou Revue critique des ouvrages de peinture, sculpture et gravure exposés au musée Napoléon en l'an 1810. Paris: Aubry, n.d.

Observations sur le Salon de l'an 1808. Paris: Ve Gueffier, Delaunay, 1808.

Ojalvo, David, and Françoise Demange. *Léon Cogniet, 1794–1880.* Exh. cat. Orléans: Musée des Beaux-Arts, 1990.

L'Orient: Concept et images. Fifteenth Colloquium of the Institut de Recherches sur les Civilisations de l'Occident Moderne. Civilisations, no. 15. Paris, 1987.

Ozouf, Mona. *La Fête révolutionnaire, 1789–1799.* Paris: Gallimard, 1976.

Pacho, Jean-Raymond [signed P.]. "Histoire Moderne." *Le Moniteur universel* 327 (23 November 1827): 1618.

Paquet, Jean. "Les Deux Champollion dans le milieu universitaire grenoblois." *Bulletin Mensuel de l'Académie Delphinale* 12, no. 1 (1973): 29–43.

Peisse, Louis. "Salon de 1834.—(Quatrième article.)" *Le National* (11 March 1834): 1–3.

Petit Palais, Paris. *Exposition du centenaire de la conquête de l'Algérie, 1830–1930.* Exh. cat. Paris: Petit Palais, 1930.

Petrey, Sandy. "Pears in History." *Representations* 35 (Summer 1991): 52–71.

Pigeory, Félix. *Les Monuments de Paris . . . sous le règne du Roi Louis-Philippe.* Paris: A. Hermitte, 1847.

Piussi, Anna Ruth. "Images of Egypt during the French Expedition (1798–1801): Sketches of a Historical Colony." Ph.D. diss., St. Antony's College, Oxford University, 1992.

Planche, Gustave. "De L'Ecole Française au Salon de 1834." *Revue des Deux-Mondes* (1 April 1834): 46–84.

Pliny. *Natural History.* Trans. D. E. Eicholz. Vol. 10. Cambridge: Harvard University Press, 1962.

Pluchonneau Aîné. *Paris aujourd'hui. Poème historique des monumens érigés achevés ou embellis de la capitale et de ses environs, pendant 14 ans du règne de S. M. Louis-Philippe Ier.* Paris: E. Proux, 1844.

Porter, Sir Robert Ker. *Travels in Georgia, Persia, Armenia, Ancient Babylonia, etc., etc. during the Years 1817, 1818, 1819, and 1820.* 2 vols. London: Longman, Hurst, Rees, Orme, and Brown, 1821.

Porterfield, Todd B. "Egyptomania." *Art in America* 82, no. 11 (November 1994): 84–91, 149.

Quatremère de Quincy, Antoine-Chrysostome. *De l'Architecture Egyptienne, considérée dans son origine, ses principes et son goût, et comparée sous les mêmes rapports à l'Architecture Grecque.* Paris: Barrois l'aîné et fils, 1803.

Quoniam, Pierre. "Champollion et le Musée du Louvre." *Bulletin de la Société Française d'Egyptologie* 95 (October 1982): 47–61.

Rabbe, Alphonse. "Exposition de 1827. Restitution du Salon carré et ouverture du nouveau Musée." *Courrier Français* 351 (17 December 1827): 4.

Regard, Maurice. "Eugène Delacroix et le Comte de Mornay au Maroc (1832), (Documents Inédits)." *Etudes d'Art* 7 (1952): 31–60.

"Résumé du Salon de 1828." *Observateur des Beaux-Arts* (8 May 1828): 33–34.

Rey, Joseph. "Notice historique sur les Sociétés secrètes qui ont existé en France pendant la Restauration." *Le Patriote des Alpes* 12, no. 1772 (26 October 1847): 1–2.

Rosenberg, Martin. "Raphael's Transfiguration and Napoleon's Cultural Politics." *Eighteenth-Century Studies* 19, no. 2 (Winter 1985–86): 180–205.

Rosenthal, Donald A. "Joseph Franque's *Scene during the Eruption of Vesuvius.*" *Philadelphia Museum of Art Bulletin* 75, no. 324 (March 1979): 2–15.

———. "A Mughal Portrait Copied by Delacroix." *Burlington Magazine* 119, no. 892 (July 1977): 505–6.

Roserot, Alphonse. "La Statue de Louis XV par Bouchardon." *Gazette des Beaux-Arts* 17 and 18 (1897). 17: 195–213, 376–90; 18: 159–70.

Rosset. *Moeurs et Coutumes, Turques et Orientales: Dessinées dans le pays en 1790.* N.p., 1790.

Rothenberg, Gunther E. *The Art of Warfare in the Age of Napoleon.* Bloomington: Indiana University Press, 1978.

Roullet, Anne. *The Egyptian and Egyptianizing Monuments of Imperial Rome.* Leiden: E. J. Brill, 1972.

Rubin, James Henry. "Ingres's *Vision of Oedipus and the Sphinx*: The Riddle Solved?" *Arts Magazine* 54, no. 2 (October 1979): 130–33.

S———. "Campagne pittoresque du Luxor, par M. Léon de Joannis." *L'Artiste* 1 (1835): 199.

Said, Edward W. *Orientalism.* New York: Random House, 1978.

———. "Orientalism Reconsidered." In *Literature, Politics and Theory,* ed. Francis Barker et al., 210–29. Papers from the Essex Conference, 1976–84. London and New York: Methuen, 1986.

"Salon de l'an IX." *La Gazette nationale {ou} Le Moniteur universel* (6 vendémiaire, year X): 21–22.

"Salon de 1806." *Le Publiciste* (10 October 1806): 1–3.

"Salon de 1827." *La Pandore* 1637 (12 November 1827): 2.

"Salon de 1827. La Nouvelle Ecole." *La Pandore* 1649 (24 November 1827): 2.

"Salon de 1827. La salle des séances." *Journal du Commerce* (14 January 1828): 2.

"Salon de 1827. M. Gudin.—M. Delacroix." *France chrétienne* 3, no. 46 (22 February 1828): 3–4.

"Salon de 1827. Troisième Exposition.—Revue." *Journal du Commerce* 2959 (7 February 1828): 2.

"Salon de 1828." *La Pandore* 1725 (9 February 1828): 2.

"Salon de 1828." *La Pandore* 1736 (20 February 1828): 2.

Salvolini, François. *Traduction et analyse grammaticale des Inscriptions sculptées sur l'obélisque égyptien de Paris.* Paris: Dondey-Dupré, 1837.

Sazerac, Hilaire-Léon. *Lettres sur le Salon de 1834.* Paris: Delaunay, 1834.

Schapiro, Meyer. "The Joseph Scenes on the Maximianus Throne in Ravenna." *Gazette des Beaux-Arts* (July 1952): 27–38.

Scheffer, Ary. "Salon de 1827." *Revue Française* 1 (1828): 188–212.

Schlenoff, Norman. "Baron Gros and Napoleon's Egyptian Campaign." In *Essays in Honor of Walter Friedlaender,* 152–64. New York: Institute of Fine Arts, 1965.

Schneider, Donald David. *The Works and Doctrine of Jacques-Ignace Hittorff, 1792–1867.* 3 vols. New York: Garland, 1977.

Sebbar, Leïla. *Scherazade: Missing, Aged 17, Dark Curly Hair, Green Eyes.* Trans. Dorothy S. Blair. London: Quartet, 1991.

Sérullaz, Maurice. *Delacroix.* Paris: F. Nathan, 1981.

———. *Delacroix: Aquarelles du Maroc.* Paris: Fernand Hazan, 1951.

———. *Mémorial de l'exposition Eugène Delacroix.* Exh. cat. Paris: Editions des Musées Nationaux, 1963.

———. *Les Peintures murales de Delacroix.* Paris: Editions du Temps, 1963.

———, ed. *Dessins d'Eugène Delacroix, 1798–1863. Inventaire général des dessins. Ecole Française.* Paris: Réunion des Musées Nationaux, 1984.

Seznec, Jean. "Herculaneum and Pompeii in French Literature of the Eighteenth Century." *Archaeology* 3, no. 7 (Autumn 1949): 150–58.

Shils, Edward. *Center and Periphery: Essays in Macrosociology.* Chicago: University of Chicago Press, 1975.

Siegfried, Susan Locke. "Naked History: The Rhetoric of Military Painting in Postrevolutionary France." *Art Bulletin* 75, no. 2 (June 1993): 235–58.

Silver, Kenneth E. *Esprit de Corps: The Art of the Parisian Avant-Garde and the First World War, 1914–1925.* Princeton: Princeton University Press, 1989.

———. "Matisse's Retour à l'ordre." *Art in America* (June 1987): 110–123, 167, 169.

Silvera, Alain. "Egypt and the French Revolution: 1798–1801." *Revue Française d'Histoire d'Outre-mer* 69, no. 257 (1982): 307–22.

Silvestre, Théophile. *Les Artistes français.* Vol. 1, *Les Romantiques.* Paris: G. Crès, 1926.

Siméon, Joseph-Jérome. "Dépôt du rapport sur le projet de loi concernant les monuments de la Capitale." *Archives Parlementaires* 105b (10 June 1836): 175.

Smalls, James. "Making Trouble for Art History: The Queer Case of Girodet." *Art Journal* 55, no. 4 (Winter 1996): 20–27.

Soboul, Albert. *A Short History of the French Revolution, 1789–1799.* Trans. Geoffrey Symcox. Berkeley: University of California Press, 1977.

Sonnini, C. S. *Voyage dans la Haute et Basse Egypte, fait par ordre de l'ancien gouvernement, et contenant des observations de tous genres.* Paris: F. Buisson, year VII.

Sonolet, Louis. "Le Général baron Lejeune." *Gazette des Beaux-Arts* 33 (1905): 282–302.

Spector, Jack J. *Delacroix: The Death of Sardanapalus.* Art in Context, ed. John Fleming and Hugh Honour. New York: Viking Press, 1974.

Speed Art Museum, Louisville. *Ingres, In Pursuit of Perfection: The Art of J. A. D. Ingres.* Exh. cat. Louisville: Speed Art Museum, 1983–84.

Stafford, Barbara Maria. *Voyage into Substance: Art, Science, Nature, and the Illustrated Travel Account, 1760–1840.* Cambridge: MIT Press, 1984.

Steinberg, Leo. *Other Criteria: Confrontations with Twentieth-Century Art.* London: Oxford University Press, 1972.

Stevens, Mary Anne, ed. *The Orientalists: Delacroix to Matisse. The Allure of North Africa and the Near East.* Exh. cat. Washington, D.C.: National Gallery of Art, 1984.

Sturken, Marita. "The Wall, the Screen, and the Image: The Vietnam Veterans Memorial." *Representations* 35 (Summer 1991): 118–42.

Sweetman, John. *The Oriental Obsession: Islamic Inspiration in British and American Art and Architecture, 1500–1920.* Cambridge: Cambridge University Press, 1988.

Tardieu, A. "Salon de 1834. (Deuxième article)." *Courrier Français* 63 (4 March 1834): 1–2.

———. "Salon de 1834. (Septième article)." *Courrier Français* 89 (30 March 1834): 1–2.

Tawadros, Ceylan. "Foreign Bodies: Art History and the Discourse of Nineteenth-Century Orientalist Art." *Third Text* 3–4 (Spring–Summer 1988): 51–67.

Taylor, Maxine. "French Scientific Expeditions in Africa during the July Monarchy." *Proceedings for the Annual Meeting of the Western Society for French History* 16 (1989): 243–52.

Thiers, Adolphe. "Discours sur le budget de l'Algérie, prononcé le 9 juin, 1836 à la Chambre des Députés." In *Discours parlementaires de M. Thiers,* ed. M. Calmon, vol. 3, 507–8, 512–16. Paris: Calmann-Lévy, 1879.

———. "Discussion du budget d'Alger et des autres possessions françaises dans le nord de l'Afrique." *Archives Parlementaires* 105 (9 June 1836): 154–59.

———. "Discussion du projet de loi concernant l'achèvement de divers Monuments Publics de la Capitale." *Archives Parlementaires* 105 (16 June 1836): 447.

Thornton, Lynne. "La Renaissance des Orientales." *Connaissance des Arts* 329 (July 1979): 77–84.

Thury, Héricourt de. "Note sur l'obélisque de Louqsor, lue à l'Académie des Sciences dans sa Séance du 20 Janvier 1834." *Moniteur du Commerce* 253 (22 January 1834): 3.

Tocqueville, Alexis de. *De la colonie en Algérie.* Ed. Tzvetan Todorov. Brussels: Editions Complexe, 1988.

————. *Ouevres complètes.* Ed. Jacob Peter Mayer. Vol. 3, part 2, *Ecrits et discours politiques.* Paris: Gallimard, 1985.

"Transport en France et érection de l'obélisque de Luxor." *Magasin Pittoresque* 1 (1837): 3–7.

Trapp, Frank Anderson. *The Attainment of Delacroix.* Baltimore: The Johns Hopkins University Press, 1971.

Tulard, Jean. "Bonaparte en Egypt." *L'Histoire* 61 (November 1983): 30–41.

University of Michigan Museum of Art. *Pompeii as Source and Inspiration: Reflections in Eighteenth- and Nineteenth-Century Art.* Exh. cat. Ann Arbor: University of Michigan Museum of Art, 1977.

Vaillant, P. "Champollion et les origines du déchiffrement des hiéroglyphes." *Bulletin Mensuel de l'Académie Delphinale* 8, no. 12 (1973): 23–28.

Van Nimmen, Jane, and Ruth Mirolli. *Nineteenth-Century French Sculpture: Monuments for the Middle Class.* Exh. cat. Louisville: Speed Art Museum, 1971.

Vaulchier, Claudine de. "Iconographie des décors révolutionnaires." In *Les Architectes de la Liberté, 1789–1799.* Ed. Annie Jacques and Jean-Pierre Mouilleseaux, 255–79. Paris: Ecole Nationale Supérieure des Beaux-Arts, 1989–90.

Vergnaud, [A. D.]. *Examen du Salon de 1834.* Paris: Delaunay, 1834.

————. "Figaro au Salon." *Le Figaro* 429 (15 December 1827): 914–15.

————. "Figaro au Salon. Les nouvelles salles." *Le Figaro* 432 (18 December 1827): 926–27.

————. "Figaro au Salon." *Le Figaro* 3, no. 38 (7 February 1828): 1–2.

————. "Figaro au Salon. MM. Champmartin, Steuben et Delacroix." *Le Figaro* 3, no. 49 (18 February 1828): 2.

Verrier, Michelle. *Les Peintres orientalistes.* Paris: Flammarion, 1979.

Viator. *Sur l'Emplacement de l'Obélisque de Louqsor.* Paris: Decourchant, 1833.

Viel-Castel, Louis de. *Histoire de la Restauration.* 20 vols. Paris: Calmann-Lévy, 1860–80.

Villèle, comte de. *Mémoires et Correspondance.* 5 vols. Paris: Perrin, 1888–90.

Vitet, L. [signed L. V.]. "Beaux-Arts." *Le Globe* 6, no. 39 (8 March 1828): 252–55.

W. "Salon de 1834. (Quatrième article.)." *Le Constitutionnel* 34 (23 March 1834): 1–2.

————. "Salon de 1834. (Sixième article.)." *Le Constitutionnel* 101 (11 April 1834): 1–2.

Walzer, Michael. *Regicide and Revolution: Speeches at the Trial of Louis XVI.* Trans. Marian Rothstein. Cambridge: Cambridge University Press, 1974.

Waquet, Françoise. *Les Fêtes royales sous la restauration, ou L'Ancien Régime retrouvé.* Paris: Arts et Métiers Graphiques, 1981.

Weber, Max. "The Nation." In *Nationalism,* ed. John Hutchinson and Anthony D. Smith, 21–25. Oxford: Oxford University Press, 1994. From "The Nation," in Max Weber, *Essays in Sociology,* trans. H. H. Gerthe and C. Wright-Mills, 171–77, 179. London: Routledge and Kegan Paul, 1948.

Wein, Jo Ann. "Delacroix's *Street in Meknès* and the Ideology of Orientalism." *Arts Magazine* 83 (June 1983): 106–9.

White, Hayden. *Tropics of Discourse: Essays in Cultural Criticism.* Baltimore: The Johns Hopkins University Press, 1978.

————. "The Value of Narrativity in the Representation of Reality." In *On Narrative,* ed. W. J. T. Mitchell, 1–23. Chicago: University of Chicago Press, 1981.

Whiteley, J. "The King's Pictures." *Oxford Art Journal* 12, no. 1 (1989).

Wiesen, D. S. "Herodotus and the Modern Debate over Race and Slavery." *Ancient World* 3, no. 1 (April 1980): 3–6.

Wittkower, Rudolf. *The Impact of Non-European Civilizations on the Art of the West.* Cambridge: Cambridge University Press, 1989.

Wollen, Peter. "Fashion/Orientalism/the Body." *New Formations* 1 (Spring 1987): 5–33.

Woolf, Stewart. "The Construction of a European World-View in the Revolutionary-Napoleonic Years." *Past and Present* 137 (November 1992): 72–101.

————. "French Civilization and Ethnicity in the Napoleonic Empire." *Past and Present* 124 (August 1989): 96–120.

Yoyotte, Jean. "Champollion et le Panthéon Egyptien." *Bulletin de la Société Française d'Egyptologie* 95 (October 1982): 76–108.

Ziegler, Christiane. "Le Musée égyptien de Champollion." *La Revue du Louvre* 4 (1990): 264–66.

Index

Abd-el-Kadar, 206n.33

Abel de Pujol, Alexandre-Denis, 8–9, 109, 134, 182nn. 4 and 6, 183n.7, 196–97n.64; *The Children of Joseph Blessed by Jacob,* 197n.65; *Egypt Saved by Joseph,* 106–9, 196n.64, fig. 57; *Joseph Interpreting the Dreams of the Pharaoh's Butler and Baker,* 197n.65; *Lycurgue présente aux Lacédémoniens l'héritier du trône,* 196–97n.64

Aboukir, 13

Aboukir Bay, 44, 53

Acre, 44, 53

Agulhon, Maurice, 154n.3, 157n.1, 160n.13

Alaux, Jean, 109, 111

Alazard, Jean, 202n.15

Alcassar-El-Kebir, 203n.16

Alexandre, Arsène, 59, 173n.19, 175n.37

Alexandria, 24, 30, 162n.18, 174n.31, 194n.51

Algeria, 3, 6, 10, 15, 124, 138, 141, 145, 147, 152, 166n.48, 199n.78, 204n.22, 206n.33, 207n.33; French imperialism in, 3–4, 8, 11, 40–41, 43, 78, 109, 115, 127, 130, 131, 135, 138, 140, 167n.48, 168n.54, 169n.56, 207n.33; and memory of Egyptian campaign, 40–41, 115. *See also* women, Algerian

Algerian Revolution, 11, 147, 148, 150, 213n.7

Algiers, 3, 4, 11, 40, 121, 123, 127, 131, 138, 154n.3, 201n.6

Ali Bey, 198n.77

Alloula, Malek, 207–8n.41, 211n.1

Angelin, J.-P., 35, 37

Angoûleme, duc d', 102, 193n.49

antiquities, Egyptian, 8, 84, 91–92, 95–96, 100, 105, 114, 132, 156n.10, 182n.4, 185n.12, 186n.19, 191n.37, 199n.79, 200n.83; and French war trophies, surrendered to British, 8, 91, 186n.19. *See also* obelisks; Rosetta stone; Sphinx; zodiac of Denderah

antiquities, Greek, 84, 105, 182n.4, 186n.19, 191n.37, 200n.87

antiquities, Roman, 84, 91, 182n.4, 186n.19, 200n.87. *See also* Apollo Belvedere; Belvedere Torso

Apollo Belvedere, 81, 92, 135

Arc de Triomphe, 13, 15, 38, 78

Assemblée Nationale, 15, 17, 40. *See also* Palais Bourbon

Athanassoglou-Kallmyer, Nina, 206n.29

Auguste, Jules-Robert, 179n.72, 204n.23

Augustus, Caesar, 25

Aulanier, Christiane, 182n.6, 199n.79

Baltard, Louis-Pierre, 26, 163n.22

Barré, Jean-Jacques, *Victorious Gaul Rediscovering Ancient Egypt,* 114, 200n.83, fig. 62

Barthélemy, Auguste, 25

Bataille, Georges, 160n.15

Baumer, F. L., 211n.61

Belvedere Torso, 81, 93, 94

Bendiner, Kenneth Paul, 155n.9, 178n.56

Bénédite, Georges, 192n.39

Bénédite, Léonce, 145

Benjamin, Roger, 212n.4

Bergdoll, Barry, 160n.13

Bernasconi, Dominique, 211n.58

Bernini, Gian Lorenzo, 91

Berthier, Louis-Alexandre, 66

Berthollet, Claude-Louis, 45, 112

Bertin family, 206n.34

Blacas, duc de, 102, 186n.18, 191n.36, 197n.65

Bonaparte, Napoleon. *See* Napoleon I

Bonfils family, 211n.1

Bonnat, Léon, 115–16

Borel, Pétrus (Joseph Pétrus), 13, 35, 166n.48; *L'Obélisque de Louqsor,* 13

Bouchardon, Edme, 17; Equestrian Monument of Louis XV, 6, 17, 19–20, 33–34, 82, 163n.22, figs. 4 and 5

Bourbon regime, 9, 10, 22, 45, 81, 82, 83, 91, 94, 102, 105, 111, 192n.41, 210n.53

Boutard, Jean-Baptiste, 52, 63, 64, 65–66, 68, 71, 72, 173n.20, 179n.69, 180n.76

Boyer, Jean-Pierre, 206n.33

Brossollet, J., 174nn. 31 and 34, 175n.37

Burty, Philippe, 122

Byron, George Gordon, Lord, 105, 117, 205n.23

C. (critic), 176n.46

Cailleux, Alphonse de, 183n.8

Cairo, 44, 53, 61, 68–71; revolt of, 68–71

Callet, Antoine-François, *Allegory of the Eighteenth of Brumaire,* 8, fig. 1

Cana, 47, 49

Canova, Antonio, 188n.25, 197n.65

Caraffe, 33, 41; monument proposal, Place de la Concorde, 33–34, 41, fig. 17

Cartelier, Pierre, 20

Chabas, F.-J., 99

Chamber of Deputies, 5, 32, 40, 169n.58

Chambre des Pairs, 25, 38

Champmartin (Callande de Champmartin), Charles-Emile, 129, 205n.28

Champollion, Jean-François, 9, 24–25, 30–31, 32, 33, 34, 82, 84, 92, 95, 98, 99–104, 108, 119, 158n.2, 162n.18, 164n.25, 165n.36, 191n.36, 193n.50, 194nn. 53 and 54, 195nn. 56 and 58, 199n.79, 200n.83; *Attention!,* 102; as curator-organizer of Musée d'Egypte, 9, 81, 97, 99–101, 103–4, 182nn. 3 and 4, 183n.7, 191n.37, 191–92n.38, 192nn. 39 and 41; and deciphering hieroglyphs, 9, 28, 38, 97, 98, 99, 101, 103, 163n.23, 193n.46, 194n.51; design of obelisk of Charles X, 102, 164n.25, fig. 56; *L'Egypte sous les Pharaons,* 101, 192n.43; *Lettre à M. Dacier,* 101, 193n.45; "Notice Sommaire sur l'Histoire d'Egypte," 31, 109; as theme in painting cycle, 9, 82, 97, 98–99, 100–101, 190nn. 33 and 35

Champollion-Figeac, Jacques-Joseph, 31, 84, 92, 95, 99, 101, 104, 108, 169n.57, 183n.6, 188n.28, 191n.37, 192n.41, 192n.44, 194n.53, 200n.83

Champs-Elysées, 17

Chapeaurouge, Donat de, 188n.26

Charlemagne, King of the Franks, 137, 184n.11, 210n.55

Charles, *Jean-Jean at the Seraglio,* 138, 141, fig. 76

Charles VIII, King of France, 137, 210n.55

Charles X, King of France, 8, 20, 21, 25, 86, 87, 92, 109, 111, 160n.13, 164n.25, 166n.42, 184n.11, 191n.38, 200n.83, 206n.33

Chassaignac, Mme, 66; *Général baron Lejeune,* 127, 177n.55, fig. 35

Chateaubriand, vicomte de, 24, 189n.31

Chaudonneret, Marie-Claude, 159n.11

Chaussard, Pierre, 50–51, 63, 64, 173n.20, 176n.49

Chevrier, Jules, *Caricature of Egyptology,* 99, fig. 55

Clarac, Frédéric de, 63, 199n.79

classicism, 52, 95, 129, 134, 136, 145, 173n.19, 183n.7

Clement XI, Pope, 156n.10

Clovis I, King of the Franks, 109, 137, 184n.11, 210n.55

Cogniet, Léon, 98, 115, 116, 122, 200n.87; *Bonaparte in Egypt,* 116; *Egyptian Expedition under the Orders of Bonaparte,* 111–14, 115, 121–22,

199n.82, fig. 61; *Glory Distributing Laurels to War and Science*, 98, 189–90n.33, fig. 52; grisaille frieze, 115–16; *Jean-François Champollion*, 97–99, 190nn. 33 and 35, fig. 54

Colson, Guillaume-François, *Entry of General Bonaparte in Alexandria*, 178n.60

Consulate, 11, 20, 154n.3, 171n.8

Cortot, Jean-Pierre, 20; Monument Expiatoire, 20–21, fig. 9

Couder, Louis-Charles-Auguste, 85, 97, 184n.8

Council of State, 32

Coupin, P. A., 187n.23

Cracked Jug, The, 143–44, fig. 78

Crow, Thomas, 171n.8

Crusades, French, 7, 47, 49, 61, 76; memories of, 7, 47–49, 61, 76, 105, 174n.31

Cuno, James Bash, 159n.12

Dantan, Jean-Pierre, *Jean-Baptiste-Apollinaire Lebas*, 140–41, fig. 78

David, Jacques-Louis, 52, 129, 136, 196n.64, 205n.23, 208–9n.47

D. B. (critic), 65

Debray, Auguste-Hyacinthe, 180n.74

Decamps, Alexandre-Gabriel, 122, 129, 134, 135, 205n.28, 209–9n.47

Decazes, Louis-Charles, 195n.58

Dejoux, monument to Desaix, 26, 163n.22, fig. 12

Delaborde, Henri, 200n.87

Delacroix, Charles, 204n.22

Delacroix, Eugène, 11, 105, 119, 127, 128, 129, 144, 145, 147, 148, 179n.72, 201n.7, 202n.12, 203n.18, 203–4n.20, 205n.28, 206n.34, 210n.55, 211n.56; *The Approach to Meknès*, 125, fig. 70; *Death of Sardanapalus*, 117, 119, 123, 201n.2, 204n.22, 206n.30, fig. 64; as documenter, 121–27, 130; *The Favorite Slave of the Persian Ambassador*, 204n.22; *Greece on the Ruins of Missolonghi*, 105; *A Harem in Algiers*, 124, 202n.13, fig. 69; *Meknès Street Scenes*, 205n.28; notebooks of, 124–25, 129, 130, 137, 202n.14, 202–3n.16, 203n.19; North African trip of, 10, 11, 123–25, 127, 130–32, 134, 137, 140,

206n.31; Palais Bourbon commission, 137–38; *The Persian Ambassador*, 204n.22; *Scenes from the Massacres of Chios*, 128–29, 204–5n.23, fig. 71; visit to a harem, 131–32, 134, 138, 140, 201n.6, 202n.13, 207n.41; *The 28th of July, Liberty Leading the People*, 119; *The Women of Algiers* (ca. 1848), 119, fig. 66

Delacroix, Eugène: *The Women of Algiers* (1834), 10, 11, 116, 117, 118, 119, 145, 147, 148, 152, 206n.29, 208n.43, 209n.45, fig. 65; and Algerian women writers and artists, 150–52; critical response to, 11, 121, 122, 127, 134–35, 201–2n.9, 208–9n.47; as documentation, 10, 121–23, 124, 127, 134–35, 202n.15, 203–4n.20; and military conquests, 135–41; and Orientalism, 116, 132, 133, 134, 135; and Orientalist painting, 10, 116, 119, 121–22, 125, 127, 144, 202n.12, 203–4n.20; as reassessment of antiquity, 135–36

Delaroche, Paul, *Execution of Lady Jane Grey*, 122, fig. 68

Delécluze, Etienne-Jean, 91, 104–5, 134, 191n.37

Denon, Dominique-Vivant, 26, 74, 101, 174n.31, 177–78n.56, 180n.74, 186n.19; as arts administrator, 26, 81, 163n.22; as author and artist, 29–30, 32, 33, 47, 66–67, 71, 73–74, 127, 161n.18, 165n.32, 166n.42, 174n.31, 177–78n.56; as subject in works of art, 73, 81, 93, 102, 112, 181n.1; *Voyage dans la Basse et Haute Egypte*, 29–30, 33, 66, 73, 74, 165n.32

Desaix, Louis-Charles-Antoine, 26, 63, 66, 163n.22

Description de l'Egypte, 29, 30, 32, 45, 57, 82–83, 92, 95–96, 98, 101, 105, 109, 114, 115, 131, 181n.2

Desgenettes, René, 53–55, 56, 58, 61, 175n.35

Desoria, Jean-Baptiste-François, *Arrival of the French Army at the Port of Tentoura in Syria*, 175n.34

Détournelle, 33, 41; monument proposal, Place de la Concorde, 33–34, 41, fig. 17

Dhombres, Nicole and Jean, 174n.32

Dibner, Bern, 168n.49

Didot printers, 179n.71

Directory (Directoire), the, 11, 20, 34, 44, 72, 74, 153n.3

Djebar, Assia, 150; *Les Femmes d'Alger dans leur appartement,* 150

Doudeauville, Ambroise-Polycarpe de la Rochefoucauld, duc de, 104, 195n.56

Drovetti, Bernardino, 92

Dupuy, General, 68

Durand collection, 92, 186n.19

Du Sommerard, 192n.38

East, critique of: barbarism of Egypt, 29, 32, 35; barbarity of Turks, 50, 105, 210n.55; cruelty of East, 117; decadence of East, 71, 131, 133, 134, 136, 141, 144, 204–5n.23, 207n.41; decadence of Egypt under Muslims, 30, 33, 105, 163n.22; decay of Egypt, 30, 35, 36, 74, 76, 141, 162n.18; despotism of East, 136, 137, 144, 148, 211n.56

East-West contrasts, 7, 38, 41, 43, 45, 50, 63, 71, 72, 91, 108, 117, 132, 136, 144, 175n.34, 207–8n.43, 211n.56; gendered, 7, 10, 36, 37, 108, 196n.64; moral, 10, 35–36, 49–50, 56, 71, 72, 134, 176nn. 46 and 49; technological, 35–36, 38, 137, 168n.49; religious, 47, 56, 61, 71, 95, 108, 134, 138; racial, 108, 138

Ecole Militaire, 86

Ecole Polytechnique, 45, 190n.33

Edgeworth de Firmont, Abbé, 20

Egypt, ancient, 6, 7, 10, 25, 27, 30, 31, 33, 35, 38, 63, 95, 96, 99, 102, 104, 105, 108, 109, 112, 114, 156n.10, 163n.22, 169n.56, 190n.36, 204n.22; and monotheism, 91, 95, 188n.28; as origin of civilization, 8, 29, 87, 91, 92, 108, 109, 138, 192n.43; Roman triumph over, 7, 25, 26, 30, 156n.10, 163n.22. *See also* antiquities, Egyptian; pharaohs; histories of civilization, cyclic, modern France and ancient Egypt

Egypt, contemporary, 6, 8, 11, 15, 29, 30, 31, 32, 33, 35, 36, 38, 41, 44, 63, 71, 74, 76, 87, 102, 104–5, 111, 112, 169n.56, 204n.22

Egypt, personifications of, 86, 87, 89, 97, 98,

106–8, 111, 114, 185n.13, 200n.83, fig. 58

Egypt and agriculture, 109, 198nn. 75 and 76

Egyptian campaign, paintings of, 6–7, 8, 10, 43–79, 106, 127, 128–29, 141, 173n.19, 174–75n.34; authenticity in, 7, 47, 51–52, 59–61, 64–66, 67, 72, 73, 74, 127, 172n.13; critical response to, 45, 49–50, 51, 56, 59, 63, 64–66, 68, 72; and historical memories, 7, 47, 54, 56, 74, 76; and moral contrasts, 7, 10, 47, 49–50, 56, 64, 71, 72, 74

Egyptian campaign, savants of, 29, 30, 45, 82, 83, 101, 112, 171n.6, 177n.56, 181n.2, 200n.83. *See also Description de l'Egypte*

Egyptian campaign and occupation, 3, 5, 8, 11, 25, 26, 28–30, 33, 43, 44, 57, 59, 61, 68, 79, 81, 83, 84, 91, 92, 104, 112, 115, 135, 138, 163n.22, 165n.36, 171nn. 6 and 8, 174nn. 23, 29, and 32, 180n.78, 193n.44, 200n.83; British victories in, 32, 44–45, 53, 115; memory of, in July Monarchy, 15, 40, 115; memory of, and Algeria, 40–41, 115; and the Revolution, 43, 44, 52, 72, 76, 173n.19. *See also* Syrian campaign; imperialism, French

Egyptians, ancient, as black, 108, 197n.71, 198n.72

Egyptology, French, 9, 29, 30, 33, 38, 45, 81–82, 83, 84, 86, 99, 100–101, 111, 114, 115, 162n.21, 163n.23, 165n.36, 181n.2

El Arich, 53

El-Bekir square, 68, 72

Empire, French, 3, 4, 6, 7, 10, 11, 20, 41, 45, 78, 81, 85, 98, 101, 102, 109, 115, 122, 141, 152, 154nn. 3 and 7, 156n.11, 160n.15, 205n.23

England, 43, 44, 83–84, 105, 109, 175n.37

Enlightenment, 17, 43, 67–68, 81, 91, 92, 94, 100, 108, 136, 173n.19, 177n.56, 181n.2, 197n.71

Estienne, Charles, 147

ethnography, 138, 191n.37

Exposition artistique de l'Afrique française, 11

"Exposition au profit des Grecs," 105

Exposition Coloniale, 145

Exposition du centenaire de la conquête de l'Algérie, 1830–1930, 11

Fanon, Frantz, 148

Farcy, Charles, 187n.23

Férusac, baron de, 195n.56

Fontaine, Pierre-François-Léonard, 22–23, 111, 160n.13, 183n.7

Fontana, Domenico, 35, 38

Forbin, Auguste de, 84, 182–83n.6, 183n.7, 183–84n.8, 186n.19, 188n.26, 199n.79; *La Mort de Pline*, 187n.24

Fourier, Jean-Baptiste-Joseph, 30, 45, 101, 193n.44

Fragonard, Alexandre-Evariste, *Francis I Receiving the Pictures and Statues Brought from Italy by Primaticcio*, 85, 184n.8, 187n.24

Franque, Jean-Pierre, 7; *Allegory of the Condition of France before the Return from Egypt*, 74–76, 180n.75, fig. 40

Franque, Joseph, 180n.75; *Scene during the Eruption of Vesuvius*, 187n.24

Freud, Sigmund, 71, 159n.9, 161n.16, 179n.68

Fromentin, Eugène-Samuel-Auguste, 203–4n.20

Gabriel, Jacques-Ange, 17, 25

Gau, *Antiquités de la Nubie*, 165n.36

Gautier, Théophile, 162n.20

Gaza, 53

Géricault, Théodore, 179n.72, 204–5n.23; copy of *Battle of Nazareth* (Gros), 205n.26

Gérôme, Jean-Léon, 204n.20, *Snake Charmer*, 207n.43

Girodet (Girodet-Trioson), Anne-Louis, 7, 9, 56, 78, 178–79n.64; *Revolt of Cairo*, 7, 68–74, 115, 129, fig. 36

Giza, 61

Gosse, Nicolas-Louis, 185n.12

Gossman, Lionel, 196n.64

Grandet, Pierre, 191n.37

Grasilier, Léon, 194n.53

Greece, 8, 87, 109, 111, 127, 154n.3, 204n.22

Greece, ancient, 25, 81, 84, 91, 92, 93, 94, 95, 109, 136, 144, 186n.20, 188n.25, 208–9n.47. *See also* antiquities, Greek

Greek War of Independence, 78, 105, 128, 188n.26, 204–5n.23

Grégoire, Abbé, 154n.7

Greuze, Jean-Baptiste, 143–44; *The Broken Pitcher*, 144

Grigsby, Darcy Grimaldo, 173n.19

Gronkowski, Camille, 11

Gros, Antoine-Jean, 7, 9, 11, 47, 50, 51, 61, 67, 68, 72, 73, 78, 86, 98, 117, 121, 128, 129, 173n.19, 175n.35, 179n.71, 179–80n.74, 182n.4, 183n.7, 205n.23; *The Battle of Aboukir*, 50, 53, 115, 172n.18, 173n.19, 176n.49, 181n.80, fig. 26; *Battle of Eylau*, 173n.19; *The Battle of Nazareth*, 45–53, 56, 59, 61, 72, 78, 127, 171n.8, 172nn. 13 and 18, 179n.71, 205n.26, fig. 22; *Bonaparte at Arcole*, 199n.82; *General Bonaparte Visiting the Pesthouse at Jaffa*, 7, 53–61, 67, 78, 115, 128–29, 173n.19, 174n.31, 175n.38, figs. 27–29, 63; *The Genius of France Animating the Arts and Succoring Humanity*, 85, 111, fig. 60; *His Majesty Haranguing the Army before the Battle of the Pyramids*, 74–76, 173n.19, 180nn. 74 and 76, fig. 39; *The King Giving the Musée Charles X to the Arts*, 85, 97, 100, 105, 111, fig. 43; *Mars Crowned by Victory, Listening to Moderation*, 85, 195n.61

Guardi, Francesco, 132, 206n.29

Guérin, Pierre-Narcisse, 7, 78, 98, 177n.55, 190n.33; *Bonaparte Pardoning the Rebels in Cairo*, 68–74, 115, 178n.58, fig. 37

Guillotin, Joseph-Ignace, 18, 159n.9

guillotine, 18–19, 20, 21, 24, 159n.9

harem, 10, 117, 131–34, 135, 138, 140, 141, 148, 206nn. 29 and 31, 207n.41

Hautecoeur, Louis, 11

Hegel, Georg Wilhelm Friedrich, 28–29

Heim, François-Joseph, 92, 183n.7; *Vesuvius Receiving from Jupiter the Fire that Will Consume Herculaneum, Pompeii, and Stabia*, 92, fig. 47

Heliopolis, 13

Hemphill, Richard, 164n.26

Hennequin, Philippe-Auguste, 64; *Battle of the Pyramids*, 63–64, 176n.49, fig. 34

Herodotus, 108, 197n.71

Hersey, George L., 210n.53

history of civilization, cyclic, 7, 30, 31, 32, 56,

105, 112, 165n.36; Egypt's renewal under France, 30, 31, 32, 41, 44, 74, 76, 104, 112; modern France and ancient Egypt, 33, 35, 38, 63, 87, 104–5, 106, 108–9, 115, 167n.45, 169n.56, 192n.43; modern France and contemporary Orient, 32, 35, 71, 82, 84, 87, 108, 109, 137, 138, 156n.11, 161n.17; modern France and Islamic East, 26, 27, 44, 56, 61, 105, 170–71n.5
Hittorff, Jacques-Ignace, 15, 25, 28, 31, 38, 158n.2, 163n.22, 165nn. 32 and 36, 169n.57, fig. 2
Hollier, Denis, 161n.16
Homer, 50–51, 86, 95
Hugo, Victor, *Orientales,* 129, 162n.20
Humbert, Jean-Marcel, 181n.1

Imbaba, 61
imperialism, 8, 40, 43, 44, 84, 169n.56, 173n.19, 178n.63, 211n.62
imperialism, French, 6, 104–15, 128, 145, 153n.3; art in the service of, 4–5, 7, 10, 11, 41, 45–47, 51, 68, 78, 84, 106, 112–15, 119, 138, 154n.3, 156n.11; in the Mediterranean, 3, 41, 127; and national identity, 5, 33, 106, 147; in the Near East, 3, 4, 5, 7, 11, 31, 33, 40, 41, 45, 78, 82, 83, 105, 109, 128, 138, 167n.46; in North Africa, 4, 44, 127, 138, 140; and the Revolution, 5, 43. *See also* Algeria, French imperialism in
Ingres, Jean-Auguste-Dominique, 98, 122, 145, 182n.6, 183n.7, 208n.47; *Apotheosis of Homer,* 94–95, 188n.26, fig. 51; *Martyrdom of Saint Symphorian,* 122, fig. 67; *Oedipus and the Sphinx,* 98, 99, fig. 53
Institut d'Egypte, 45, 57, 101, 198n.76
Institut de France, 32, 45
Isabey, Louis-Eugène-Gabriel, 131, 206n.35
Istanbul, 44, 53, 204n.22

Jaffa, 53, 174n.23. *See also* Gros, *General Bonaparte Visiting the Pesthouse at Jaffa*
Jal, Auguste, 89, 108, 136, 189n.31, 195–96n.61
Joannis, Léon de, 35–36, 166n.51; lithograph, *Lowering of the Obelisk,* 33–36, fig. 18

Johnson, Lee, 205n.29, 208n.45
Julius II, Pope, 86
July Revolution, 4, 21, 22, 25, 78, 85, 97, 111, 122, 158n.2, 190n.33, 194n.51, 199n.79
Jung, Carl, 208n.43
Jung, T., *Erection of the Luxor Obelisk,* 37–38, fig. 19
Junot, Andoche, 47, 49, 51

Kaeppelin, *Erection of the Luxor Obelisk,* 37–38, fig. 19
Karnak, 45
Kemp, Wolfgang, 157n.1, 169n.58
Kléber, Jean-Baptiste, 112, 163n.22, 180n.76, 181n.1, 200n.83
Kriz, Kay Dian, 212n.6

Laborde, Alexandre-Louis-Joseph de, 13, 24, 33, 160n.15; *Description des obélisques de Louqsor,* 13, 32
Laffey, John, 153–54n.3
Lafitte, Louis, 181n.2, 200n.83
Lamennais, Félicité de, 95, 188n.28
Landon, Charles-Paul, 175n.40
Langlois, Eustache-Hyacinthe, 66, 211n.56
La Rochefoucauld, Sosthènes, vicomte de, 83, 84, 182n.6, 183–84n.8, 186n.19, 195n.56
Larrey, Dr. Dominique, 57, 59, 174n.23, 174–75n.34, 175n.43
Laviron, Gabriel, 134, 201n.9
Lebas, Apollinaire, 35, 38, 140–41, 168n.55
Leblond, Frédéric, 204n.22
Leclant, Jean, 198n.72
Lejeune, Louis-François, 61, 64, 65, 66, 67, 68, 73, 127, 177n.54, 211n.56; *Battle of Aboukir,* 175n.34; *Battle of Marengo,* 171n.8; *Battle of the Pyramids,* 61–68, 78, 176n.49, 180n.74, fig. 32
Lemot, François Frédéric, 18; statue of Liberty, 15, 18, 19, 34
Lenoir, Alexandre, 191n.37, 192n.38, 198n.75
Leo XII, Pope, 102
Lepère, J.-B., 165n.32
L'Hôte, Nestor, 100, 163n.23, 191nn. 37 and 38, 192n.43

Louis IX, King of France, 49

Louis XIV, King of France, 91, 137, 184n.11, 210n.55

Louis XV, King of France, 6, 17, 20, 82, 167n.43

Louis XVI, King of France, 6, 17, 19, 20–21, 82, 91, 159n.9

Louis XVIII, King of France, 8, 20, 24, 25, 30, 82, 83, 91, 159n.12, 166n.42, 181n.2, 193n.45, 200n.83

Louis-Philippe, King of France, 4, 6, 15–16, 19, 21, 22, 24, 25, 26, 40, 78, 104, 114, 119, 130, 160nn. 14 and 15, 166n.42, 180n.74, 181n.80, 181n.2, 199n.82, 206n.33, 208n.43

Louvion, J. B., *The Dagger of the Patriots Is the Hatchet of the Law,* 19, fig. 7

Louvre. *See* Musée du Louvre

Luxembourg Museum, 145

Luxor, 6, 13, 27, 28, 30, 31, 33, 38, 45, 74, 161n.18

Luxor temple, 6, 13, 33, 156n.1, 165n.32, 166n.42, fig. 16

McClellan, Andrew, 185n.15

Madeleine, church of the, 15, 17, 25, 40

Marie-Antoinette, Queen of France, 19, 82

Mars, Mlle (Anne-Françoise Boutet), 130–31, 206n.34

Martel, Charles, 137

Matisse, Henri, 145, 147, 148, 212nn. 2 and 3; *Odalisque in Red Trousers,* 145, 148, 152, fig. 80

Mauzaisse, Jean-Baptiste, *Le Code Napoléon couronné par le Temps,* 187–88n.25; *Time Displaying the Ruins that He Creates and the Masterpieces He Leaves to Discover,* 93, figs. 49 and 50; —, sketch for, 93–94, fig. 50

Meknès, 125

Melling, Antoine-Ignace, 133–34, 207n.41; *Interior of a Part of the Harem of the Grand-Seigneur,* 133, fig. 73; *Voyage Pittoresque de Constantinople et des rives du Bosphore,* 133

Mémoires de l'obélisque de Louqsor, 32, 33

Meniet, A., *Rape of the Sultan's Favorite,* 140, 141, fig. 74

Menu, Bernadette, 157n.1

Mérimée, J. F. L., 130; *De la peinture à l'huile,* 125

Merle, Marcel, 154n.7, 186n.20

Méry, Joseph, 167n.44, 168n.54

Meynier, Charles, *The Nymphs of Parthenope Carry the Penates and Are Driven by Minerva to the Banks of the Seine,* 86–87, 92–93, 196n.61, fig. 45

Miel, Edme, 13; *Le Constitutionnel,* 13, 38

military accomplishment, French, 7, 33, 40, 74, 111–15, 137, 141, 196n.61

Mirolli, Ruth, 160n.15

Mitchell, W. J. T., 211n.1

Mollaret, H., 174nn. 31 and 34, 175n.37

Monge, Gaspard, 45, 112

Mornay, Charles Edgar de, 130–31, 202n.14, 206n.33, 206n.34

Morocco, 10, 127, 130, 135, 138, 140, 145, 204n.22, 206n.33

mosque of El-Azhar, 68, 71

Mozart, Wolfgang Amadeus, 132

Muhammad Ali, Pasha of Egypt, 24, 111, 140, 161n.17, 162n.18, 186n.19, 194n.51, 198n.77, 208n.43

Murat, Joachim, King of Naples, 71

Musée Charles X, 84, 85, 86, 94, 95, 100, 105, 106, 121, 182nn. 4 and 6, 186n.19, 188n.25, 197n.65, 200n.83. *See also* Musée d'Egypte

Musée d'Egypte, 8, 9, 10, 78, 81–116, 122, 141, 158n.2, 160n.13, 182nn. 3 and 4, 199n.79; decorative program of, 81, 84–85, 86, 109, 183n.7; painting cycle of, 8–9, 82, 84, 85–95, 97, 99, 117, 122, 182n.6, 183n.8, 187n.24, fig. 44; painting cycle, critical response to, 86, 89, 108, 115–16. *See also* antiquities, Egyptian; Egyptology, French; Musée Charles X

Musée des Antiquités du Louvre, 91, 191n.38

Musée du Louvre, 8, 15, 81, 82, 84, 91, 94, 116, 121, 136, 151, 158n.2, 160n.13, 182n.3, 185n.15

Musée Ethnographique du Bardo, 123

Musée Ethnographique, Paris, 138

Musée Naval, Louvre, 27

Musée Royale, 91, 92, 183n.8

Musset, Alfred de, 78

Napoleon I, 24, 25, 26, 30, 33, 41, 43, 52, 53,
 61, 76, 81, 94, 101, 102, 114, 127, 166n.42,
 170n.3, 178n.58, 179–80n.74, 193n.46,
 198n.76; and coup of 18 brumaire, 8, 44–
 45, 76; and Egyptian campaign and occu-
 pation, 3, 5, 6, 8, 11, 29, 44, 45, 58, 68,
 71, 74, 76, 79, 83, 98, 112, 138, 154n.3,
 162n.18, 171nn. 5 and 6, 174nn. 23 and
 29, 174–75n.34, 181n.2; healing touch of,
 56, 58–61; image of, 56, 57, 58, 68, 71,
 72, 74, 76, 94, 102, 112, 114, 116, 178n.60,
 187n.25, 189–90n.33, 199n.82, 204n.22;
 as patron, 6, 22, 26, 45, 47, 53, 68, 81, 83,
 127, 178n.58; and Syrian campaign, 53–56,
 58, 59
Napoleonic regime, 3, 8, 9, 63, 76, 78, 82, 92,
 94, 111
Nazareth, 47, 49, 53
Nazareth, Battle of, 47, 53; and painting compe-
 tition, 47–49, 51, 53, 127, 173n.20
Nelson, Horatio, Lord, 44, 53
neoclassicism, 52, 53, 64, 81, 122, 155n.8
Niati, Houria, 150; *No to Torture*, 150, fig. 82
Nochlin, Linda, 8, 155–56n.9, 188n.26, 207–
 8n.43

Obelisk at the Place de la Concorde, 6, 13–41,
 74, 78, 104, 132, 156–57n.1, 160n.15,
 161n.16, 162n.20, 166n.42, 169nn. 56 and
 58, 211n.56; acquisition and removal of,
 24–25, 28, 29, 30, 31, 33, 34, 35, 37, 140–
 41, 166n.42, 166n.48, 208n.43; antiquity
 and history of, 25, 28–29, 31, 33, 163n.22;
 as apolitical, 6, 15, 24, 25, 27, 157n.1,
 160n.15, 161n.17; and Egyptian campaign,
 24, 28–31, 33, 104, 162n.18, 165n.36,
 166nn. 37 and 42; inscriptions on, 28, 31,
 38–40, 140, 169n.57, figs. 20 and 21; instal-
 lation and erection of, 13, 29, 34, 35, 37–
 38, 40, 166n.42, 169n.56; and Ramses the
 Great, 29, 31, 32, 33, 38–40; situation of,
 13–15, 22–24, 25, 158n.2; textual associa-
 tions of, 28, 29, 31, 32–34, 35, 41, 134,

140–41, 156n.1
obelisks, 25, 27, 31, 34, 95–96, 132, 158n.2,
 161nn. 17 and 18, 162n.18, 163nn. 22 and
 23, 164n.25, 189n.31; in art, 6, 20, 26, 89,
 93, 94, 141; in Louis-Philippe's programs,
 26–27; in Napoleonic programs, 26,
 163n.22; papal Roman use of, 25–26;
 Roman acquisition of, 25, 34, 166n.42;
 as victory trophies, 25, 27, 30, 31, 32, 141,
 166n.42. *See also* Champollion, design of
 obelisk of Charles X
Ojalvo, David, 189n.33
Orientalism, 8, 96, 101, 132, 133, 134, 145, 147,
 150, 155–56n.9, 156n.11, 166n.51, 170n.3,
 175n.34, 177–78n.56, 204–5n.23
Orientalist painting, 11, 73, 115–16, 121, 122,
 129, 135, 145, 148, 150, 155n.9, 156n.11,
 208n.47, 212n.4; authenticity of, 7, 8, 66,
 73, 115, 121–23, 127, 131, 133, 135, 155n.8,
 203–4n.20; origins of, 8, 10, 73, 115, 121–
 22, 127, 179n.72
Orléans, duc d' (Philippe Egalité), 19
Ottoman Empire, 8, 44, 78, 105, 111, 128, 134,
 154n.3, 198n.77, 204n.23. *See also* Greek
 War of Independence

Palais Bourbon, 137. *See also* Assemblée Nationale
Pasha of Egypt. *See* Muhammad Ali
Peisse, Louis, 115
pharaohs, 15, 27, 38, 63, 89, 95, 100, 102, 103,
 106–8, 114, 163n.22. *See also* Egypt,
 Pharaonic; Ramses the Great; Sesostris
Philipon, Charles, 21–22, 37; *Monument Expia-
 poire*, 21–22, 37, 159n.12, fig. 10
Picasso, Pablo, 11, 147, 150; *Guernica*, 148; series,
 Women of Algiers, 147–48, 150; *The Women of
 Algiers, "O,"* 148, fig. 81
Picot, François-Edouard, 8–9, 134, 182n.4,
 183n.6, 184n.8, 185n.12, 187n.24; *Cybele
 Opposing Vesuvius to Protect the Cities of Stabia,
 Herculaneum, Pompeii, and Resina*, 85, 93,
 fig. 48; *The Death of Jacob*, 185n.12; *Study
 Crowned with Laurels and the Genius of the Arts
 Unveiling Ancient Egypt for Greece*, 85, 87–91,
 95, 96–97, 106, 108–9, 114, fig. 46

Pigeory, Félix, 166n.42

Pius VII, Pope, 76, 188n.25

Piussi, Ann Ruth, 171n.6, 181n.2

Place de la Concorde, 5, 13–15, 26, 29, 82, 141, 160n.14, 161n.15, 210n.53, fig. 2; Directory monument for, 20, 33–34; history of, 6, 15–24, 31, 41, 157n.1; July Monarchy program for, 6, 15–16, 24, 28, 34, 40, 43, 157n.1, fig. 11

Place de la Révolution, 6, 11, 16, 18, 19, 21, 72

Place des Victoires, 26, 86, 163n.22

Place des Vosges, 17

Place du Carroussel, 19

Place Louis XV, 6, 16–17, 20, 82, 86, fig. 3

Place Louis XVI, 16, 20

Place Royale, 17, 86

Planche, Gustave, 122, 127, 134, 208n.45

Pliny the Elder, 34

Pont Neuf, 26

Porter, Sir Robert Ker, *Travels in Georgia, Persia, Armenia, Ancient Babylon, etc.,* 130, 206nn. 30 and 31

Pradier, Jean-Jacques, 184n.11

Pujol. *See* Abel de Pujol

Pyramids, 13, 61, 63, 64, 76, 89, 127, 180n.74, 194n.51, 211n.56

Pyramids, Battle of the, 32, 61–64, 180n.74

Quatremère de Quincy, Antoine-Chrysostome, 186n.17

Quinet, Edgar, 175n.34

Racine, Jean, 132, 195n.58

Ramses the Great, 29, 30, 31, 32, 33, 40. *See also* Sesostris

Realism, 122

Regnier (Reynier), Jean-Louis, 61

Republic, the, 19, 101

Revolution of 1848, 119

Richard, Adolphe, *Les Fruits de la victoire,* 138, fig. 75

Rigo, Jules-Alfred-Vincent, *The Clemency of His Majesty the Emperor toward an Arab Family,* 178n.60; *The Clemency of His Majesty the Emperor toward the Divan in Egypt,* 178n.60

Robespierre, Maximilien, 9, 20

Robespierre Guillotining the Executioner, 20, fig. 8

Romanticism, 8, 10, 29, 33, 52, 61, 67, 68, 78, 86, 96, 105, 119, 122, 128, 134, 163n.35, 167n.48, 173n.19, 179n.72, 185n.13, 195n.58, 197n.64, 203n.19, 204–5n.23

Rome, 6, 87, 102, 135, 136, 164n.25, 169n.56, 188n.25, 197nn. 64 and 65, 200n.87

Rome, ancient, 10, 13, 25, 34, 81, 84, 87, 91, 92, 93, 94, 95, 109, 136, 137, 144, 169n.56, 186n.20, 188n.25, 208–9n.47. *See also* antiquities, Roman

Rome, imperial, 15, 25, 27, 163n.22

Rosetta stone, 8, 45

Rosset, 205n.29, 207n.41; *Moeurs et Coutumes Turques et Orientales,* 130; *Turk with His Wives,* 132, fig. 72

Roubaud, Benjamin, *An Oriental Delight,* 138, fig. 77

Royer-Collard, Pierre-Paul, 195n.58

Sacy, Silvestre de, 101

Sahut, M. C., 189n.31

Said, Edward, 8, 155–56n.9, 170n.3, 175n.34, 177n.56, 204n.20, 205n.28

Saint-Denis, church of, 82

St. Peter's square, 25; obelisk in, 25, 35, 163n.22

Salons, 7, 8, 41, 45, 61, 79, 98, 144; of 1801, 47, 50, 52, 53, 72; of 1804, 47, 58, 59, 65; of 1806, 50, 61, 63, 65, 172n.18, 176n.49, 178n.60, 180n.74; of 1808, 68, 72; of 1810, 74, 76, 175n.34, 177n.55, 197n.65; of 1812, 178n.60; of 1824, 128; of 1822, 197n.65; of 1827, 85, 86, 100, 108, 185n.12; of 1827–28, 98, 117; of 1828, 89, 98, 190n.35; of 1831, 85, 119; of 1833, 185n.12; of 1834, 111, 116, 119, 121, 134, 201nn. 6 and 7

Salt collection, 92

Sardanapalus, 117, 125. *See also* Delacroix, *Death of Sardanapalus*

Schlenoff, Norman, 175nn. 35 and 37, 179n.71

Schneider, Donald David, 157n.1, 161n.17, 163n.22

scientific accomplishment, French, 7, 13, 15, 34–36, 56–58, 61, 84, 98, 99, 101, 105, 111,

137, 141, 169n.56; and Near East, 57, 115. *See also* technology and Near East

Sébastiani, François-Horace-Bastien, 78

Sebbar, Leïla, *Sherazade,* 150–52

Senefelder, Alois, 66

Sérullaz, Maurice, 203–4n.19

Sesostris, 30, 31, 38–40, 74. *See also* Ramses the Great

Siegfried, Susan Locke, 67, 173n.20

Signac, Paul, 203n.19

Siméon, vicomte de, 25, 168n.55

Sphinx, 99, 197n.71

Stafford, Barbara Maria, 177–78n.56, 202–3n.16, 203–4n.20

Steuben, 109, 111

Stevens, Mary Anne, 155n.9

Sturken, Marita, 161n.16

Suez Canal, 44, 116, 198n.76

Sultan of Morocco, 130, 206n.33

Syrian campaign, 53–55, 59, 68, 78

Syrian campaign, paintings of, 6–7, 45, 47, 53, 68, 72, 76–78. *See also* Egyptian campaign, paintings of

Talleyrand, Charles-Maurice de, 44, 74, 101

Tardieu, A., 115, 134

Taunay, Nicolas-Antoine, 173n.20

Taylor, Baron, 162n.18, 165n.37

technology and Near East, 38, 40, 74, 169n.56, 198n.77; and removal of obelisk, 34, 35, 37–38, 168n.49

Terror, the, 19, 20, 101, 195n.56

Thebes, 13, 30, 32, 37, 45, 111–12, 161n.17

Thierry, Augustin, 195n.58

Thiers, Adolphe, 15, 21, 25, 38, 40, 41, 43, 44, 115, 157n.2, 163n.22, 168n.55

Tocqueville, Alexis de, 5, 6, 15, 154n.5

Triple Alliance, 105, 109, 182n.6, 196n.63

Tripoli, 41

Tuileries palace, 15, 17, 40, 169n.58

Tunis, 41

Ultras, 102–3, 105, 194n.51

Valenciennes, Pierre-Henri de, 65, 66, 68

Van Mour (Vanmour), Jean-Baptiste, 206n.29

Vatican, 76, 171n.5, 187n.25, 197n.65. *See also* St. Peter's Square

Veit, Philip, *Colosseum Restored,* 187n.25

Vendôme column, 32

Venus, Medici, 81

Venus de Milo, 93, 94

Vernet, Horace-Emile-Jean, 66, 179n.72, 182n.4, 204–5n.23; *Julius II Giving Wreaths and According Honors to Michelangelo and Raphael,* 85, 183n.8, fig. 44

Vernet, Joseph, 68

Versailles, 53, 177n.55, 180n.74, 181n.80

Vessière, Monsieur, 36

Viard, 190n.35

Villèle, comte de, 196n.63

Villot, Frédéric, 136

Vincent, François-André, *Battle of the Pyramids,* 63, 176n.49, 180n.74, 185n.12, fig. 33

Vinchon, Auguste-Jean-Baptiste, 185n.12

Volney, C. F., 43, 44, 76, 108, 167n.46, 197n.71; *Les Ruines,* 30

Watteau, François-Louis-Joseph, 180n.74

Weber, Max, 4–5, 171n.7, 178–79n.63

Wein, Jo Ann, 205n.28, 208n.45

West, Benjamin, 135

White, Hayden, 172n.13

Winckelmann, Johann Joachim, 187n.21, 191n.36

Wollen, Peter, 201n.2

women, Algerian, 11, 131–32, 135, 138, 140, 147–48, 150–52. *See also* Delacroix, *Women of Algiers*

women, Oriental, Western image of, 11, 36–37, 131–32, 134, 138, 143–44, 145, 147, 148, 150, 152, 166n.51

Woolf, Stewart, 170n.4, 180n.78

zodiac of Denderah, 186n.17, 194n.51

Photography Credits

Bibliothèque Nationale, Paris (figs. 3, 9, 11, 12, 13, 15, 16, 18, 30, 38, 41, 72, 73, 75)

Caisse Nationale des Monuments Historiques et des Sites, Paris (figs. 44 [top right, center right, bottom left, bottom center], 45, 47, 48, 57, 58 [bottom], 61, 63)

Christie's Images, New York: © 1998 Estate of Pablo Picasso/Artists Rights Society (ARS), New York (fig. 81)

H. D. Connelly (figs. 42, 62, 79)

Giraudon (fig. 29)

International Council for Women in the Arts (fig. 82)

Musée de l'Armée, Paris (fig. 35)

Musée Denon, Châlon-sur-Saône (fig. 55)

Musée des Beaux-Arts, Nantes (fig. 23); photo P. Jean (figs. 22, 24)

Musée des Beaux-Arts, Orleans (fig. 52)

Musée National d'Art Moderne, Centre Georges Pompidou, Paris: © 1998 Succession H. Matisse, Paris/Artists Rights Society (ARS), New York (fig. 80)

Musées de la Ville de Paris (figs. 4, 8, 17); photo Briant (fig. 7); photo Habouzit (figs. 10, 14, 19, 74, 76, 77); photo Joffre (fig. 78); photo Pierrain (fig. 6); photo Toumazet (fig. 5)

Musée du Louvre, Paris: photo Etienne Revault (fig. 46)

National Gallery, London (fig. 68)

New Orleans Museum of Art (fig. 28)

Réunion des Musées Nationaux, Paris (figs. 1, 25, 26, 27, 31, 32, 33, 34, 36, 37, 39, 40, 43, 44 [top left, top center, center left, center, bottom right], 49, 50, 51, 53, 54, 58 [top], 59, 60, 64, 65, 66, 67, 69, 70, 71)

Wallraf-Richartz Museum, Cologne (fig. 2)